花樓

圖機花

鉄鈴

老鴉翅

澁木

樓門

衝盤

坑

衢腳

坑

包頭機此處
不低斜下安
兩腳

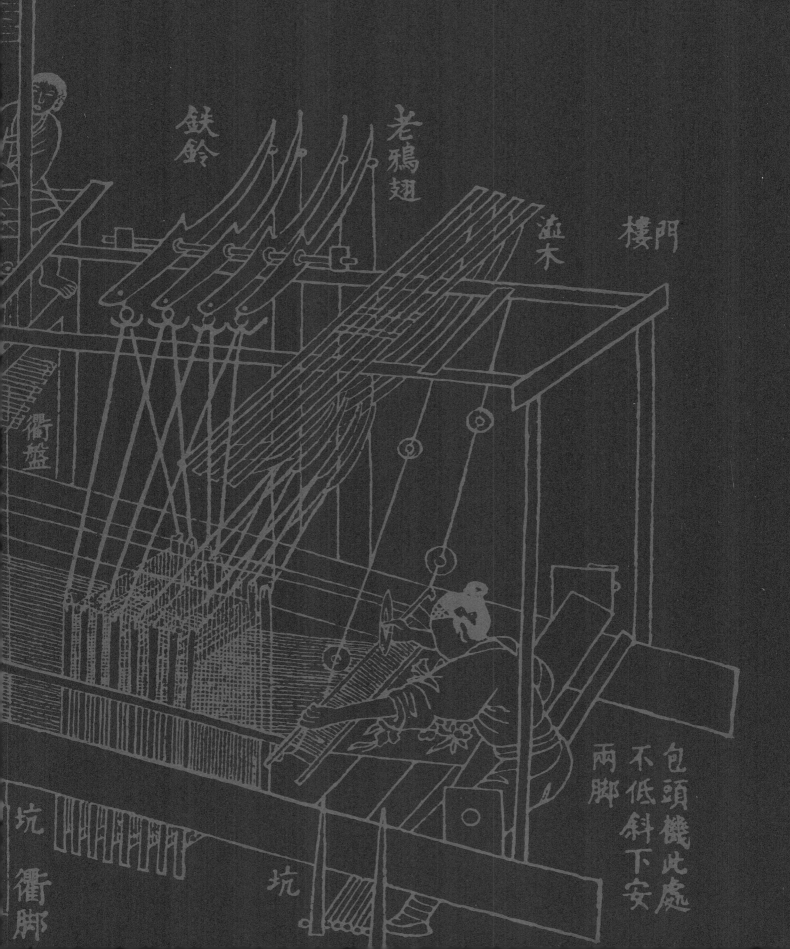

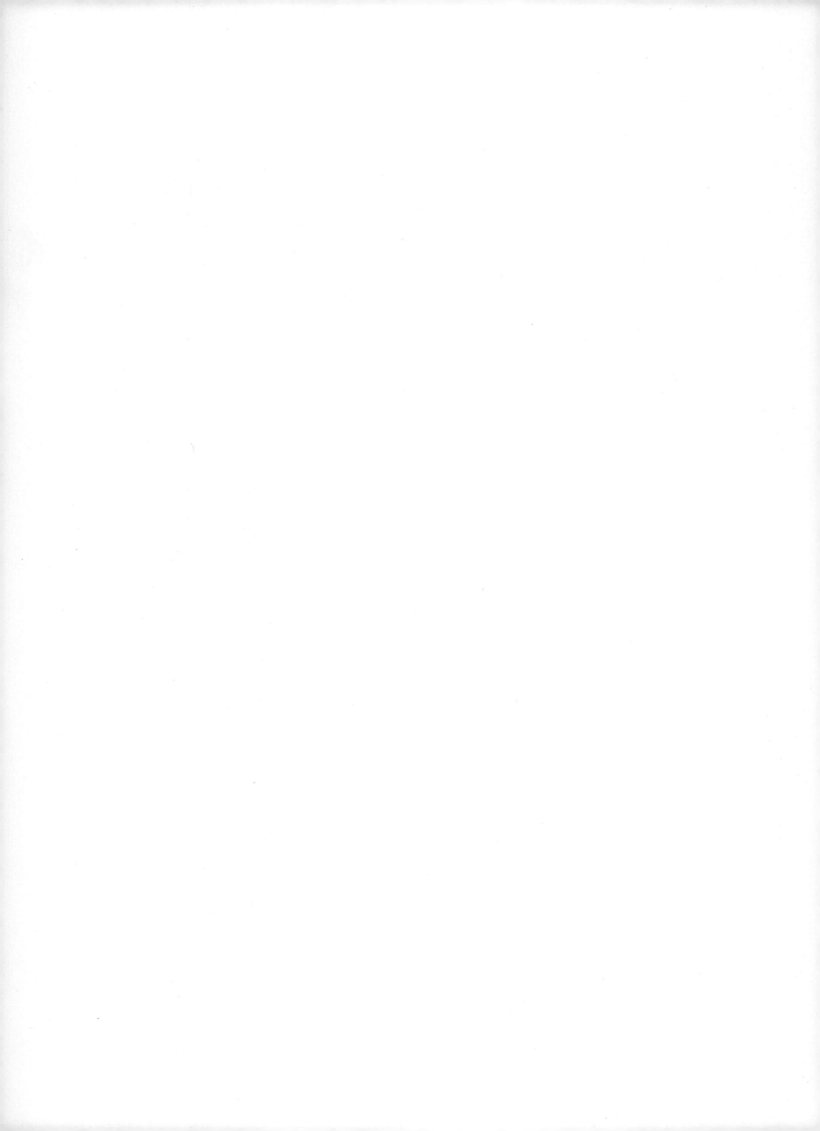

Chinese Textile Designs

Gao Hanyu

Translated by Rosemary Scott and Susan Whitfield

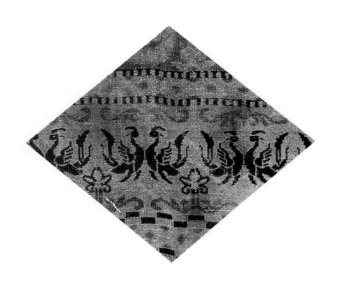

VIKING

Acknowledgements

I embarked on my research into the history of Chinese textile technology under the enlightened guidance of several respected teachers and experts in the fields of spinning, weaving and dyeing in China, in particular Professor Chen Weiji, deputy head of the Textile Industry Bureau; Wang Yeqiu, head of the National Relics Management Bureau; and Sun Yiqing and Zhuang Min, respectively head and deputy head of the Bureau of Primary National Relics. I was also given instruction by Professor Xia Nai, vice-principal of the Chinese Academy of Social Sciences, on the archaeology of spinning and weaving, and this made me resolve to devote my life to research into the history of spinning and weaving in ancient China.

During the course of my work on this current volume, I also received the support, guidance and help of the Chinese Historical Museum, the Palace Museum (Beijing), Hunan Provincial Museum, Fujian Provincial Museum, Xinjiang Archaeological Research Institute, Xinjiang Uighur Autonomous Region Museum, Chengde Bishushanzhuang Palace Museum, Liaoning Provincial Museum, Dunhuang Cultural Relics Research Institute, Dunhuang County Museum, Hubei Provincial Museum, Suzhou Museum, Zhenjiang Museum, Zhejiang Museum, Zhejiang Library, Henan Xinyang Cultural Palace and Henan Sheqi Cultural Palace. I would like to offer all of them my sincere and heartfelt thanks.

The fact that this book was completed for publication was due to the devoted guidance given by Wang Guozhong, head of the Shanghai City Publishing House; Xu Fusheng and Gao Xiaozhan of the Shanghai Science and Technology Publishing House; the Shanghai Textile Scientific Research Institute; and all my colleagues at the Textile History Research Organization who gave me their unstinting support throughout the project. In addition, Xu Jin expended considerable effort and skill in the production of the illustrations. To these and to all the others, I would like to say thank you.

Gao Hanyu

VIKING

Published by the Penguin Group
Penguin Books Ltd, 27 Wrights Lane, London W8 5TZ, England
Penguin Books USA Inc., 375 Hudson Street, New York, New York 10014, USA
Penguin Books Australia Ltd, Ringwood, Victoria, Australia
Penguin Books Canada Ltd, 10 Alcorn Avenue, Toronto, Ontario, Canada MV4 3B2
Penguin Books (NZ) Ltd, 182–190 Wairau Road, Auckland 10, New Zealand

Penguin Books Ltd, Registered Offices: Harmondsworth, Middlesex, England

First published in Chinese under the title *Zhongguo Lidai Zhi Ran Xiu Tulu*
by The Commercial Press Ltd, Hong Kong Branch, 1986
This translation first published in Great Britain by Viking 1992

1 3 5 7 9 10 8 6 4 2

Typeset in Linotron Trump Mediaeval by Wyvern Typesetting Ltd, Bristol, UK
Colour Separation by Goody Color Separation (Scanner) Ltd, Hong Kong
Printed in Hong Kong by C & C Joint Printing Co. (H.K.) Ltd

A CIP catalogue record for this book is available from the British Library

Library of Congress Catalog Card No. 88–51494

ISBN 0–670–81897–6

Contents

Preface

China has historically been known as 'the silk country'. The history of weaving, embroidery and dyeing of silk through successive dynasties encompasses some of the most valuable technological developments of ancient China. As early as the fourth or fifth centuries BC, the rich, multicoloured designs of woven, printed and embroidered silks travelled across Asia along the Silk Road and were disseminated to almost every country in Asia, Europe and Africa. To this day China's silks and embroideries are world renowned. The beautiful brocades, regarded by many as pearls of Eastern craftsmanship, have had, and are still having, a far-reaching influence on the textile industries of the world.

Internationally, students researching the historical development of ancient cultures have placed great importance on the textile relics of China. Major museums in France, Sweden, Great Britain, the USSR, the USA, India, Syria and Japan all greatly value their collections of woven, dyed and embroidered Chinese textiles. For the last several decades, researchers of many nations have devoted considerable attention to the study of this aspect of Chinese culture. The following paragraphs provide a necessarily brief summary of that research.

In 1937 the Swedish archaeologist Vivi Sylwan published a paper, 'Silk from the Yin Dynasty', on his research into the textiles of that period. In 1949 he followed this up with a monograph, *Investigation of Silk from Edsen-Gol and Lop-nor*, concerned with excavations from these sites in Xinjiang Province. In 1961 the Russian scholar Professor E. Lubo-Lesnichenko published *Catalogue of Chinese Silks and Embroideries of the Chan-kuo and Han Collection in the Hermitage Museum*. Japanese archaeologists published *Ancient Chinese Spun Silk* in 1947; Professor Yoshiko Harada published *Han Dynasty Silks* in 1962 and, among his other papers, 'Chinese Dress and Personal Ornaments of the Six Dynasties' in 1966. Thereafter, Professor Satō Taketoshi of Osaka University directed his attention to the collection of ancient Chinese historical material and, combining the work of several excavations, published *Research into Ancient Chinese Spun Silks*. Subsequently, 106 items of ancient Chinese silk and embroidered objects were removed from the Mogao Caves at Dunhuang in China and taken to Paris, where they were analysed, investigated and put into systematic order. The research was published in *Tissus de Touen-houang Mission Paul Pelliot*, Vol. 13, by K. Ribond, G. Vial and M. Hallade, which appeared in 1970. In 1979 Dr Junro Nunome of the Kyoto Technical University published the fruits of over forty years of research in *The Origin of Sericulture and Ancient Silks*. In this well-illustrated book he describes the results obtained using modern technology to carry out scientific analyses of 102 items of silk dating from Tang and Song times from among the 3000 specimens of textiles housed in the Shōsō-in in Nara, Japan.

During the 1970s, as a result of the increasing interest in the Silk Road, many academics from a number of countries visited the important sites and ruins along the route in Shaanxi, Anhui and Xinjiang to gather material for research on the culture, technology and religion of the region. Several hundred papers on various aspects of the areas concerned were published. Many countries, of which Japan was one, also established research groups and large organizations to study the ancient history of Dunhuang and Turfan with the aim of making a systematic study of this area of increasing interest.

Up to this time, however, there had been no comprehensive study of the scientific, technological, cultural and artistic significance of the silks and embroideries of the Han and Tang dynasties excavated at sites along the ancient Silk Route. In 1972 the present author took part in the investigation and appraisal of the silk textiles excavated from Han tomb No. 1 at Mawangdui, Changsha, Hunan Province. After five years of research, in 1980, 'A Study of the Textiles Unearthed from Han tomb No. 1 at Mawangdui, Changsha' was published by the Cultural Relics Publishing House. Papers such as this one, dealing with classifications within a specific period, are relatively rare. Publications which take the form of a pictorial record are even less common. One such work, however, is *The Silk Road: Silks from Han to Tang* published in 1972, also by the Cultural Relics Publishing House, and containing some sixty-six illustrations – which were later reprinted by a Japanese organization. In 1976 Japanese scholars managed to assemble a systematic catalogue of the Chinese silks held in Japanese collections. The work was called *Chinese Dyed Silks* and used illustrations to supplement the text. In 1982 a further volume was published by the Japan Study Research House, which contained over ninety illustrations of tapestries and embroideries from the Song to Qing dynasties, in the collection of the Liaoning Museum. In addition, a Chinese American, Li Ru Kuan, spent several years collecting and recording objects mainly from the Qing period. His *Blankets from the Region West of the Great Wall* is the only pictorial introductory record of woven woollen textiles.

The present author has for many years been studying the technological history of spinning and weaving in China. Following some ten years of concentrated research into dyed and embroidered silks and tapestries, and also into related media and extant texts, the author has striven to elucidate the historical development of weaving and dyeing skills in China during successive dynasties. The 275 colour

photographs which have been carefully selected to illustrate *Chinese Textile Designs* are, for the most part, being published for the first time, so that the book is, in itself, an important cultural record. It is hoped, therefore, not only that this volume will provide a comprehensive introduction to the history of Chinese textiles through the ages, their development and the dissemination of the technology and decorative skills involved in their production, but also that the high quality of photographic reproduction will, in itself, be seen as a work of art of some merit.

Although China is the birthplace of silk production, preserved examples of ancient silks are rare compared with the number of ancient ceramics, lacquerware and bronzes still in existence. Although many of these artefacts have undergone burial for long periods, silks are the most liable to suffer damage and disintegration. There are some excavated relics which have been above ground for barely ten years and yet already show signs of becoming fragile and damaged. Archaeologists, historians and art historians are, therefore, working alongside museums, collectors and connoisseurs from all countries to collect and research the silk fabrics. Aided by this cross-cultural cooperation, they are carrying out a systematic analysis and producing meticulous publications, striving to record the original appearance of ancient silks for the benefit of future generations. This publication shares that aim.

Translators' Note

Several complications arise in translation from Chinese into English that do not occur in translation between European languages. One such problem is that Chinese characters physically occupy less space than the equivalent English and so a certain amount of abridgement of the text of this volume has been necessary.

In romanizing Chinese names and terms the *pinyin* system, which is the most universally accepted, has been used. In this system, as in all others, different characters are often romanized in the same way. This allows many puns in Chinese, but also means that more than one definition may occur under a single entry in the glossary.

Chinese emperors are most usually referred to by their reign names rather than their personal names, and hence 'the Kangxi Emperor' would be the correct form. However, since this sounds awkward in English, the more familiar form, 'the emperor Kangxi', has been used.

Chronology

Neolithic period	*c.*7000–*c.*1600 BC
(Xia Dynasty	*c.*2100–*c.*1600 BC)
Shang Dynasty	*c.*1600–1027 BC
Western Zhou	1027–771 BC
Eastern Zhou	770–256 BC
Spring and Autumn Annals period	770–476 BC
Warring States period	475–221 BC
Qin Dynasty	221–206 BC
Western Han	206 BC–AD 8
Xin Dynasty (Wang Mang interregnum)	AD 9–23
Eastern Han	25–220
Three Kingdoms period	220–280
Western Jin	265–316
Eastern Jin	317–420
Northern and Southern Dynasties	420–580
Northern Dynasties	
Northern Wei	386–534
Eastern Wei	534–550
Western Wei	535–556
Northern Qi	550–577
Northern Zhou	557–580
Southern Dynasties	
Song	420–479
Qi	479–502
Liang	502–557
Chen	557–589
Sui Dynasty	581–618
Tang Dynasty	618–907
Five Dynasties period	907–960
Liao Dynasty	907–1125
Song Dynasty	960–1279
Northern Song	960–1127
Southern Song	1127–1279
Jin Dynasty	1115–1234
Yuan Dynasty	1279–1368
Ming Dynasty	1368–1644
Qing Dynasty	1644–1911

1

A General Survey

Early Skills

By the middle of the palaeolithic period – about 500,000 years ago – the early peoples who lived on the banks of the Yellow River were already able to make nets and corded implements. Over 1000 stone balls have been excavated from the remains of cave dwellings at Datong in Shanxi Province, which it has been suggested were used as weights attached to nets to throw over wild animals during hunting. The fibre used to make these nets was, at first, made from the entire liana plant, but later it was made using only the outer part of the stalk, shredding it finely and then joining the strands together by rolling and pinching them it between the fingers.

Man had always used grasses, leaves and animal skins as he found them to provide shelter and warmth. By the end of the palaeolithic period, he had acquired plaiting and sewing skills too. Fibres, cord, plant stems, grasses, leaves and small strips of animal skin were combined to form larger strips of material that could be wrapped around the body. In the early periods sewing was done using an awl to make the holes, and then cord or animal tendons were passed through the holes. Stone awls and bone needles have been discovered at the palaeolithic site at Zhoukoudian near Beijing. One needle is 82 mm long and 3.2 mm at its thickest point. It is smooth with a fairly small, narrow eye and has a reasonably sharp point. Some scholars believe that this needle was used by Peking man to weave, and if this is correct the needle predates the spindle as the earliest weaving implement.

With the arrival of the neolithic period, small communities began to establish themselves and, successively, primitive agriculture and animal husbandry began to be practised. As a result the demand for basic necessities increased. In terms of textiles this came to involve the growing of hemp to twist into rope, the raising of sheep to get wool and the rearing of silkworms for silk. At the same time, some of the more basic implements used in the spinning and weaving of cloth were invented and efficiency in the production of silk and other woven materials was considerably enhanced. An elaboration of these developments in the neolithic period can be divided into three stages, as follows.

1. Spinning and silk-reeling

Building on his experience of rubbing hemp between the hands to produce cord, man developed these skills. The twisted hemp thread was the product of beating and then loosening the hemp fibres or peeling the stalks and outer layers of the plants and then splitting or tearing them to form fine strips, which were combined to form a continuous yarn. The earliest examples in China of this type of textile fibre are made from hemp, kudzu vine, ramie (Chinese grass), piemarker and other bast-fibre plants. The traditional skills in the twisting of hemp fibres, or spinning, have not, even today, been completely replaced by mechanization.

In time, however, it was found that the tension produced by a rotating body facilitated quicker and more even spinning. This rotating body was generally made from stone, wood, clay or bone. It was round and was known as a spindle whorl. A stick was inserted through the middle of the spindle whorl to allow winding of the thread and this was called a spindle rod, or rotating rod. The spindle whorl and rod together were called the spinning *zhuan*, or the *wa*. A great number of these spindle whorls have been excavated at Cishan in Hebei Province dating from at least 5000 BC. The somewhat later site at Hemudu in Zhejiang Province, dating from about 4700 BC, has yielded several notched spindle whorls made of red earthenware, as well as objects made of plied piemarker yarn. From other sites, grey, black and multicoloured earthenware spindle whorls have subsequently been excavated, some engraved with a variety of geometric designs. The non-Han peoples of Xinjiang, Gansu, Qinghai and other provinces continued even after the neolithic period to use the hand spindle to spin coarse, rather distinctive yarn from sheep's wool, a practice that has continued in some areas to the present day.

It is generally believed that sericulture was already being practised at the time of the Yellow Emperor (taken as some time in the neolithic period). There are a number of excavated items which support this view, such as a small ivory cup from Hemudu (dating from at least 4000 BC), on which a silkworm design has been carved, and a silk woven fabric with a twisted warp, dating from about 3500 BC, which was found at Qingzhi in Henan Province. Also, from about 2800 BC, a silk sash, silk fibres and silk tabby weaves were found at Qianshanyang in Zhejiang Province.

There are many different species of silkworm, the finest silk being produced by those fed on a diet consisting mainly of mulberry leaves. The two principal components of the silkworm's cocoon are the silk filament and the sericin, or gum, that binds the filament cocoon together. Since the sericin softens and dissolves in water, it is easy to reel off the silk filament by immersing the cocoons in water, enabling the silk fibres to be separated out. Even before the Xia dynasty the Chinese people had discovered this fact, and from it developed the technique of using boiling water to reel off the silk. Two small brushes

excavated from Qianshanyang closely resemble the cord brushes used for the reeling of silk in later times. The pictographic character *sao* (to reel silk), which has been found in Shang-dynasty oracle-bone and shell inscriptions, looks as if it could represent a reeling cauldron with water and cocoons, a *zhen*, or probe (to lift the threads), and what look like hands drawing off the silk.

2. From braiding and hand-weaving to the simple loom

Weaving skills were developed from the braiding and weaving of the nets, baskets and mats used by fishermen and hunters. In the 'Xici' chapter of the *Yi Jing* (*Book of Changes*) it says of Fuxi that he braided fibres in order to make nets for fishing. At an early neolithic site at Hemudu, some fragments of woven reed mat have been excavated. In addition, many neolithic sites have produced considerable numbers of pottery utensils with the marks of woven or braided material impressed into the clay. From careful examination of these impressions as well as the few remaining fragments, it is possible to see that by this time primitive fabrics had been superseded by bast fibres and silk. The weaves too had developed, from plain weaves to those that could produce patterns.

The most primitive form of weaving did not make use of implements. Using only the hands, the warp threads were held taut and in order and then raised one at a time to allow the weft thread to be passed from side to side. Gradually implements came to be developed to make this process easier. First, a shed stick was used to divide the odd and even warp threads, the literal translation of its name being 'divide-pattern stick'. When this stick was raised or lowered, a shed was formed through which the weft thread could be passed. A further development was the use of a rod with loops of thread hanging from it through which individual warp threads could be passed. Since this facilitated an exchange of position between the upper and lower warps, thereby forming a new shed for the weft thread, the inconvenience of moving individual warps was avoided, and efficiency was considerably increased. This device was called a heddle rod and could be made from either wood or bamboo.

When there were many warp threads pulled by one heddle rod it was called a combined heddle. In order to produce a decorative design, several heddle rods could be used and, by separating out several groups of warp threads, each on a separate heddle, and controlling these by lifting the heddle rods in a specific series, different, fairly simple designs could be produced. After the weft thread had been passed through the shed, a flat blade-like stick called a sword-beater was used to beat the weft into position. Sometimes the ends of the warp threads were tied fast to a wooden stake or post, while for other types of weaving the warps were wound around a wooden pole, called a warp beam, securely fixed between two uprights. The end which had already been woven could be wrapped around another beam, called a cloth beam. With a primitive body-tensioned, foot-braced loom the ends of the warp threads were attached to the weaver's waist, and the warps were held taut by the weaver treading the pole around which the warp was looped under her feet. Parts of primitive looms, about 7000 years old, have been identified from excavations at Hemudu, including heddle rods, warp beams, sword-beaters and a bent wooden stick used to draw the weft. These loom parts closely resemble the major components of waist looms which are still in use today among non-Han Chinese people of every region. The sorts of loom mentioned, with only a few minor amendments, would have been able to produce the kind of geometrically patterned silk fabrics and the meander- and rhomboid-patterned damasks that have been excavated from the Shang-dynasty site at Anyang, Henan Province.

3. From applying colours to using dye

Primitive peoples have often chosen a natural object – frequently an animal – to be a symbol or emblem of their family, tribe or clan. This natural object then becomes imbued with socio-symbolic significance and is known as a totem. The Chinese Xia family, for example, are believed in remote antiquity to have used a snake as their totem, while the Eastern Yi people took the phoenix. Images of these totems were often depicted on buildings or vessels, using the juice of plants and powdered minerals to produce different colours. Examples are the fish designs on painted pottery of the Yangshao culture found at Banpo, the depiction of a man's head on pottery from Majiayao and the red, orange and yellow abstract designs on spindle whorls excavated at Qujialing. In activities like these the seeds of dyeing technology were sown.

Cinnabar (mercuric sulphide) has been found scattered under a male corpse of the neolithic period excavated at Ledu in Qinghai Province. This was the most widely used mineral for colouring woven materials, clothes and personal adornments in the era of China's slave-owning society. Other finds have been a stone mortar and pestle which had been used for grinding red mineral colours, unearthed at Xiyicun in Shandong Province, and a set of colour painting implements, including some black pigment (manganese oxide), an inkstone and a pottery cup, from Jiangzhou in Shaanxi Province. The earliest method of dyeing was to apply the dye like paint. At a site at Qingtai in Henan Province (dating from about 3500 BC) gauze fabrics have been found which are deep red through the application of dye. Traces of dyed red colour can also be seen on strips of thin silk and silk cord excavated at Qianshanyang.

Technical Progress

Science and technology, as well as economics and culture, developed rapidly during the Xia, Shang and Zhou dynasties. The technology used in reeling, spinning, weaving, embroidery and dyeing was progressively improving, metal, for example, often replacing wood for parts of the loom equipment. Silk-reeling implements developed from a hand-operated bamboo brush to a reeling mechanism operated by a treadle. This type of treadle machine emerged in the Han dynasty and by the Tang and Song periods was in widespread use. Until the modern filature machine was invented in Europe in the nineteenth century, this was the most advanced filature equipment in the world. Another, separate, development was the collecting of filaria, a type of worm, from the leaves of the Chinese maple by the people of Guangxi Province, in the Northern Song period. The filaria were put into a strong vinegar solution to rinse and break them in two, so that it was then possible to extract the silk. This method of obtaining silk is very similar to that employed in the production of modern vinegar fibre – spun silk.

The disadvantage of the neolithic spindle, used for spinning, was that it needed to be stopped and rotated to allow control and winding. By the Shang and Zhou eras various forms of hand-operated spindle wheel were in use. The earliest of these had a single spindle, but to increase efficiency the hand operation was replaced by a treadle mechanism (the treadle spinning-wheel emerged in the Han dynasty) and the single spindle was replaced by multiple spindles up to a maximum of five. Both the hand- and foot-driven wheels require human power, however, which restricted the possibilities for increased production. In the Song dynasty a multiple-spindle spinning-wheel which exploited natural power was first seen. The Yuan-dynasty *Nong shu* (*Agricultural Treatise*) records a thirty-two spindle, water-driven wheel which could spin 100 catties (1 catty = 1.5 lb) of hemp in one night. Elsewhere, right up to the eve of the Industrial Revolution in Europe, spinning-wheels still had only one spindle as the technology had not yet been developed to control two spindles simultaneously. During the latter days of the feudal society in China, in the river valleys and coastal areas of Zhejiang and Jiangsu Provinces, a type of large spinning-wheel emerged whose spindle cup was turned by the tension inherent in the design. The thread it produced is remarkably similar to that of the open-ended spinning machines in use today. The principle of using the tension produced by the spinning to sustain the controlling mechanism is quite distinctive.

The mechanization of weaving developed first from the very primitive apparatus to looms on which the warps were set at an inclined angle instead of horizontally or vertically and which had a treadle mechanism for producing the sheds, and from there to looms with multiple heddles and treadles. Early advances are attested to by the various names for spun and woven materials found on bone and shell inscriptions and in early Qin documents, as well as on bronze objects. The remnants of woven material found with ancient bronze vessels excavated from a Shang-dynasty tomb at Taixicun, Gaocheng, Hebei Province, and from the well-preserved tomb of a woman at Anyang, Henan Province, include finely woven tabbies of various types, crêpes and gauzes, silk damasks with rhomboid designs, *leiwen* (thunder pattern) and other geometric designs.

By the Warring States period a many-heddled, many-treadled loom was already in use, and during the Han dynasty the three basic weaves, namely tabby, twill and satin, were developed to include complex variations on the basic binding systems. In the Western Han a loom with 120 heddles and treadles was used by the wife of Chen Baoguang. In the Three Kingdoms period Majun invented a 'combined raised heddle method', or drawloom, which allowed the movements of sixty heddles to be controlled using only twelve treadles. The looms for producing damask weaves, which first appeared in the Warring States period, had advanced considerably by the Tang dynasty. The drawloom corresponded to the modern stored-information looms. The many-treadled, many-heddled loom had the 'information' required for the pattern stored in the system of threading the heddles. Thus, to produce a design, weavers only had to use the treadles (thereby controlling the heddles) in the correct order, without having to consider the complexities of the sheds. Each type of more recent loom (including the Jacquard loom, patented by Joseph Marie Jacquard in 1804, which had a mechanism using punched cards to select the shed to be opened in the weaving sequence) has been developed on the basis of this ancient Chinese loom.

From the Shang dynasty, increasingly brilliant embroidery can be seen on fabrics, sometimes supplemented with painting. From the Shang and into the Warring States period it was quite usual for the common people to undertake embroidery in addition to that produced in the workshops established by local officials. The principal types of design at this time were geometric and twisted-grass patterns. The stitch used for this embroidery was, without exception, chain-stitch. The earliest examples of a zoomorphic design are to be seen on an Eastern Zhou embroidery with phoenix design, excavated from a tomb at Pazyryk in the Altai region of the Soviet Union, and another, also with phoenixes, excavated from a Chu tomb at Changsha, Hunan Province. The twenty-one pieces of Chu embroidery that have been preserved intact from Warring States tomb No. 1 at Mashan, Jiangling, Hubei Province, all display different designs in vivid colours and of exquisite composition, the like of which had not been seen before.

The artistic influences of Chu culture can be observed in the lifelike animal designs of dragons, phoenixes and tigers. During the Han dynasty, various types of satin-stitch also came into use and figures began to be incorporated into designs.

The characteristics of many types of dye derived from plants were well known to the people of the Xia, Shang and Zhou dynasties and, by the beginning of the Warring States period, dyeing and painting skills had been systematically developed. It was at this time that the technique of employing mordants, or fixatives, in dyeing was invented. In the Han dynasty, chemicals began to be used in the colouring of woven goods, such as mined sand and chalk, mercuric sulphide, vulcanized lead (to produce a grey colour), mica, and gold and silver powder. Woodblock-printed patterns began in China during the Warring States period. By the Western Han dynasty, designs using relief printing blocks were being produced in three colours. Seven colours were used on designs produced with intaglio blocks and added applied colour. Stencil resist-dye printing, where white designs appear against a blue background, started in the Qin and Han and had reached a mature point in its development by the Northern Song. The Sui dynasty saw the emergence of polychrome stencilled dyed designs. The production of designs by the wax-resist method also emerged in the Qin and Han periods, while tie-dyeing began in the Eastern Jin. By the Tang there was mercurization (fixing) of the base colour and alkaline printed designs employing the principles of synthetic resist printing. Printing using gold leaf and sprinkled gold powder was developed after the Song dynasty. These traditional Chinese skills have had a major influence on the history of printing and dyeing.

Organization of the Developing Industry

By the Xia dynasty, spun and woven materials were already items for trade, though it was only after the Shang period that the trading of silk became widespread. The increase in specialization, trade and production coincided with the establishment of regulations governing all areas of textile manufacture. Bone and shell inscriptions indicate that as early as the Shang period an official government position, Head of Sericulture, had been set up. Thereafter, during the Zhou, eight bureaux were established to organize the gathering of raw materials and the management of spinning, weaving and dyeing. There was a bureau for the management of hides, for example, and others for the management of the kudzu vine, dyeing plants, women's affairs, silk, hemp and so on. The Head Dyer was responsible for the refining of the dye colours and their application to silk, while the Feather Official was responsible for the collecting of feathers and the marking or collation of different colours.

Sericulture was very closely regulated in the Zhou dynasty. It was forbidden to raise silkworms during the summer and an improved species was bred which hibernated three times for each metamorphosis. Minutely detailed instructions were issued for the bathing of newly hatched silkworms, which could not eat damp leaves; for the ventilation of nesting boxes; and for the standardization of all silkworms. The patterns and colours for spun and woven materials to be used by the different classes in society were also regulated by this time. Colours were divided into primary and secondary. There were five primary colours – blue, red, yellow, white and black – and then secondary colours such as bright red, green, blue-green, purple and chestnut brown. The pure colours were to be used on outer garments and the surfaces of items made for the upper classes; the secondary colours on items for the lower classes, undergarments, and interior surfaces. The upper garments were permitted to be used as undergarments, but the lower garments could not be worn above. Because of technological restrictions, fabrics with elaborate weaves, printed designs and colour tie-dyes were in short supply and so painters often provided the decoration.

More and more spun and woven goods were being produced. The Silk Road to the Mediterranean was opened up in the reign of the Han emperor Wudi, in the second century BC, and considerable quantities of Chinese woven goods were transported along it. Moreover, because sericulture was unknown outside China, there was a big trade also in silk thread, to be used by Westerners for their own weaving. (It was only during the second and third centuries AD that sericulture was introduced into Dashi, in the region of modern-day Kashmir, and during the fourth century that it came to India. It was not until the sixth century, when a Persian was sent to China to study the production of silk, that all the techniques required for the production of silk spread to Byzantium and Arabia.) Woven goods became one of the mainstays of the feudal society and a complex infrastructure was required to control their production and taxation. From the Qin and Han to the Sui and Tang dynasties, the organization of spinning and weaving fell into three categories: handicraft industries run by local government departments, handicraft industries individually established in the towns and cities and work undertaken on a cottage-industry basis in the countryside. The Han-dynasty court established the Eastern and Western Weaving Departments and at the same time three clothing departments were set up to oversee the clothing and personal ornaments of the imperial family. In the Northern and Southern Dynasties period, each political regime set up government departments to be responsible for weaving and dyeing. During the Tang, such departments comprised twenty-five different workshops for weaving, dyeing, embroidery and so

on, within which very fine distinctions were made in the division of labour. The handicraft industries set up in the towns and cities and the rural cottage industries were also flourishing throughout this period. In the Han dynasty, for example, it was said of the families of Chen Baoguang and Zhang Anshi that 'the women spun and twisted the hempen thread and they had seven hundred skilled slaves to work for them'. In the Tang dynasty a family from Dingzhou had no fewer than five hundred machines for producing silk fabric.

All this production was heavily taxed. On his northern tour of inspection, the Han emperor Wudi collected a million or more bolts of silk fabric in tribute from all the places he had passed through. By the Wei and Jin dynasties this system had been formalized, with the *Regulations for Cloth and Thread* stipulating the amount of silk fabric, cotton wadding and silk thread that had to be handed over to the authorities each year. The *diaoyong* system was an innovation of the Tang dynasty. *Diao* referred to the total amount of *ling*, *juan* and *sha* silk and other cloth produced by each district, a fixed amount of which would be transferred and given over to the local authorities. *Yong* was a reference to the fact that the payment in *juan* silk and other cloth could be substituted for corvée duty. Du You (in the *Tong Dian*) notes that in the Tianbao reign period (742–756) the *juan* and *jin* silk given for *diao* and *yong* comprised slightly more than two-thirds of the total of the land tax and other levies. The records of these taxes indicate that spread throughout the country there were over one hundred prefectures that produced silk fabric from the *Bombyx mori* silkworm. This can be compared with the situation in the Northern and Southern Dynasties when nineteen prefectures were producing silk thread and cotton, and twenty-seven were producing hemp cloth. Between these two periods the centre of China's weaving and embroidery industries had moved to the southern half of the country – in particular to south of the Yangtze River in Jiangsu and Zhejiang Provinces – and by the late Tang the three most important institutions for weaving production were established in Jiangning, Suzhou and Hangzhou.

From the Song dynasty to the Qing was the Golden Age of weaving, embroidery and dyeing. In the Song dynasty great quantities of spun and woven materials were required not only for the nation's use in the form of military supplies, but also as gifts to the northern courts of the Liao and Jin kingdoms. The 'Shihuozhi' section of the *Song shu* (the economics monograph in the *History of the Song*) mentions that great quantities of unbleached silk formed part of the taxes for each district, and that almost as much was presented as tribute. In the Southern Song, despite the fact that the area ruled by the Zhao house was only half the country, the total amount of silk and hemp spun and woven goods received in taxes exceeded that of the preceding Northern Song, which had controlled a much greater area. The government-run weaving manufactories extended into the prefectures at this time. Besides the output from the official textile department in the capital, many different kinds of fabric were woven or traded in the prefectures of Xijing, Zhending, Qing and Zi. Wenzhou in Jiangning was known for gauze and Yi and Haozhu traded in damasks and crêpe respectively. Daming specialized also, in weaving a type of crêpe. From Song times through to the Ming dynasty the department in Tong County, Zhejiang Province, 'made a profit of 10,000 *jin* per day from its looms', and so the silk that it produced came to be known as *jin*.

Bureaux responsible for the production of gauze and embroidery were established throughout the country during the Yuan dynasty. Bureaux for weaving and dyeing, for twills and damasks, were under the control of local officials. In large prefectures, special offices were set up to regulate miscellaneous skills. In addition to bureaux controlling the manufacture of silk, cotton production was also to come under official control. In the Song dynasty the non-government-controlled cotton industry had undergone rapid change as a result of a breakthrough in the area around the Yangtze which enabled an annual cotton crop to be grown; in the first year of the Yuan dynasty, offices were established to administer silk cotton (kapok – the fine cotton wool surrounding the seeds of the plant), and 'the people were required to hand over 100,000 bolts of cotton cloth annually'.

In the Ming and Qing dynasties, those in power gave great encouragement to the spinning and weaving industries and closely supervised the taxation of production of raw-material fibres, spinning, weaving and dyeing in rural areas. By the Qing dynasty the privately owned silk-weaving mills in Hangzhou, Suzhou and Jiangning were so extensive that they had a thousand looms and employed between three and four thousand workers – out-producing the government-run manufactories.

The Development of Decorative Designs

The dyed and woven designs of ancient China not only provide evidence of the skills of the craftsmen, but also to a certain extent are reflections of their daily life and belief systems. The designs on dyed and woven goods shared with other arts-and-crafts products limitations that prevented the achievement of the realism possible in the fine arts, which enjoy the flexibility of the brush. On woven fabrics the best use had to be made of particular fibres, threads, weaves, dyeing and printing methods and embroidery to achieve the designer's aims. At the same time, the selection of theme for the design, its form of expression and even the choice of colours were all influ-

enced to a considerable extent by socio-economic conditions – considerations linked to cost and aesthetic appreciation. The exquisite dyed and woven items that have survived are all characterized by the distinctive style of Asian peoples, which more often than not incorporates designs which have specific auspicious meaning.

The looms that were available in the Shang dynasty were rather simple and crude, and were not able to produce very complex or heavily patterned weaves. However, it seems certain that during this period the decoration of spun and woven articles was augmented by the addition of painted designs. Although there are as yet no extant examples of this, nevertheless it is possible to cite considerable circumstantial evidence for its existence. An earthenware spindle whorl, for example, excavated from a neolithic site at Qujialing, Hubei Province, was found to be coloured with symbolic designs similar to the *taiji* (a symbol of harmony) and the eight trigrams (ancient symbols associated with divination), suggesting a connection with decoration on primitive spun and woven materials. There is also an extremely close connection between Shang-dynasty patterns and characters. The cloud and thunder patterns, for example, evolved from characters found on bronze vessels.

The designs on Zhou-dynasty damask weaves were more advanced versions of Shang designs. In comparison to the earlier looms, those of the Zhou dynasty were considerably improved, and the Zhou paid particular attention to precision of line in their art. Embroidered objects executed in a relatively mature chain-stitch were also produced at this time, the twisted-grass pattern, for example, revealing the relatively more representational designs possible in the embroiderer's art, as compared with those that could be achieved on woven damask. Historical texts indicate that the regularization of clothing was already reaching an advanced stage in the Zhou period, if we are to judge from the twelve symbols which were designated to be used for imperial clothing and adornments, and this in turn explains the steps forward made in the application of colour generally.

Among the geometric designs to be found on the damasks of the Spring and Autumn Annals period are criss-cross, *bing-ding* (the third and fourth of the Heavenly Stems) and tortoiseshell. Even more spectacular, however, are the stylized designs of men, birds, beasts, flowers and plants. On embroidered wares, complex meandering and intertwined designs based upon mythical animals are to be found. The colours used in woven and embroidered patterns also became very splendid. Typical examples of designs of this period are to be found in the material remains excavated from the ancient lands of the Chu state – that is, present-day Hunan and Hubei. The designs reflect the spirit of romanticism found in the *Chu ci* (*Songs of Chu*), which can also be seen in the remains

of the totems of the Eastern Yi minority peoples and in the very fine, slim and elongated style of Chu clothes. (It is said that 'the Chu kings were fond of slender waists so that there were many hungry people in their country'.) The themes and styles of the designs seen on woven goods of the Western and Eastern Han dynasties were quite diverse and reflected the vitality and slightly primitive quality of the ancient Chu style.

Some themes occurred quite frequently, such as birds and animals, floating clouds, landscape and characters against a diaper background. Aspirations for a fortunate life are reflected in such inscriptions as 'ascending the heights to see clearly in all directions', and 'all things as one desires'. Similar preoccupations are reflected in designs such as those depicting the *zhuyu*, or dogwood tree (the leaves of which were believed to avert evil), and other lucky symbols.

One aspect of the pattern types of the Wei and Jin and the Northern and Southern Dynasties was that they continued Han traditions while at the same time incorporating influences derived from Buddhist art. In comparison to the Han, their style was more compact and decorative. The characteristic intertwined-stem design was a development of the Han floating-cloud design (one explanation of this being the influence of India and other foreign countries), and in its turn a precursor of the Tang grass pattern. 'The king of the barbarians leading a camel' (plate 213) and other such designs are obviously influenced by Western styles.

During the Sui and Tang dynasties, twining stems, round flowers, small flowers, posies and various other new motifs gained in popularity. They were all characterized by a style that was well developed and had large, dense, strong and brightly coloured designs. The 'Lingyang style', after the great Tang dynasty painter Dou Shilun, was famous for its designs, which included metal thread and motifs such as paired turtledoves, flying rams, soaring phoenixes, swimming fish and 'heavenly' horses. The circlet-of-pearls design, which had already been seen in the Northern and Southern Dynasties, was also fashionable. This latter design was commonly supposed to have been imported from the Sassanian Persian empire. The Tang grass design evolved from the twisted-honeysuckle-branch and twisted-grass motifs. These were sometimes composed of a variety of flowers and plants and produced a squared continuous design. The 'precious flower' design evolved under the influence of Buddhism, Daoism and other religions, and was formed as a composite with the lotus as its main part combined with S-shaped cloud motifs and so on. This became a symbol of good fortune. Wild boars, bears, lions, deer and other animal designs, as well as a considerable number of themes imported from countries to the west, were also employed. Throughout the Tang period everything connected with the spirit of the age seemed to be incorporated into the designs.

The textile craftsman's ability to produce highly decorative weaves was greatly enhanced in a number of ways, in particular by the development of *jin* weave with floating polychrome weft, by the skilled use of metal threads in weaving and by the art of colour gradation and blending. There were also printed patterns, and designs produced using the wax-resist and tie-dyeing techniques. Among the fashions of Tang times were coloured skirts and 'Persian striped trousers', so various types of striped design were much employed on dyed and woven fabrics.

In the Song period, the spirit of the famous bird-and-flower painting style of the Imperial Painting Academy exerted considerable influence on the patterns produced on woven goods. These paintings gave rise to the realistic style of design, depicting sprigs of flowers with the 'addition of colour to the flowers', which was later to become the principal design on silk material. Designs also adopted folk themes, while themes from the popular religions of the Han and Tang waned somewhat. The style of the designs was delicate and fresh; the colours were matched subtly and simply. Geometric designs, such as the eight trigrams, were produced in a more complex but regulated way. In the Yuan dynasty, metal thread was often employed to enrich the designs and this in turn had an influence on the styles of the Ming and Qing.

The designs seen on dyed and woven fabrics, including tapestry, in the Song, Yuan, Ming and Qing periods can be grouped into various categories.

Naturalistic designs
This type of design either consisted of realistic flowers, plants, trees, fish, insects, bees and butterflies, or closely imitated original landscapes or figure paintings by famous artists. In the case of normal silk woven pictures or those produced by the tie-dyeing technique absolute precision was not achieved, but silk tapestries were remarkably accurate and true to life. This level of realism can be seen in the Song-dynasty tapestry 'Lotus pool with ducklings', in the Yuan tapestry 'Secretly stealing the peaches in the East', and in the Ming-dynasty Han Ximeng embroideries based on paintings of the Song and Yuan periods.

Designs incorporating a moral message
This type of design incorporated borrowed characters, analogous meanings, pictographic elements, homonyms, moral meanings and other elements, including flower, plant, bird and insect motifs, to form designs composed of joyful and auspicious symbols. The peony, for example, symbolized 'wealth and honour'; combined with the Chinese flowering crab-apple, it then implied 'wealth, honour and immortality'; and with peaches 'wealth, riches and longevity'. The pine, bamboo and prunus represented 'the three friends of winter'; the prunus, orchid, bamboo and chrysanthemum were called 'the four lords'.

Among designs that combined animals and plants were magpie and prunus, representing 'joy that rises to the tips of one's eyebrows', and lotus and fish, representing 'successive years of plenty'. Designs such as these containing auspicious meanings are typical of Chinese traditional designs.

Designs to denote social standing
The robes and hats of the emperors were decorated with twelve imperial symbols, in continuous use from the Zhou and Qin periods. In the dragon-and-phoenix design used by the empress and concubines, the dragon appeared in various forms: upright, ambulant, coiled, paired, large and small. The system regulating the designs used on clothing in the Ming and Qing dynasties stipulated that if the design was to be sewn on in the region of a civil official's chest or back, it should be a bird, such as a red-crowned crane, or a goose, oriole or quail. If the wearer was a military official, then an animal design could be used, such as a leopard, brown bear, young tiger, rhinoceros or hippopotamus. The choice of particular emblems did not, however, remain constant between the Ming and Qing dynasties.

Designs derived from history and legend
Among these were designs which incorporated ideas taken from religious beliefs, such as 'many immortals celebrating longevity', 'the Eight Immortals crossing the sea', 'the great auspicious design', the large and small 'eight precious objects' and 'Secret Eight Immortals'. Of these, the 'Secret Eight Immortals' consisted of attributes of Ludongbin, Zhang Guolao and the other mythological characters who make up the Eight Immortals, and who symbolize longevity without growing old. The eight Buddhist symbols of good fortune were canopies, precious vessels, the wheel of Dharma, the double fish, the conch shell, lotus, parasol and endless knot. Among tapestries woven during the Ming and Qing dynasties were some depicting scenes from legends, with titles such as 'Chang'e, the moon goddess, approaching the moon', 'The Heavenly Maid scattering flowers', 'The Hall of long life', 'The apricot-blossom village', 'The Seven Sages of the bamboo grove' and 'The twenty-four paragons of filial piety', all of which were popular at that time.

Designs incorporating auspicious characters
Integrated compositions using characters such as the Buddhist swastika symbol, the 'longevity' character, the character for 'good fortune' and the character for 'happiness' as the principal components of the designs, and thus representing an auspicious blessing, were fashionable during the Ming and Qing dynasties. For example, in the 'five blessings encircling longevity' design, the 'longevity' character is surrounded by five bats. The bats are a pun since the Chinese word for bat is *fu*, a homophone for the word

for happiness. Thus, five bats may stand for the five blessings of long life, ease, wealth, honour and joy. The depiction of the Buddhist swastika and the 'longevity' character with the eight Buddhist symbols of good fortune forms the 'long life' design. The 'longevity' character, five bats, peaches and the Buddha's hand citrus plant create the 'doubly auspicious blessings and long life' design. The 'longevity' character combined with the spotted deer, the pine and the crane is known as the 'prolonged life' design.

2

Woven Fabrics

The most versatile type of raw fibre used in the production of woven fabrics was silk. The historical development of ancient Chinese silk textiles is discussed below.

Sha *(Open Tabby)* and Hu *(Crêpe)*

Sha and *hu* are both tabby weaves. The openness and fineness of the weave is created by threading only alternate dents of the reed. (The strips of the reed are called leaves, and the spaces between them are called dents.) There is a certain confusion between the two weaves in that the *Shi ming* *(Explanation of Names)* defines *hu* as *sha*, while the *Yu pian* *(Jade Compilation)* explains *sha* as *hu*. The Tang-dynasty scholar Yu Shigu, however, in his annotation of the *Han shu* *(Han History)* explained them thus: '*Sha* and *hu* are woven from spun silk thread. *Sha* is fine and *hu* is crinkly.' It has usually been accepted, therefore, that *sha* and *hu* were two separate materials before the Tang and that the criterion for distinguishing them was whether they were crinkly or not.

In ancient times the characters for *sha* and 'sand' were the same, perhaps because the holes in the fabric were so fine that only grains of sand could pass through them, hence the name 'sand silk'. *Sha* was in fact developed from the nets used to sieve grains of pigment. Later the character for '*sha*' became a combination of the characters for 'little' and 'silk', the weft and warp threads being so fine in comparison to *juan* (plain tabby silk) that, for a given area of cloth, much less silk was required.

The holes formed by the warp and weft threads are almost square in *sha* fabric, and ancient books give the definition: 'square-holed (material) is called *sha*'. *Sha* is also, therefore, called 'square-holed *sha*'. The statement '*sha* is as fine as emptiness' is found in an ancient poem, and the material is also known as 'square-emptiness *sha*'. The holes are spread evenly over the surface of the cloth and make up about 75 per cent of the surface area, giving it a fine, soft texture.

Plain *sha* was used extensively in the Han and Qin periods for summer clothing and for shrouds. A piece of otherwise plain *sha*, decorated with applied gold and silver, has been excavated from the Han-dynasty Mawangdui tombs in Changsha, Hunan Province.

In the Tang dynasty, workshops for the weaving of *sha* fabric were specifically set up by the county magistrates' offices, and in addition the weaving of *sha* was widespread among the general populace. It was the fashion in the Tang for people to use lightweight fabrics for their clothing and personal adornments, and great quantities of *sha* and gauze were increasingly required. Documents record the names '*Wu sha*', 'flower-drum rest *sha*' and 'fine guest *sha*'. The latter is as thin as mist and Bozhou was the area renowned for its production. (Nowadays it is produced in Bo County in Anhui Province, and in Luiyi in Henan Province.) According to tradition there were only two families from Tang to Song times who knew how to weave this very fine *sha*, and in order to protect their secret they intermarried for generations.

In the making of *sha* the basic fabric was often printed or coloured. White tie-dyed *sha*, pale printed *sha*, *sha* with a yellow mandarin-duck design, green *sha* with a printed design of a huntsman and sky-blue fine guest *sha* with applied gold designs have all been excavated from Tang tombs at Astana in Turfan, Xinjiang Province.

The areas for the weaving of *sha* in the Song dynasty were modern-day Jiangsu and Zhejiang Provinces in the south. Out of the tribute paid to the emperor in *sha* and *hu* by the entire country (6611 bolts), 94 per cent of it (6213 bolts) came from the south. Collections of *sha* have been found in the Southern Song tomb of Zhou Yu at Jintan, Jiangsu Province (the contents of which have been dated to AD 1244), in Huang Sheng's tomb at Fuzhou, Fujian Province (dating from AD 1247), and in a Southern Song tomb at Wujin, Jiangsu Province. Of these the Fuzhou tomb contained the largest quantity of this material. A damaged fragment of fine *sha* was one of the finds. Its structure was 20 warps × 24 wefts per cm, the thickness of the warp and weft threads being 0.08 mm and the holes between the threads making up 84 per cent of the surface area.

The *sha* of the Ming dynasty was decorated and coloured as a monochrome patterned *sha*. A decorated *sha* dragon robe from the Dingling tomb of the Ming emperor Wanli (1573–1619) near Beijing, and a *sha* decorated with clouds and cranes preserved in the Palace Museum are both exquisite.

Although both *hu* and *sha* use a plain weave, the

surface of *hu* is crinkly, due to the use of a thicker thread with a pleasing uneven surface. The number of twists in the warp threads used in a *hu* could be as high as 1000 or more per metre and, in addition, different permutations of S- and Z-twists in the warps and wefts could be used to achieve different uneven appearances on the surface of the fabric. After the fabric had been woven, it still required boiling and scouring in order to ensure its characteristic appearance.

A fragment of silk cloth found on a bronze drinking vessel excavated from the Shang-dynasty site at Taixicun, Hebei Province, has twisted warp and weft threads with uneven surface and fine, even holes. It is assumed that this is the earliest *hu*. At Warring States tomb No. 44 at Shijiakuang, Changsha, the remains of a pair of pale-brown crêpe *sha* mittens have been excavated. The density of the fabric is 38 warps × 30 wefts per cm, and there are firming twists in all the warp and weft threads. Threads with S-twists and threads with Z-twists are both used in the warp, arranged in specific sequence. The weft threads have an S-twist. The quality of this woven material is fine and it has an obviously crinkly appearance.

Pieces of pale crêpe *sha* have been excavated from Han tomb No. 3 at Mawangdui, Changsha. The least dense have 34–36 warps per cm and the most dense 60–64 per cm. The density of the wefts is either 28–30 per cm or 58–60 per cm. The twists are S-twists and there are between 200 and 2400 twists per metre. The fabrics have been boiled and scoured to fix their form and the unevenness of the surface is apparent. In Tang tomb No. 105 at Astana, Xinjiang Province, a resist-dyed piece of green *sha* was found, decorated with a hunting scene on a crêpe *sha* base. This makes use of yarn which has been thrown, or tightly twisted, so that the surface of the fabric displays a horizontal, long narrow pattern of wrinkles across the surface.

The Southern Song crêpe *sha* has a comparatively low density (28–30 warps × 20 wefts per cm) and fine yarn (0.04 mm warps and 0.05 mm wefts) as seen in the crêpe *sha* excavated from the Southern Song tomb of Huang Sheng, Fujian Province. Warps with both S- and Z-twists were used, and these were arranged in groups alternately in the ratio 6:2 so that the groups of S-twisted threads are fairly close together while the Z-twisted threads are fairly well separated. The structure of the warp threads is apparent and there is a regular distribution of the spaces between the threads. This type of crêpe *sha* is even more pleasing to the eye than those of the Han and Tang dynasties.

Luo *(Gauze)*

Luo is a woven silk material in which the warps are crossed, producing openings in the fabric. The source of gauze-weaving skills is to be found in the weaving of net used for hunting in antiquity. At this time, *luo* indicated an implement for catching birds. Gauze is fine and thin, the openings in it are stable and able to stand up to use, and ancient man later used this material for summer clothing and for curtains. There were quite a number of different types of gauze in ancient China and these can be divided into plain and patterned gauzes. A distinction can also be made according to the type of weave, between those with a regular and those with an uneven crossed-warp form. Two typical examples of the former type are those on which two warps are crossed – one over one – and those on which three warps are crossed in the configuration one over two. The latter often had a plain-tabby or other simple weave for its pattern base, though it could be combined with a three-over, one-under twill weave or a double-faced plain weave. The uneven crossed-warp gauzes have a chain-like appearance and hence by some they have been called chain gauzes. There are also different varieties with different configurations of crossed warps. Plain and monochrome patterned gauzes are in the majority of those found, but there are also a number of high-quality pieces to which gold has been added, such as woven-gold gauze and decorated-flower gauze.

Many gauzes have been excavated from Chu tomb No. 1 at Mashan, Hubei Province, and from the Chu tombs at Changsha, Hunan Province. (The state of Chu was one of the largest and most powerful during the Warring States period.) The quite rare three-thread gauze, in which two warps cross three wefts, has been excavated from the former. *Er bei* ('ear-cup') monochrome patterned gauzes, smoke-coloured lozenge-patterned gauzes, dark geometrically patterned gauzes and a large number of plain gauzes have also been excavated from Han tomb No. 1 at Mawangdui. These gauzes were used for scent bags, mittens and curtains, or as a base material for embroidery. The patterns are careful and fine, the most outstanding being the *er bei* example.

Although relatively few gauzes have been excavated from Tang-dynasty sites, the following names are among those mentioned in documents: melon-seed gauze, peacock gauze, precious gauze, cloud gauze, phoenix-pattern gauze and cicada gauze. In the Song dynasty, gauze-weaving skills progressed. The tribute in gauze presented by Song officials increased to 100,000 bolts. Among these, new varieties of monochrome patterned gauze were numerous. Documents record the names of longevity vine, the paired phoenixes, the flaming pearl, the chrysanthemum and so on. In Jintan, Wujin, Jiangsu Province, and Fuzhou, Fujian Province, and from other Southern Song tombs, quite a number of patterned gauzes have been excavated. The greatest variety was among those excavated from Huang Sheng's tomb at Fuzhou, which included one camellia-patterned and one peony-patterned gauze (plates 235 and 236). The peony gauze has a three-

warp cross; when the reed is threaded, three warp threads make one set and pass through the same dent.

The Yuan dynasty was notable particularly for the advances made in the use of gold, with varieties such as the melted-golden-thread gauze and the golden-*sha* gauze. The *Tian shui Bing shan ji* (*Records of Tianshui and Bingshan*) mention more than fifty-five types of patterned gauze to be found in the Ming dynasty.

Qi *(Patterned Tabby)* and Ling *(Twill)*

Qi is a woven tabby patterned with twill, while *ling* is a woven silk of twill weave with a twill-weave pattern. In early Qin documents, *qi* already appears quite regularly and there are also a number of excavated examples which corroborate the textual evidence. Fragments remain of a meander-pattern *qi* and a *leiwen* (thunder pattern) *qi* found adhering to bronze drinking vessels excavated from the Shang-dynasty site at Anyang. A piece of *qi* with a lozenge pattern, on a bronze sword hilt excavated from a Western Zhou tomb at Baoji, Ruijiazhuang, Shaanxi Province, has a density of 34 warps × 23 wefts per cm, while another fragment of lozenge-patterned silk with a weft-patterned weave has a density of 70 warps × 40 wefts per cm and a fairly large weft pattern.

The *qi* with paired birds and plant-and-flower decorations excavated from Han tomb No. 1 at Mawangdui is a new addition to the varieties seen at that time. The pattern repeat on this piece is large, its conception new and original, its decoration appropriate and its style lucid and lively. The design employs a fine-thread *leiwen* to provide a frame on four sides around a continuous lozenge pattern with the addition of paired birds, flowers and plants, the many motifs being used in sequence. The piece is in 'Han-style weave'.

In the Tang the production of *qi* was greater still. There were workshops for the weaving of *qi* set up in the districts as well as government dyeing shops and weaving mills. It can be seen from material found at the Tang tombs at Astana, Xinjiang Province, that designs of interlocking rings and circlet of pearls and tortoiseshell designs were frequently used on *qi*. Several of the Buddhist banners from Dunhuang, Gansu Province, have a *qi* base with added embroidery and painting, such as the herring-bone design example preserved at the Dunhuang Cultural Relics Research Institute (plate 222).

From the Song dynasty, apart from those decorated with geometric designs, it is possible to find some examples with plant and flower designs produced in a very lifelike style. A lozenge-and-chrysanthemum *qi* from the tomb of Huang Sheng at Fuzhou makes use of an alternating arrangement of coarse and fine weft threads. The coarse threads appear in the areas of the design and the fine threads are seen only in the areas of plain weave. The number of warp threads covered by the floating-weft pattern varies. In the Yuan-dynasty tomb of Qian Yu at Wuxi, Anhui Province, a collection of *qi* was found which had simple clear designs and a soft texture. They had been used as the outer fabric for everyday clothes and trousers.

Ling was a development of *qi*. Documents from the Tang and Song dynasties contain a great many references to *ling* and, more often than not, mention it in conjunction with *jin*. Among the surviving material from this period are many varieties of *ling*. The most representative of them are those described as 'separate units and single direction' *ling* and 'same units and different direction' *ling*. The designs on Tang-dynasty *lings* were frequently small geometric patterns, and the work showed an appreciably increased level of precision and attention to detail. Among the names for small geometric designs recorded in documents are: tortoiseshell, bird's head, bird's eye, snake skin, bamboo branch, fish mouth, persimmon calyx, chequered, waves, horse's eye and the tree of heaven. Bird and animal designs underwent a transformation in the Tang and became extremely formalized. The principal use of *ling* during this period was for the clothes of officials. Within the official government dyeing and weaving establishment there was a specialized section for the manufacture of *ling*.

The Song dynasty carried on the Tang manufacturing processes and continued to stipulate the use of *ling* for official clothing. A Lingjin (twill and brocade) bureau was established at Bianjing (present-day Kaifeng) and in Huzhou there was a *ling*-weaving mill. At this time, realistic bird-and-flower designs were fairly widespread, and they were simple and elegant in the traditional style.

From the beginning of the Yuan dynasty, *ling* came to be much used for mounting paintings and calligraphy, and many patterns were therefore small and geometric. The tomb of Qian Yu contained book-wrappings of swastika-patterned *ling*. Many old mounts dating from the Yuan, Ming and Qing dynasties are of fine *ling*.

Jin *(Brocade, or Damask)*

Jin is a general term for polychrome warp-faced silk materials with a compound-tabby or twill weave. The character is a combination of the characters '*bo*' (silk) and '*jin*' (gold), the idea being that *jin* was valued as highly as gold. There were several different types, such as polychrome warp-faced *jin* weave, polychrome compound-weft-weave *jin* and double-faced *jin*. The weaving methods of each were different but all required the highest level of skill. Gold and silver thread was often included in the silk woven using this technique.

The history of *jin* can be traced back over 3000

years. Warp *jin* with two- or three-coloured warp patterns appearing in sequence, *jin* including extra warps used for the design and a *jin* with a relief pattern – its three-dimensional effect achieved by the use of uncut pile – were popular during the period of the Warring States and the Han dynasty. An example of these early *jins* is the *jin* with paired dragons and phoenixes (plate 4) from the Warring States period. The *jin* materials excavated from Han tomb No. 1 at Mawangdui included polychrome relief-patterned *jins* and uncut-velvet *jins*, as well as the more usual two- and three-coloured Han *jins*. The relief and velvet types are characterized by their complex designs and three-dimensional appearance. An often seen feature of Han *jins* is the incorporation into the design of characters for good luck, written in ancient style.

Warp-faced *jins* were still predominant in the Wei, Jin and Northern and Southern Dynasties. Many had designs of wild animals or flowers, and some both. Most of the excavated materials from these periods have come from the Astana tombs, Xinjiang Province. They include *jins* decorated with designs of figures, with tree-and-leaf designs of the Northern Dynasties (plate 29), designs of paired sheep and birds (plate 32), designs of small circles, and lozenge-and-honeysuckle designs (plate 28). Already they show the influence of Tibetans and other non-Chinese people. Usually five-coloured, these *jins* employ the technique known as 'distinguishing the involved coloured warps'. The tree-patterned *jin*, for instance, used light red, sapphire blue, leaf green, pale yellow and pure white. It has a density of 112 warps × 36 wefts per cm. In addition, examples of *jin* fabrics with new designs such as 'peacock and "noble" character' and 'barbarian king leading a camel' have been excavated from the same site.

Although warp *jins* dominated before the Tang dynasty, during the Tang a large number of weft *jins* appeared, indicative of a major turning-point in weaving skills. It was easier to produce the pattern using shuttles carrying the coloured threads of the weft than using the warp threads, and, therefore, weft *jins* were able to avoid the limitations imposed by warp patterning, and it was possible to weave even large pieces with single-set pattern designs. Certain Tang-dynasty weft *jins* are very similar to some of the Northern Dynasties warp *jins*, the designs simply having been turned through ninety degrees, which seems to indicate a definite connection between them.

There was also a type of *jin* in the Tang dynasty characterized by gradated bands of colour. This *yunwen* (halo-pattern) *jin* was traditionally supposed to have been first produced during the reign of Wu Zetian. It had various designs of plants and flowers on a background of coloured stripes. Some were made into stitched clothes with nine bands of colour, each with five or six shades, all with weft-faced patterns.

The Tang characteristics of elaborate richness, gaudy colour and uniformly arranged decoration can be seen on silks excavated from the Tang tombs at Astana. Among these are *jins* with animal designs (plate 38), with large deer and circlet of pearls (plate 36), birds and flowers (plate 39) and *luan* phoenixes and circlet of pearls (plate 218). The circlet-of-pearls design was first seen in the Northern Dynasties, some believe influenced by Sassanian Persian designs. There are those who believe that it is the design described in writings of the Song and Yuan dynasties as the 'road of spheres' pattern, while others assert that it is not as complex. The plant designs later called 'Tang grasses and flowers' found on some patterned *jins* had an important influence on woven silks in Japan. There are still a considerable number of Tang silks preserved in Japan, including those in the Shōsō-in, the Hōryu-ji, the Shinkō-ji and the Tōdai-ji. One typical example has a design of flowers and characters in two colours – green and turmeric gold – and has a density of 150 warps × 55 wefts per cm. Its background weave is a twill with a three-thread diagonal, while the pattern weave is a six-thread twill.

In the Song and Yuan dynasties various changes were made in aspects of *jin* pattern design, weave structure and production technology, from which Song woven-gold *jin* and decorated *duan* (satin) developed. What was later called a Song *jin* was in fact a development of the Tang weft *jin*, which typically had a layered weft with a warp-twill background and weft-twill pattern. Song *jins* employed two or even more colours in a single area using a method known as 'divide areas, change colour' (also called 'living colours'). The style of their patterns is beautiful and precise, and the colours simple and elegant. The pattern is formed by a method of adding the coloured pattern on the top in a style like that of drawings from life, or by adding realistic birds and flowers to framing devices. The designs of the Song *jins* were influenced by the style of the Imperial Painting Academy. The development of this style was connected with the custom prevalent at the time of using famous and precious silks to mount paintings and calligraphy.

Jin woven with gold thread is often simply called woven gold, or, in the Yuan dynasty, *nashishi*, which is a transliteration of the Persian word *nasīch*. Woven-gold *jin* used a flat or rounded gold thread as the pattern weft, this use of gold in the design being the distinguishing feature of the material. The addition of gold to silk woven fabrics in ancient China probably began in the Warring States period, but it only really became popular with the rule of the Jin Tartars in northern China, and reached its zenith during the Yuan dynasty. One factor may have been the northern peoples' traditional love of adornment, but another was certainly the great quantity of gold obtained by the upper classes of these peoples as the spoils of war. Historical documents record the use of a great quantity of twisted gold thread during the Jin dynasty and the production of fabric to decorate the palace alone required the efforts of 1200 weavers over

a period of two years. In the record of his travels, Marco Polo tells of how in the Yuan army woven gold was used for tents, the *jin* cloth stretching several miles.

A woven-gold *jin* with a design of paired dragons has been excavated from the late Yuan-dynasty tomb of Madam Cao, mother of Zhang Shiceng, in Suzhou; another, with a design of five monkeys, has been found in the Yuan-dynasty tomb of Qian Yu at Wuxi. A *juan* (plain tabby) robe excavated from a Yuan tomb at Yanhu, Xinjiang Province, has trimmings on the edges of the sleeves, and on the neck and shoulders, made of woven gold with a decoration of water and lotus flowers. Another motif found on woven-gold *jin* is an image of a Bodhisattva with slender eyebrows, large eyes, drooping nose and small mouth. The Buddhist canon the *Dacangjing* (the Chinese Tripitaka) was often bound with woven-gold *jin*.

The double-layered *jin* that was fashionable during the Ming and Qing dynasties, also known as *gaiji*, was a double-faced plain weave of damask type. It was often two-coloured and known as, for example, purple-and-white *jin* if these two colours were the ones used. One variety had gold or other glittering materials woven into the design. The upper face of the double-layered *jin* was smooth and the pattern carefully produced, the colours refined and the weaving relatively straightforward. Surviving examples from the Ming dynasty include the 'three friends of winter' (pine, prunus and bamboo) and 'happiness at the beginning of spring' designs, the woven-gold walnut design in the Palace Museum, Beijing, and an undergarment with a white ground and a design of 'blue flowers falling into flowing water' from the Dingling tomb (north of Beijing). From the Qing period there is a *jin* with a design of blue flowers and the 'four harmonies' on a white ground, now in the collection of the History Department of Nanjing University. Most *jins* of the Ming and Qing had flower and plant designs, but patterns which contained auspicious meaning were also fairly common and skilfully executed. In comparison to the designs of the previous periods, more attention was paid to the depiction of form and the harmony of the arrangements.

The style of *jins* changed between the early and later Qing periods. During the Kangxi reign period (1662–1723) imitations of Song and Ming styles were common, the best being *jins* in Song style and form but with much finer workmanship. The colours were beautifully elegant and deftly arranged using the shading technique. During the Qianlong reign period (1736–96) the patterns became more complex, there was a greater variety of styles and foreign influences such as those of Islamic Persia made themselves felt. The later Qing saw the emergence of a tendency to indulge in excessive detail and complicated colour combinations, but there was, nevertheless, no lack of exquisitely wrought fabrics.

Duan *(Satin)*

Duan is a silk woven material with a satin weave. Only either the warp or the weft threads can be seen on its surface and hence the upper face of the fabric is shiny and smooth. By the Tang period many different kinds of silk woven goods were made using *duan*. *Jin duan*, embroidered *duan* and black-thread *duan* are names appearing in the records of that time. Under the Northern and Southern Song, the Liao and the Jin dynasties, the varieties of *duan* increased rapidly, and in the Yuan and Ming it became a fashionable material to use for clothes. Prior to the Ming dynasty most *duans* were five-*duan* (five-threaded) or six-*duan* (six-threaded), but at the height of the Qing dynasty fabrics were often eight-*duan*. Among the different types of *duan*, those that enjoyed the highest reputation were the figured *duan*, the glittering *duan*, the Song *jin duan* and the imitation *duan*.

The figured *duans* are polychrome silk fabrics on which the design has been achieved using the technique of damask weaving, as seen on Nanjing 'cloud *jins*'. The designs tended to be quite large and the colouring particularly rich. For example, a figured *duan* with a design of flower sprays, plants and butterflies (plate 128), dating from the reign of the Qing emperor Kangxi, has wefts in almost thirty different colours. The figured *duans* with gold in their decoration can be divided according to their colours: pale gold, green/blue gold, red, deep-red and pale-red gold, purple gold and many others. Those *duans* into which metal threads were woven in order to produce a patterned background were also called 'precious-metal ground'. There were in addition the figured *duans* made in the Ming dynasty for the covers of Buddhist scriptures, such as the example in the Palace Museum with a design of 'abundant harvest of five grains' (plate 84), or the piece in the Zhejiang Library with a design of 'precious flowers' on a green ground (plate 83).

Ku duan (treasury *duan*), also referred to as *gong duan* (tribute *duan*), was produced in state-run weaving mills to be used as tribute for the benefit of the treasury, hence the name. Plain *ku duan*, which was not patterned and had an eight-*duan* weave, was the most common, but there was also a type of reversible, figured, eight-*duan* called 'patterned *ku duan*'. This could be monochrome, employing the same colour for pattern and ground, or polychrome, using different colours for pattern and ground. An example of the latter type, from Chengde, Hebei Province, is the *duan* with a design of hexagons and linked circles (plate 121). The density of *ku duans* was approximately 130 warps × 50 wefts per cm. They were tightly woven and the material was thick and strong.

Rong *(Pile, or Velvet)*

The surface of *rong*, including silk *rong*, has a raised nap, or pile. The appearance of its upper surface is like swansdown, and hence it is also known as 'swansdown *rong*'. It is different from the two-dimensional warp-and-weft structure of ordinary materials in that the pile stands up at right-angles to the lie of the warps and wefts.

The *rong juan* and *rong jin* silks excavated from Han tomb No. 1 at Mawangdui, and from the tomb of Mozuizi at Wuwei, Gansu Province, may be regarded as the first *rong* fabrics. In the Southern Song the inhabitants of the Yanshan region made a kind of pile *jin*. In the Xianchun reign period (1265–74) both the government- and locally-run weaving mills in the region of Hangzhou produced a type of *jin* with a pile background, which perhaps belonged to the category of *rong* woven fabrics. In the Yuan dynasty there was a particular type of cut-pile silk material that was used to make the emperor's winter clothes, while in the Ming and Qing there were quite a few popular *rong*-type materials. The principal among these were Zhang *duan* and Zhang *rong*, which were traditionally supposed to have been produced in Zhangzhou, Fujian Province.

The Zhang *duan* was a damask-type woven material which used both *duan* and *rong* techniques together to produce the patterned ground. When the warp threads were many different colours then it was known as 'polychrome Zhang *duan*'; wefts of one or two colours were used. When, in addition to the coloured wefts, gold thread was incorporated into the material it was then known as 'gold-coloured *rong*'. In certain versions the gold floating wefts completely covered the base weave, and the material was then known as 'gold-ground polychrome *rong*'. Those fabrics on which a small shuttle had been used to produce a damask design with a multicoloured warp were known as 'adorned *rong duan*'. In the case of Zhang *duan* with applied colour, the paint was applied to the areas of monochrome cut pile. Surviving examples that may be regarded as typical are a Zhang *duan* with a design of a hundred bats (or blessings) and swastikas (plate 131), dating from the Yongzheng reign period (1723–36), and an example with a design of scrolling branches and lotus (plate 132), dating from the reign of Kangxi, both in the collection of the Palace Museum.

Zhang *rongs* may be divided into plain and patterned types. The patterned ones are also known as 'patterned swansdown *rongs*'. These were produced by marking the pattern on the uncut fabric with chalk while it was supported on a firm platform. The pile was then cut according to the marks and the pattern was formed by a combination of cut and uncut pile. This process was known as 'carving the pattern'. In the Gushan collection at Fuzhou, there is a deep-red patterned *rong* of this type dating from the Wanli reign period (1573–1619). A double-faced *rong* from the Dingling Ming-dynasty tomb has a unique regular pile on both sides.

In the reign of Qianlong of the Qing dynasty the Uighur peoples combined the skills of dyeing warps with the technique of using a nap-pole to raise the warp in the production of their *mashilu* cloth (plate 115). The *zai rong* silk carpets produced by the Uighurs are also well known.

Woven Wool Materials

Among the materials woven using wool in ancient times, the fine ones are called *ji* and the coarse ones *he*. Similar types of woven woollen material may be called by different names in different regions. A wool rug is known as a *qushu*, for example, in one area of Xinjiang and as a *tadeng* in Xizang (Tibet) and one area of Qinghai. The earliest surviving woven woollen fabric is a woollen shroud almost 4000 years old, discovered at Lop Nur, Xinjiang Province. By the time of the Qin and Han dynasties wool-weaving skills were already quite advanced and varieties of woven woollen materials included tabbies, twills, layered-weft tabbies, gauzes, wool tapestries and *zai rong*. Two common wool fabrics were *banji* and *xiehe*. *Banji* is a fine damask-weave woollen cloth. A coloured *banji* strip, excavated at Wubao in Hemi, Xinjiang Province, has coloured yarn and both tabby and twill weaves. A *ji* fabric, with a design of men, animals and grapes, and a *banji* with a tortoiseshell pattern were excavated from an Eastern Han tomb at Minfeng, Xinjiang Province. These both use the technique of weft patterning, and their patterns are clear and distinct with fresh and bright colours. *Xiehe* is a coarse woollen material made using a plain-weave technique. A blue *xiehe* excavated from an Eastern Han tomb at Minfeng is a two-over, two-under twill with a density of 13 warps × 16 wefts per cm. Its surface is smooth. Many of the woven woollen materials recovered from a Tang-dynasty site at Tuokumu, Bachu, Xinjiang Province, have an even lower density of ten threads per cm and are quite coarse *he* material.

The most important type of ancient Chinese woollen carpet was the *zai rong* carpet. A fragment excavated from the Eastern Han site at Minfeng was made using hoof-shaped knots. The base fabric has a density of 7–8 warps × 4 wefts per cm and there are four rows of knots to every five weft threads. A fragment of carpet on which the S-knot has been used was excavated from a Northern Dynasties site in the Miran area, Xinjiang Province. Although the knots are not very firm, nevertheless the S-shaped knots made with simple tools represent an advance in rug-weaving technology. Carpets produced in this way were more even and more dense.

3

Tapestries

The general term for tapestry in Chinese is *kesi*, 'carved silk'. It is a particular type of woven silk handicraft product which uses coloured wefts to produce the pattern and form the pattern outlines, so that the effect is as if the silk thread were cut.

The weaving technique in tapestry differs from that employed in producing brocade or embroidery; it is the technique of 'returning the weft after the appropriate warp has been passed'. The material was made on an ordinary wooden loom of the type used for plain-weave fabrics. When weaving a tapestry, the warp threads were first set up on the loom and then a rough sketch or pattern guide was placed face upwards beneath the warp threads, so that the sketch could be seen through the warps. The weaver could then paint the multicoloured design on to the warp threads using a brush. Small boat-shaped shuttles about 10 cm long were used to hold the different coloured silks required for each part of the design. There was no need to pass the weft thread of any one colour through the whole width of the shed and the colour could be changed at any point along the shed as indicated by the pattern guide. There was, therefore, a continuous changing over of shuttles holding different coloured silks, inevitably requiring the attainment of a high degree of artistry and skill. The structure of this sort of weave follows the principles of having a 'fine warp and thick weft', a 'plain warp and coloured weft' and a 'straight warp and twisting weft'. That is, the warp is undyed and fine while the weft is multicoloured and thick, so that only the coloured weft is seen. Because the coloured weft threads completely cover the woven surface of the tapestry, any shrinkage of the weft threads after the tapestry is finished will not affect the design on the surface.

Tapestry fabrics were already very popular in the Tang dynasty, and Tang tapestries with grass pattern still survive in Japan. The technique of returning the weft after it has passed the appropriate warp is one with a long history, its origin perhaps to be found in the weaving of brocade cloth in the Eastern Zhou dynasty. But all such weaving was in wool and it was only in the Tang that silk tapestry emerged. The popularity of silk tapestry in the Tang dynasty is not only recorded in historical documents, but is also attested to by the considerable number of material relics that have been excavated or handed down from that date. Examples are: a fragment of tapestry discovered by Stein with the Tang grass-circle design; a piece of tapestry with the grape-and-scrolling-plant design, unearthed on his expedition in Xinjiang Province in 1942 by the Japanese archaeologist Otani;

several fragments of Tang grass-patterned silk tapestry from the Nara period, now preserved in the Shōsō-in in Japan; and a Tang silk tapestry belt decorated with geometric designs and rhombuses, which was discovered by a Chinese archaeologist in 1973 at the Astana site.

Even before the Tang dynasty, Chinese woven brocades were famous outside China. The techniques used to weave tapestries during this period were principally influenced by brocading. Most of the tapestries were of the *qi* (regular) or *ping* (even) type. Slits were still visible at the places where the pattern ended on a particular warp thread, and these were called 'water roads'. Many of the designs at this time incorporated the brocade flower-and-plant and bird-and-animal motifs. Since these required a considerable amount of time and effort and were limited also by the techniques of matching and blending colours, geometric designs were the most frequently used instead. Tapestry was much used to make silk belts, small bags and other small decorated objects.

The *qiang* (overlapping) tapestry and *tao* (dovetailing) tapestry techniques were developed during the Tang dynasty. For the former, threads of different colours were used to shade gradually the colours on the back and front of the tapestry, and for any small and delicate parts of the design such as buds and leaves. Here, layers of threads of gradating colours overlapped in sequence. The length of the individual threads was irregular so that the length of the water roads was reduced. Since the Tang weavers were not skilled in the blending of colours the arrangements of the colour shading were not so very rich, but with the technique of weaving gold thread into the ground, the surface of the cloth appeared considerably more sumptuous than had previously been possible.

Tapestry weaving in the Northern Song dynasty developed further, building on the foundations laid down in the Tang period. In addition to the *qi*, *qiang* and *tao* techniques, the new techniques of *gouke* (united weft) and *shuangke* (double-wrapped weft) were developed. Designs were even more meticulously produced than in the Tang, and the colour gradations even richer. The shortness of some of the weft threads in the *shuangke* technique meant that the coloured threads were arranged in rough circles. In the cloud-and-feather design produced using the *shuangke* technique, the threads were fine and closely woven, so that by arranging each colour in relation to its neighbours the design had an especially decorative three-dimensional effect.

In the Song dynasty the main centre of tapestry production followed the seat of government to the regions of Zhejiang and Jiangsu, south of the Yangtze River. The nature of tapestry goods developed from being merely utilitarian to being used for ornamentation and art objects, in particular as imitations of famous paintings and calligraphy. The exquisite skills of the tapestry weaver in producing woven

brocade and printed and embroidered goods could not wholly convey the painter's art, but an appearance of three-dimensionality could be achieved which was lauded at the time for its ability to surpass the original.

Zhu Kerou and Shen Zifan were among the most outstanding of the large number of masters in this art at the peak of its development. Zhu Kerou was from Yunjian (present-day Songjiang County in Shanghai) and lived during the Southern Song dynasty. During the reign of the emperor Gaozong (1127–63) he employed female weavers to create exquisite representations of people, trees, rocks, flowers and birds. His skills in tapestry weaving were equal to his skills with a paintbrush and he was much admired by later generations. Among those of his works that have survived to the present day are a scroll with a design of ducks on a lotus pond (in the Shanghai Museum), and a peony tapestry and a butterfly-and-camellia scroll (both in the Liaoning Provincial Museum). The technique he used to weave his tapestries, the 'long-and-short qiangke', or 'chan', technique is also called the 'Zhu tapestry' technique and is still used today. A peony tapestry of his, 25.3 × 24.7 cm, uses five colours on a blue background. There are two shades of blue – light and dark – four shades of yellow, four of green, a bright red and a white, so that, in effect, he has employed twelve different coloured threads. The 'long and short' technique was used for the petals of the peonies, where long and short weft threads of differing shades were irregularly juxtaposed to produce a gradation of colour in the spaces between the main blocks.

The innovations in tapestry weaving in the Yuan and Ming dynasties were limited, but there was great originality shown in the disposition of the coloured threads. In the Yuan period some tapestries were woven with 'circular' (twisted) gold thread, while characteristic of the Ming dynasty were tapestries composed of gold threads, peacock feathers and two-ply reinforced twisted thread. In the Yuan dynasty there were two types of gold thread, the 'pure circular gold' and the 'pale circular gold', each having a thickness of only 0.2 mm with ninety-six threads per cm. Peacock-feather thread for tapestry weaving was made by combining the individual strands of the feather with silk floss. The results were dazzling gold and blue patterns whose colours never fade. A kesi dragon robe from the Dingling Ming-dynasty tomb, and a Ming-dynasty table-mat and chair-cover with dragon designs, both in the Palace Museum, all have peacock feathers woven into their designs. Another type of tapestry weaving, which in fact dated back to the Tang, was the 'fish-scales' technique, which was mainly used for the scales of dragons on dragon robes but also for the 'excess of good fortune' fish-scales and for the feathers on birds. This method of weaving made these depictions appear even more lifelike by adding to their three-dimensional quality.

The weavers of the Yuan and Ming dynasties continued the tradition of imitating the calligraphy and paintings of ancient artists, and some very large examples of this type of work have been discovered. Among these are the tapestries depicting Qiu Ying's 'The sound of the lute at a waterside pavilion', and the design of an ancient armillary sphere, now in the Liaoning Provincial Museum. The Ming tapestry entitled 'Yaochi celebration' is 260 cm high and 205 cm wide, while the tapestry made after Zhao Chang's 'Flowers and plants' is 244.5 cm long and 44 cm wide – both rare large tapestries.

Tapestry was used for a great variety of objects in the Ming period. In addition to mounts for paintings, calligraphy, albums, scrolls, Buddhist images and so on, tapestry was popular for all sorts of robes, trousers, court boots, bedding, curtains, chair-covers, tablecloths, hanging screens and other ornamental items. Apart from designs of flowers, birds, painting and calligraphy, a considerable number of pieces had designs depicting episodes from ancient legends. These all present a vivid appearance and the figures portrayed are remarkably lifelike.

In the main, the technology of the Qing continued with the traditional tapestry of the Song, Yuan and Ming. There were, however, a few technological developments. Firstly, there was the 'double-faced tapestry' technique. This was often used for fans, screens, room-dividers and elements of clothing and ornaments. Using this technique an identical pattern could be produced on both sides of the material. In the middle of the Qing period the technique of 'three-coloured gold' was invented, in which three types of twisted gold and silver thread – pure circular gold, pale circular gold and a silver colour – were employed on a deep-coloured background, highlighting individual parts of the design so that the finished product dazzled the eyes. There were also the 'three blues' and 'ink' techniques. The former involved the use of three blue colours – deep blue, purplish blue and a bluish white, perhaps with the addition of gold – on a pale ground to form the pattern, with gold thread used for the outlines. An example of this type of work is the tapestry depicting double dragons threaded through jade bi rings (plate 137), now in the Bishushanzhuang Museum in Chengde. With the ink tapestry technique, three shades of colour – black, dark grey and pale grey – were used to form the pattern on a pale ground, with either a dark or a gold colour used to outline the designs. These colours were fashionable in the late Qing and had an especially refined and elegant look.

The technique of combining tapestry and embroidery was arguably at its most innovative during the Qing. In its later stages, it developed into a style that combined tapestry, embroidery and painting. The technique was mainly used for tapestries depicting men, landscapes, birds and flowers, insects, and fish, as well as decorative themes which had

metaphorical meanings, such as wishes for good luck, high office and longevity. A typical example of one of these tapestries is the one made in Suzhou and now preserved in the Palace Museum. This tapestry with additional embroidery showing 'The nine suns dissipating the cold' is 213 cm high and 119 cm wide. Figures and sheep are embroidered in five colours; the background and the background designs are all woven using the tapestry technique, while flowers have been added on top of the tapestry and the embroidery using paint.

In the Qing court, tapestries of every kind were used to decorate clothes and room furnishings, for example the emperor's dragon robes, his hanging room-dividers, folding screens, bedding, curtains, small bags, perfume sachets, hangings for sedan chairs, fan covers, fans, palace step covers and so on. Many enormous Buddhist images and other religious pictures were also being produced at this time. The quantity of tapestries produced in the Qing was without precedent.

4

Printing and Dyeing

Dyeing and printing are the techniques by which colours or designs are added to fibres, yarns or woven fabrics. Dyeing usually involves giving colour to an entire item; printing is applied to discrete areas. Both processes developed from the 'applied colour' technique by which colour was put on by hand to produce a design on woven materials.

The material most commonly dyed and printed in ancient China was silk, but wool, hemp, cotton and even blended fabrics were also enhanced in this way. Different types of colour and dye were used in a great variety of styles. Printing using relief and intaglio blocks was a development of the application of colour by hand. The combination of dyeing with other skills produced the techniques of colouring woven materials using the wax-resist method, the stencil and tie-dyeing methods, weft pre-dyeing and so on. The technique of printing designs on textiles using gold leaf and gold powder developed from embossing and tracing in gold. Later, printing moved on from the use of flat wooden blocks to cylindrical rollers, which facilitated the production of colourful printed and dyed fabrics.

Applying Colour by Hand

This technique involves the use of a ready-mixed colour to paint a design on to woven fabric or clothing, and historical documents do in fact refer to this as 'painting'. The professional status of such painters was established as early as the Zhou dynasty, and kings wore their painted garments. Such painting was in fact a characteristic of the Zhou kings' apparel and was indicative of their elevated position in society. By the time of the Spring and Autumn Annals and the Warring States periods, however, such painted garments were worn by a much broader social group. Two silk paintings, one showing an imperial dragon boat with figures (plate 5) and the other a phoenix and woman (plate 6), have been excavated from a Chu tomb at Changsha, Hunan Province. These were both produced by the application of mineral dyes to an unbleached silk base.

In Han tomb No. 1 at Mawangdui, Changsha, a long silk painting was found which depicts a scene from the daily life of the deceased. The piece is in nine colours and demonstrates the considerable skill of the early Han painter. From the same tomb, a plain-weave robe decorated with applied colour has a design painted on with a brush, using colours such as vermilion, white, silver-grey and black in sequence, to depict branches, tendrils, buds, flowers, leaves, stamens and calyxes.

From a combination of ancient written sources and extant examples of goods produced, it can be seen that the skills of applying paint to woven fabrics have a long and unbroken history. These skills were also passed on to areas outside China. The famous dyed and hand-painted wares from Kyōto in Japan, for instance, still preserve features of this tradition.

Dyeing

By the Zhou dynasty the dyeing of silk thread, feathers and silk woven goods was widespread. It was controlled by special administrative organizations and carried out by artisans appointed by the local authorities. Documentary evidence exists in the *Zhou li*, which says: 'Dyers are masters of dyeing silk thread and fabrics.' In the 'Monograph on selection of officials' it says: 'The Zhong clan dyed feathers', while the 'Yue ling' ('Monthly commands') section of *Li ji* (*Record of Rites*) notes: 'In the summer months, the ladies of rank wore officially dyed elegant designs.'

Coloured silk thread was dyed first before use in woven designs; dyed silk fabric was woven first and then dyed. Different technological processes were involved in these two ways of producing coloured material. Coloured silk thread could be woven into patterned cloth or made into embroidery thread. In the Zhou dynasty the wearing of embroidered clothing

was restricted to those of the highest ranks. The saying, 'lower officials do not wear woven materials' referred to the fact that low-ranking officials were prohibited from wearing coloured woven clothes the thread for which had been pre-dyed (thus enabling multicoloured patterns to be woven into them). This, of course, also included embroidered clothes.

Dyed feathers were used to decorate banners and also the empress's carriage. The feather-dyeing of the Zhong clan would also have involved sticking the coloured feathers (from pheasants and cockerels as well as ones that had been dyed) on to the silk cloth used for making the garments worn in the temple when sacrifices were being offered.

In the period of the Warring States, dyeing technology flourished. Both mineral and vegetable dyes were used. The use of mineral dyes involved either applying the dye by painting it on or immersing the silk fabric in the dye. The dyes used included cinnabar red, haematite-iron red, orpiment yellow, dark green and clam shell burned to produce lime (for white). Dyeing using vegetable dyes involved immersing in dye and the use of mordants (substances used to fix colours). The colours used were blue from the indigo plant, purple from gromwell, red from madder, yellow from hispid arthraxon and from Cape jasmin and black from acorns. The range of colours from mineral and vegetable dyes was fairly complete at this time. Confirmation of this can be seen in the bright and colourful figured silks excavated from Warring States tomb No. 1 at Mashan, Hubei Province.

There were also strict regulations at that time governing the colours and patterns of silk clothes and adornments. The officially appointed Feather Officer used the feathers of the five-coloured Tartar pheasant as the standard for the colour and lustre of dyes. Colours were divided into two major categories: pure and blended. Blue, red, yellow, black and white were the five pure colours, while green, bright red, jade green, purple and another kind of yellow were the five blended colours. The distinction between the upper and lower classes was marked by the use of the pure and blended colours. Princes wore yellow, officials wore blue, red, white and black, while the common people were only allowed to wear blended colours, produced by mixing the pure colours. Green, for instance, was a mixture of blue and yellow; vermilion and white were mixed to produce bright red; green and white produced jade green; purple was a mixture of vermilion and black; and yellow and black produced dull yellow.

In the slave owning society, clothes (including headgear and footwear) were made in accordance with twelve symbols which stipulated the colours and patterns to be used to differentiate between the social classes. The emperor, who represented the might of heaven on earth, wore clothes and adornments that symbolized heaven and earth, in particular the black

cap and yellow robe. The designs on his upper garments were of the sun, moon and stars, and on his lower garments there were designs of mountains, dragons and pheasants. The colours and patterns of the clothes of both high and low officials were also strictly regulated and no infringement of the distinctions between the pure and blended colours was tolerated under any circumstances.

By the Warring States period of the Zhou dynasty the technology for multiple-immersion dyeing and mordant dyeing of silks was quite advanced. In the *Shi jing* (*Book of Songs*) it is said that, 'after one immersion the fabric is orange, after two it is pale red and after three it is deep red'. The explanation is that when madder is used for dyeing silk the colour becomes progessively deeper with each immersion in the dye. The process of obtaining a deep red by multiple immersion continued to be employed by succeeding generations. It was also possible to obtain a variety of shades of blue using indigo. The technique of using a mordant (such as sulphate of iron) in conjunction with vegetable dyes like madder and gromwell had also been developed. According to the account of the Zhong clan in the *Zhou li*, it took 'three immersions to obtain red, five immersions to obtain dark purple and seven immersions to obtain black'. This may indicate the use of a mordant with madder to dye a deep red and sulphate of iron being used as a mordant when dyeing deep purple or black. This is one of the first records of dyeing in China using the principles of chemical reaction.

By the Han dynasty the technique of using mordants with vegetable dyes to produce red, purple and black had progressed a step further. Woven silk materials dyed with madder using a mordant have been excavated from the Han tombs at Mawangdui, and at Fuhuangshou, Jiangling, Hubei Province. With the development in the Han dynasty of combinations of primary colours – red, yellow and blue – the spectrum was extended to ten colours with thirty-nine different tones. With more dyeing materials being made available and immersion and mordant dyeing becoming more advanced during the period from the Han to the Tang, the range of colours was extended even further. By the Ming dynasty it numbered fifty-seven shades and by the Qing dynasty hundreds more had been added. The technology for dyeing with natural colourants had developed to the extent that there were so many different colours that it was 'difficult to find names for them all'.

The inventor of modern synthetic dyes was an Englishman, W. H. Perkin, who in 1856 developed a purple aniline dye. After this, synthetic alizarin red and a synthetic indigo blue were successfully developed. They were cheap, convenient, of a consistent quality and produced fresh and lustrous colours. They gradually replaced natural dyes, and dyeing technology developed along with them. Natural dyes are, however, still used in certain cases.

Block Printing

Block printing is the process whereby a carved pattern block, with coloured paste applied to its face, is placed on cloth, thereby printing the pattern upon it. During the Warring States and Spring and Autumn Annals periods, master craftsmen had to respond to the increase in the variety of pigments available for painting on cloth. The technique of using these carved blocks was the resulting development. The earliest objects with decoration using this method were discovered in the coffin of a Warring States tomb at Guixi, Jiangxi Province. One example (plate 189) has been block printed with an irregular pattern in the same style as painted designs.

Block printing in the Qin and Han dynasties can be divided into two main types: that using blocks carved in relief (*yang* designs) and that using blocks carved with fretwork or stencils (*yin* designs). The former involved applying the colour to the areas of the pattern which were in relief, and then, according to the requirements of the design, repeatedly positioning the block on the flat silk fabric, in the same way as affixing a seal. The earliest example of relief-block-printed fabric discovered to date is a plain weave embellished with gold and silver from the Han tomb at Mawangdui. The pattern is in three parts and thus required three printing blocks. The first block produced the outline design of twisted grass-like curves, the second an animal mask formed by more curves and the third small gold dots. The lines of the pattern are quite fine, the space between them and the dots being less than 1 mm, but they are still distinct and forceful, showing considerable skill, while the pigment itself is smooth and even so that it covers the surface well. There are no flaws caused by splashes or too-heavy application of the pigment, and the repeating blocks have been carefully juxtaposed so that the pattern has an unbroken appearance.

The method of printing with stencil blocks involved carving the design in the negative on and through the face of the block. The block was then held firmly in position, flat on the surface of the fabric, while the coloured pigment was applied through the holes in the stencil so that when the block was taken away the design was left on the material. This method was more efficient than the use of relief-carved blocks since the greater size of the stencils made it easier to print a larger area.

In the Han dynasty this type of stencil printing was combined with the skills of the painters to produce a new technology of stencil printing with the addition of painted details. A piece of plain-weave fabric excavated from the Han tombs at Mawangdui is an example of this method and uses several colours, including vermilion red (mercuric sulphide), white (mica), silver (vulcanized lead) and black (charcoal). The fabric has a continuous undulating pattern depicting a liana vine. Each of the pattern units has as

its background motif a curling tendril of the vine which is the key to the position of the pattern as it is printed. The additional features such as the leaves, flowers and buds are painted on using a brush after the printed sections have been applied. The form and placement of these painted features is not strictly fixed.

The production efficiency of this type of printing was increased when one stencil was made to comprise four pattern units. However, 200 applications were still needed to print every metre of 800 pattern units. The process of painting on the additional features was in six stages: first, the painting of the flowers in vermilion red; second, the painting of the buds in black; third, the leaves in grey-black, fourth, outlining the tendrils in silver-grey; fifth, outlining the calyxes in a brownish grey; and, finally, outlining petals and additional dots painted in white. This created a pattern with even curves and fresh bright colours. By employing this technique of printing and painting plain-weave fabric, using the simplest pattern unit and embellishing it with bright harmonizing colours, it was possible to achieve rich, varied, intricate designs. The time and effort involved in making fabrics of this type was second only to that used to produce embroidery. Nevertheless, the technique represented a complete break from the ancient woven brocades and embroidered patterns, and allowed designs with their own distinctive style of fresh elegance and resplendent colours and patterns.

During the Tang the traditional block-printing technique developed in various areas such as multiple-set printing and printing on a coloured ground, and the level of printing skills reached a new high. A light plain-weave gauze of a sky-blue colour and with applied gold, excavated from the Tang tombs at Astana, Xinjiang Province, is the product of a combination of skills – printing using several colours, dyeing and applying gold. First the design was printed on to the blue-dyed silk fabric and then it was further embellished by the addition of painted gold. The spacing and positioning of the designs are even, with no irregularities, and the covering properties of the pigments are excellent, masking the sky-blue ground colour in the areas of the design.

By the Song dynasty the technology of block printing was already close to perfection. One development, however, was seen in the printing of zoomorphic designs using the stencil method. A great number of printed garments was discovered in the Southern Song tomb of Huang Sheng at Fuzhou, and these have designs depicting lions playing with coloured balls (plate 54), peonies and phoenixes, butterflies and peonies, and children and lotus – all revealing a high level of printing skill and technology in the meticulous application of the colours.

The Ming dynasty saw a continuation in the development of block printing. The fabric printed in the region of Hangzhou using blocks carved from

hardwood had very ingenious designs, and was transported and sold to the whole of China and even Japan and the South-east Asian countries.

Resist-dye Stencil Printing

As the skills of block printing and dyeing using indigo blue developed, fabrics with a white pattern on a blue ground became widespread. According to historical records this sort of patterned cloth, 'started to be made in the Qin and Han, and for a long time was worn by both the upper and lower classes'. By the Northern and Southern Dynasties the technology was fully developed and the method was as follows. The cotton or silk fabric was placed between two identically patterned stencils. These were firmly clamped together and the indigo dye was daubed or poured on to the uncovered areas. When the stencils were released the white pattern was revealed. If, instead, a dye-resistant white paste was applied, when it dried the fabric could be soaked in the liquid indigo dye. When the paste was removed later, one had a white design against a blue ground on both sides of the cloth. The paste (lime) was also known as 'resistant ashes'. The material produced in this way was variously known as 'blue cloth patterned in white', 'Yao speckled cloth' and 'sprinkle-pattern cloth'.

According to the *Tang yu lin* (*Tang Forest of Anecdotes*), in the time of the emperor Xuanzong (712–56) the younger sister of Liu Jieyu (a female palace official) persuaded the craftsmen to produce a stencil-press for dyeing. This was kept secret at the time, but later gradually became more widely known. A piece of Tang silk excavated in Xinjiang Province has the Tang pattern of small linked circles forming rings like pearl bracelets, the inner and outer rings being linked together by a line. This design could definitely not have been produced using an ordinary carved stencil; perhaps the elements were linked across the design spaces using raw silk and glue as reinforcement, or possibly separate printing blocks were used. Such stencilling skills formed the technological basis upon which the later developments in paper-mould printing and screen printing were founded. According to the *Song shu*, the stencil-press technique was based on a similar one used for Tang soldiers' uniforms and Palace Guards' hats.

During the Song dynasty, the exercise of control over clothing, seen in the Tang, was maintained. In the monograph on apparel it is stipulated: 'At the court all clothing made of embroidered brocade must, without exception, be exchanged for stencil-printed plain weave. The military Bian officials should wear a yellow stencil-printed robe decorated with paired phoenixes, the five horse-carriage attendants must wear stencil-printed unbleached silk with a design of flowers and phoenixes.' Under the emperor Zhenzong (998–1023) the people were forbidden to wear black-speckled, stencil-printed or dyed clothing and, moreover, were not permitted to engage in the trading of stencil blocks. This prohibition was lifted in the Southern Song and resist-dye stencil-printed clothing became extremely popular among the people.

In the Ming dynasty it became possible to use this technique with all colours and it was known as 'delete-print design'. The blue-and-white cloth made using lime paste and indigo-blue dye was, however, still widely used.

Wax-resist Dyeing (Batik)

The dye-resistant agent used to create the design on batik cloth was wax. The process is also known as 'wax dyeing'. Batik was made in the Qin and Han dynasties by the non-Han peoples of the south-east, making use of the water-resistant properties of insect wax, beeswax or pine resin. These were painted on to fabrics which were then dyed, thereby producing a pattern. Batik with a white design on a blue ground was made by taking a copper knife, dipping it into liquid wax and drawing the pattern on the material. After the wax had hardened the material was immersed in liquid indigo dye at normal temperature. After the dyeing process was complete, the wax was removed using boiling water. Another method was to paint cotton or silk with wax and then crumple it up so that the film of wax adhering to the fabric cracked in places. The fabric was then soaked in liquid dye and where the wax was cracked small amounts of dye penetrated, producing an irregular 'cracked ice' pattern on the material. Other vegetable dyes of different colours could be used, but indigo was the most common.

From a fragment of batik cloth with a design of flowers and plants, excavated from the Eastern Han ruins at Niya, Minfeng, Xinjiang Province, it can be seen that the designs were fine and meticulously produced. Batik fabrics from the Northern and Southern Dynasties sites along the Silk Road include not only cotton batik, but also blue woollen batik cloth with additional designs. Ornamental screens made using batik fabric were already in vogue by the Tang dynasty and, at this time, precious gifts were presented to Japanese envoys. The Shōsō-in Imperial Repository in Japan has in its collection a four-leaved screen made of batik fabric which dates from this time. Batik fabric fragments discovered at the Tang tombs at Astana and in the Mogao Caves at Dunhuang are very richly coloured. Among the batik pongees is one example with a cloud design on a red ground and others with brown, yellow, green and white grounds. There are also plain-weave fabrics with batik design, including one with a flower-and-tree design on a yellow ground and others depicting hunting scenes on yellow and green grounds. In the latter, hunters with bows and arrows are shown

riding on galloping horses in pursuit of their quarry. Clouds float above them and in the foreground flowers, grasses and trees are intermingled with deer and hares, while in the background are mountains and rocks. These are depicted in a lively and vivid way, similar to that of a line drawing produced with brush and ink, without romanticizing the subject.

In the Song dynasty the development of batik fabrics in the Central Plains area was rather slow and was progressively superseded by other printing techniques. In the areas inhabited by the various minority peoples, however, they continued to flourish.

Tie-dyeing

Tie-dyeing was used on some of the finest silks. Sections of the fabric were gathered up by hand or using a needle or a hook and then knotted with waxed thread following particular designs. The fabric was then immersed in liquid dye. Since the dye could not penetrate the knotted parts of the material, a pattern was formed when those areas were released at the end of the dyeing process. The nature of the coloration and arrangement was imprecise. The technique was also known as 'gathered dyeing' (gathered colour shades) and 'knotted dyeing'.

The technique of tie-dyeing did not require any special tools. A fish-roe design (see plate 216) could be produced by putting millet grains in the sections to be tied up with waxed thread before dyeing. The so-called 'young deer' pattern could be achieved by using a hook to gather up the material which after dyeing had spots the shape of plum blossoms. If small spherical shapes were used in the tied areas, and the material was gathered to form large round pockets which were subdivided and tied again, many unusual patterns could be produced resembling large and small bunches of flowers.

A tie-dyed material with a red ground, dating from the second year of the Jianyuan reign period (AD 344) and excavated from one of the Astana tombs, is indicative of the level that tie-dyeing technology had reached by the time of the Eastern Jin. Two fragments of tie-dyed pongee were discovered in another of the Astana tombs which dates from the fourth year after the founding of Xijing (AD 418). The designs on them have the strange varied and repeated patterns characteristic of the 'fish-roe' and 'agate cloth' types.

In the Tang dynasty, as the development of a wide variety of vegetable dyes coincided with advances in the printing and dyeing handicraft industries, the richly patterned and skilfully made tie-dyed fabrics became more and more popular. In the monograph on apparel in the *Xin Tang shu* (*New Tang History*), it is recorded that among the general populace the women were fond of wearing 'blue-green dyed fabric, plain-coloured silk flat hats, and shoes patterned with small flowers and grasses'. Around Shu Prefecture at this time a 'drunken eyes' dyed cloth was made, as well as the famous Shu red brocade. The 'drunken eyes' cloth was a tie-dyed material with a design that looked as if a bright-red silk net had been spread over the fabric.

It was in the Tang dynasty that tie-dyed fabrics reached Japan and examples are included among the collections of precious objects in many ancient temples. Even now the high-quality kimonos worn at traditional Japanese wedding ceremonies still bear decorative designs including the famous 'fish-roe', 'young deer' and 'Tang flowers' patterns.

Printing in Gold

In the Song dynasty all aspects of printing in gold were developed to meet the increase in trade in silks and in the court's gifts to the northern dynasties such as the Liao, Jin and Xixia, as well as in response to the prevailing fashion among the Nuzhen, Hui, Mongols, Uighur and Tibetans, who had a fondness for clothes trimmed with gold and silver.

According to the *Dong jin meng hua lu* (*The Eastern Capital: a Dream of Splendours Past*), shops and workshops selling and making goods associated with this technique flourished, though for a time the ordinary people were forbidden to wear them. In the monograph on clothing in the *Song shu*, it notes that in the seventh year of the Xianping reign period (AD 1000) the people were forbidden to possess either clothes adorned with precious metals or metal-decorated screens. However, considerable quantities of gold were still used to decorate the clothes of the northern peoples and the court officials. More than 300 articles of clothing and adornment were excavated from the Southern Song tomb of Huang Sheng in Fuzhou. Many of the gowns are trimmed at the neck and hem and on the sleeves with glittering and dazzling designs printed in gold (see plates 240–47). From close examination it can be seen that gold printing was at a technologically advanced stage – gold having been painted, traced, stuck or scattered on the fabric to produce the design. Some of the gold decoration had been combined with applied colour, and there were all sorts of magnificent variations.

Printing with gold involved mixing gold or silver powder with an adhesive to form a gold paint. This was then applied to the pattern block, which was in turn pressed on to the fabric to produce, for instance, a flower-and-leaf design or to provide an outline. Colour could then be applied inside the gold outline of, say, a leaf.

The technique of gold outline printing is also known as 'drawing in gold'. It was accomplished as follows. A coloured design of plant scrolls was first produced using the normal colour-printing method. The lines of the pattern were fairly indistinct and so gold was used to pick out the edges, clearly defining

the different shades of colour and the graceful intricacies of the design. The branches were given their colour by printing and the flowers embellished with gold paint. In this way a contrast was provided and each part had its own charm.

The technique of applying a design in gold leaf involved putting adhesive on to the printing block and then printing the design on to the fabric in glue. After this glue had been allowed partially to dry, gold leaf was stuck down on to the patterned areas. A calender (stone roller) was then used to ensure that the gold leaf was firmly stuck to the fabric. When the adhesive had dried, the gold-leafed areas were gently beaten and any gold leaf that was not stuck to the design was peeled off, leaving the design in gold adhering to the upper side of the fabric. Sometimes paint was applied within the design to give a combined gold and paint pattern. Textile relic No. 134 from the tomb of Huang Sheng, a brown-coloured garment lined with gauze, has a border pattern on the front-opening edges that has been applied using the gold-leaf and paint method described above. The borders on the front openings of this garment have a design of tree peonies, hibiscus and roses on which the gold leaf still securely adheres even today. The plant designs look as good as new, and magnificent golden shafts of light are strongly reflected off the surface. The designs produced using gold leaf appear even more elegant than those employing painting or outlining in gold.

The technique of applying scattered or sprinkled gold involved placing a stencil block on a flattened, even piece of fabric and applying a mixture of colour and glue through the pattern holes in the block. When the block was removed, and the design in colour and glue was revealed, crushed gold leaf was sprinkled or pressed on to the sticky areas. When the glue and colour were dry, the back of the fabric was beaten so that any bits of gold that were not stuck in place would fall off and the gold additions to the design would be revealed. This type of design with sprinkled gold had its own particular style due to its irregularities. Textile relic No. 263 from the tomb of Huang Sheng, a skirt, has a design of paired phoenixes and tree peonies produced in this way. Compared with the designs produced using painted and outlining gold, this type of design has relatively broad pattern lines and the gold areas are strong, so that the fabric has an even richer, more glittering and more sumptuous feel.

In the Jin and Yuan dynasties, objects made with printed-gold material were much in demand as indicators of a person's position in the social hierarchy, symbolizing his extravagance. Fabrics with areas of printed gold have been excavated from the site of the Yuan-dynasty Jining Road in Inner Mongolia. The designs on these are composed mainly of large clusters of flowers and branches. They are exceptionally brilliant and sumptuous. These printed-gold designs cannot withstand rubbing, since the gold is less firmly attached than that on the brocades which has been applied using strips of gold thread. With the coming of the Ming and Qing dynasties, the technique of printing gold on to fabric was progressively transferred to everyday items, such as lacquerware.

5

Embroidery

Embroidery, which is known by various names in Chinese, is a handicraft in which a needle threaded with coloured thread (silk, floss or cotton) is used to add stitches to a material (silk or cotton) in set designs and colours, thereby creating a pattern, picture or characters. In embroidery there are three considerations to be taken into account: the choice of threads of various colours, the appropriate thickness of the threads and the different stitches to be used.

Chain-stitch

Chain-stitch and satin-stitch are the most ancient in Chinese embroidery. In chain-stitch, embroidery threads form interlinked loops so that the resulting pattern resembles a chain, hence its name. On the outer surface it also looks like a pigtail and is therefore popularly known as pigtail-stitch. Traces of chain-stitch embroidery have been found on a bronze drinking vessel excavated from the Shang-dynasty tomb of Fuhao at Anyang. In 1976 traces of a rolled-grass pattern were excavated from a Western Zhou tomb at Ruijiazhuang in Baoji. The outlines of the embroidery were principally done in single-ply chain-stitch. In one area of the embroidery the effect has been strengthened by using double-ply threads and the stitching is neat, even and carefully executed.

According to the *Zhou li*, 'all embroidery is stitched in accordance with painting'. In the monograph on selection of officials it is stated that: 'The painter and the embroiderer share their task.' This seems to indicate that the patterns of Zhou-dynasty embroidery were fairly complicated and were therefore first painted on to the fabric before being stitched by the embroiderers. Alternatively it could indicate that painting and embroidery were combined to produce a complex pattern design.

Because paint was liable to come off handicraft items and because many of the complicated designs could not be achieved using only weaving techniques, there was a fairly rapid development of embroidery with its excellent colours and designs. By the Eastern Zhou, embroidered designs were already quite rich. A

remnant of *qiequ* pattern (resembling a silkworm design) in chain-stitch, of the early Spring and Autumn period, has been excavated from Guangshan, Xinyang, Henan Province (plate 190). Although some of its stitched design has disintegrated, nevertheless the double chain-stitch can be clearly seen as the distinguishing method outlining the hollow *qiequ* pattern.

In 1982 twenty-one pieces of embroidered fabric with various designs were found at tomb No. 1 at Mashan, Hubei Province, dating from the late Warring States period. Most of these were on a *juan* silk base with the exception of one on a gauze base. This find of Chu silks, the like of which had never been seen before, was excellently preserved and retained magnificent colours. Several different colours of thread had been used: brown, reddish brown, deep brown, deep red, vermilion red, purple red, pale yellow, golden yellow, earth yellow, yellowish green and cobalt blue. The thread was two-ply with a maximum width of between 0.15 and 0.4 mm, but mainly between 0.15 and 0.25 mm. Dragons and phoenixes provided the main theme of the designs, which were embellished with flowers and plants and took individual and unusual forms.

During the Qin and Han dynasties, production of embroidery flourished and the range of items widened rapidly. By Han times, specialist embroidery mills had been set up and the office of the Lingshi was established by the court to administer them. According to the records for the time of the emperor Wudi in the *Han shu*, in the final year of his reign (87 BC) there were two specially appointed officials at court, the Embroidered Clothes Justice and Bringing to Correction Officer and the Embroidered Clothes Imperial Officer, who represented the centrally administered legal code: 'Wearing embroidered clothes, wielding the flogging rod and the executioner's block, they disperse in pursuit of arrests, and the Provisional Governor guards and punishes (those who are arrested).' It seems, therefore, that those who were later known as Embroidered Axe Officers were in fact specially appointed imperial law officers, who had the power of life and death. In the Han dynasty the practice of officials at the imperial court being required to wear embroidered clothes became more usual and the walls of the palace also were lined with embroideries. In the *Xi du fu* (*Prose Poem on the Western Capital*) by Ban Gu, for example, it says: 'The Zhaoyang Hall of the Palace was so magnificent, as grand as Xiaocheng, that the timbers of the rooms could not be seen at all. Everything was encased in bags decorated with embroidered aquatic plants and tied with black silk ribbon.' The *Zheng shi shu* (*Memorial on Administrative Matters*) notes: 'The beautiful axe-symbol embroideries were the clothing of the ancients. Nowadays the wealthy and the merchants use them as wall hangings for their honoured guests.' At the same time, embroideries constituted the highest class of imperial gift presented to the noble families of the Xiongnu (Huns) by the Han court, and furthermore these items travelled along the Silk Road as articles to be traded with China's friendly neighbours. The production of these items also flourished among the people.

Notable centres of production in the Han dynasty were the prefectures of Qi, Wu, Chu and Shu. In the Eastern Han period, Wang Chong in the *Lun heng* (*Critical Essays*) recorded that: 'There is not a woman in Qi who is not able to embroider,' and moreover, 'master embroiderers can stitch curtains and clothes; the workers who stitch detail are not able to weave brocade.' Clearly, embroidery and the weaving of brocade were regarded as two separate professions. However, the skills required for embroidery were greater than those needed for the weaving of *jin*. In order to produce the same pattern the embroiderer would need more time than the *jin*-weaver, making embroidery even more expensive.

Many embroidered goods dating from the Han period have been excavated, particularly in Hunan, Hubei and Shanxi Provinces, and along the Silk Route. The greatest number are from tomb No. 1 at Mawangdui, Changsha, and these also have the richest designs. The inventory found in that tomb notes that the principal clothes were embroidered with *xinqi*, floating clouds and the Chinese character for 'longevity'. There were also embroideries with patterns of *zhuyu*, clouds, checks, *purong*-stitch and feather appliqué. The traditional Chu chain-stitch is used on all of them. The stitches and the dimensions of the loop are no more than two-thirds the size of those seen on embroideries of the Warring States period. The colours include crimson, vermilion, earth yellow, golden yellow, sapphire blue, lake blue, cloud purple and dark blue. The stitching is neat and even, and the radians are identical. The lines of stitches are close together and regular, though the arrangement of the stitches is unconventional. For example, on the side of the head of a strangely shaped phoenix among floating clouds, the eye has been made in the shape of a lozenge and the space in the centre has been given a fine single row of chain-stitch to give expression to the eye. The use of a seed knot that appears behind the single row of chain-stitch enhances the effect. This provides a foundation for the development of knot-stitch.

The majority of excavated Eastern Han embroidered goods have come from four important sites along the Silk Road: the Han ruins at Wuwei in Gansu Province; the Han tombs at Niya and Lop Nur in Xinjiang Province; an Eastern Han Xiongnu (Hun) tomb at Noin Ula in Mongolia; and Palmyra in Syria. In 1959, six Han embroideries were found at the site at Niya. One of them, an embroidered border on a green *juan* base, has a design of bunches of rolled grass, clumps of golden bellflowers, lozenge-shaped vortex patterns, beanpod-shaped paired leaves, tall

graceful wild flowers and, appearing from among the flowers and leaves, the heads and clawed front feet of two very appealing long-eared hares. The structure of the *ruyi* design on embroideries with cloud-patterned *ruyi* and with cloud-patterned *ruyi* and flowers and plants is fluent and smooth and, compared to the embroideries of the Western Han, full of feeling. The designs still retain, however, the artistic features of the two Hus (Hunan and Hubei) and the embroideries of the Chu region.

Chain-stitch is the stitch used on all these Eastern Han embroidered items, but different stitching techniques can be seen. A closed chain-stitch is the one most often used for the patterned borders and for the fine lines of the cloud pattern, whereas an open chain-stitch is used to fill in the flat areas of the open flowers. The combination of these two types of chain-stitch gives a feeling of solidity.

Fragments of fabric embroidered with designs of animals, grapes and vines from around the Eastern Jin state, dating from the time of the Three Kingdoms (304–439), have been excavated at Minfeng, Xinjiang Province. The chain-stitch used on them has incorporated many changes and the grape design has an even more decorative effect than a painting. It is one of the best-loved designs of the peoples of Gansu and Xinjiang Provinces.

Embroideries from the Northern Wei are rare, but fragments of an embroidery dating from AD 487 (plates 34 and 206) were discovered at Dunhuang. The following text was found on part of the preserved remnant: 'Made for King Guang Yang to promote peace.' The pattern design shows men and women making sacrifices as its main theme. The figures' clothes are adorned with peach-shaped honeysuckle and, together with the square Wei-style stele characters, are typical of the Northern Wei. A single line of chain-stitch is used on the yellow silk to embroider the borders of the clothes, the flowers and plants, branches and tree trunks, the edges of the leaves and the frames of the character panels. A double row of chain-stitch is used for the honeysuckle designs, the characters themselves, the feathers on the caps and so on. The surfaces of the leaves are covered with multiple rows of chain-stitch and the leaf veins are distinguished by the use of contrasting coloured thread. The chain-stitch used in the Northern Wei differs in appearance from that used on Han-dynasty embroideries. The distance between the stitches is very small. On the edges the silk thread is relatively thick and the distance between the stitches is slightly greater – there are approximately eight stitches per cm along the row and eight across. In other areas the stitches are very densely packed with nine stitches per cm along the row and eleven stitches across, each stitch being linked to its neighbours so that they present a very solid appearance. In other areas of the border the reverse side of the chain-stitch is used, so that a continuous linked running-stitch appears on the front of the fabric while a shaped-stitch appears on the back. Clearly this stitching technique, using both right-sided and reverse-sided stitching, was a new development based on the Han-dynasty chain-stitch. The main colours employed on these fragments are red, yellow and green, but purple and blue are also used. The colours are used harmoniously and they are distinctive, clear, bold and vigorous. The stitching is varied and in every respect surpasses that of Han embroidery.

Before the Tang dynasty, several new stitches had been invented, such as the filling satin-stitch, shading satin-stitch, *qiang*-stitch, *souhe*-stitch, *zha*-stitch and *chan*-stitch. Using these, the hairs and feathers of animals and birds and the natural appearance of flower petals could be depicted much more accurately, and chain-stitch was therefore used only for tree-trunks, branches and pattern outlines.

Satin-stitch

After chain-stitch, satin-stitch is the oldest basic stitch used in China. It includes the covering satin-stitches (vertical, horizontal, oblique and open herringbone) and the shading satin-stitches (single set, double set and multiple set). Satin-stitch consists of parallel stitches arranged neatly and evenly so that they completely covered the base fabric. The stitches did not overlap, so that the technique could be used in a much more varied and expressive way than chain-stitch. It was usually used for small flowers and leaves within the design, but when the embroidery covered a large area it was also used as a base for the pattern with other stitches being added on top of it so that the length of the stitches could not be seen. Shading satin-stitches made it possible, for instance, to depict the silken texture of branches, leaves, feathers and hairs on plants, birds and animals with smooth harmonious colour changes. The technique was thus frequently used in embroideries that imitated paintings. Modern double-faced embroideries often use this stitch.

The covering satin-stitch and the single-set shading satin-stitch are first seen on chain-stitch embroideries from the Western Han tomb at Mawangdui, Changsha. In the Eastern Han, satin-stitch is seen, for example, on the flower designs of the embroideries from the Xiongnu tomb in Mongolia and on the embroidery with figures from Wuwei in Gansu Province, on some parts of which a fairly widely spaced covering satin-stitch is also found.

In the Sui, Tang and Five Dynasties periods scientific and artistic skills developed rapidly and embroidery techniques were no exception. Realism and decorative quality were the main requirements of pattern designs, and thus there were many innovations in satin-stitches. A small bag with auspicious *ruyi* decoration found in Tang tomb No. 322 has *jian-*

feng-stitch on a deep-red base fabric to form a *qin*-shaped lined cover. Both sides are embroidered in pure-yellow, sapphire-blue, pale-green and bronze threads. The embroidery design is of both large and small *ruyi* with a border of oblique satin-stitches in bronze, and silk tassels hanging from the bottom corners. This is one of the characteristic Chinese designs with a hidden meaning, and in this case *ruyi* has the meaning of 'auspicious, and wishes fulfilled'.

A Tang-dynasty embroidery of Sakyamuni and another piece with a similar design which is now preserved in a temple in Japan, primarily use a *qi* thread stitch (a variant of chain-stitch) for the outlines of the design, and a short shading satin-stitch to embroider the body. The parts of the design on which this latter stitch is employed have an especially lustrous colour-shading effect. The new techniques, the vertical satin-stitch and the *chan* split-stitch, are used for the clothing, imparting to the figure a complex and vivid appearance since the colour gradation is even finer on these areas.

Encroaching, or Straight, Stitches

The main characteristic of these various stitches is that they form a pattern with subtle colour gradations. *Qiang*-stitch uses short vertical stitches which follow the shape of the design, stitching the different parts in turn. There were generally two types of *qiang*-stitch: that in which the stitches followed the separate parts of the embroidery working from the outer edge inwards was called 'inward *qiang*-stitch', and that which was worked from the inside towards the outside was known as 'outward *qiang*-stitch'. In the latter, each layer of stitching was fitted to the inner point so that the layered embroidered pattern was neatly shaded.

The characteristic feature of the *souhe*-stitch is the irregular use of long and short stitches. The later stitches were started from a point midway along the earlier stitches so that the edges were uneven and the effect was of diffusion from the inner to the outer edge of the embroidery. The coloration of the threads could be changed from light to dark or from dark to light as desired. This stitching technique was very adaptable and produced an especially realistic effect. It was often used to embroider large flower petals and very large wing feathers, and the final embroidery had a rich velvety feel.

The designs for embroideries in the Five Dynasties and Northern Song periods were often closely connected with religion. In 1956 a collection of Northern Song artefacts was discovered in the Huqiu pagoda in Suzhou. Among the items found were four tattered wrappers of gauze with embroidered designs mostly of Buddhist lotus patterns. One of these pieces included the embroidered character for 'alms'. This was a Sutra cover, which would have been presented by an almsgiver. The embroidery threads used on this piece were of three harmonizing colours and the work was mainly done in satin-stitch, *qiang*-stitch and *souhe*-stitch.

In 1978, in the Ruiguang pagoda on the outskirts of Suzhou, an embroidered Sutra cover was found among another cache of Northern Song objects. This had a gauze base and embroidered designs of grass and flowers worked in threads of silk floss. The colours were blended gradually using an oblique *chan*-stitch and split-stitch. Although the stitching had been carefully executed, the embroidered surface was smooth and even and the ends of the threads and the knots could not be seen on either the front or the back – a type of backstitch had been used to replace knots. At the junction of two leaves, *tiao* (cross) stitch had been used and so it is not possible to describe the work as true double-faced embroidery, though it can be seen as its precursor.

The significance of Song-dynasty embroideries lies in their development from traditional clothing and everyday objects into works of art of the same type as paintings and calligraphy. The designs were not confined to plant-and-flower and bird-and-animal motifs, but frequently made use of the works of famous Tang and Song painters. Hence, in addition to depicting flowers and figures, these designs related to natural landscapes, pagodas and pavilions, rural villages and dwellings and so on, and have, with reason, been called 'embroidered paintings'. The Ming-dynasty painter Dong Qichang wrote:

The thread and stitching of Song-dynasty embroidery was very fine and close, using floss of only one or two strands and needles as fine as hairs. The filling in of the colours was excellent, and their lustre eye-catching. The interplay within the landscapes between the foreground and distant ground, mountains and water, the style and impression of depth provided by the storeyed pavilions, the impression given by the figures of looking into the distance, the gracefulness of the flowers and the liveliness of the birds surpass even paintings in their beauty.

Song-dynasty embroideries in the Liaoning Provincial Museum, such as 'parrot on plum branch with bamboo' (plate 56), 'jade terrace and crane' (plates 57–8) and 'flowering crab-apple and pair of birds', are all carefully executed realistic 'embroidery paintings' in the style of the Southern Song Imperial Academy. The second of these, which shows immortals and a jade terrace, is 25.4 cm high and 27.4 cm wide. The major part of the embroidery is satin-stitch, but the pine needles and leaves are worked using single-thread random-stitch. The roof-tiles and other details are outlined using couched twisted gold thread. The silk windows are done in satin-stitch with white thread so that they appear transparent and the half-hidden walls inside the room are depicted using brush painting. The quality of the work is marvellously fine.

The embroidery depicting a parrot, plum blossom and bamboo is fine and close, and the shading of the colour is harmonious. Satin-stitch and *souhe*-stitch are used for shading and the layered silky texture of the bird's feathers makes them look completely realistic. The stamens of the flowers have been depicted using a seed-stitch which is seldom seen. At the top of the piece there are several seals belonging to the Qing emperors Qianlong and Jiaqing along with the seals of the Jiang and Zhu families.

The variety of excavated embroidered goods dating from the Southern Song is considerable, the greatest collection being that from the Southern Song tomb of Huang Sheng at Fuzhou. Most are plant-and-flower designs but combined also with butterflies, dragon-flies, fish and aquatic plants. The embroidery techniques had changed considerably. For example, the four butterflies on the edge of an embroidery depicting butterflies and peonies are all different, each having been worked in a different way. The feeler of the first is done in split-stitch, its wings are in a type of satin-stitch and the background with circular spotted design in shaded satin-stitch, while it is outlined with couched thread. The second butterfly has feelers like the first and its large wings are also worked in a type of satin-stitch. The hanging flowers spotting the background are produced using shaded satin-stitch and the small wings make use of oblique *chan*-stitch to produce an elegant speckled pattern. *Souhe*-stitch and fur-simulation stitch are used where the large and small wings join. The wings of the third butterfly are embroidered using *qiang*-stitch and the colours are quite deep. The background and foreground, therefore, employ a pale monochrome *qiang*-stitch, and the dark wings are embroidered on top using a flat *souhe*-stitch. The fourth butterfly has satin-stitched large wings with a background net-effect produced using a flat-stitch. The small wings are also done in a type of satin-stitch, their background being spotted with a design of three ellipses. The petals of the four herbaceous peonies are both numerous and complex, while the branches and leaves are arranged around them in a harmonious way. Most of the work is done in varieties of satin-stitch, but oblique *chan*-stitch has also been used. The overall appearance of the embroidery is simple yet realistic.

Embroideries from the Yuan and Ming dynasties were even more skilled in their use of *qiang*-stitch and *souhe*-stitch, which by then were even more widespread.

Knots, Appliqué, Couching, Carving and Woven Stitches

Knot-stitch
This stitch is known by several names, including ring-stitch, tied-stitch and seed-stitch. The character-istic structure of this type of stitch is a pellet-shaped knot, produced after the embroidery thread has been pulled through the fabric, formed into a circle, coiled around and tied. The technique is quick and effective and the embroidered patterns produced in this way stand proud of the surface so that the lustre of the silk thread catches the eye. The thickness of the thread used determines the size of the resulting knots, and the speed with which they can be produced. The stitch was often used for spotted designs, eyes and flower stamens, but there are also embroideries on which it has been used to form the main areas of the design such as flowers, plants, animals and figures.

On a lined, embroidered garment from among the collection of silks from the ancient city of Jining in Mongolia, knot-stitch has been used for the centre of all ninety-nine flowers in the design. It has also been used without exception for all of the flower centres on the excavated and handed-down embroideries from the Ming and Qing dynasties.

Appliqué-work
Appliqué-work is also known as attached-fabric embroidery or attached-feather embroidery. When the embroidery is being worked, pieces of various types of material are cut to precise pattern shapes and then chain-stitch or another short stitch is used to attach them to the surface of the base material in accordance with the requirements of the design. The technique can be used by itself to produce a design or can be used in conjunction with other techniques. The earliest use of appliqué can be seen on an embroidered woollen *jin* excavated from tomb No. 1 at Mawangdui, Changsha. Multicoloured birds' feathers have been fixed on to the fabric according to the requirements of the overlapping-lozenge and *leiwen* pattern. The outlines have been produced in white and the resulting velvet-like patterned surface is very fine. An appliqué-embroidered *dalian* bag (plate 249), excavated from the Southern Song tomb of Zhou Yu at Jintan, has a patterned base material on to which has been applied a design of flowers. Over this, various stitches have been used to outline and decorate, so that the design incorporates several styles.

A waist hanging excavated from Huang Sheng's tomb (plate 247) is in the form of a double band, V-shaped at one end. It is 213 cm long and 6.2 cm wide and displays the traditional characteristics of an appliqué embroidery, complemented by details using normal embroidery skills. The design on the upper surface appears as if divided in two, each half being identical to the other. The leaves of the peonies, crab-apple flowers, camellias, indigo flowers and roses have all been appliquéd in the following manner. First the outline of the design was printed or sketched on to the surface of the base fabric. Gold foil or a woven material was then cut and put in place. The central flower petals were stitched using a vertical satin-

stitch, while the other petals were depicted using a horizontal satin-stitch which pointed towards the centre of the flower. The threads were 2–3 stranded silk. The veins of the petals of the peonies, hibiscus, hollyhocks and camellias were depicted using the layered *souhe*-stitch. The petals above the pomegranate leaves were also done in appliqué while the lower petals are done in a layered stitch.

Several fine imperial appliqué embroideries are preserved in the Palace Museum in Beijing and in the Bishushanzhuang Museum in Chengde. One such item is the very unusual embroidered back-panel with its sombre and elegant design of *taotie* (monster mask) and *kui* dragons. Qing-dynasty embroideries from the Liaoning Provincial Museum all manifest features of local embroideries. A good example is the one depicting the scene on a high river bank (plate 147) – a landscape using appliqué and floss and depicting willows, geese, peonies, butterflies and mountain monkeys.

Couching

Couching or applied-thread embroidery, is when one, two or perhaps several quite thick threads are incorporated into the surface design by means of a secondary stitch which also appears on the surface. If embroidery thread is used to stitch on a design made from gold or silver threads it is popularly known as 'circling with gold' or 'filling with gold' embroidery. If the patterned surface is covered with coiled gold or silver thread it is known as 'coiled gold/silver' embroidery. The technique was quite prevalent in Tang and Song times and has been found on excavated and handed-down goods. For example, a cap decorated with paired deer, flowers and plants (plate 59), excavated from a Liao tomb (about AD 960) at Yemaotai, in Faku County, Liaoning Province, is mainly embroidered using this technique. Another example is a small aromatics bag (plate 251) which has coiled gold, coiled silver and outlining couch-work. The skills used on this piece are at a proficient level and it has a distinctive style. A further example is the Southern Song jade-terrace embroidery, mentioned above, on which the couching of mixed threads and couching of gold thread are combined for the terrace, balustrade and supporting pillars, which thus appear in relief.

Couching was still used in the Yuan, Ming and Qing dynasties for outlining fine branches and leaf stems. Fine examples using the filled-gold technique are an embroidery with crane design and a cushion embroidered with the 'longevity' character and seven chrysanthemums, from the Bishushanzhuang Museum in Chengde.

Carved-scale stitch

Scale-stitch is also known as 'fur-simulation' stitch. It is primarily a combination of *souhe*-stitches (mixed straight stitches) and *qiang*-stitches (layered stitches) and is used to depict tigers' stripes, feathers and fish- and dragon-scales. For instance, when fish- or dragon-scales were being embroidered, a background was first produced on the fabric using layered or vertical satin-stitches. If *qiang*-stitch was then used for the scales, 'water roads' would be left between them, or backstitch could be used at these junctions to give the scales a more solid form.

This technique of embroidering scales is first seen on the butterflies' wings on Southern Song butterfly embroidery from Huang Sheng's tomb. In 1964 a garment with an embroidered design of paired dragons and clouds was excavated from the Yuan-dynasty tomb of Madam Cao in Suzhou. On this garment the technique was used to embroider the scales of the lively, paired dragons which adorn the edges. An embroidery with a pattern of carp, found in a storage cellar on the Jining Road in Inner Mongolia, also used the carved-scale technique. The stitches are arranged closely and evenly and the silken texture has natural-looking outlines and shading. The scales of the golden dragons (see plate 172) on the five-coloured court robes of the Qing emperors Kangxi, Yongzheng, Qianlong and Guangxu, and on the clothing and adornments of their empresses and concubines, found in the Palace Museum collection, all employed the carved-scale technique. When twisted gold thread is used in this design the pattern has a brilliance that was said to dazzle the eye and when it is combined with embroidery using peacock feathers the effect is incomparably beautiful and opulent.

Woven-in embroidery

Woven-in embroidery is also known as 'woven gauze' embroidery or 'woven-in pattern' embroidery. A coloured thread is passed through a plain *sha* gauze, which has often been adorned already with layered stitches, and the whole of the surface is covered with a woven-in embroidery pattern. It then possesses some of the characteristics of brocade and is therefore also known as 'woven brocade' embroidery. The most durable embroidery of this type is where the floated threads are not too long and where the fabric does not have a nap. An embroidered jacket from the Dingling tomb of the Ming emperor Wanli, decorated with flowers and plants, has a base fabric with an embroidered lozenge pattern produced using this woven-in stitch, and with the flowers and plants embroidered on top so that it has a distinctive effect like that of a pattern added to a brocade. The woven-in embroidered back-panel (plate 177), from the museum at Chengde, has an elaborate pattern of hibiscus and peonies in the artistic style of an embroidered brocade.

Gu Embroideries

Gu embroideries are a type of 'boudoir' embroidery developed among the ladies of the Ming dynasty. According to *Gu xiu kao* (*Investigation of Gu Embroidery*): 'What are today known as Gu embroideries take their name from the Ming-dynasty embroideries of the Gu family of Shanghai.' In 1556, the Gu family became renowned because of the embroideries of the imperial candidate Gu Mingshi. Because he lived at Luxiangyuan in the Jiumu district it was also known as 'Luxiangyuan Gu' embroidery.

In the development of Gu embroideries, the most prominent of the female embroiderers was Han Ximeng, the wife of Gu Mingshi's second grandson. She blended the theory of painting with the skills of embroidery to the betterment of both. In her stitching and use of colour she was ingenious and original, and her work is also known as 'the embroidery of the woman Han'.

The largest collection of Gu embroideries is to be found in the Liaoning Provincial Museum where there are some thirty-two items, including the hair embroidery 'Weaving Maid Tower figures' (plate 110). Eight of these bear the seal of Han Ximeng. Shanghai Museum has four of Han Ximeng's embroideries including one with a design of aquatic plants and shrimps. In addition to these there are handed-down Gu embroideries in Nanjing Museum, Suzhou Museum and Zhenjiang Museum, among which are depictions of a pair of perching phoenixes, the apricot-blossom village, the Three Longevities in a landscape and a crane holding the fungus of immortality (plates 100–107). From an analysis of these embroideries their artistic characteristics can be summarized as follows.

Gu embroideries were accurately modelled on famous landscapes, bird-and-flower paintings, and immortal and figure-painting masterpieces of the Song and Yuan dynasties. They were most influenced by the style of painting of the Ming-dynasty Songjiang circle of painters, known as the 'among the clouds clique'. Much of the surface pattern is a combination of embroidery and painting, using embroidery to replace paint. On the scroll of the immortals celebrating longevity, for example, some of the silk clothes that the figures are wearing have first been painted in a foundation colour and then the brocade patterns have been added using the woven-in stitch. The hillside has been painted and then merely outlined with embroidery; parts of the tree-trunks, mountain slope, large leaves and stone platform, as well as other larger sections, have been embroidered, painted and then embroidered again, while the clouds and mist have been directly painted with a brush and do not have any additional embroidery.

Secondly, the stitches used in Gu embroidery were both varied and complex. It is generally accepted that ten different types of stitch were regularly used:

satin-stitch, layer-stitch, knot-stitch, split-stitch, *souhe*-stitch, *qiang*-stitch, metal-thread couching, shading satin-stitch (both single and double) and carved-scale stitch. The innovatory technique of double-set shading satin-stitch was frequently used for the face of the Maitreya Buddha, the Eighteen Lohans and other figures, and single- and double-set shading satin-stitches were used with great facility on a number of different aspects of the surface of the embroidery. 'Lohan' is a shortened form of the transliteration 'Alohan', a Sanskrit word referring to the third grade of 'enlightened beings' in Buddhist doctrine. The Eighteen Lohans (plates 111–14) are embroidered reproductions of the likenesses of the lohans as painted by the Eastern Jin painter Gu Kaizhi. Their faces and flesh are embroidered using different-textured silk, in accordance with the different textures of the skin, worked in vertical and oblique satin-stitch so that they seem to glow with health and radiate vitality. Their clothes have been depicted using a variety of stitches, for example shading satin-stitch (single and double), *qiang*-stitch (inwards and outwards), knots and scale-stitch. The eyebrows and other fine elements of the design are vivid and very realistic, the colour and lustre of the embroidery thread is natural and the embroideries are layered, harmonious and extremely rich.

A third feature of Gu embroidery was the use of complementary and grouped colours in the colour shading. While the practitioners of Gu embroidery imitated paintings of landscapes and figures, insects and fish, birds and animals, with their richly layered colour effects, they also copied the colours of nature, thereby bringing harmony to the whole design. In the embroidery of the apricot-blossom village (plates 102–3), for example, the boy, old man, weeping willow, pine needles, wine shop, smoke from the chimney, flowing water and mud road are all embroidered with brightly coloured threads to effect as naturalistic an appearance as possible.

Fourthly, the Gu embroiderers in their choice of threads broke through the restrictions of the past, when only silk thread was used. Moreover, they set out in pursuit of a perfectly harmonious and genuine artistic effect by choosing to use authentic materials, so that it could be difficult to distinguish the real from the representational. The embroidery shown in plate 110, for instance, uses hair as embroidery thread on a plain *duan* silk base to depict the figures. The main stitch used is a single-thread straight stitch. In some places the hair thread has been drawn through obliquely with a fine needle and combined with fine soft hair to emulate the strokes of a brush.

Embroidery of the Qing Dynasty

In the Qing dynasty, the achievements of the Song and Ming dynasties, in terms both of aesthetics and

practicality, came to be fully developed. The skills of the Qing embroiderers were the highest achieved, with a great variety of stitches, abundant pattern designs and exquisite colour harmonizing.

Court embroidery

In order to satisfy the opulent and extravagant tastes of the court, the Qing administration established three weaving mills in Nanjing, Suzhou and Hangzhou where the manufacture of brocades and embroidered items could be under the direct supervision of court officials. In the imperial living quarters of the Gugong in Beijing and the palace in Chengde, the wall hangings, soft furnishings, clothing, items for everyday use, gifts and many other objects were all embroidered; indeed, the collection of embroidered goods to be found in these palaces was so vast that they could not all be listed. Princes, dukes and other aristocratic families also appreciated embroidered items.

There are outstanding examples of embroidered court robes on base fabrics of yellow *duan* silk, azure *duan* silk and red *duan* silk dating from the Kangxi, Yongzheng, Qianlong and Guangxu (1875–1908) periods in the Palace Museum, Beijing. There is also an example of a dragon robe belonging to the Emperor Guangxu (plate 172) in the museum in Chengde, which has on it the auspicious design of 'nine dragons and twelve symbols' regularly worn by the emperor. The dragons on the chest, back and shoulders are embroidered in five colours and gold. Everywhere on the garment the embroidery is vivid and lifelike. On the lower band at the back and front of the garment there is a design of juxtaposed mountains and waves. These symbolize longevity (the mountains) and happiness (the sea). Satin-stitch, layer-stitch, *qiang*-stitch, split-stitch, knots and scale-stitch are among the ten or more different stitches used in this embroidery. The dragon was the motif especially used on the clothing and adornments of the feudal imperial family. So that there could not be any confusion regarding the form of this mythological creature, the dragons used in the Qing dynasty were depicted by court artists in accordance with the 'nine likenesses', which were: horns like a deer, head like a camel, eyes like a demon, crown like a snake, belly like a crustacean, scales like a fish, claws like an eagle, soles like a tiger and ears like an ox.

The colours of both the base fabrics and the silk threads used in embroidery for the imperial family were quite distinct. Preserved in the Palace Museum, for instance, is a robe of the kind to be worn by a new prince or king, which is embroidered with peacock feathers and displays great originality. A blue *duan* silk has been used as the base material, and this has been embroidered all over with a tight, well-organized pattern using such expensive raw materials as thread made from peacock feathers, freshwater pearls and coral beads, twisted gold thread, twisted silver thread, *longbaozhu* thread (dragon robe thread) and polychrome floss thread. The dragons, cranes and bats that make up the design have been depicted using couching all over their bodies, which have been dotted with seed-pearls and coral beads. The dragon's belly, fins, horns, mouth and tail have all been embroidered with *longbaozhu* thread on to which seed-pearls have been threaded for added decoration. Twisted gold and silver thread has been used for the dragon's whiskers, and other designs have been embroidered in threads of various colours and three different shades. Finally, any gaps left in the design have been filled in using the technique known as 'spreading on blue', which involved the use of silk thread twisted together with peacock feathers. This multicoloured and sumptuous princely robe fully encapsulates all the highest achievements of the Suzhou Embroidery Bureau.

Double-faced embroidery

This was an innovation of the Qing-dynasty embroiderers, developed from the Song-dynasty two-faced embroidery. The characteristic feature of double-faced embroidery is that both sides of the final magnificent embroidered item display exactly the same design. The secret of this lay in avoiding knotting the threads on the reverse side and instead concealing them. The concealment was achieved by using a floating vertical scattered shading-stitch so as not to spoil the design on the reverse side, and the technique of *jiqie* (backstitch) to replace knots in securing the ends of the threads. *Qiang*-stitch was also used and the colour was added layer by layer; wool in the embroidery produced a fluffy effect gradually adding to the thickness. By staggering the stitches and combining the front and reverse, a double-faced embroidery was obtained with identical designs on both sides, popularly known as 'two-sided brightness'.

The Liaoning Provincial Museum has eight double-faced embroidered palace fans in its collection, two of which are illustrated in plates 166 and 167. Four have red or green *juan* silk bases and are embroidered with designs of birds and flowers. The other four are on yellow or deep-red *sha* silk bases with *petit point* embroidery. On the former, the texture of the embroidery is smooth and even, the layers of the plants and flowers are clearly shown, the birds are lively, the colours are subtle and elegant and the ends of the threads are carefully hidden so that they cannot be seen. They have been worked with consummate skill.

Calligraphic embroidery

Qing embroideries in the style of painted hanging scrolls or pieces of calligraphy were regarded as works of art. They were often made to order for officials and other persons of importance, and frequently given as gifts, having been embroidered with symbols of 'long

life', 'happiness', and so on. In the collection of the Zhenjiang Museum a curtain embroidered with a design forming the 'double happiness' character (plate 155), a scroll with a fourteen-character couplet made up of the 'hundred flowers', (plate 164), panels embroidered in the style of ink paintings of bamboo and calligraphic inscriptions (plate 165) and an embroidered hanging screen with a design of a crane, deer and pine tree are all examples of works of high artistic merit in the category of gifts made with calligraphic and painterly themes. The 'double happiness' curtain is a meticulously executed masterpiece of this genre of embroidery. It includes a great variety of embroidery stitches – six main stitches and a further ten subsidiary ones – and great attention has been paid to the depiction of the individual features and personalities of the figures. Enhanced artistic effects such as raising the nap and leaving 'water roads' have been used.

Local embroideries

In the Qing period, strongly traditional styles of embroidery were being made in all regions. Throughout the empire embroidery workshops were to be found in great profusion and it was not for many years that there was any decline. The most famous districts producing local embroideries were those of Su, Ao, Xiang and Shu. Their wares were collected and distributed by the cities of Suzhou, Guangzhou, Changsha and Chengdu respectively, and were known collectively as the 'four famous embroideries of China'. In addition there was also Jing embroidery from Beijing, Bian from Kaifeng, Hang from Hangzhou, Lu from Shandong, Miao from Guizhou, Ou from Wenzhou and Min from Fujian. These too had long traditions and possessed special local characteristics.

In Su embroidery the traditional embroidery skills inherited from the Song and Ming may be seen. It was greatly influenced by the Gu embroideries of the Ming but nevertheless has individual characteristics. In the *Gu Su zhi* (*Treatise on Suzhou*), compiled in the reign of the Ming emperor Zhengde (1506–22), it is noted that 'fineness, elegance and purity' are the distinctive features of Su embroidery. A gown in the Palace Museum embroidered with threaded pearls and peacock feathers is an outstanding example of Suzhou weaving and embroidery.

Ao embroidery first appeared among the non-Han peoples as Tiao embroidery and had the same origins as the Li people's woven *jin*. The characteristics of Ao embroidery are the thickness and softness of its cut threads which give it a velvety fur-like feel. The main stitches used are *sacha*-stitch (the *souhe*-stitch of Su

embroidery), *song* (loose) stitch, scale-stitch and chain-stitch. The patterns overlap and thus cause ripples on the surface. Gold thread was also often used on these embroideries and the colours were strong and bright. Numerous varieties of thread were used – hair from a horse's tail, for example, twisted together with floss.

Xiang embroidery, the local embroidery of Hunan Province, is a type of folk needlework which developed from the traditional Chu style. Its distinctive features are its exquisite and bold compositions, the flexible fine embroidery skills, the richness and abundance of the colours and the use of split threads which are finer than hair and untwisted, producing a velvety surface. It is, therefore, particularly well adapted for the realistic depiction of velvety patterns and it is known, in fact, as 'sheep's-wool velvet embroidery'. A particular feature of Xiang embroidery was the use of loose floss stitched on to depict lions, tigers and other animals, giving them force, power and vigour. This kind of design had a powerful decorative impact.

Shu embroidery, from Sichuan, is one of the Three Precious Articles of Shu. According to tradition, embroidery existed in Shu as early as Jin times; by the Tang and Song it was flourishing. Its characteristics are the tightness of its composition, the appropriateness of its use of the real and the representational, the precision of the stitched patterns and the evenness of the knots. The main stitch used was layer-stitch, but new stitches such as oblique *gun* (rolled) stitch, *xuanliu* (revolving and flowing) stitch, *pengcan* (shed-joined) stitch and woven-stitch were also used, giving the bird-and-flower designs a very solid appearance. The arrangement of the designs was simple, the colours resplendent – colourful but not gaudy, refined but not sombre. They were shaded with the precision of paintings.

Bian embroidery takes its name from the Song capital Bianjing (modern-day Kaifeng). In the Song dynasty an Academy of Embroidery was established at Bianjing and it employed over 300 embroiderers who worked specifically on the production of imperial garments and adornments. At the same time, embroidery skills among the people developed and improved so that Bian embroidery was for a while quite celebrated. Bian embroidery during the Qing period consisted mainly of representations of songs and stories, such as 'immortals meeting to offer blessings' (plates 178–9), 'officials wishing the emperor long life' (plates 180–81), 'eighteen scholars' (plate 182) and 'twenty-four acts of filial piety' (plates 183–4 and 185–6), which all have local characteristics.

Plates I

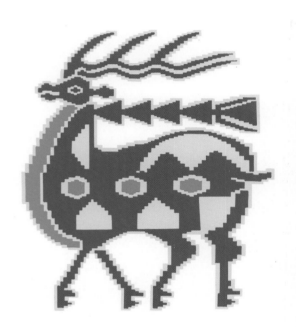

1. Looped silk ribbon with animal design Warring States

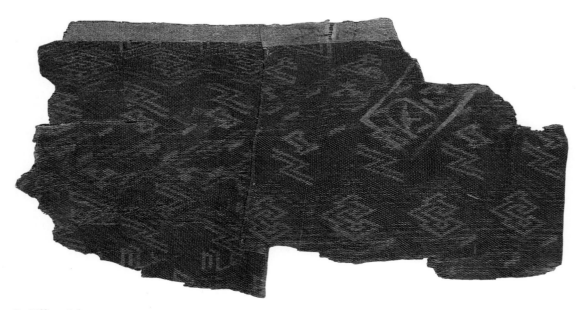

2. Silk with carpenter's square pattern on a brown ground Warring States

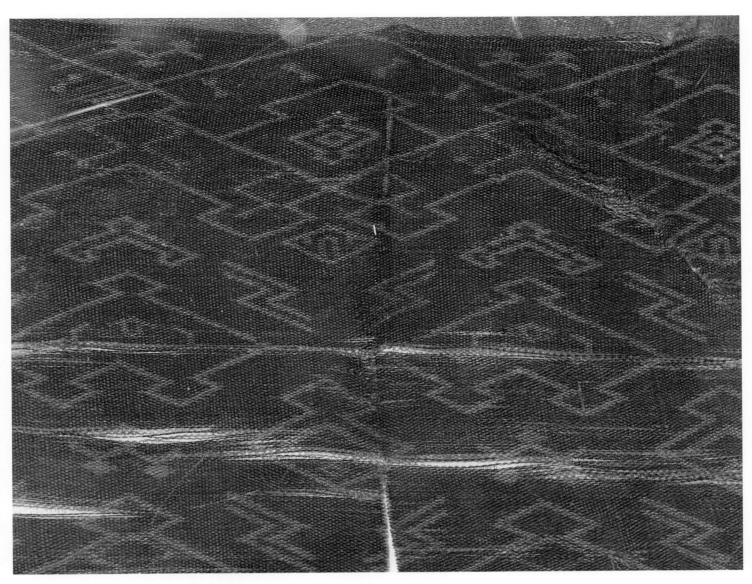

3. Silk with geometric design on a brown ground Warring States

4. Silk with red patterned band and 'secret' pattern of paired dragons and phoenixes Warring States

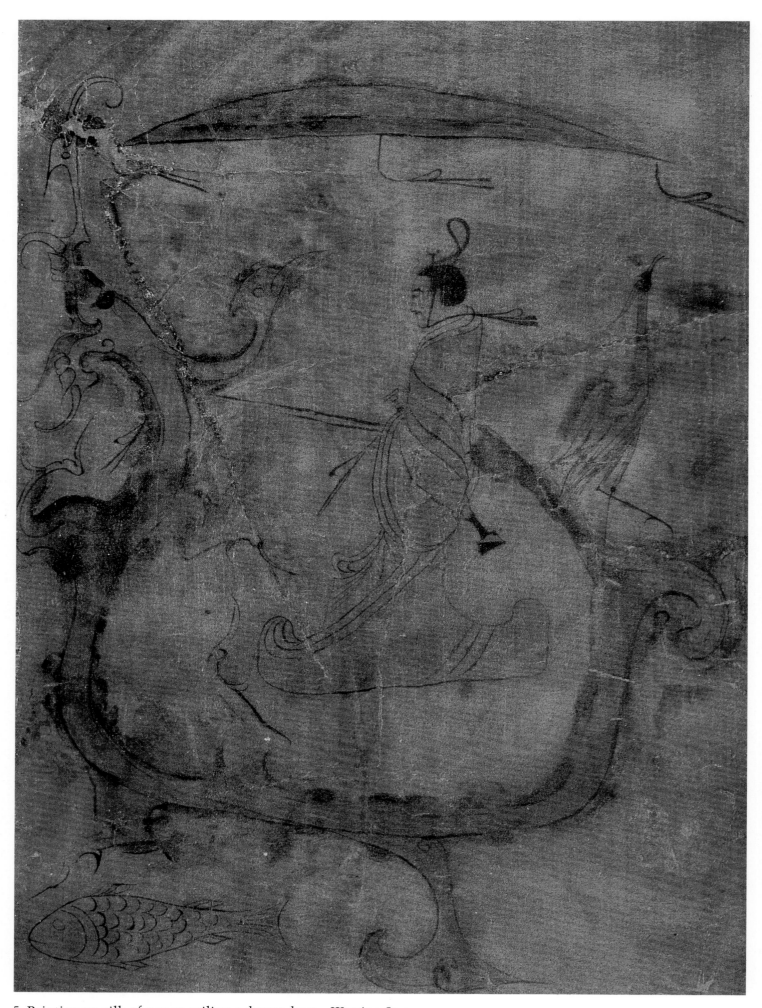

5. Painting on silk of a man sailing a dragon boat Warring States

40

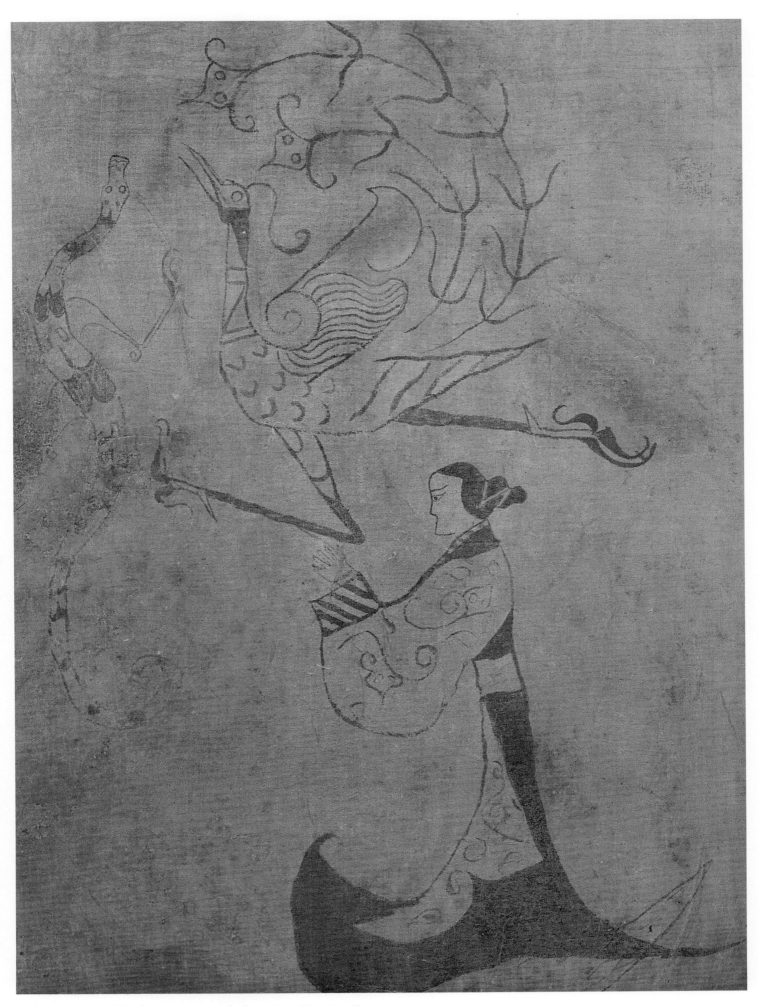

6. Painting on silk of a woman and phoenix Warring States

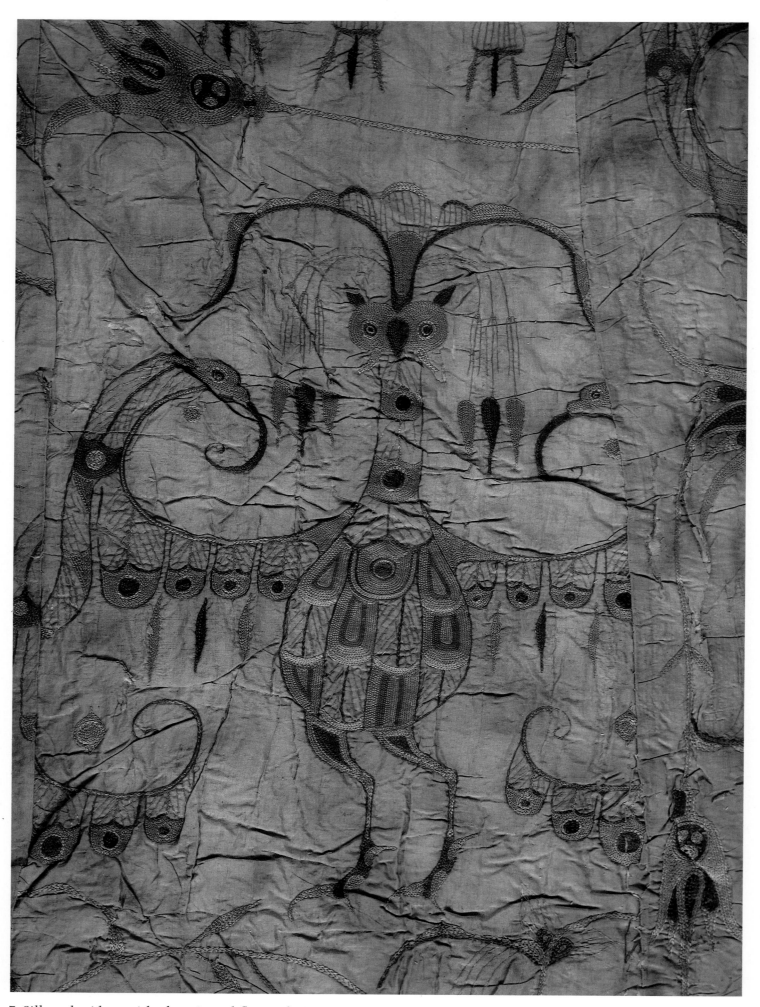

7. Silk embroidery with phoenix and flower design Warring States

42

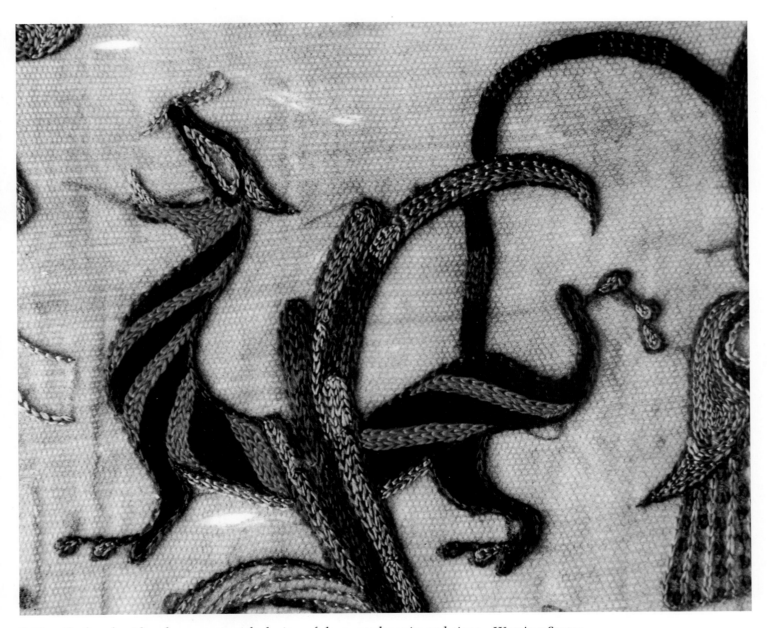

8. Detail of embroidered garment with design of dragon, phoenix and tiger Warring States

9. Wool carpet with coloured stripes Western Han

10. Vermilion gauze with 'ear-cup' shaped lozenge pattern Western Han

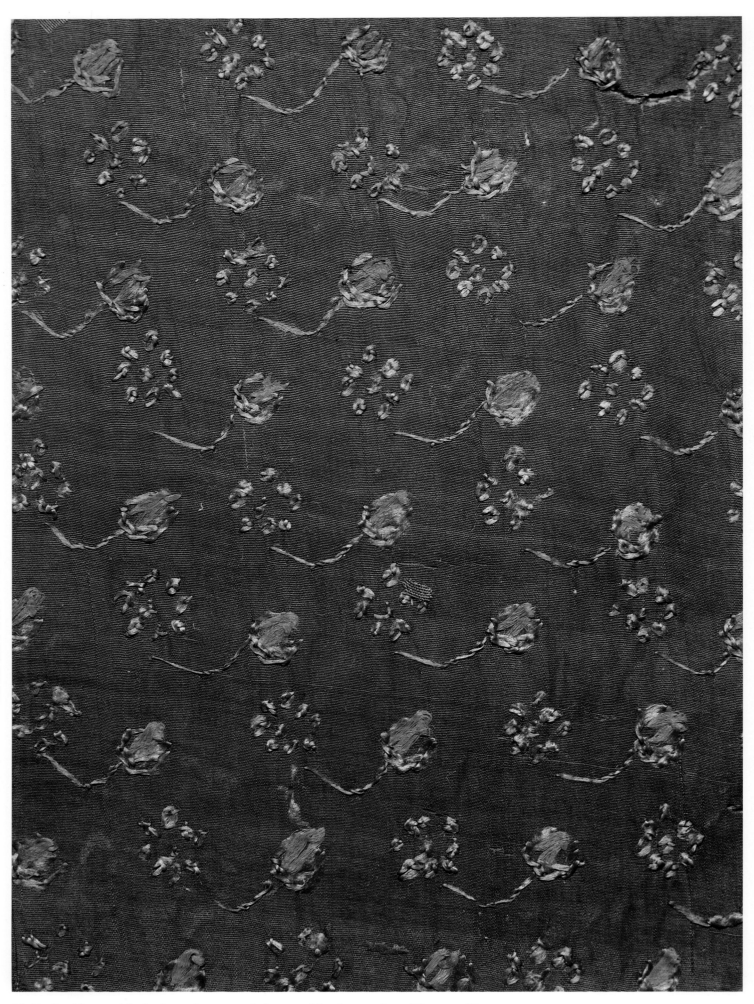

11. Embroidery with design of scattered dots and broken twigs Western Han

12. Embroidery with lozenge-checked tree pattern Western Han

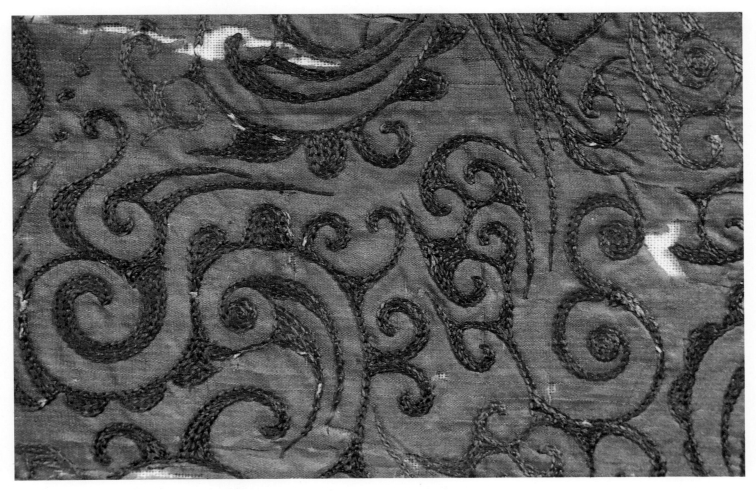

13. Embroidery with *zhuyu* (dogwood) and 'longevity' design Western Han

47

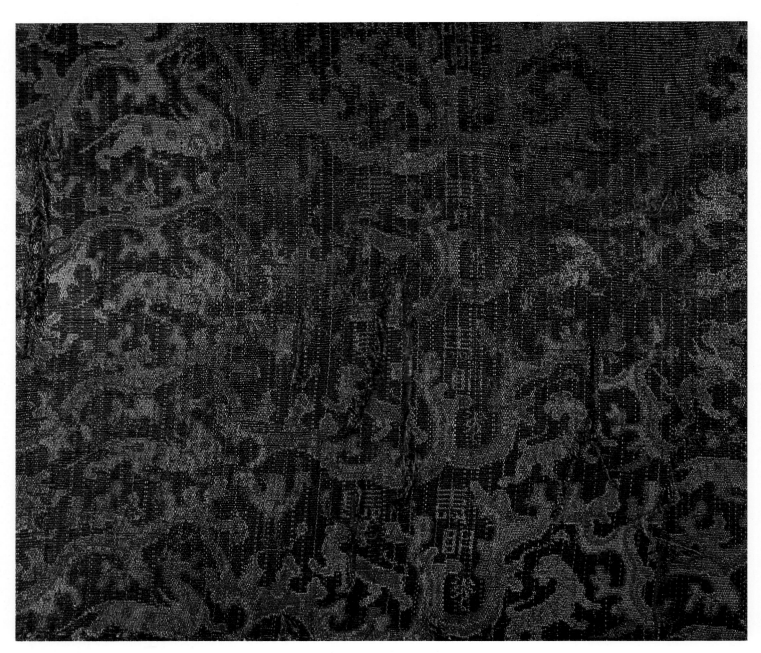

14. *Jin* with woven design of 'longevity and glory' Eastern Han

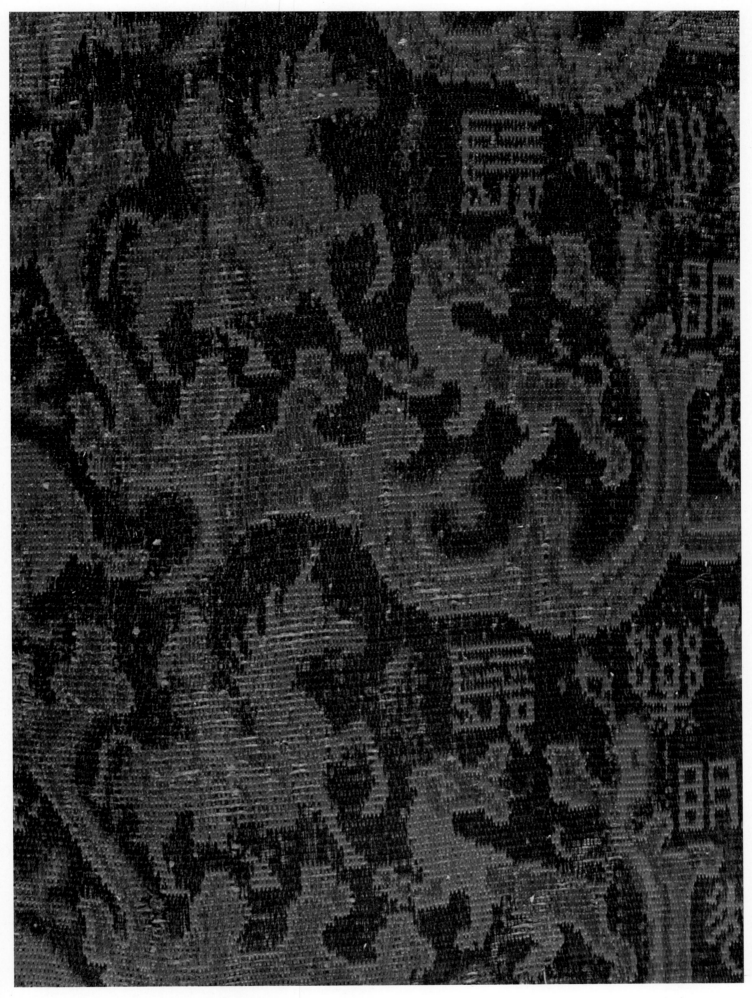

15. *Jin* with design of 'happiness and glory' Eastern Han

49

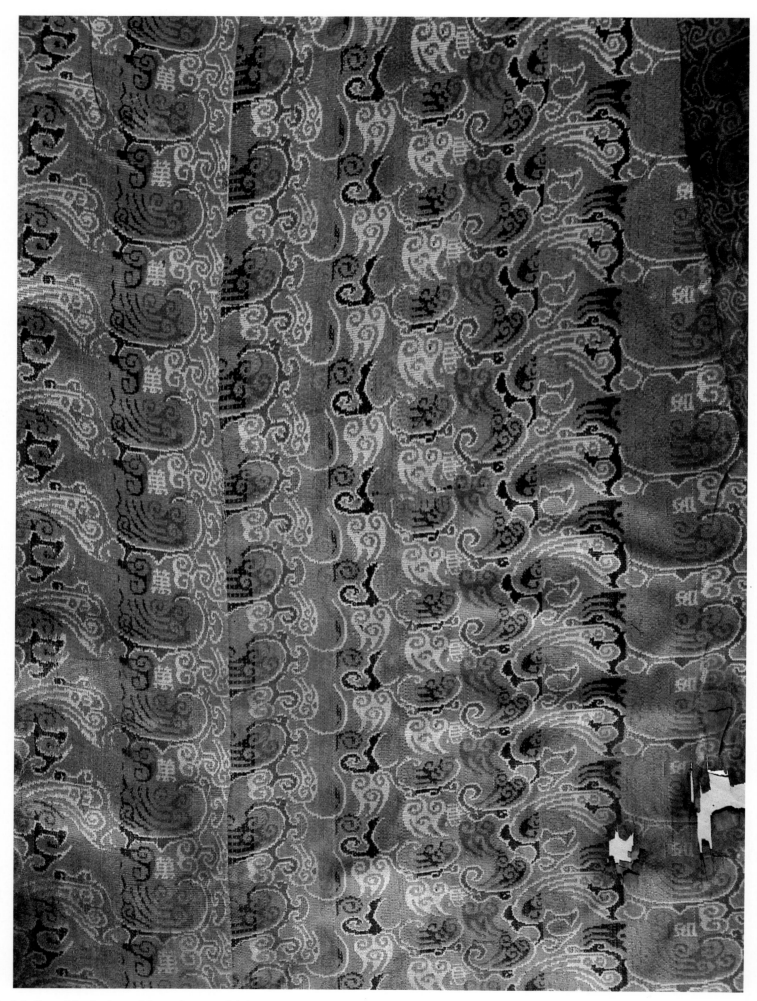

16. *Jin* with design of 'ten thousand lifetimes of wishes fulfilled' (1) Eastern Han

50

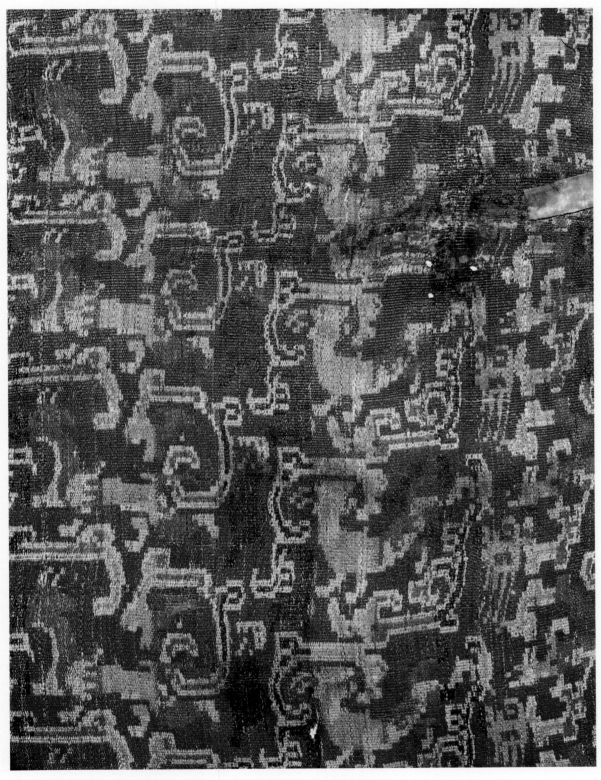

17. *Jin* with design of 'ten thousand lifetimes of wishes fulfilled' (2) Eastern Han

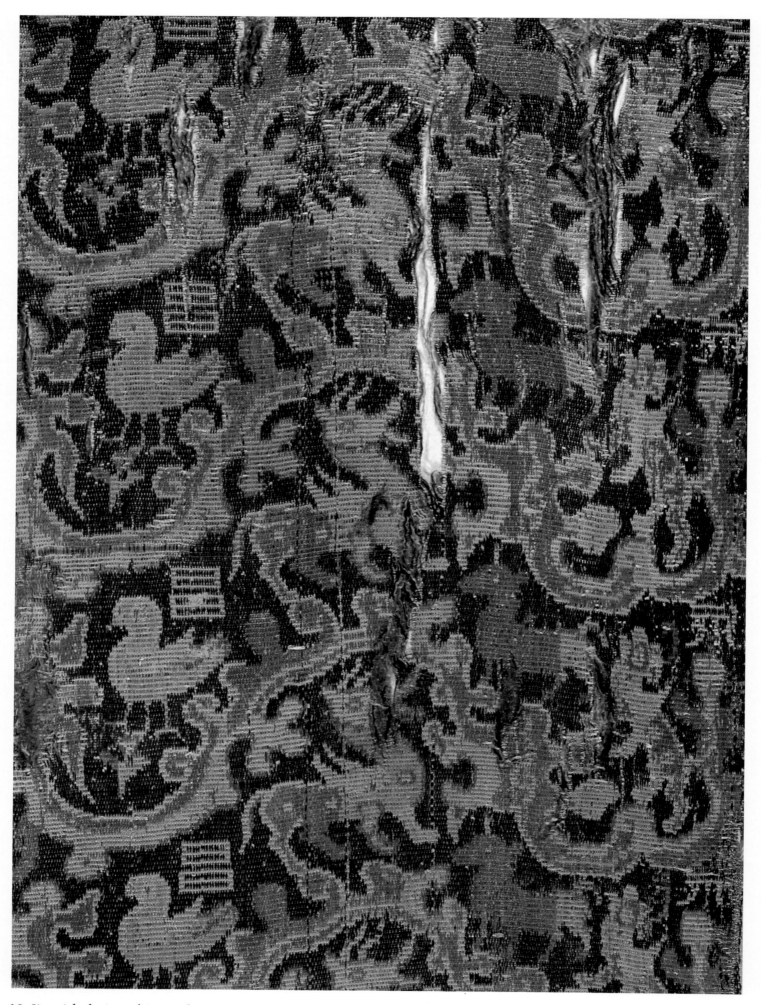

18. *Jin* with design of 'eternal prosperity' Eastern Han

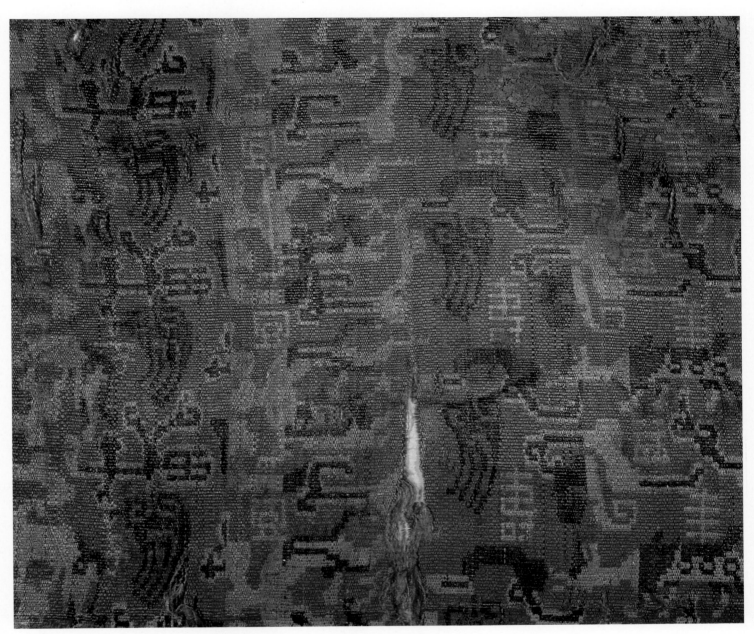

19. *Jin* with design of 'prolonged life and many descendants' Eastern Han

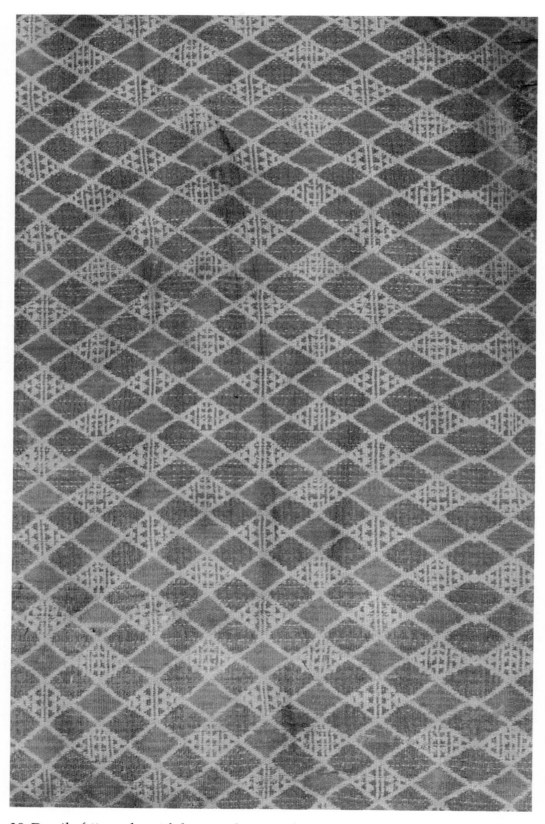

20. Detail of *jin* socks with lozenge design and '*yang*' character motif Eastern Han

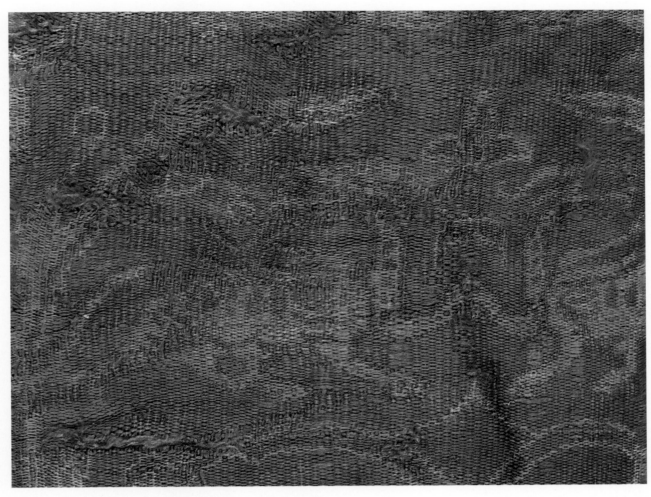

21. *Jin* with design of paired animals Eastern Han

22. *Jin* with design of elephants Eastern Han

23. *Jin* with design of 'descendants' Eastern Han

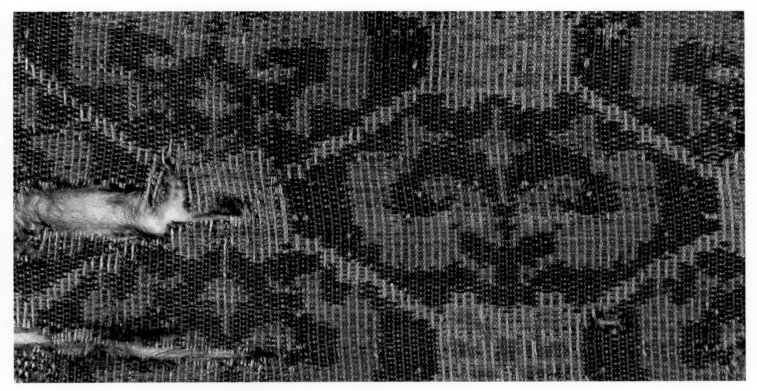

24. *Jin* with design of paired sheep Eastern Han

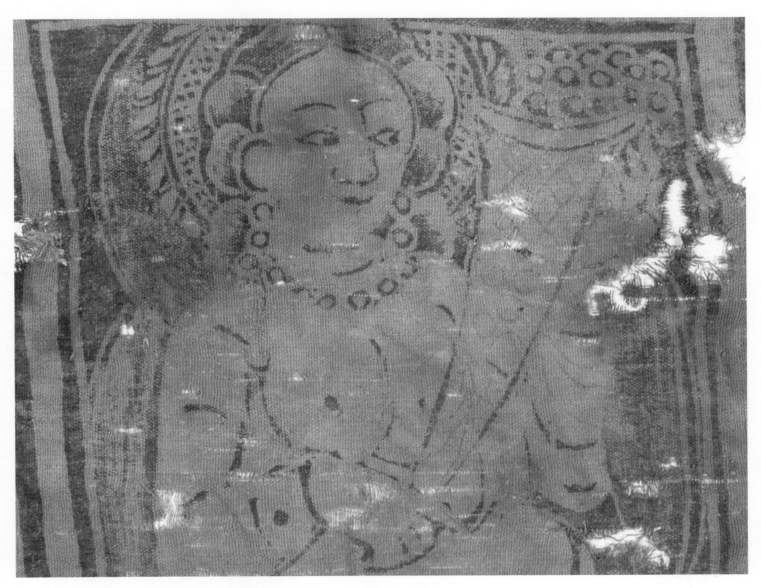

25. Detail of cotton fabric with batik design of figures Eastern Han

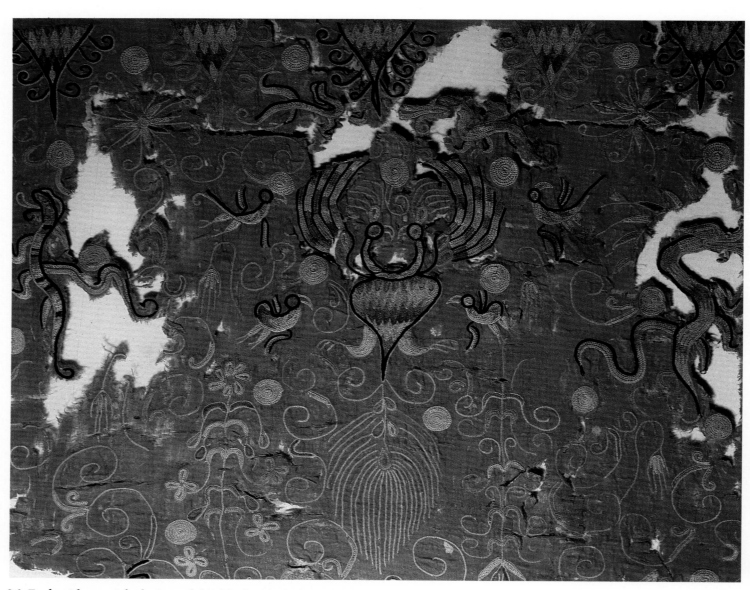

26. Embroidery with design of double-headed phoenix Eastern Jin

27. Woven wool with checked pattern Northern Dynasties

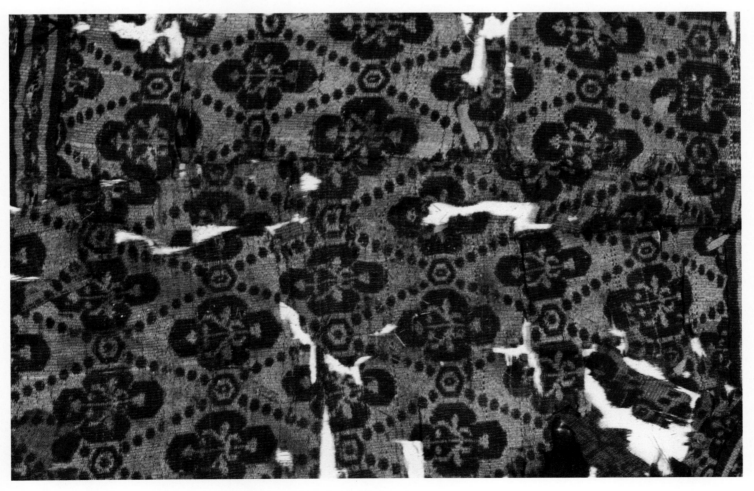

28. *Jin* with lozenge and honeysuckle design Northern Dynasties

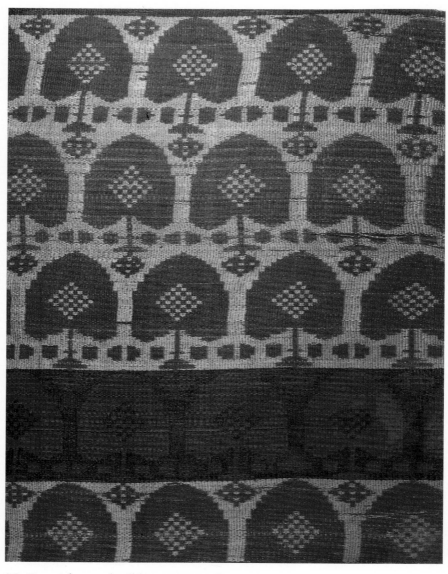

29. *Jin* with tree-leaf design Northern Dynasties

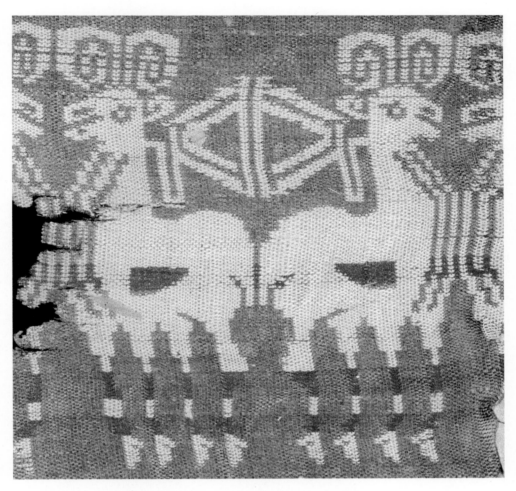

30. *Jin* cover with design of paired sheep Northern Dynasties

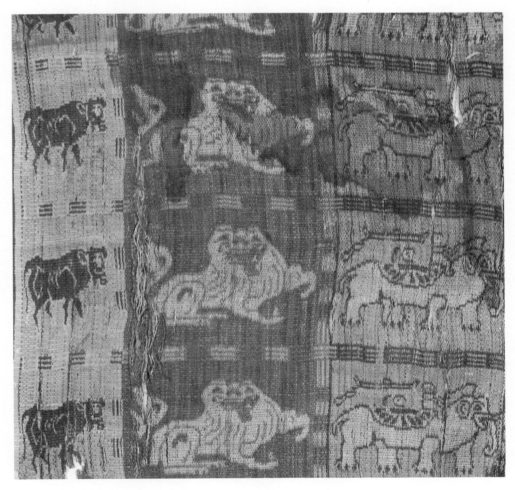

31. *Jin* with design of checks and animals Northern Dynasties to Sui

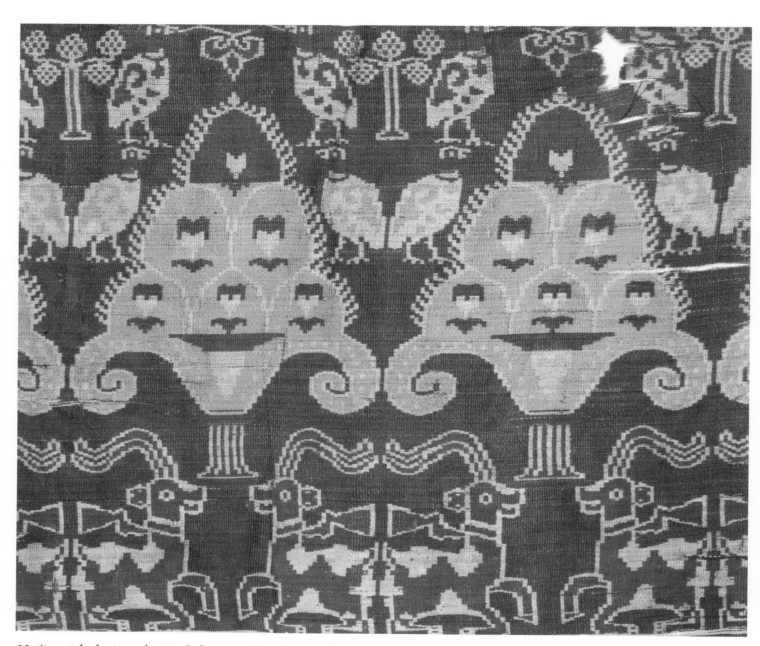

32. *Jin* with design of paired sheep and birds Northern Dynasties

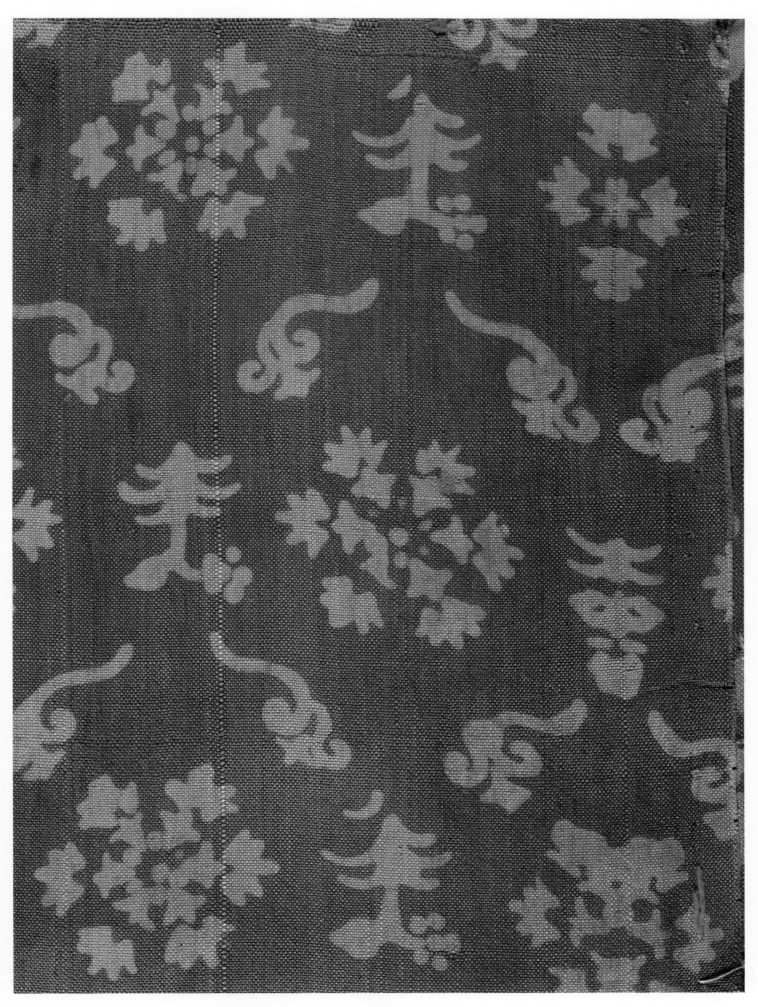

33. Resist-dye stencil printed *juan* with design of scrolling plant and posy Northern Dynasties

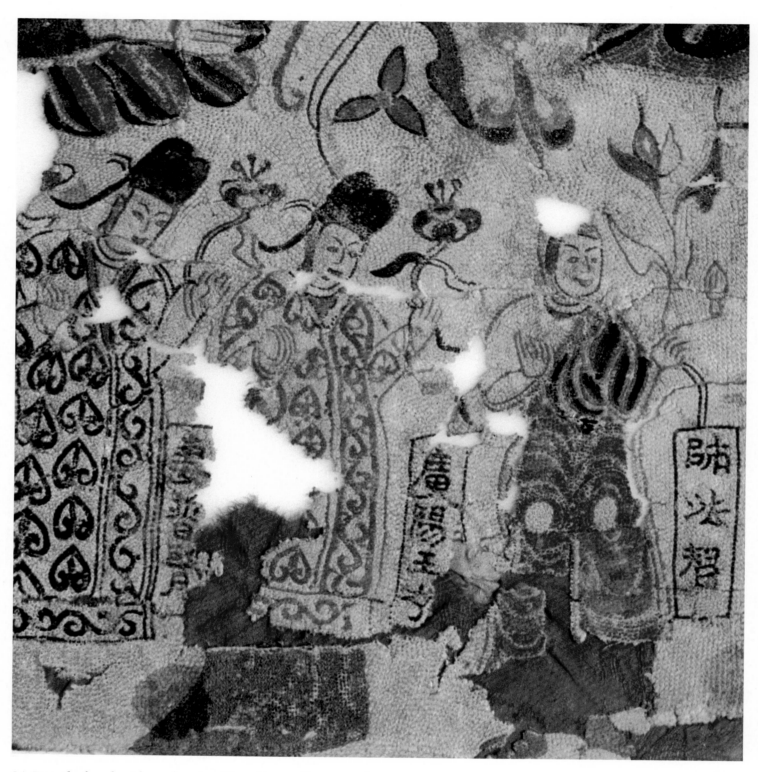

34. Detail of embroidery showing King Guang Yang supplying men Northern Wei

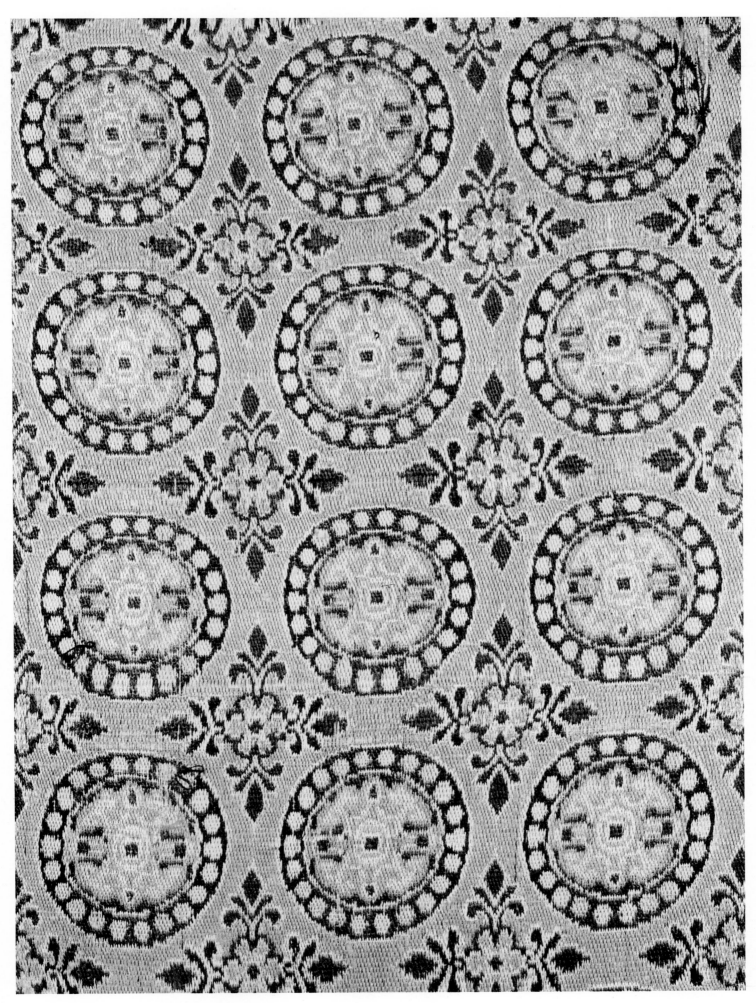

35. *Jin* with design of flower clusters Tang

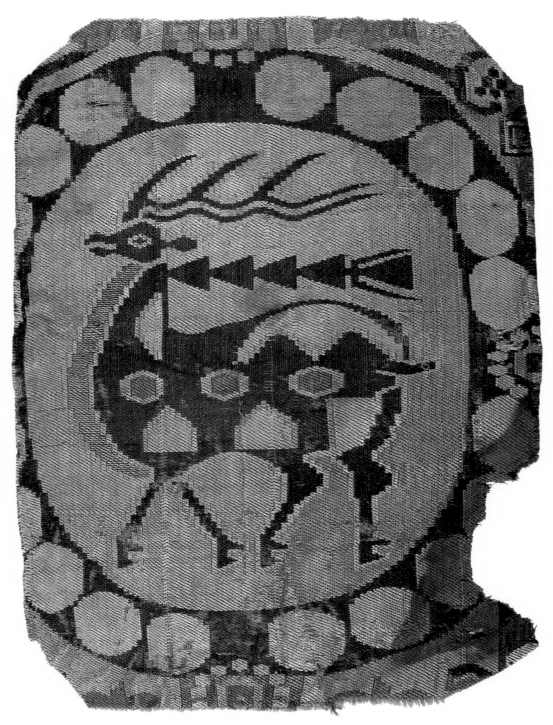

36. *Jin* with design of large deer encircled by pearls Tang

37. *Jin* with design of paired horses encircled by pearls Tang

38. *Jin* with animal design Tang

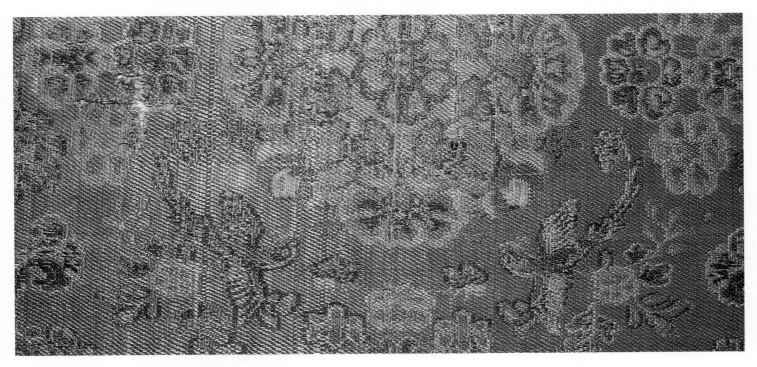

39. *Jin* with design of birds and flowers Tang

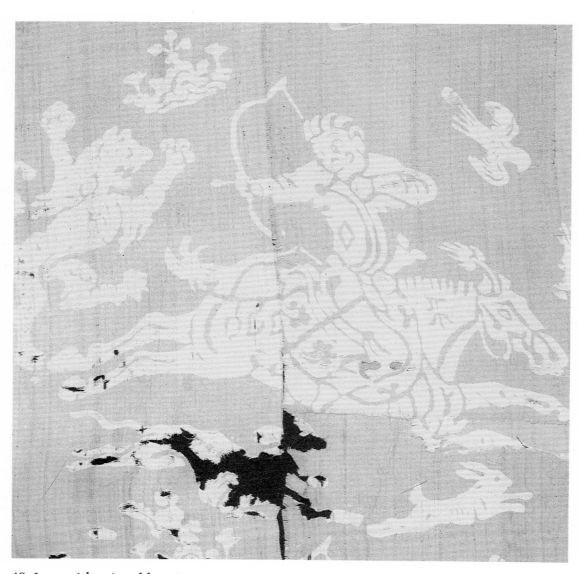

40. *Juan* with printed hunting scene Tang

41. Brown *juan* with batik flower design Tang

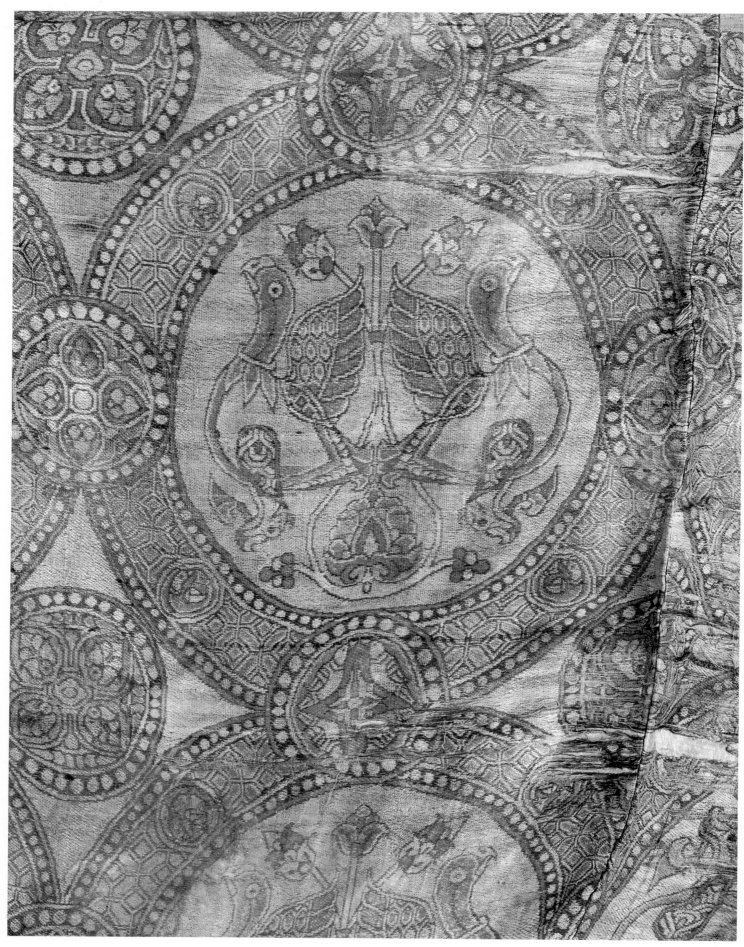

42. Detail of lined *jin* gown with design of 'circular road' and paired birds Northern Song

70

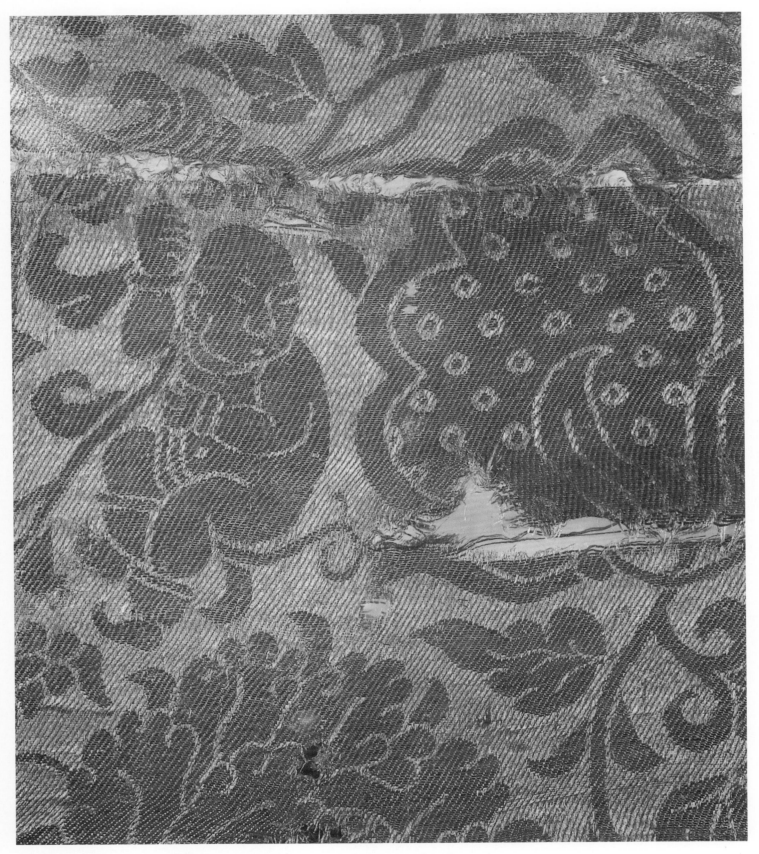

43. Detail of *ling* with design of two children playing with a peach Song

44. Gauze with design of hibiscus, camellia and
 Cape jasmine Southern Song

45. Gauze with design of entwined branch and
 'precious flower' Northern Song

46. *Kesi* with design of clouds, phoenix and peonies Song

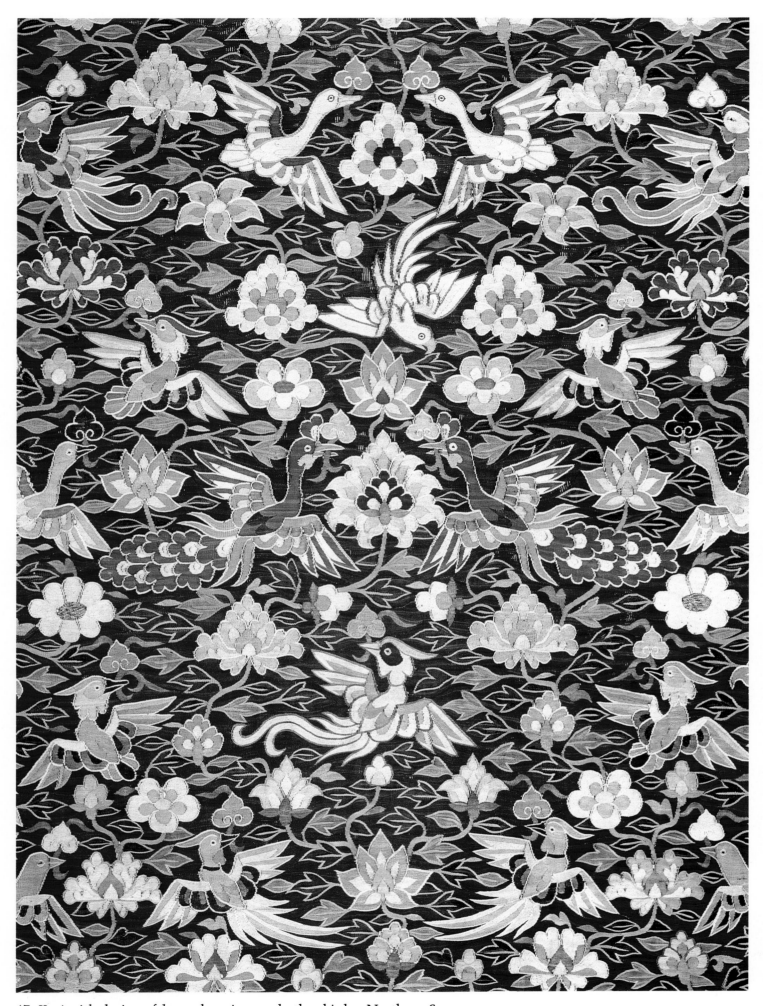

47. *Kesi* with design of *luan* phoenixes and other birds Northern Song

48. Detail of plate 47

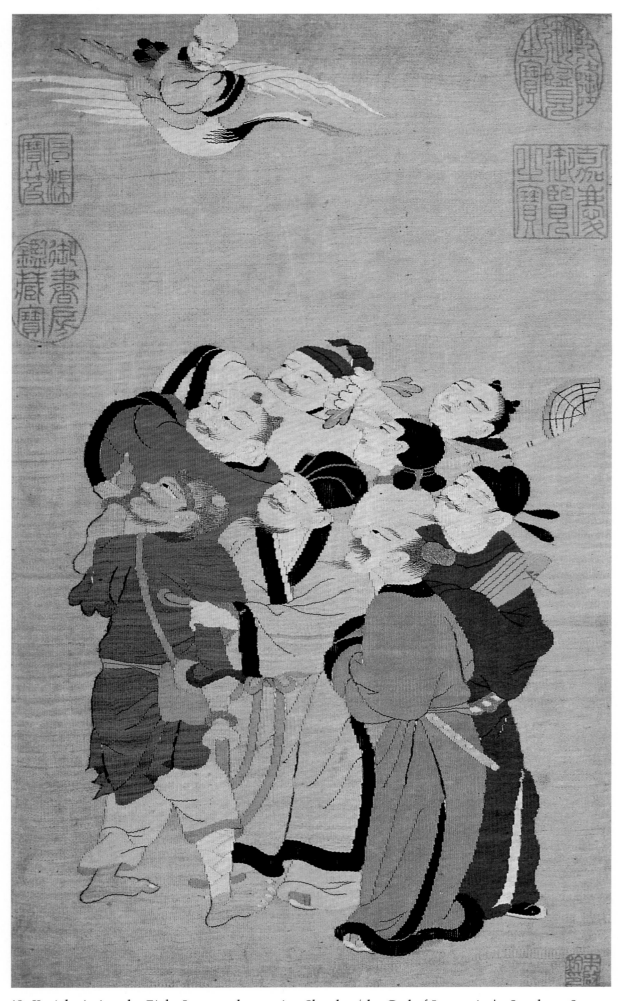

49. *Kesi* depicting the Eight Immortals greeting Shoulao (the God of Longevity) Southern Song

50. Detail of plate 49

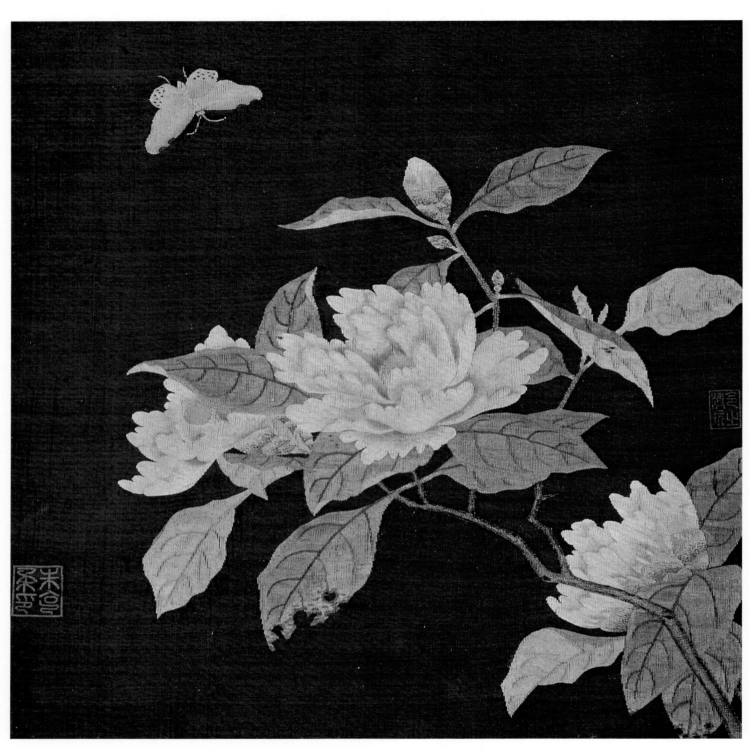

51. *Kesi* with design of camellias and butterfly, by Zhu Kerou Southern Song

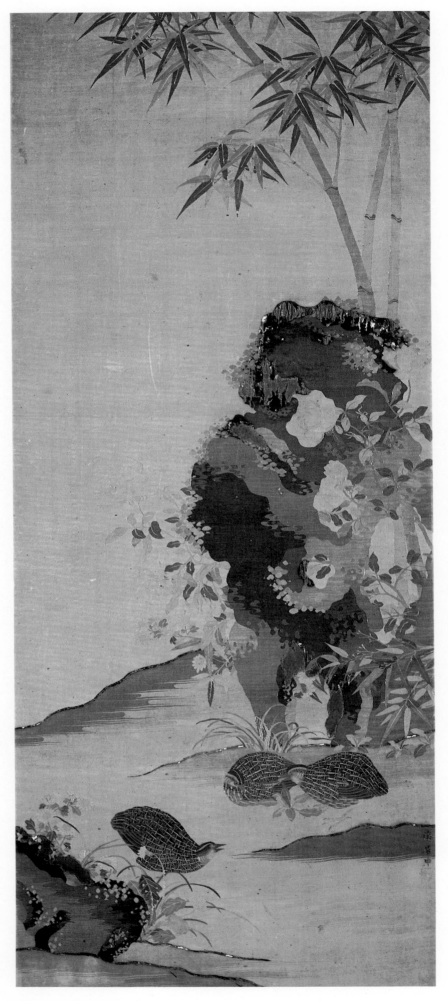

52. *Kesi* with design of Chinese roses and quails Song

53. Gauze with printed design of paired tigers Southern Song

54. Printed border with design of lions playing with coloured balls Southern Song

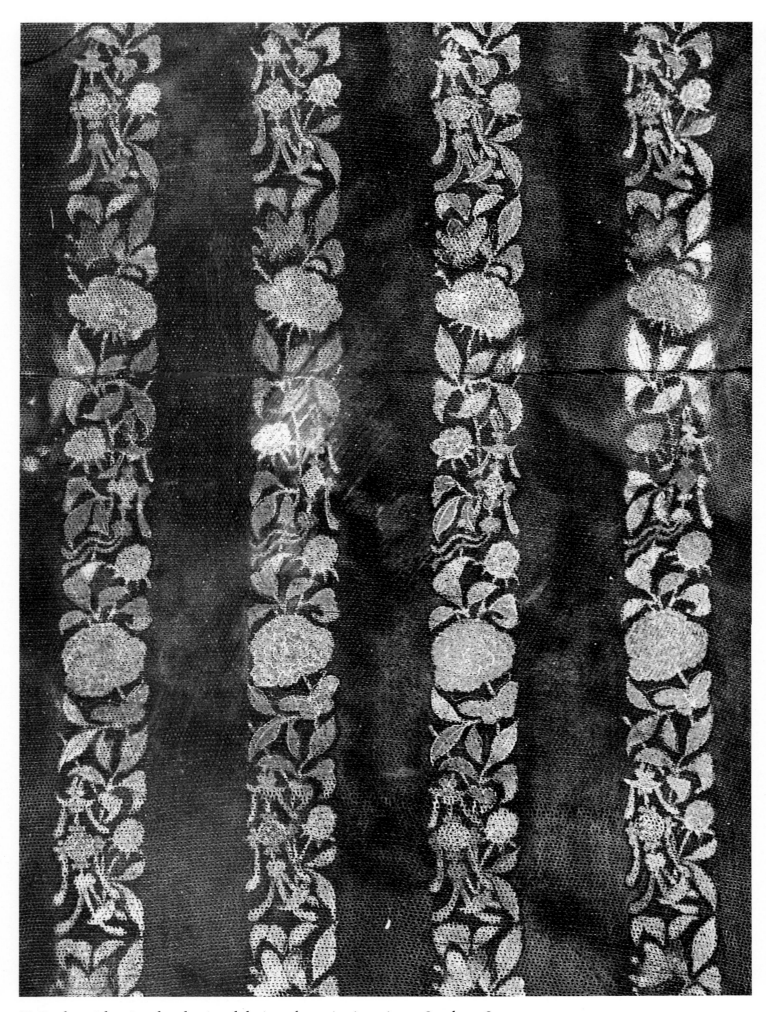

55. Border with printed and painted design of peonies in stripes Southern Song

82

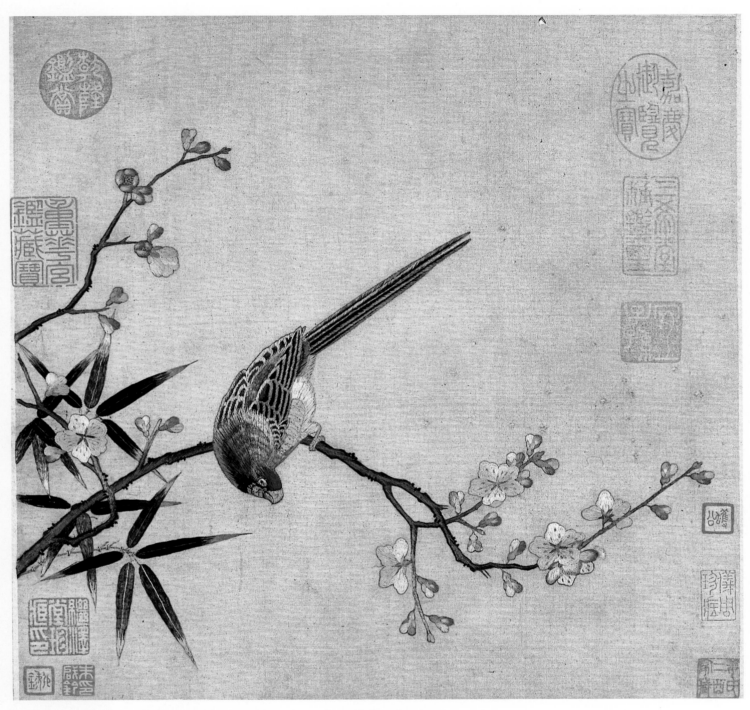

56. Embroidery depicting a parrot on a plum branch with bamboo Song

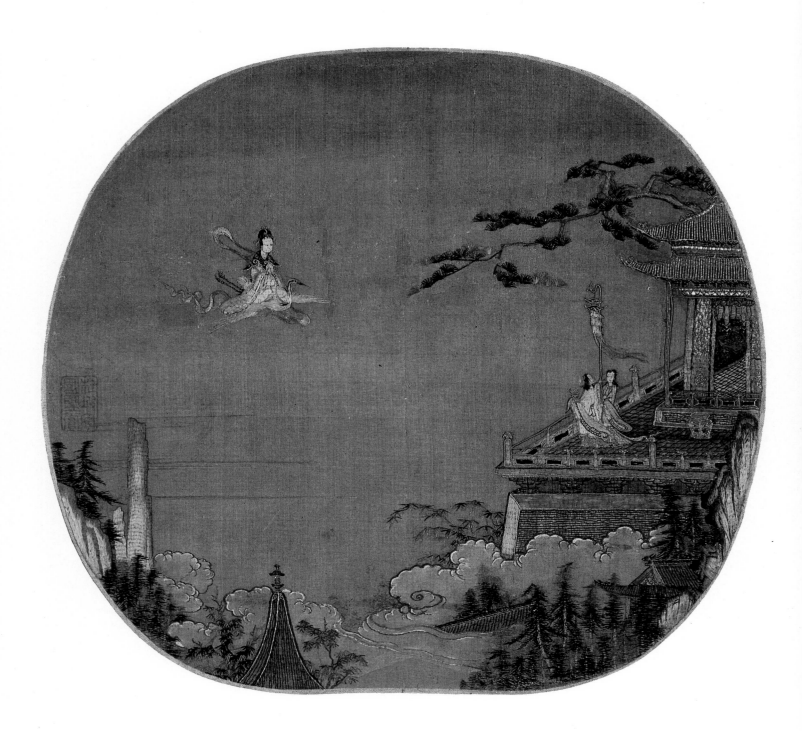

57. Embroidered picture of an immortal riding a crane towards a jade terrace Song

58. Detail of plate 57

85

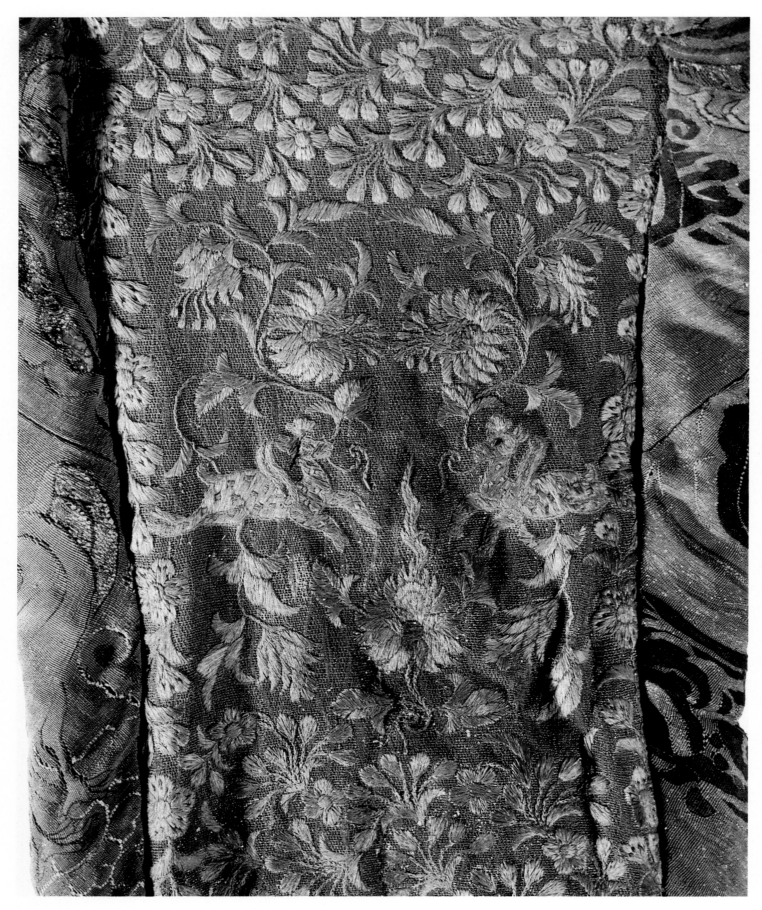

59. Detail of cap embroidered with paired deer, flowers and plants Liao

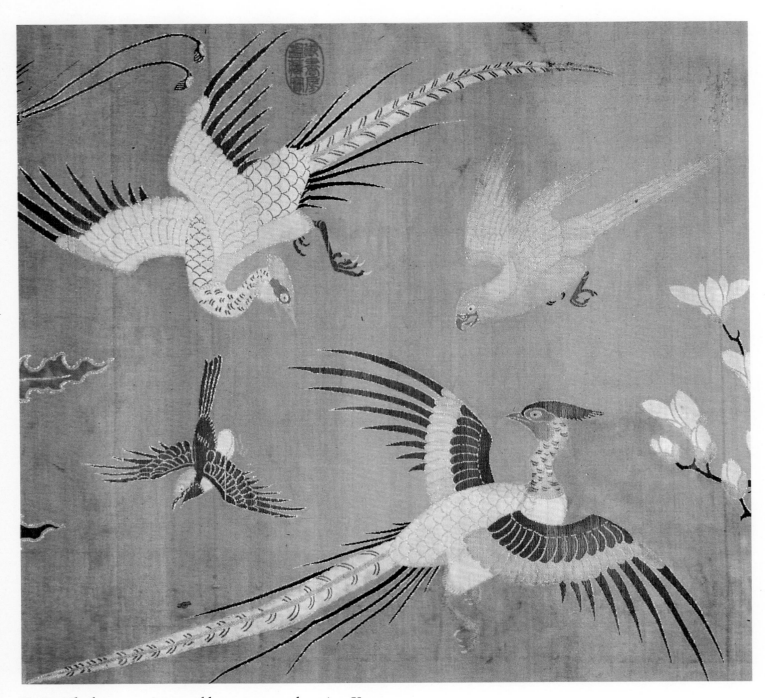

60. Detail of woven picture of homage to a phoenix Yuan

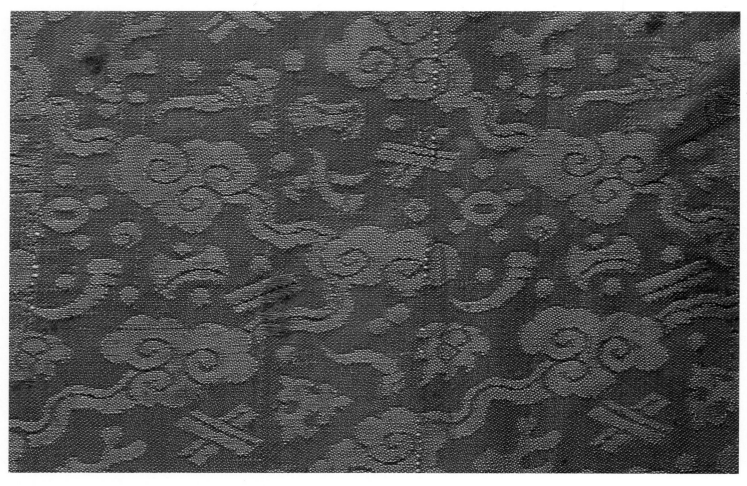

61. *Jin* with design of clouds and the eight treasures Late Yuan

62. Gauze with design of sprigs of peonies Late Yuan

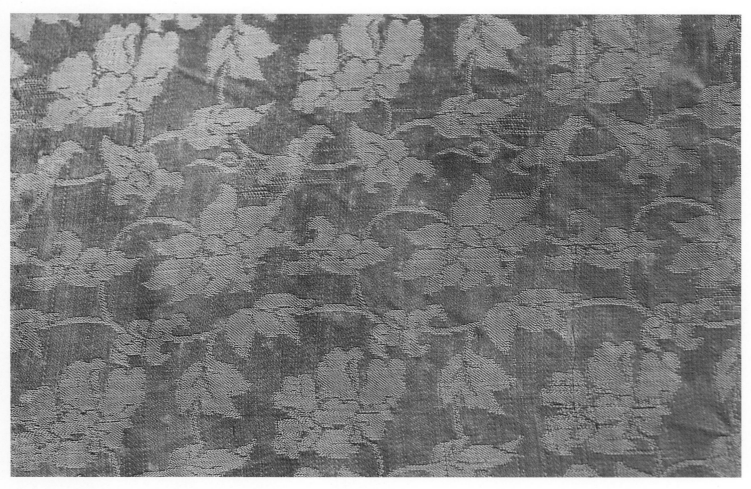

63. *Ling* with design of twining stems of hibiscus Late Yuan

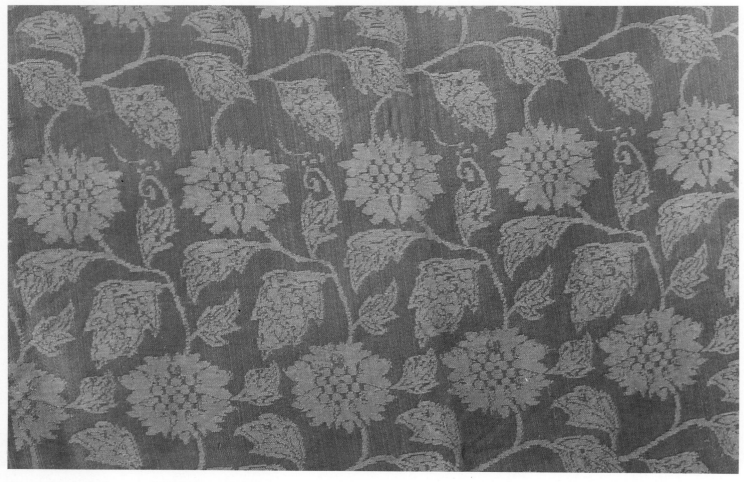

64. *Duan* with design of hydrangea branches Early Yuan

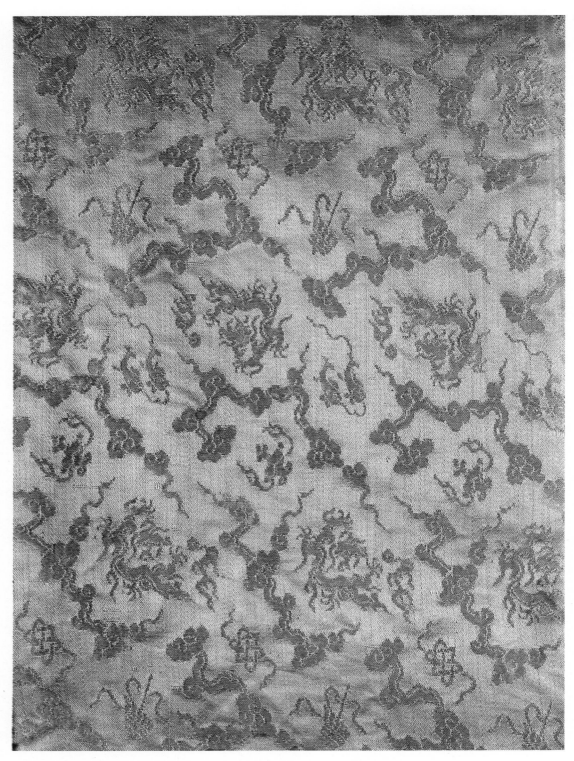

65. *Duan* with design of clouds, dragons and eight Buddhist objects Early Yuan

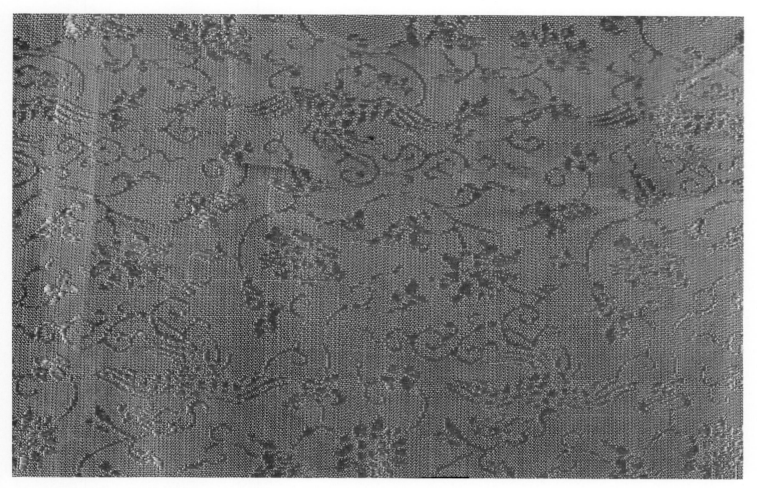

66. *Qi* with design of phoenixes among peonies Late Yuan

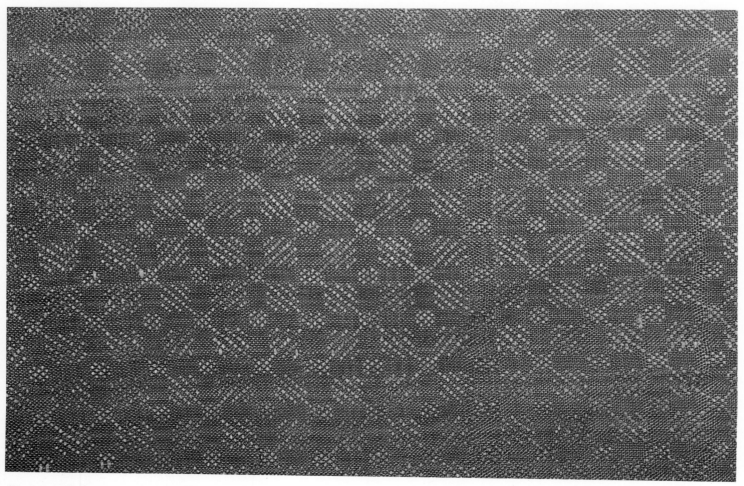

67. *Qi* with lozenge pattern Early Yuan

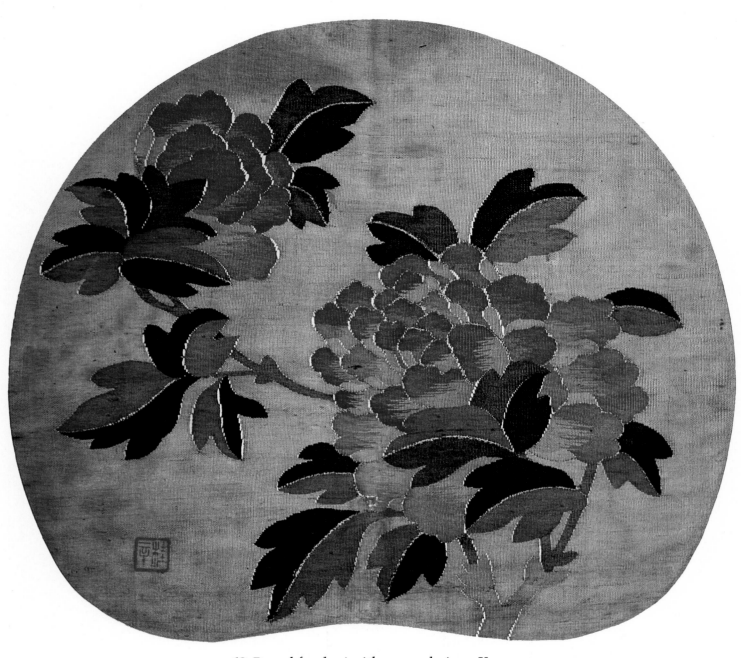

68. Round-fan *kesi* with peony design Yuan

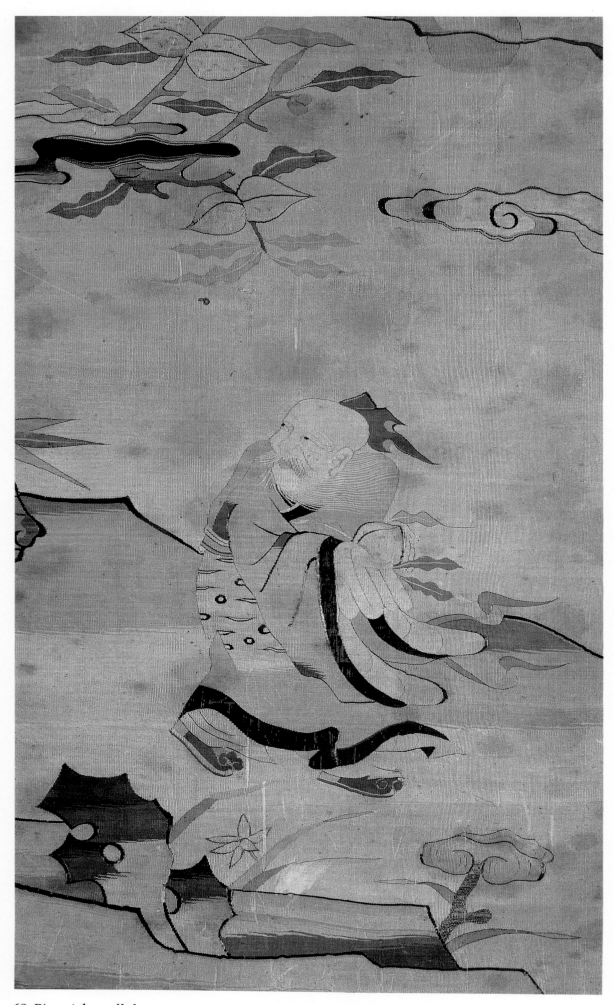

69. Pictorial scroll depicting Dongfang Shuo stealing a peach Yuan

70. *Jin* with design of lattice and scrolling branch Ming

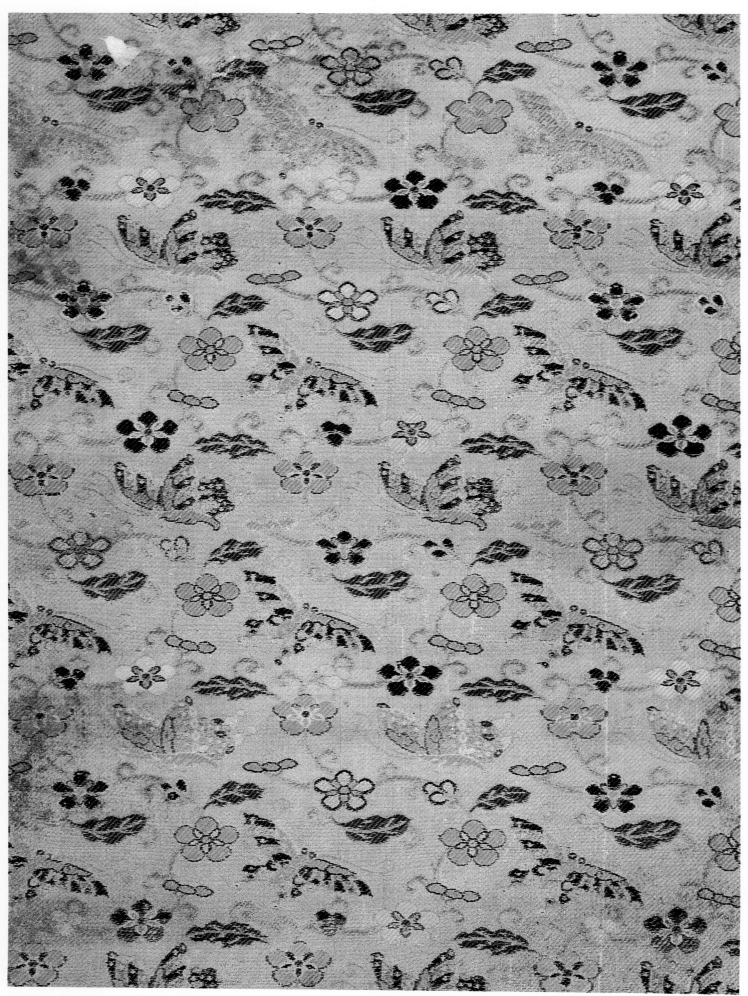

71. *Jin* with design of plum blossom and butterflies Ming

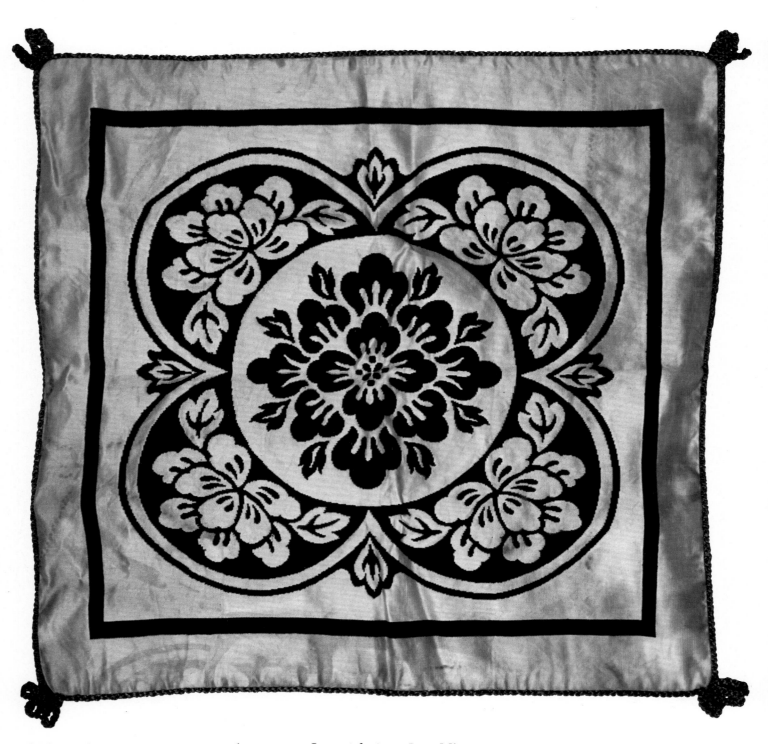

72. Zhang *duan* square wrapper with 'precious flower' design Late Ming

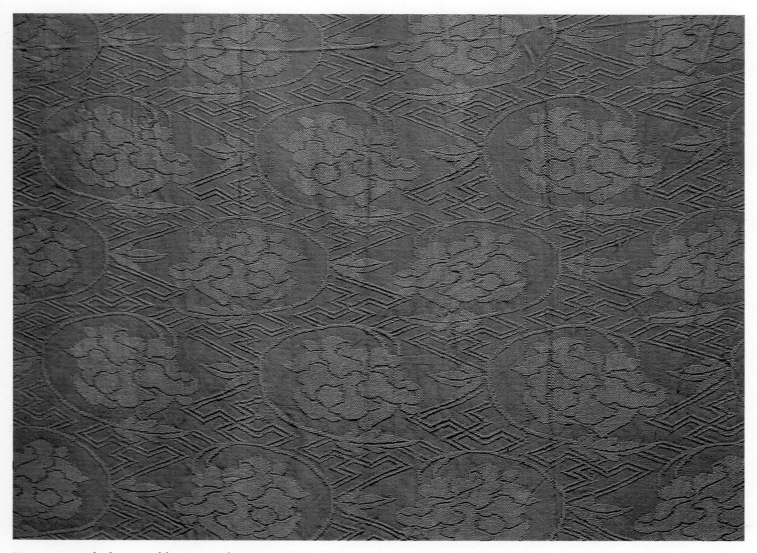

73. *Duan* with design of lattice and peony Ming

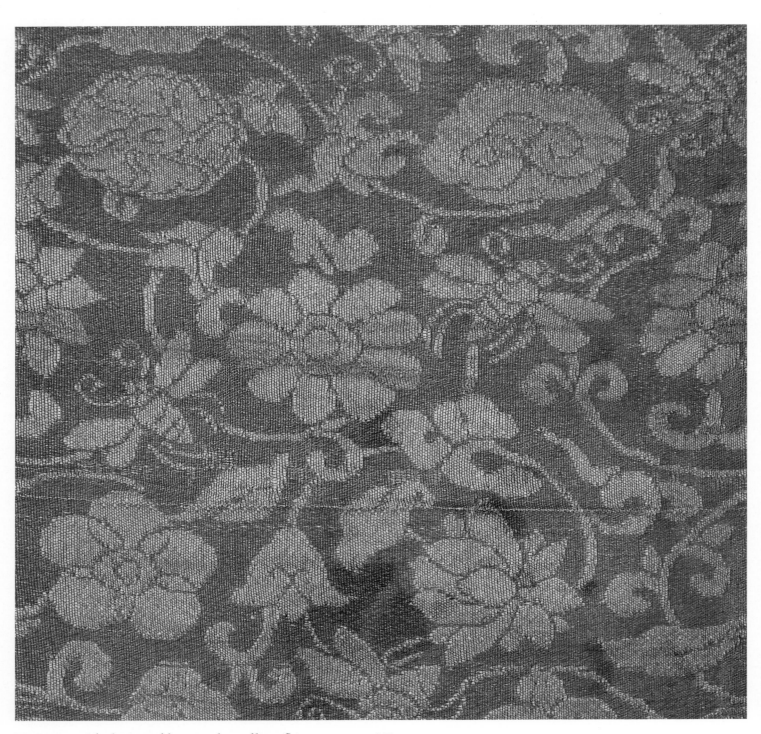

74. *Duan* with design of bees and scrolling flower stems Ming

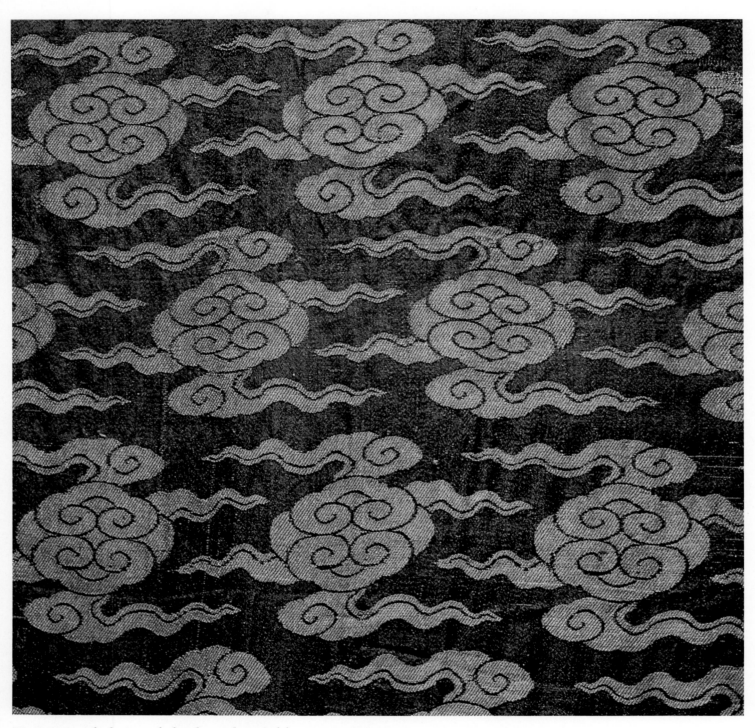

75. *Duan* with design of clouds made up of four *ruyi* Ming

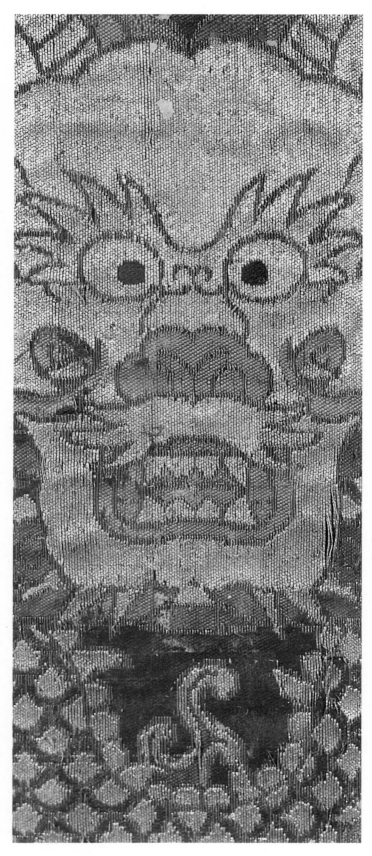

76. *Duan* with dragon's head design Ming

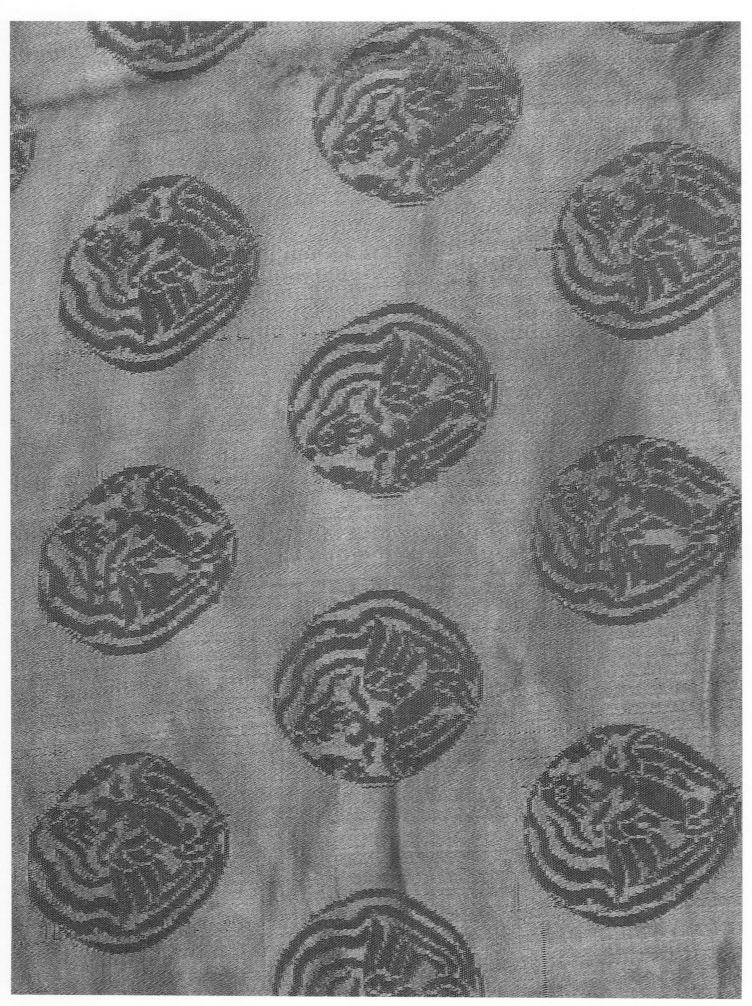

77. *Duan* with small phoenix roundel design Ming

101

78. *Duan* with design of clouds and *taiji* symbols Ming

79. *Duan* with Buddhist images Ming

80. *Duan* with design of sprigs of plum blossom Ming

81. *Qi* with design of bees and scrolling branches Ming

82. *Duan* with design of lotus and scrolling branches on a green ground Ming

83. *Duan* with blackish-green ground and 'precious flower' design Ming

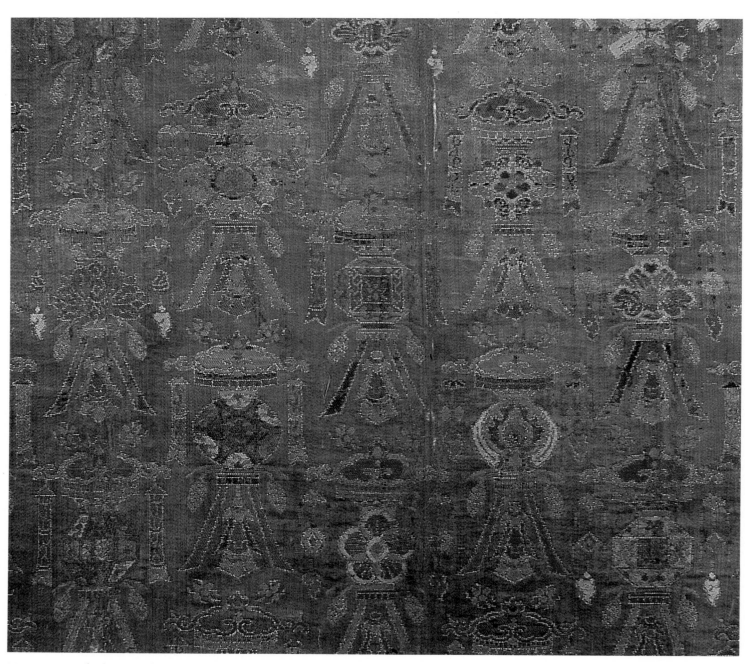

84. *Duan* with design of 'abundant harvest of five grains' Ming

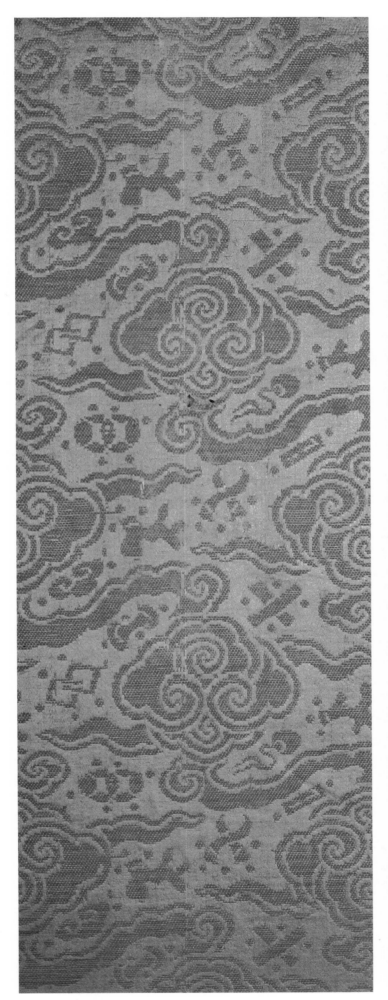

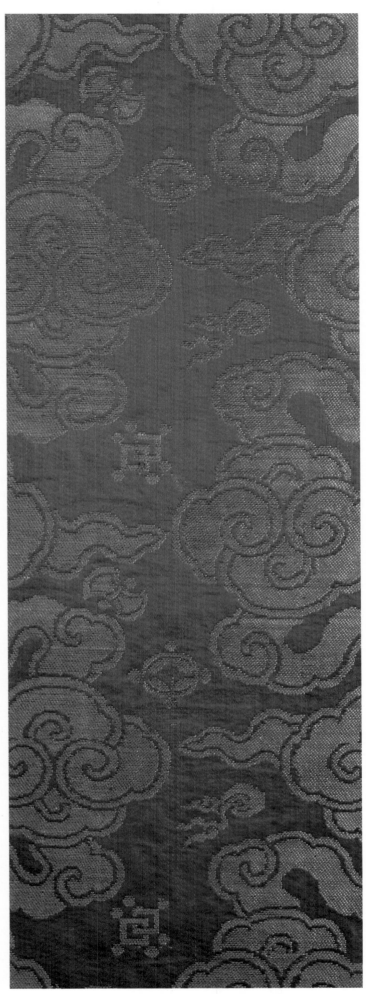

85. *Duan* with design of *ruyi*-shaped clouds and
 the eight treasures (1) Ming

86. *Duan* with design of *ruyi*-shaped clouds and
 the eight treasures (2) Ming

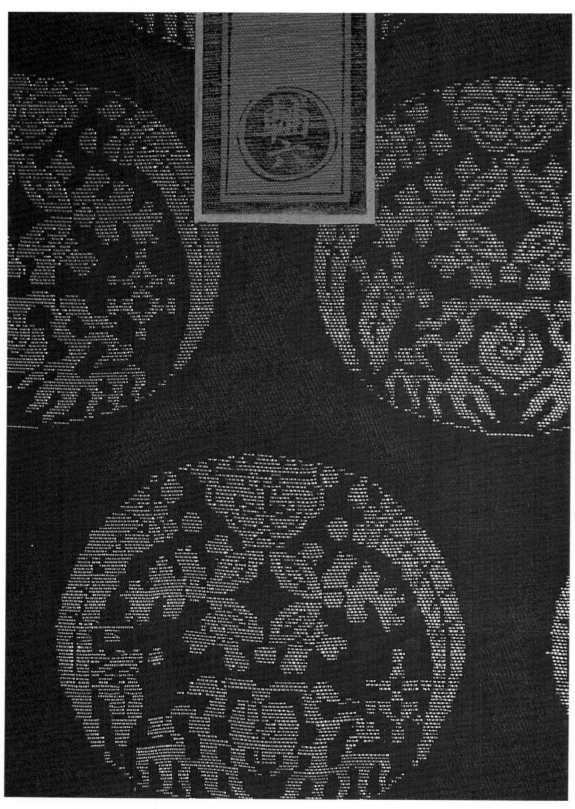

87. *Ling* with design of mixed treasures woven in gold Ming

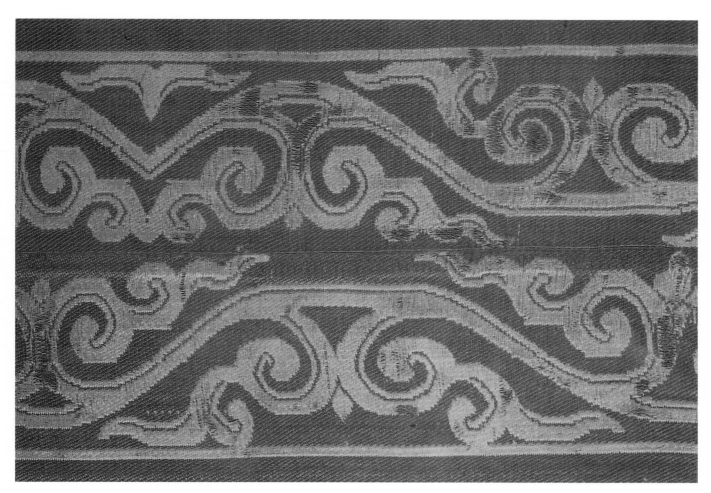

88. *Ling* with design of scrolling plants Ming

89. *Ling* with design of continuous outlined swastika lattice Ming

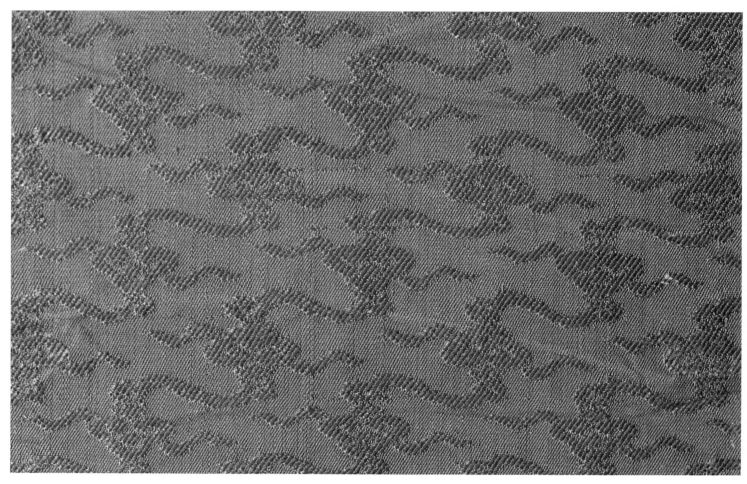

90. *Ling* with design of *ruyi*-shaped clouds Ming

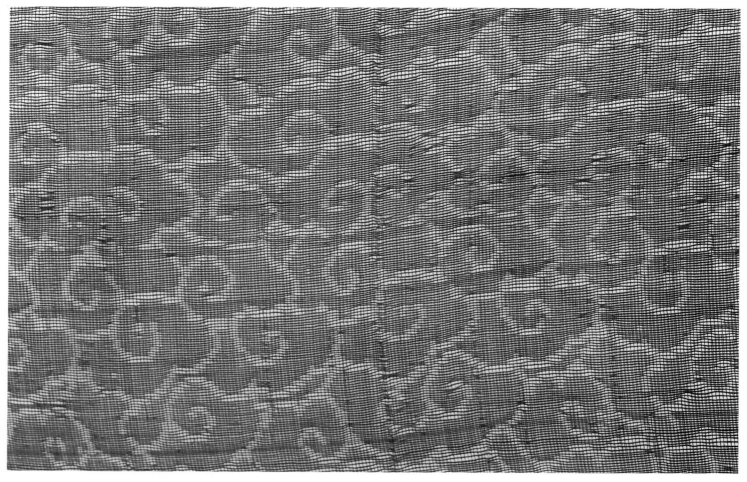

91. Gauze with cloud design Ming

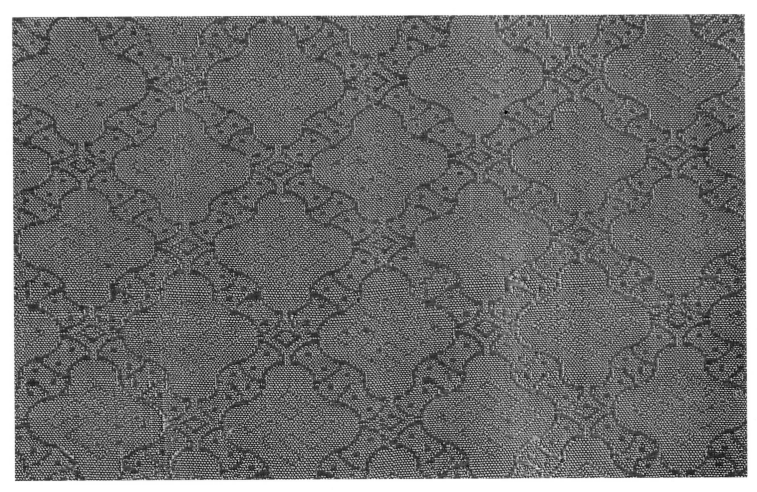

92. Silk with design of silver ingots and swastikas Ming

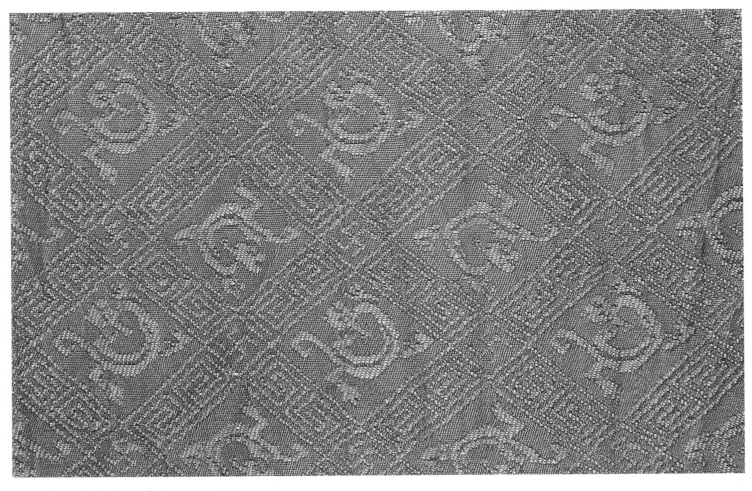

93. Silk with design of dragons Ming

94. *Kesi* with design of paired dragons with swastikas and 'longevity' characters Ming

95. *Kesi* with design of paired cranes and peaches Ming

96. Detail of plate 97

97. 'Hall of longevity' *kesi* Ming

98. Hanging with design of immortals within a 'longevity' character Ming

99. Embroidery depicting a horse being washed Ming

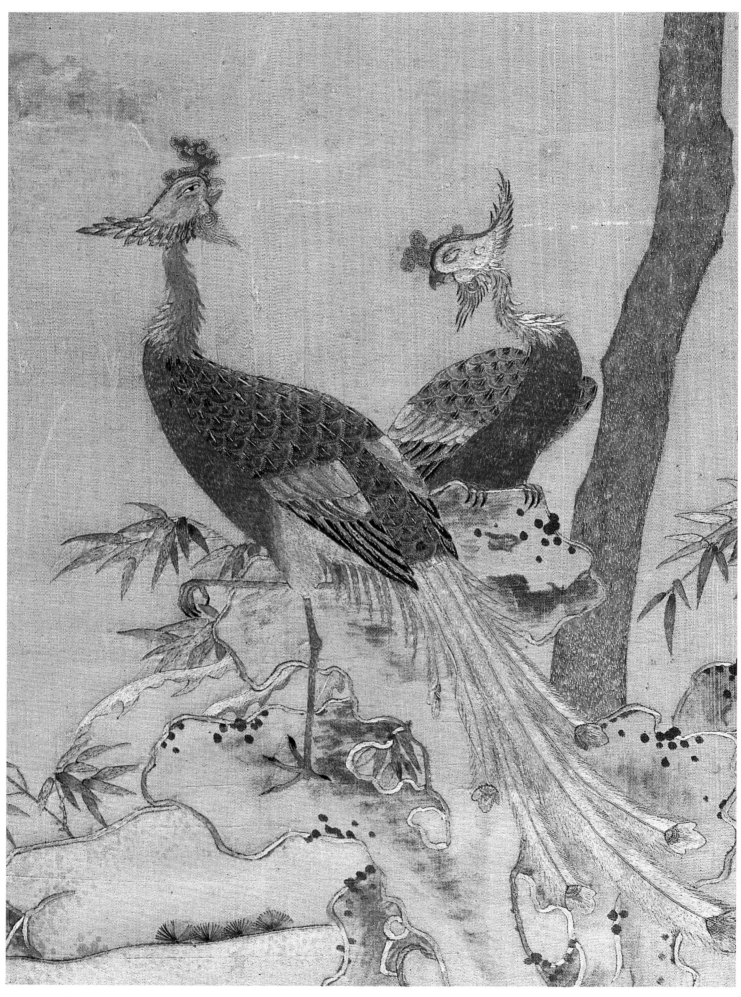

100. Detail of plate 101

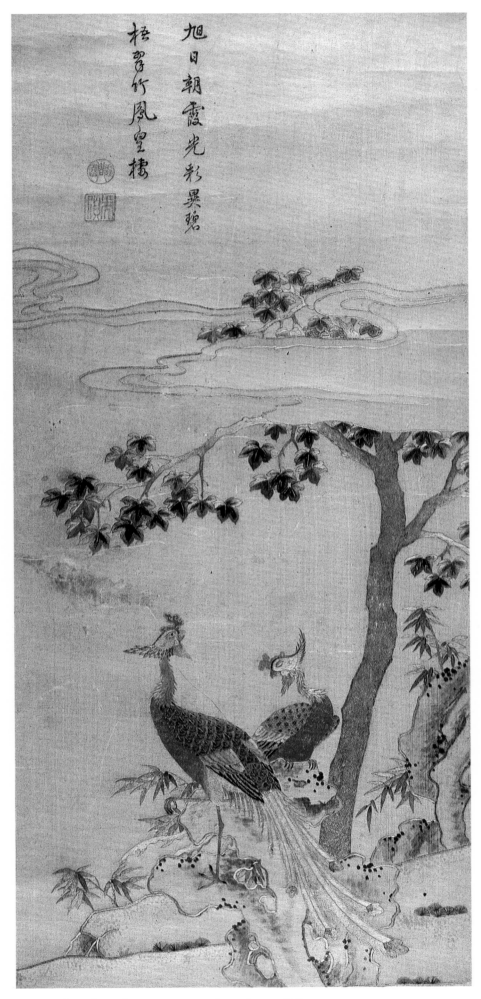

旭日朝霞光彩異碧
梧翠竹鳳凰棲

101. Embroidery depicting two phoenixes　Ming

102. Detail of plate 103

103. Gu embroidery depicting apricot-blossom village Ming

104. Detail of plate 105

105. Embroidery depicting a landscape and the Three Longevities
Ming

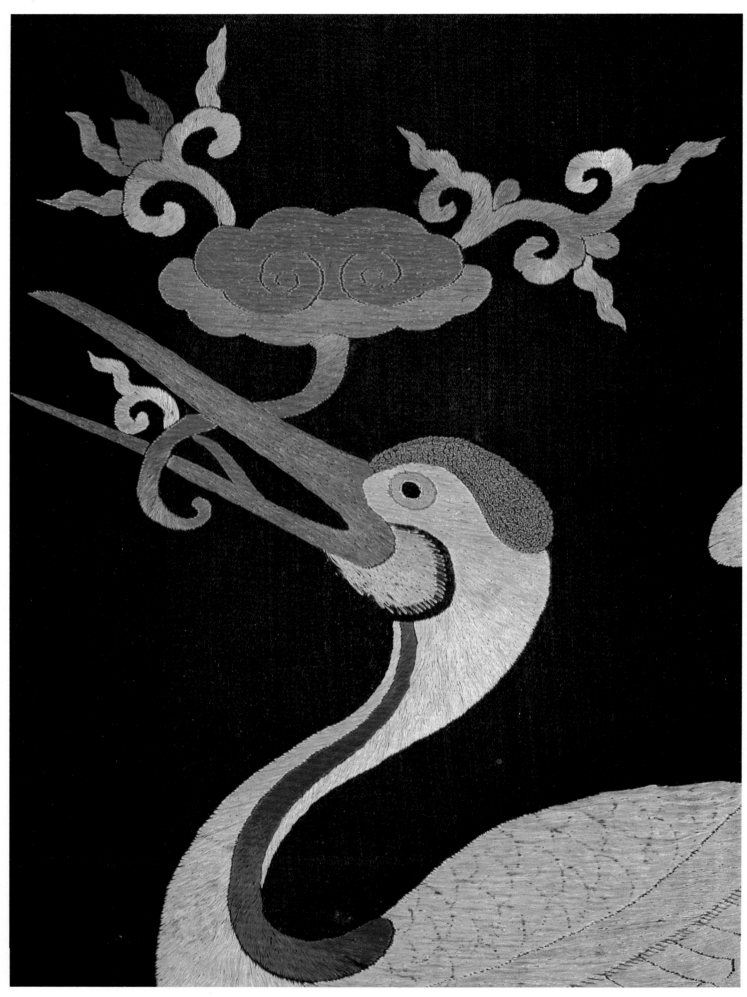

106. Detail of plate 107

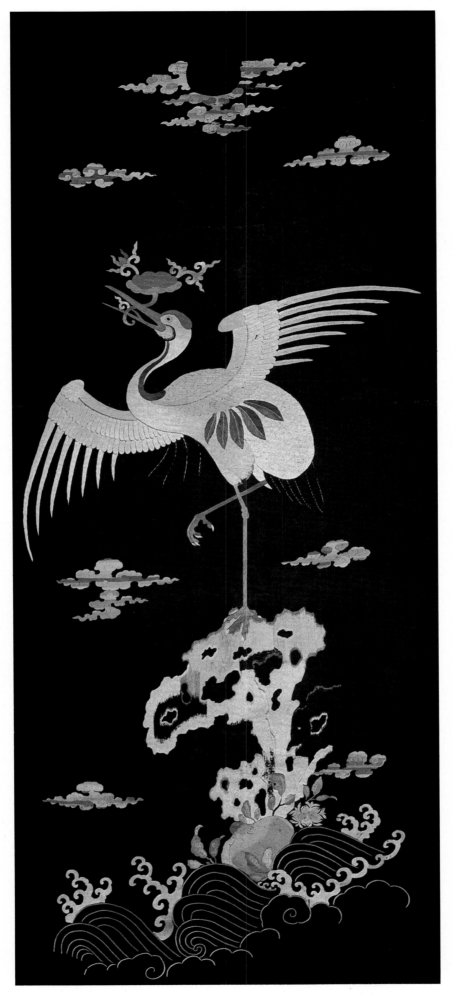

107. Gu embroidery depicting a crane holding a *lingzhi* fungus
Ming

125

108. Detail of Na embroidery depicting beautiful women Ming

109. Further detail of embroidery shown in plate 108

110. Detail of hair embroidery of Tower of the Weaving Maid figures Ming

111. Lohans embroidered in colour (1) Ming

112. Lohans embroidered in colour (2) Ming

113. Lohans embroidered in colour (3) Ming

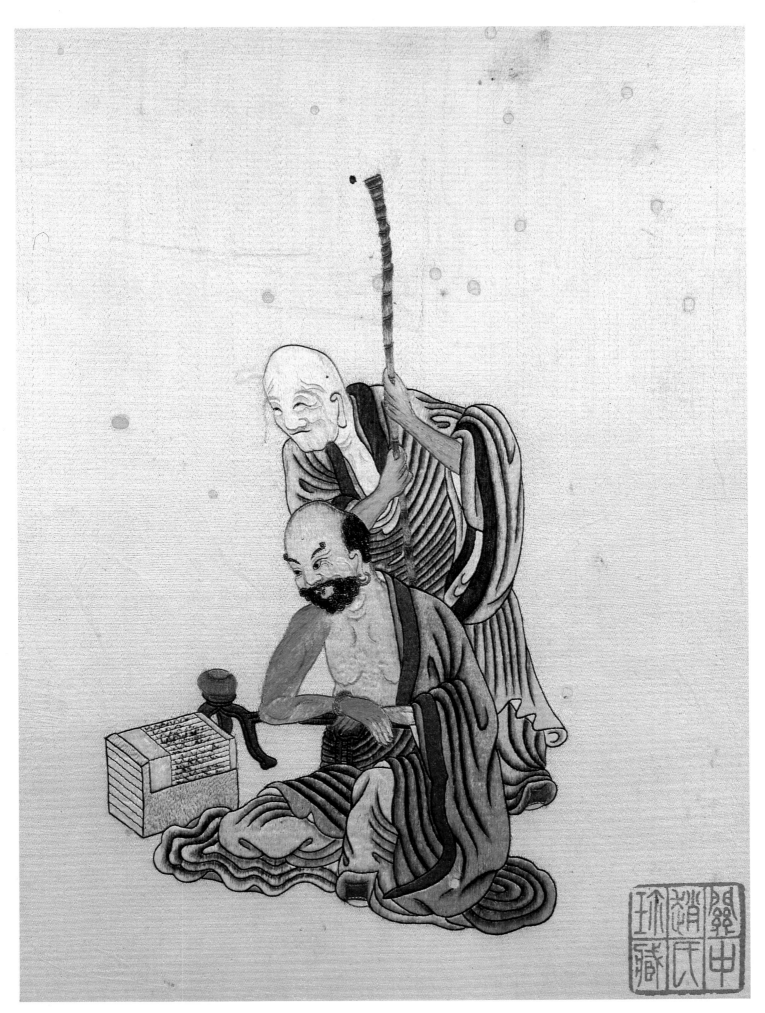

114. Lohans embroidered in colour (4)　Ming

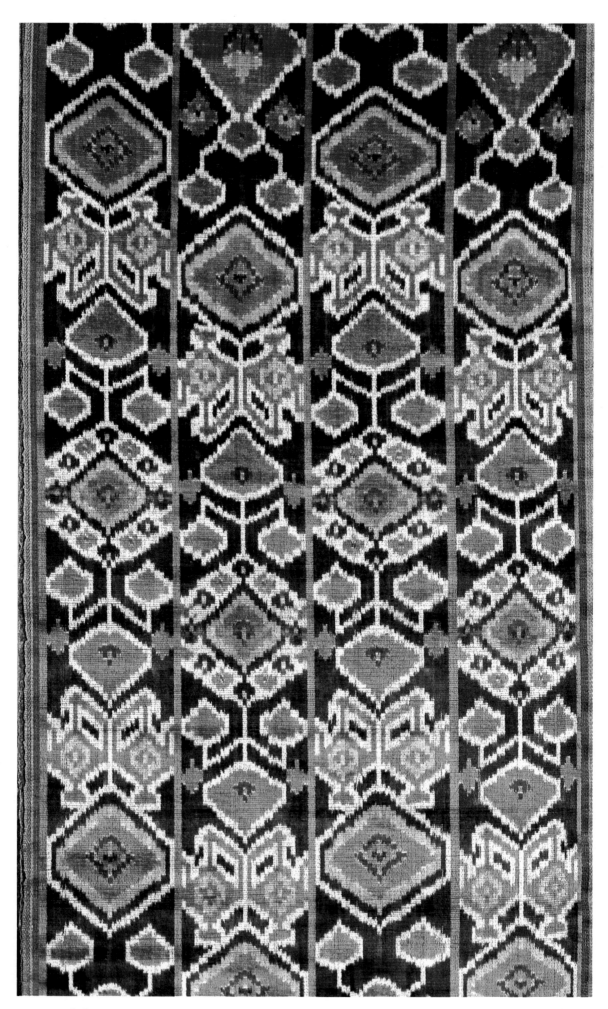

115. *Mashilu* cotton Qing

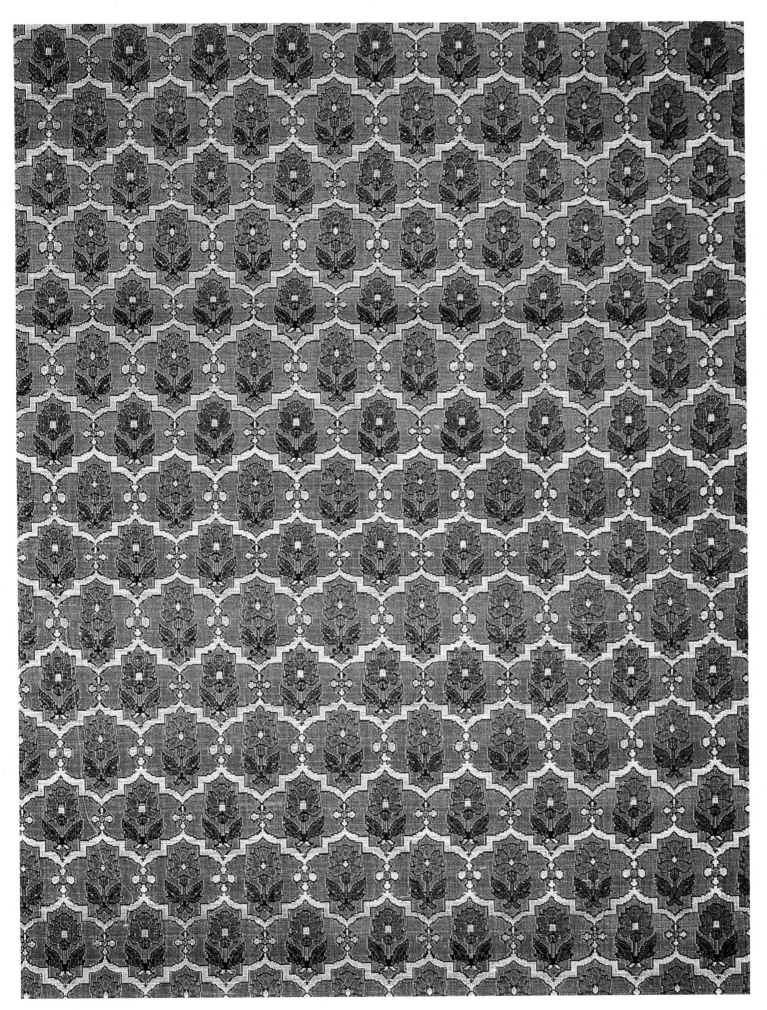

116. *Jin* with design of flowers Qing

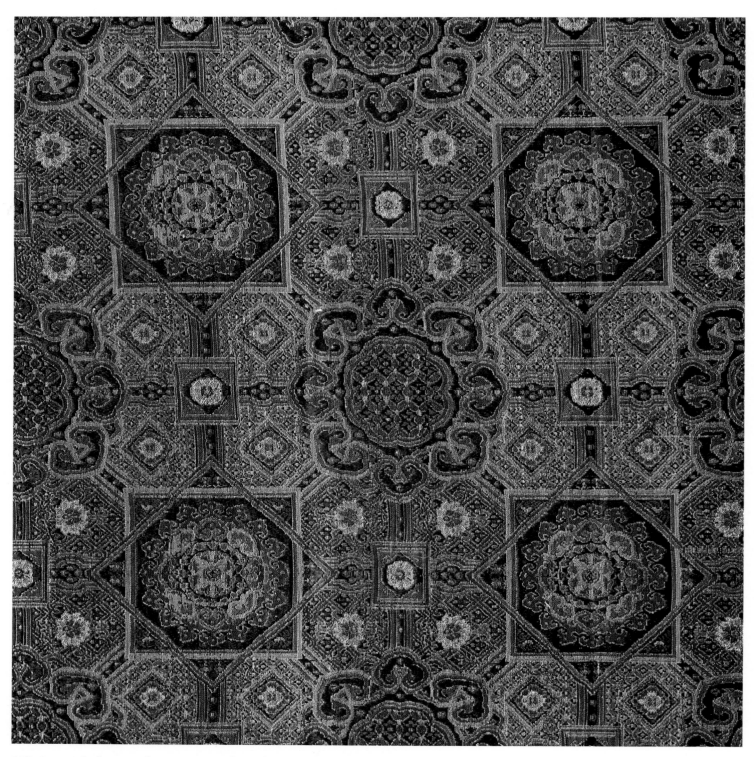

117. *Jin* with design of octagons and circles on a black ground Qing

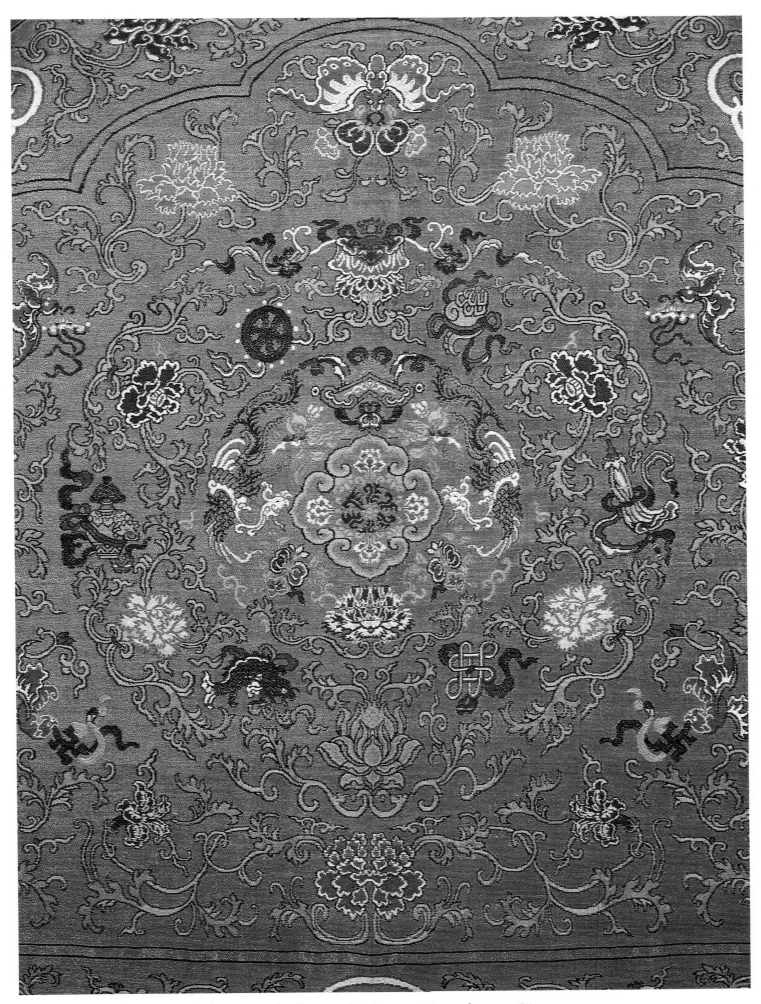

118. *Jin* with design of paired phoenixes, five bats and eight auspicious objects Qing

119. Zhuang *jin* silk rug with checked lozenge-and-flower design Qing

120. *Jin duan* with design of peaches, pomegranates and Buddha's hand citrus on
a blue ground Qing

121. *Jin duan* with design of hexagons and linked circles Qing

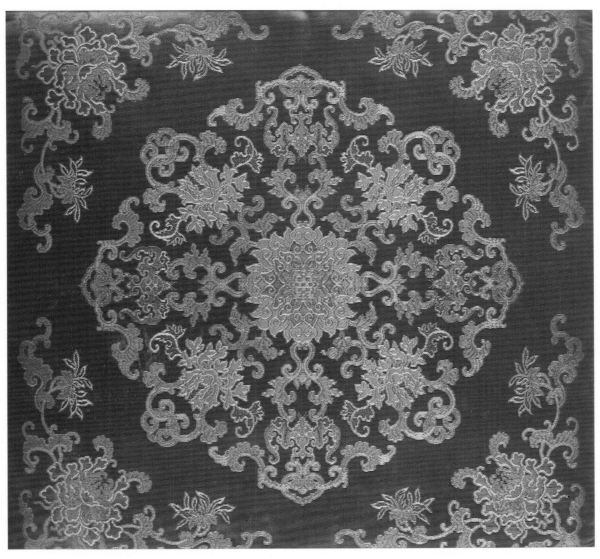

122. *Jin duan* with design of 'many blessings and precious flowers' Qing

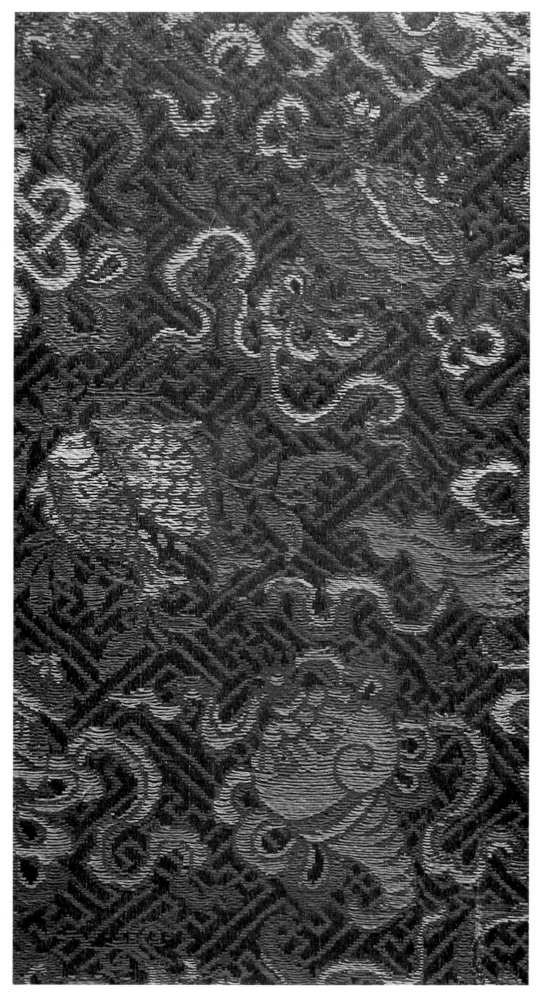

123. Detail of *jin duan* with design of swastika-lattice ground and eight
auspicious symbols Qing

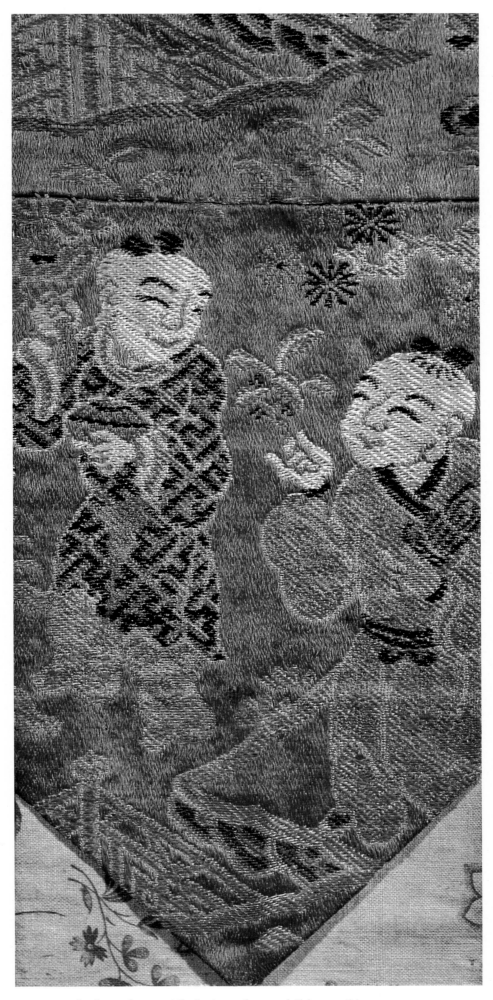

124. Detail of *jin duan* with design of two children Qing

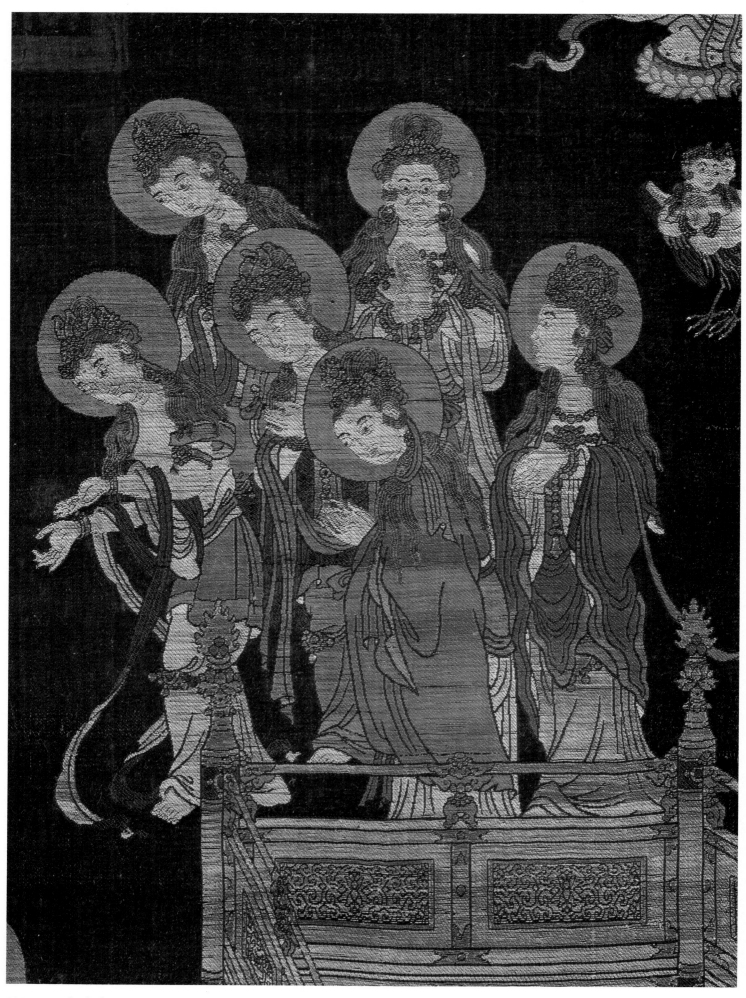

125. Detail of plate 126

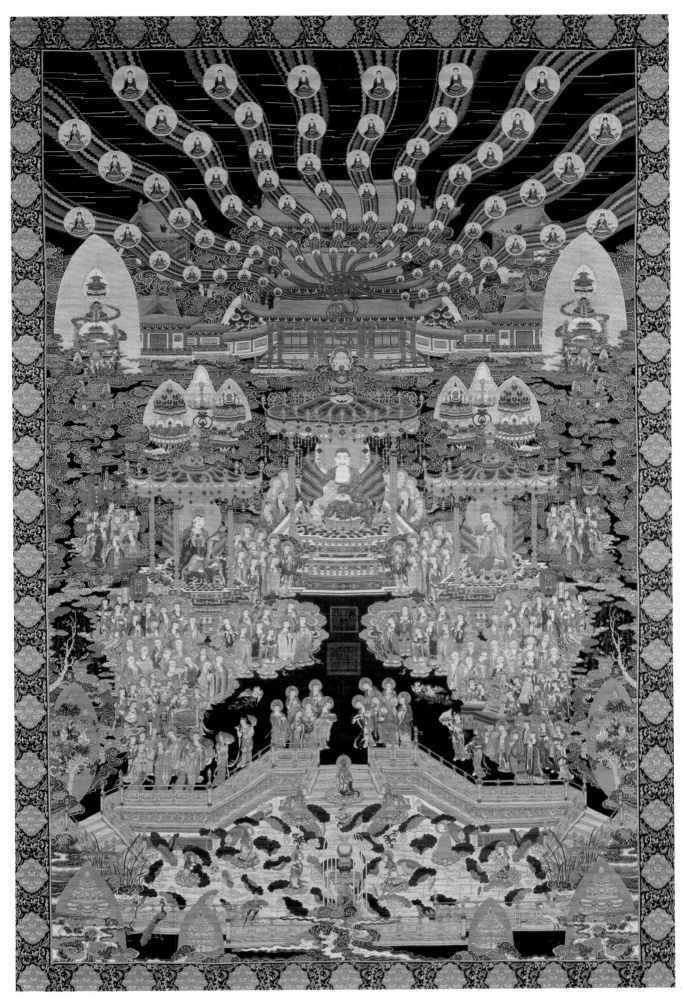

126. Hanging scroll depicting the Western Paradise Qing

127. *Duan* belt with design of pine, prunus and bamboo Qing

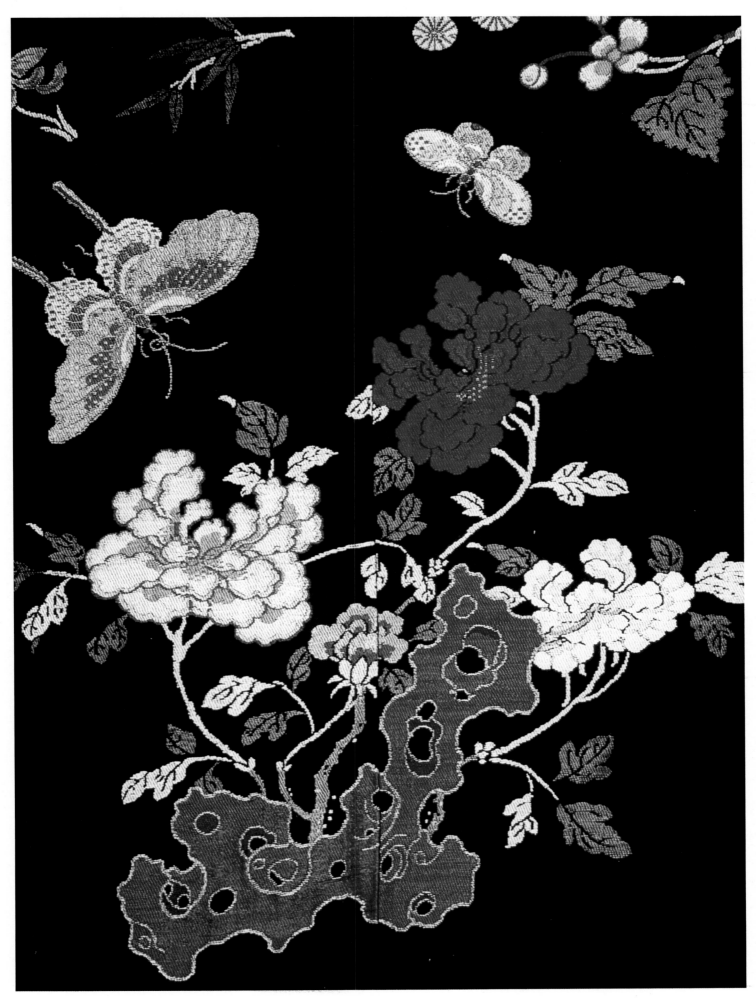

128. Detail of *duan* with design of flowers and butterflies Qing

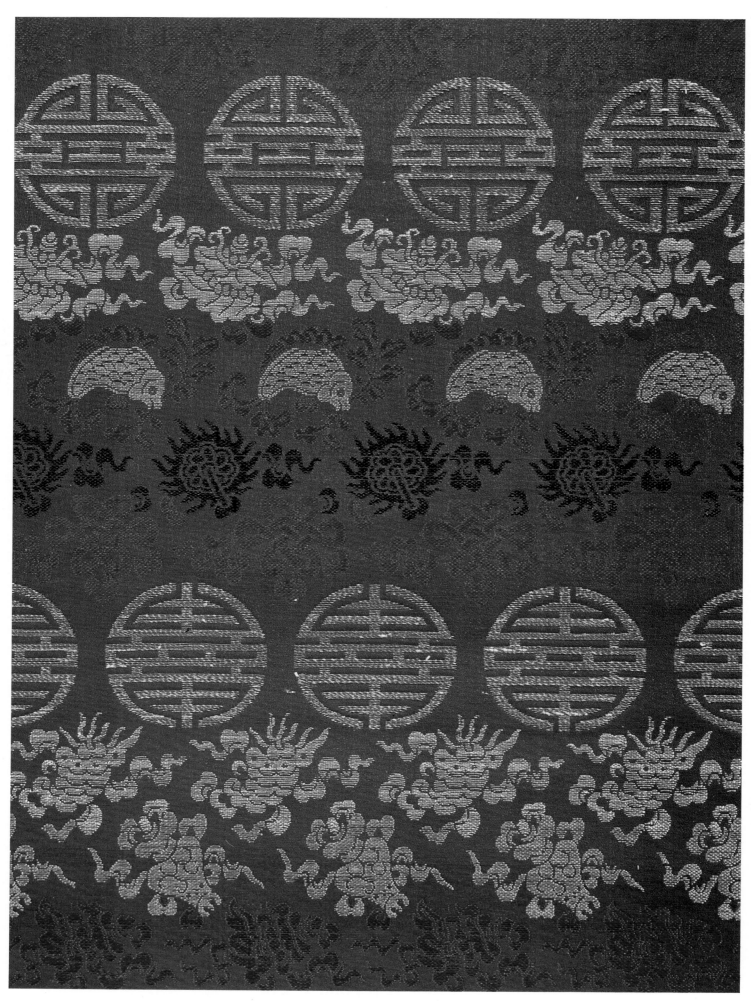

129. *Duan* with design of eight auspicious symbols and golden 'longevity' characters Qing

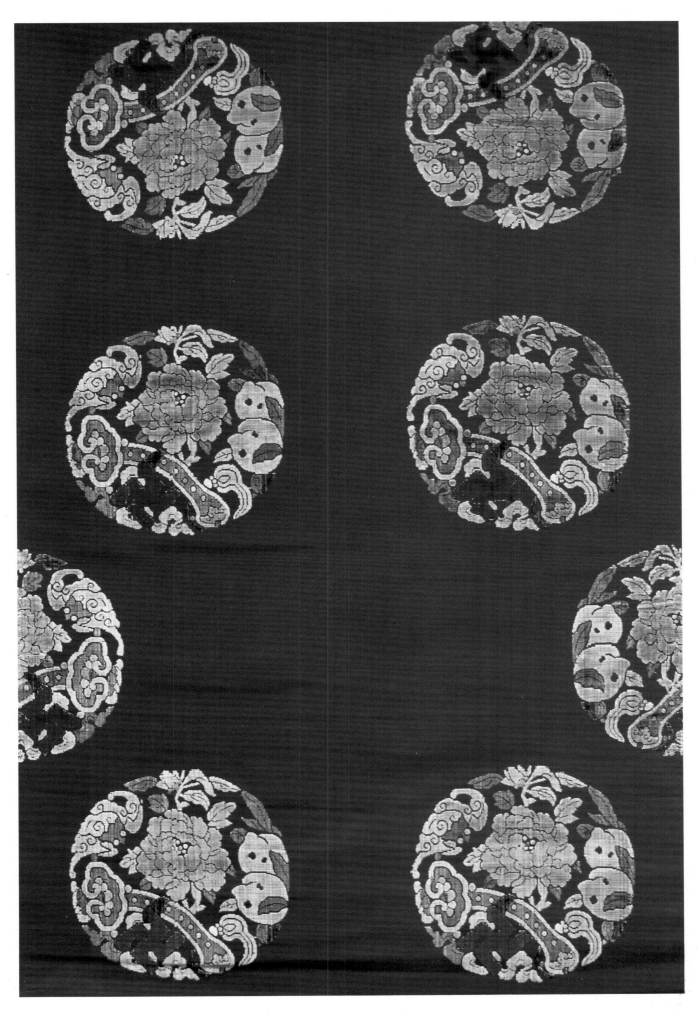

130. Zhang *duan* with painted roundel design Qing

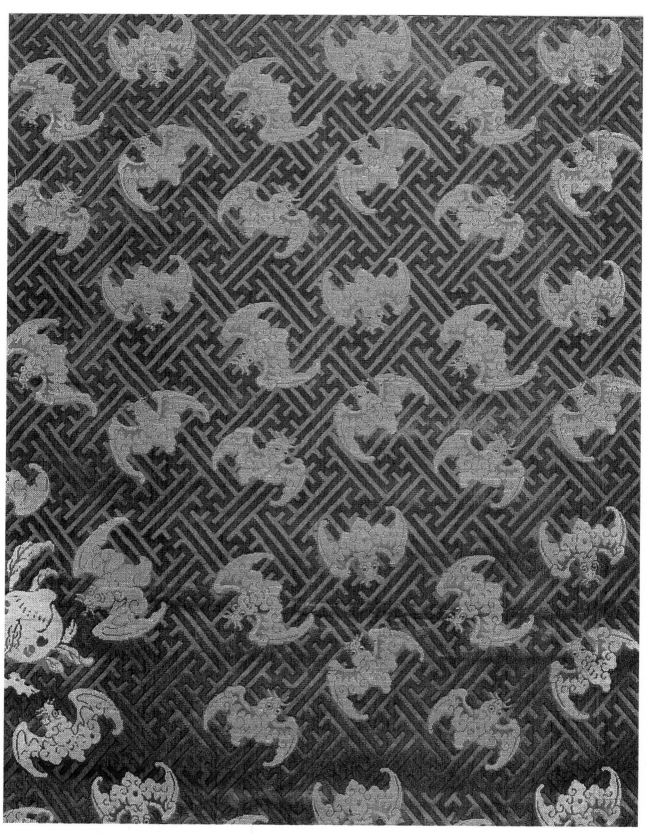

131. Detail of Zhang *duan* with design of swastikas and 'a hundred blessings' Qing

148

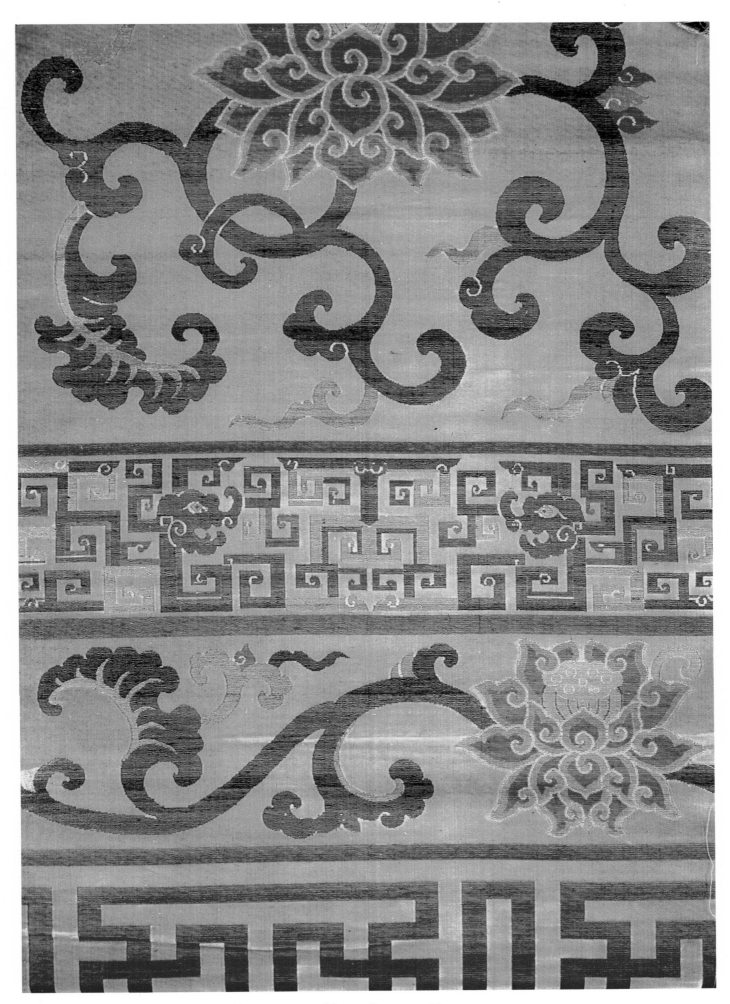

132. Nap *duan* with design of scrolling stems and lotus flowers Qing

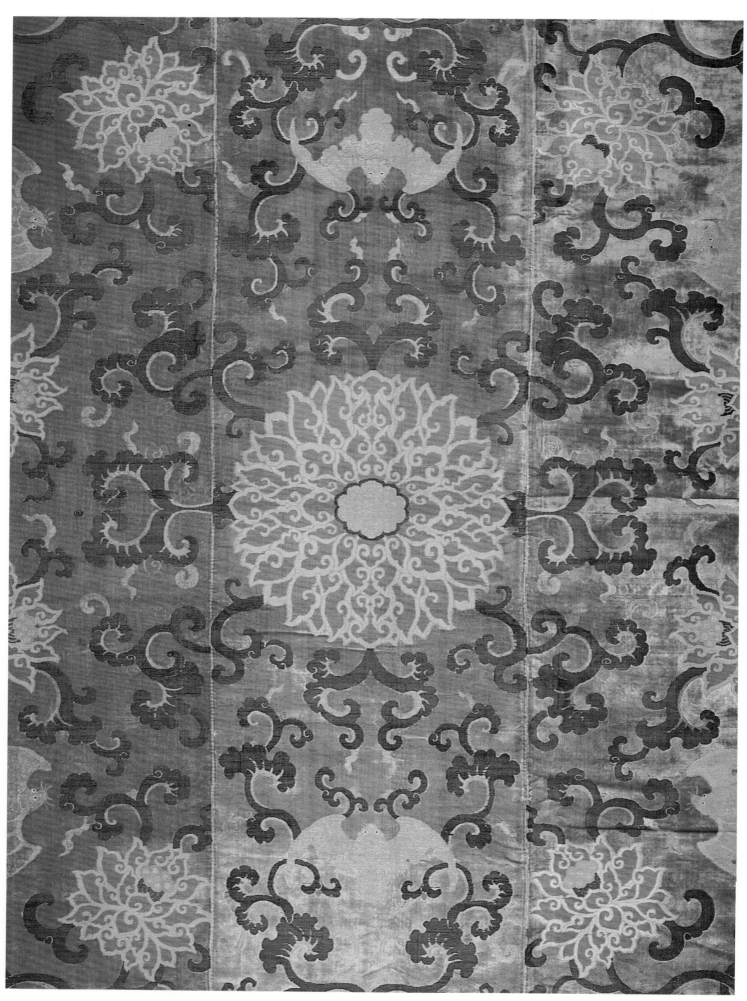

133. *Rong* quilt with polychrome design of 'many blessings' and lotus flowers Qing

134. Detail of *kesi* with design of drunken Eight Immortals Qing

135. Detail of plate 136

136. *Kesi* with design of a group of immortals celebrating with the Star God
of Longevity Qing

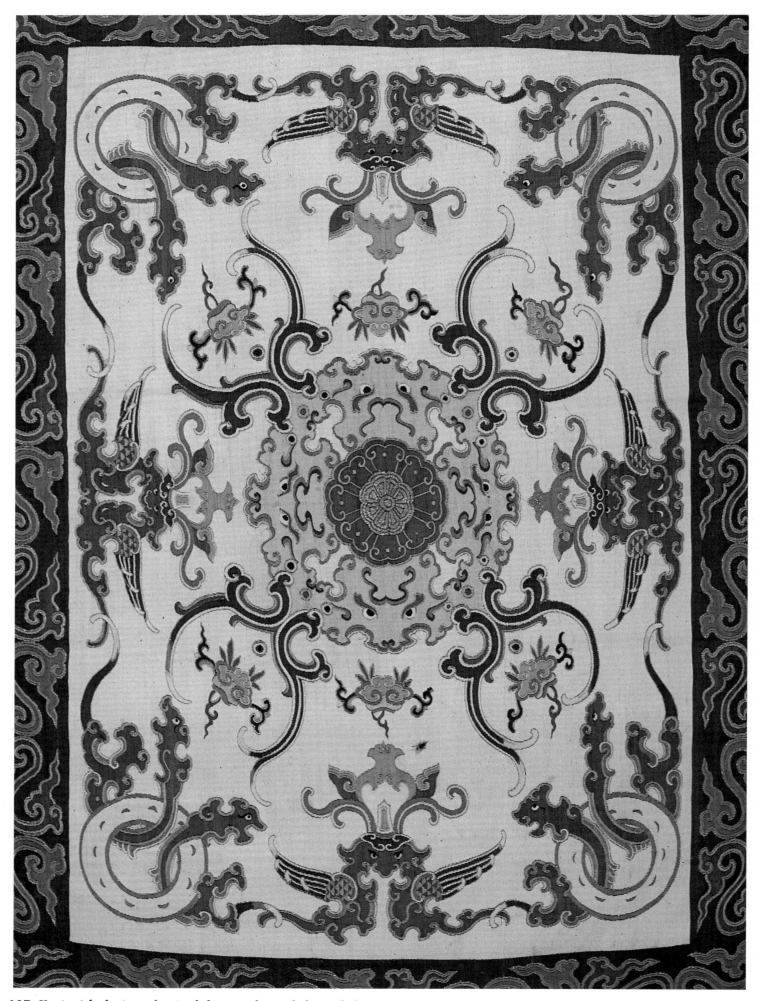

137. *Kesi* with design of paired dragons looped through *bi* rings Qing

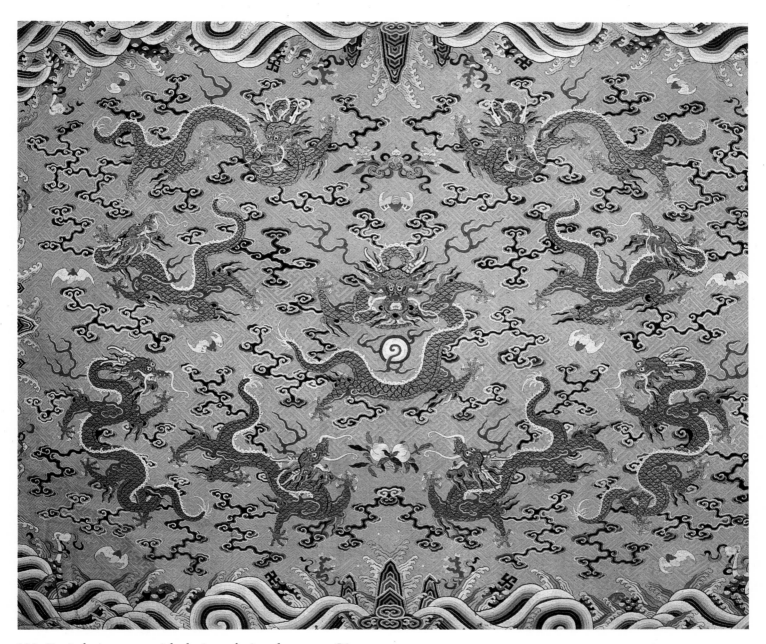

138. *Kesi* chair-cover with design of nine dragons Qing

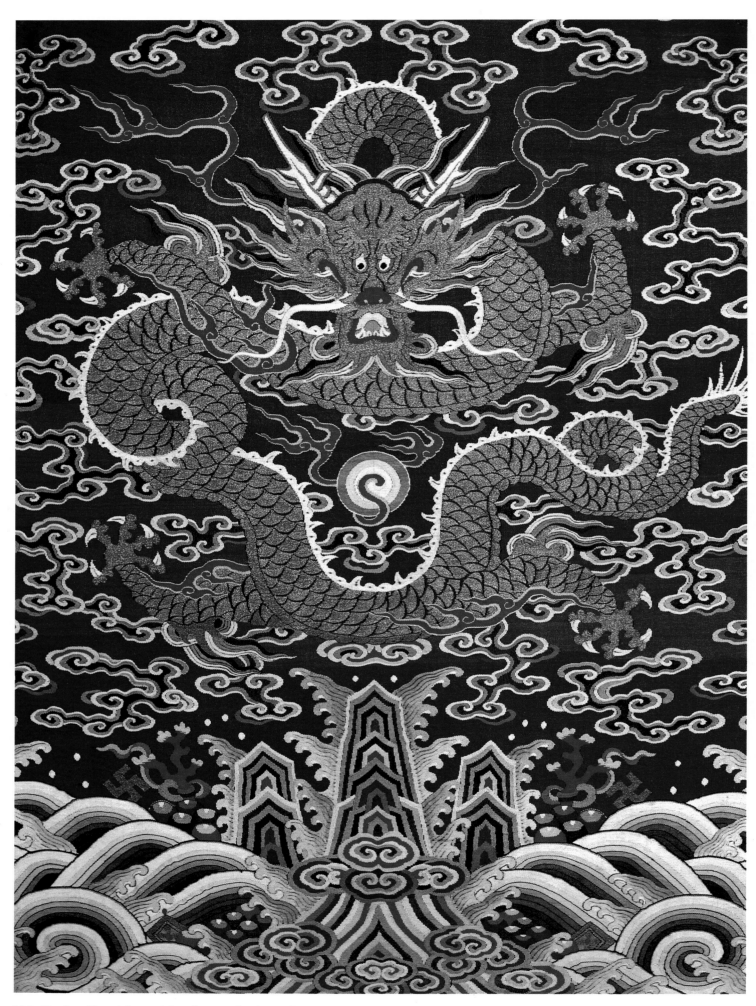

139. *Kesi* quilt with upright-dragon design Qing

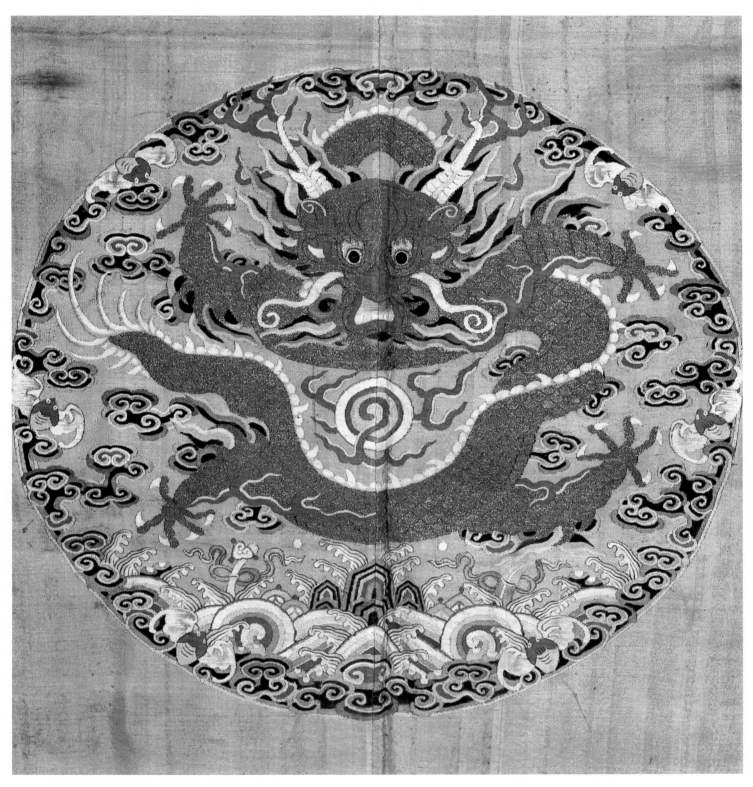

140. *Kesi* with dragon roundel design Qing

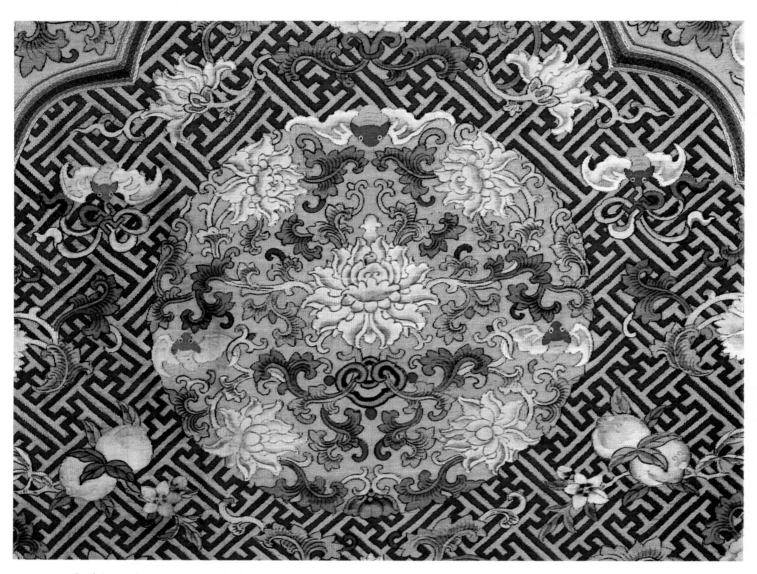

141. Detail of *kesi* chair-cover with design of 'blessings, longevity, wealth and honour' Qing

142. Printed cotton with camellia design Qing

143. Printed cotton with design of scrolling floral stems Qing

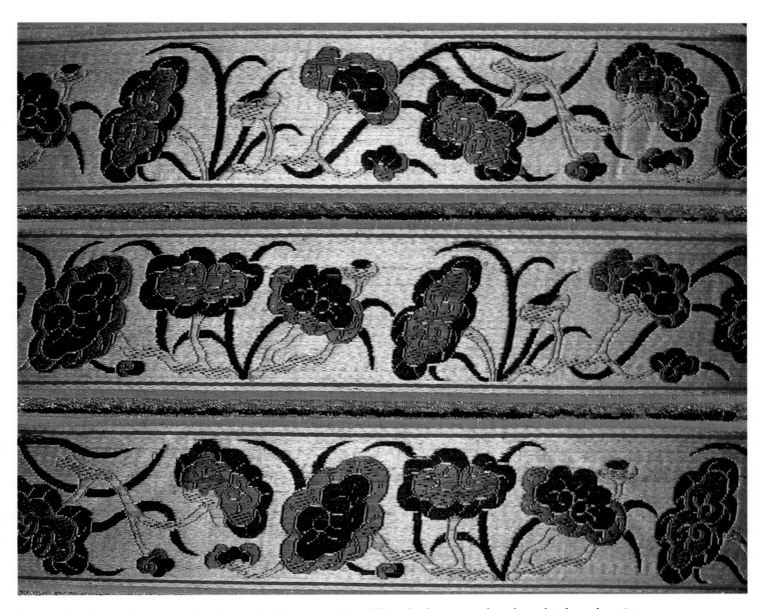

144. Embroidered decorative border with lilac ground and *lingzhi* fungus in brush-and-ink style Qing

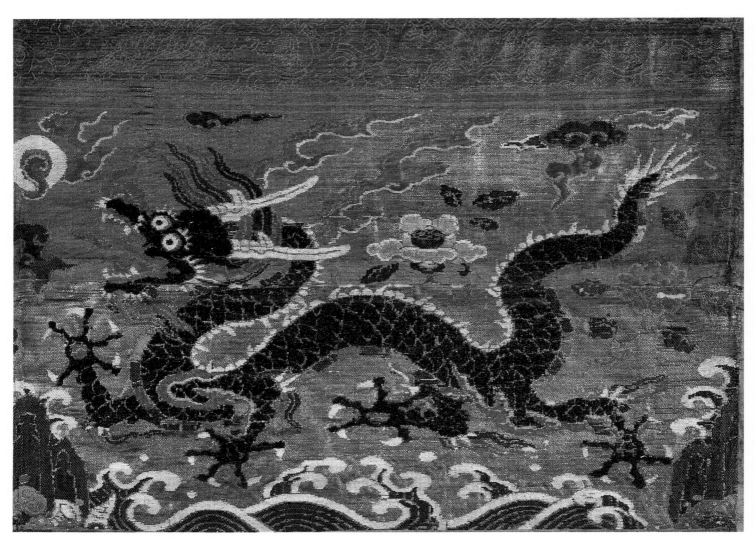

145. 'All-over gold' fabric with design of ambulatory dragon in peacock-feather thread Qing

146. Detail of purple gauze dragon robe Qing

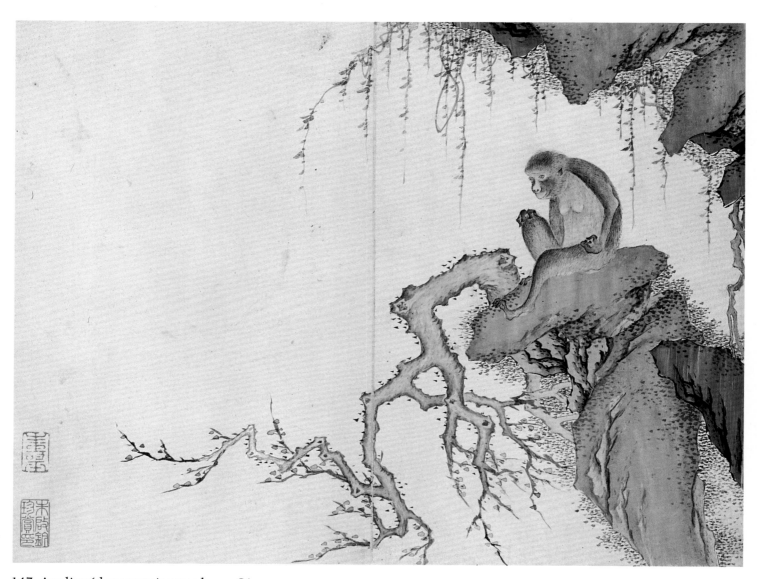

147. Appliquéd mountain monkey Qing

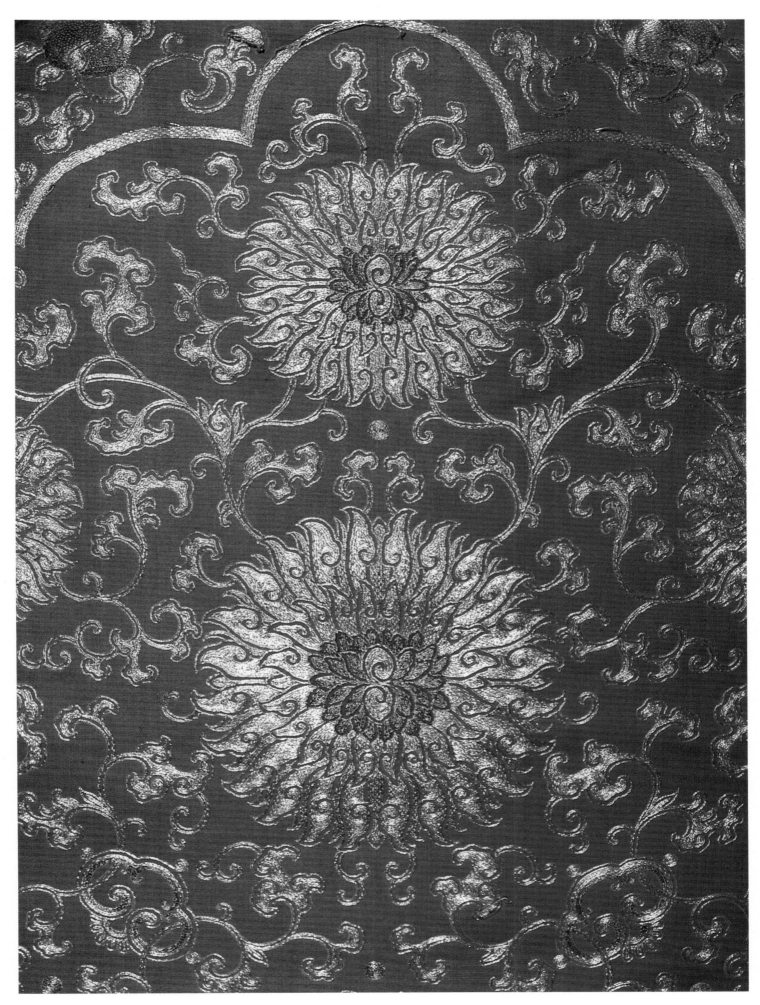

148. Detail of chair-cover decorated with flat-gold embroidery　Qing

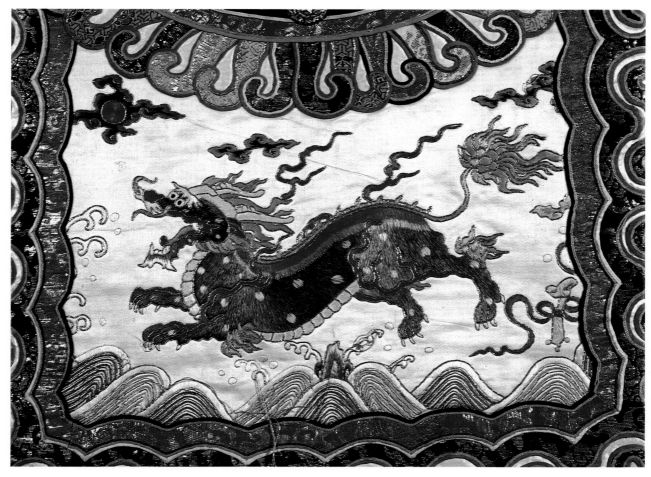

149. Detail of section of armour for a door god (1)　Qing

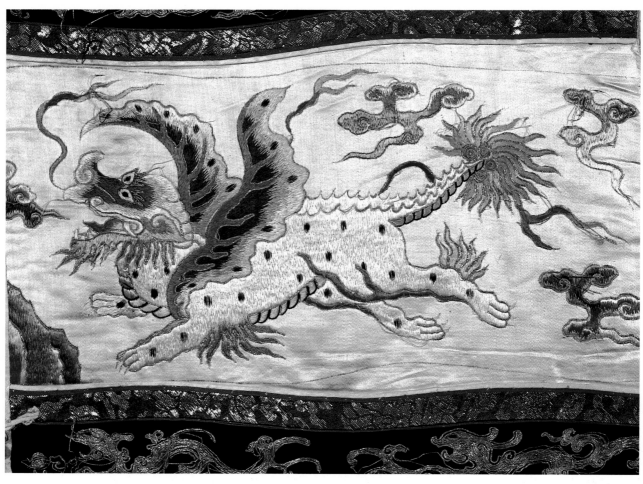

150. Detail of section of armour for a door god (2)　Qing

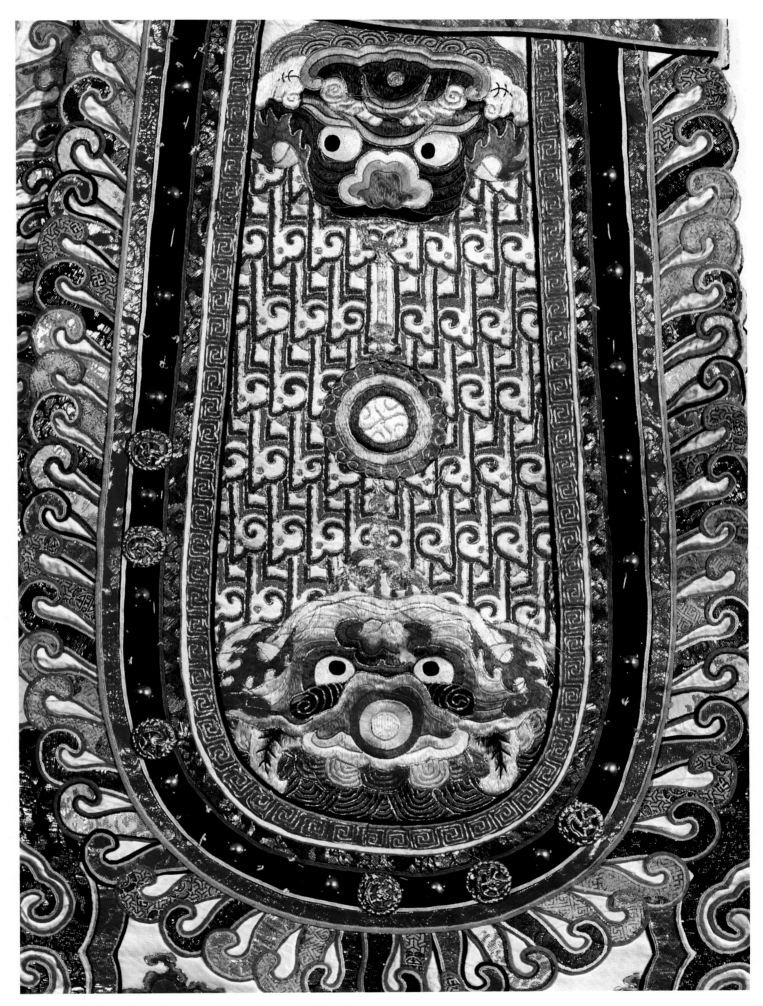

151. Detail of section of armour for a door god (3) Qing

167

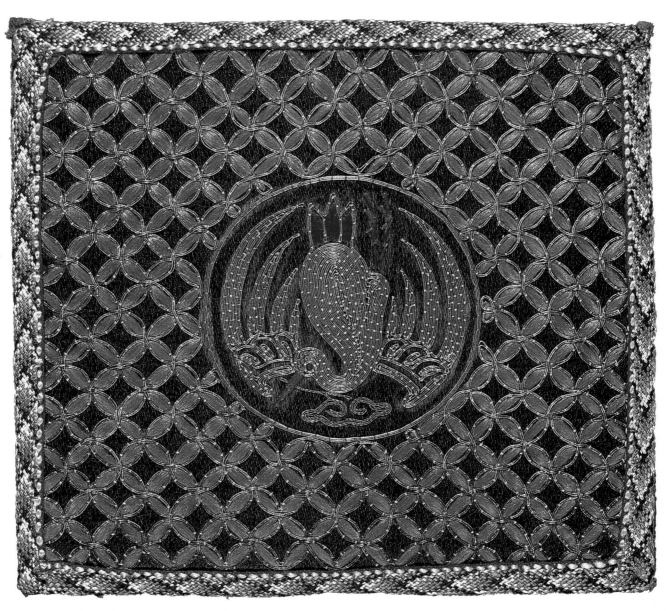

152. Couchwork embroidery with crane roundel design Qing

153. Couchwork embroidery with design of 'longevity' character roundel Qing

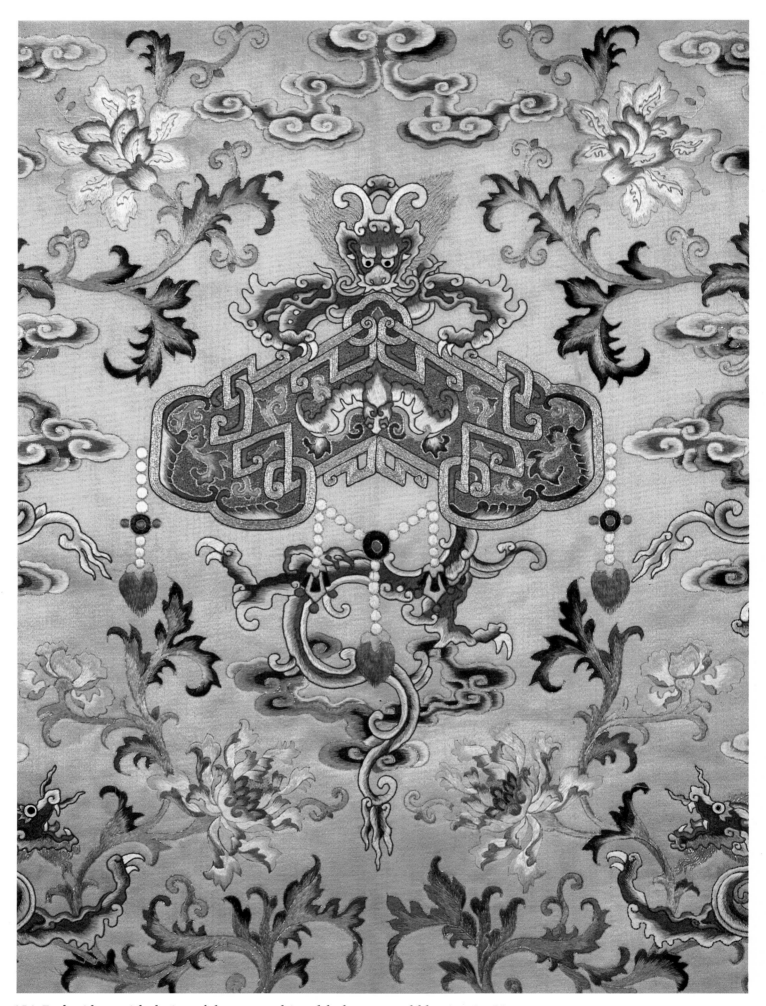

154. Embroidery with design of dragons and 'wealth, honour and blessings'　Qing

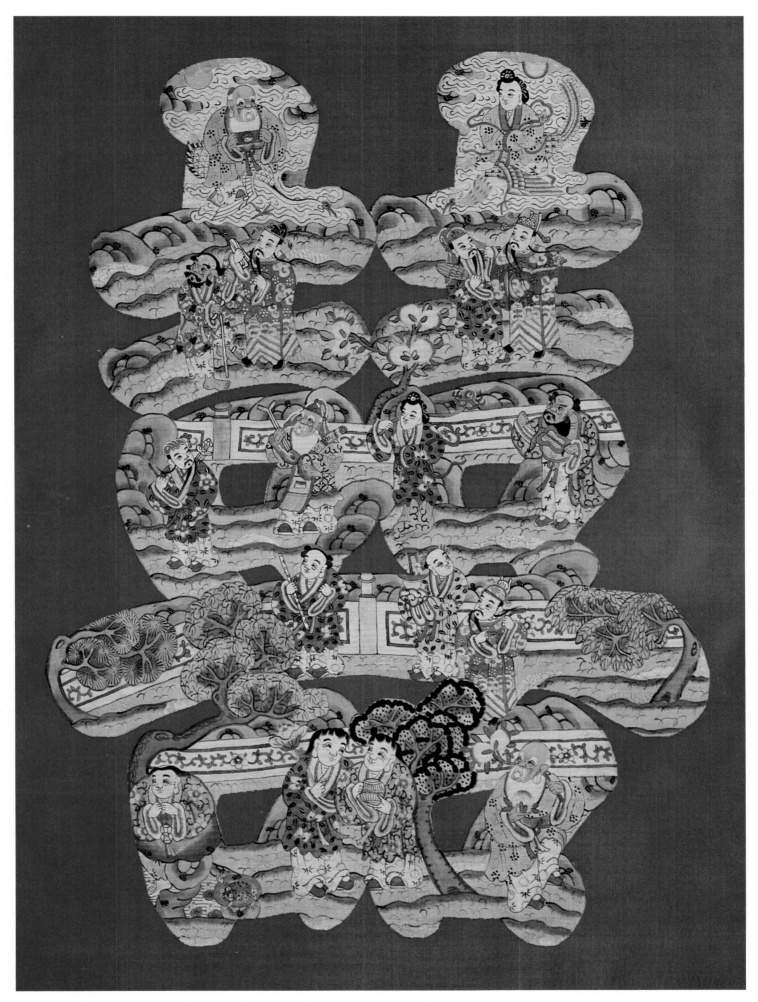

155. 'Double happiness' embroidery depicting deities and immortals Qing

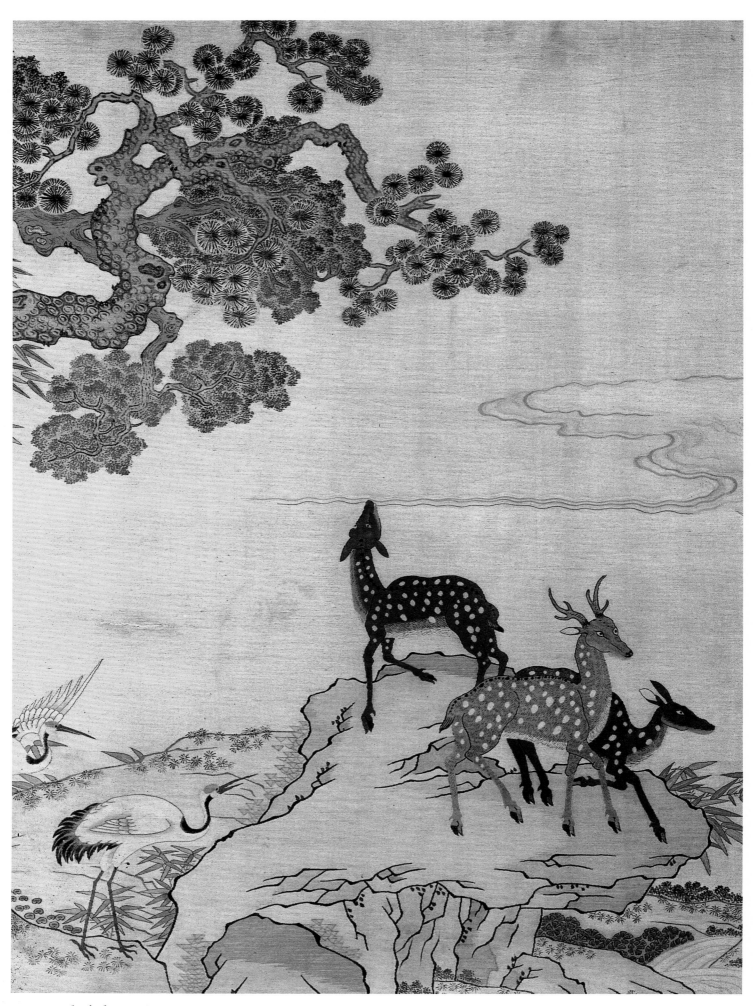

156. Detail of plate 157

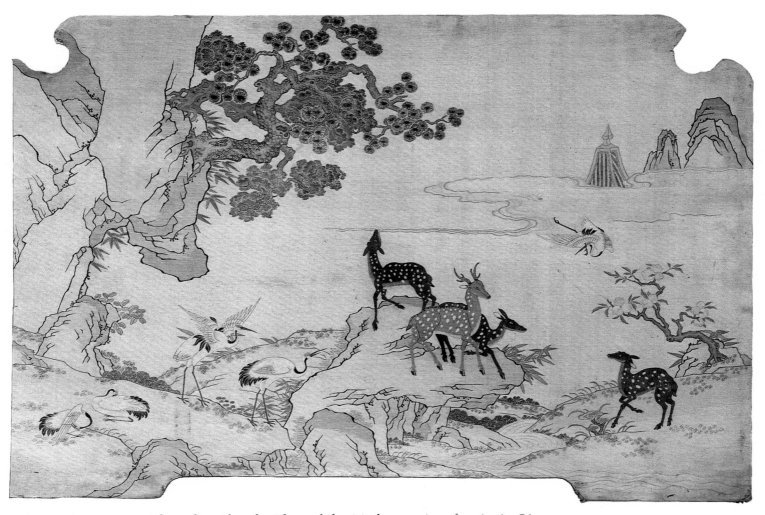

157. Hanging screen with appliquéd embroidery of the 'six harmonies of spring' Qing

158. Detail of cushion with level-gold embroidery in 'heavenly corona' pattern Qing

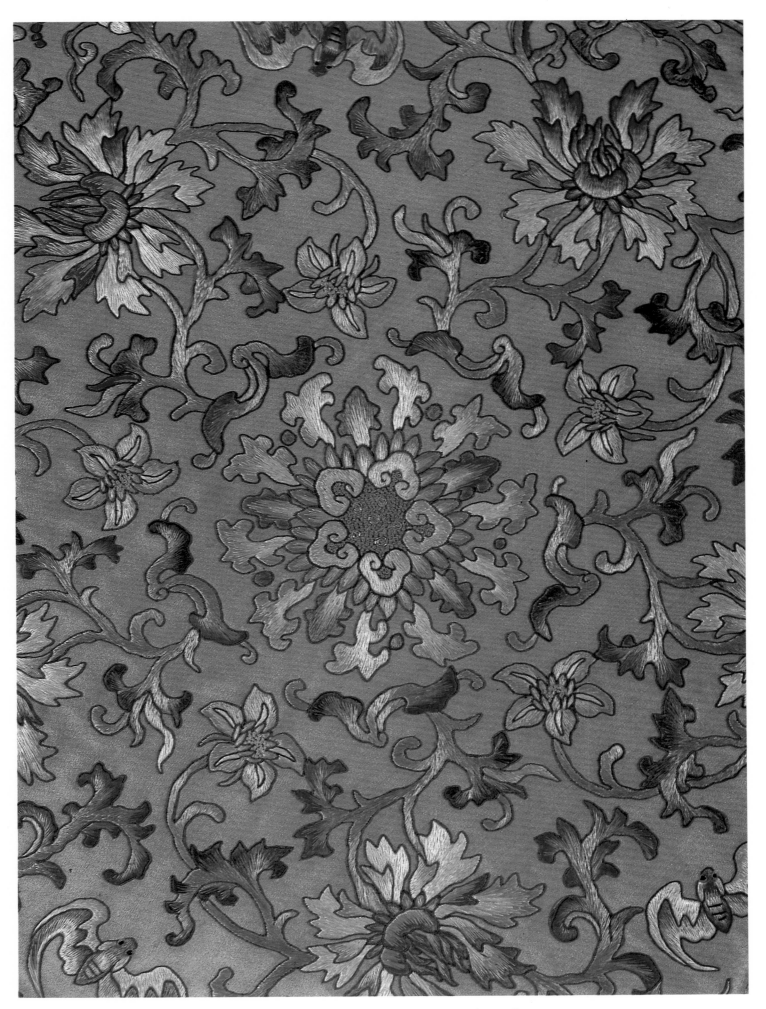

159. Detail of yellow *duan* cushion with embroidered design of 'precious lotus flowers' Qing

175

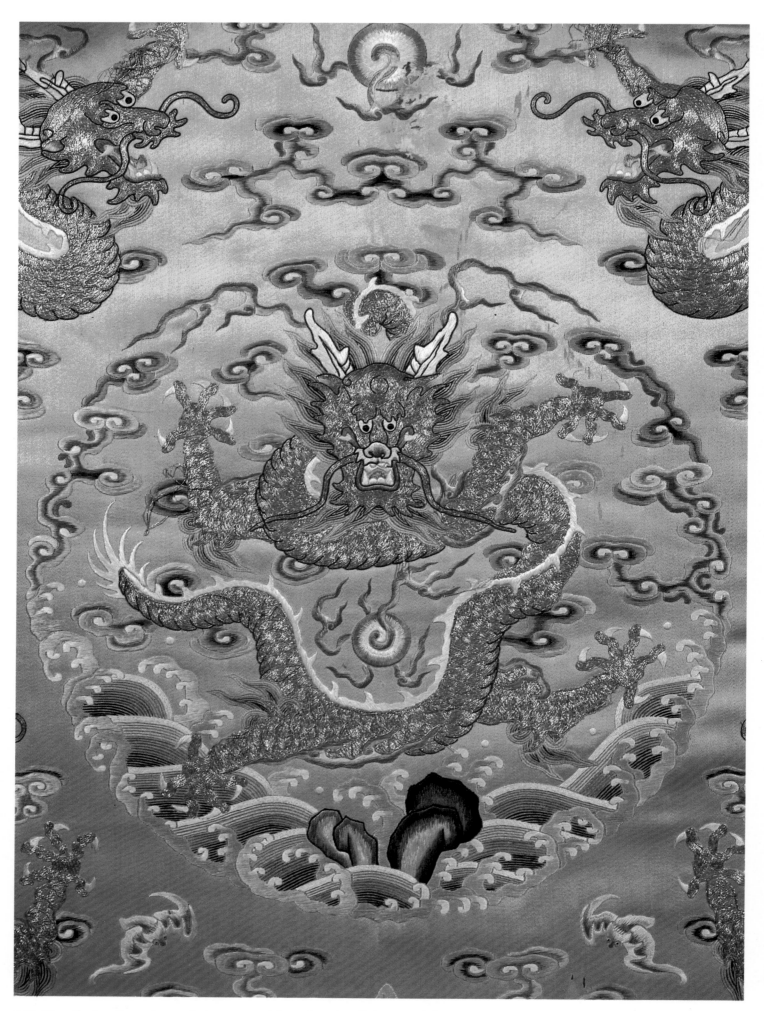

160. Detail of yellow *duan* chair-cover with embroidered design of five dragons Qing

176

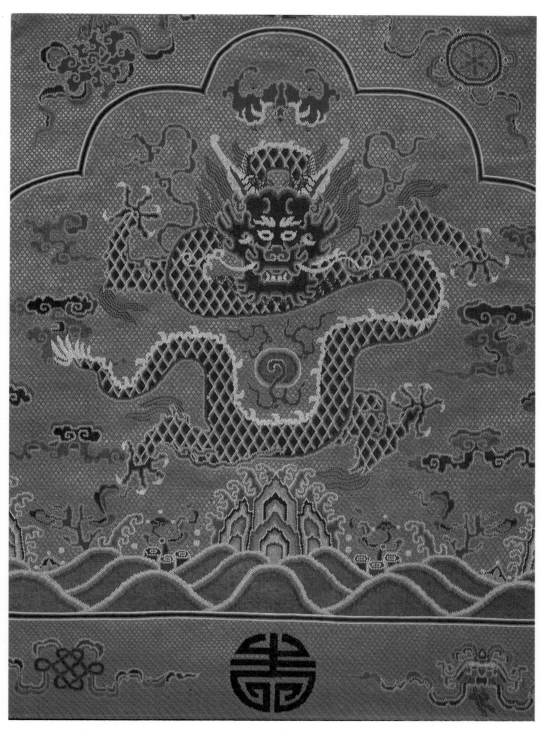

161. Detail of chair-back with embroidered design of dragons and 'blessings and
 longevity' Qing

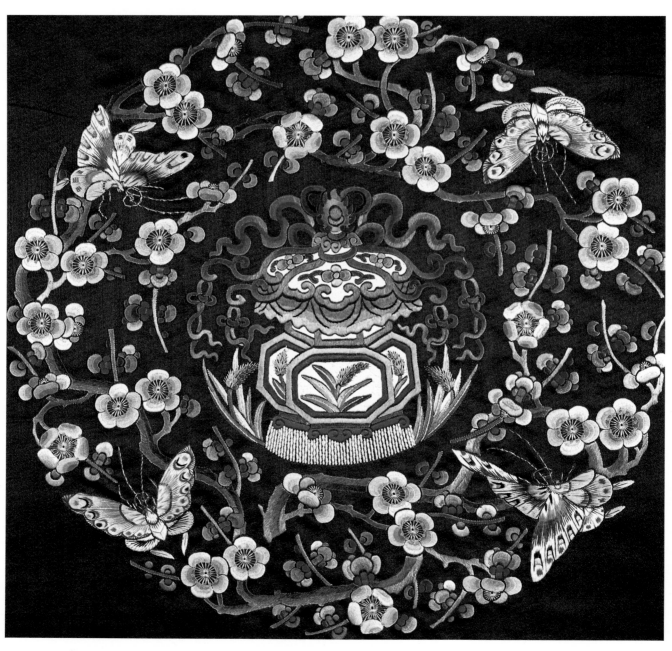

162. Butterfly embroidery on azure *duan* ground Qing

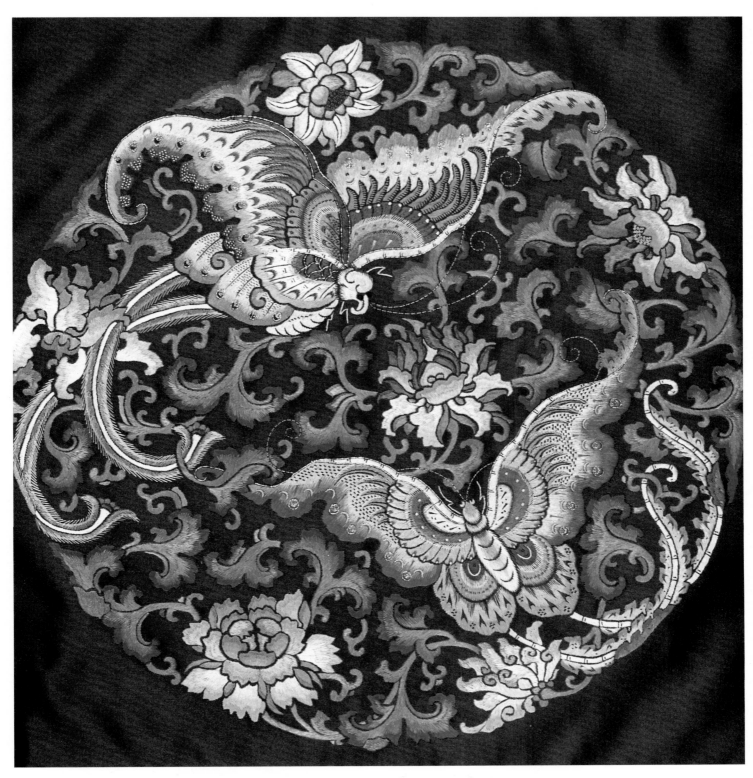

163. 'Happiness encountered by chance' embroidery on azure *duan* ground Qing

164. Embroidered scrolls of rhymed antithetical couplets Qing

165. Hanging scrolls with embroidered design of brush-and-ink bamboo painting in the style of Zheng
Banqiao Qing

181

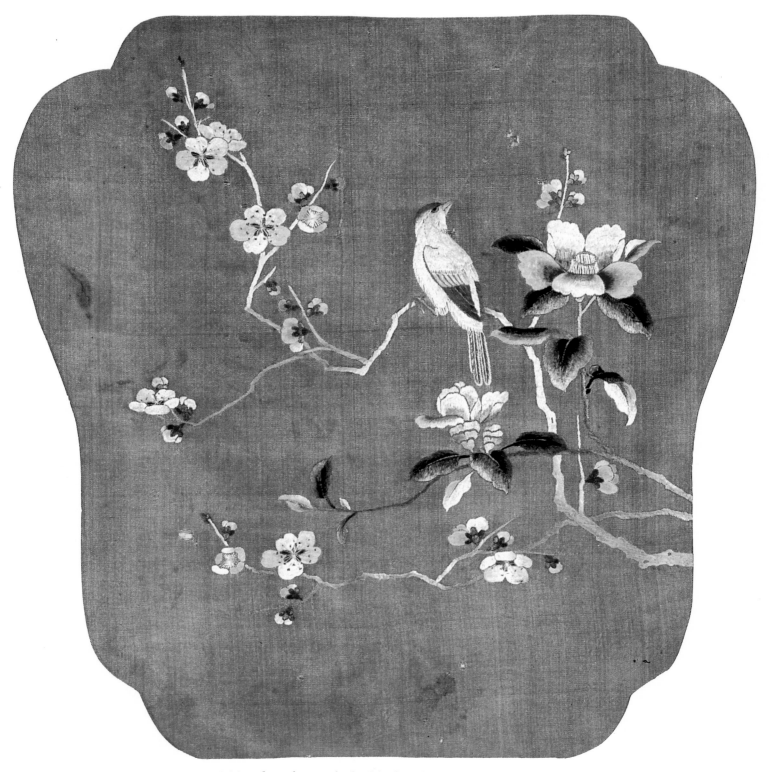

166. Palace fan with double-faced embroidery (1)　Qing

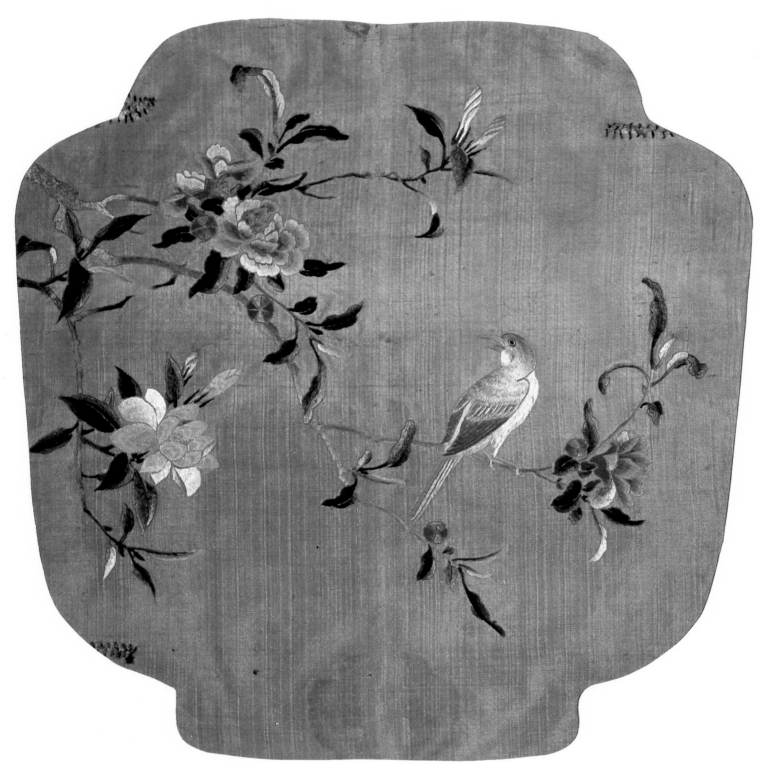

167. Palace fan with double-faced embroidery (2) Qing

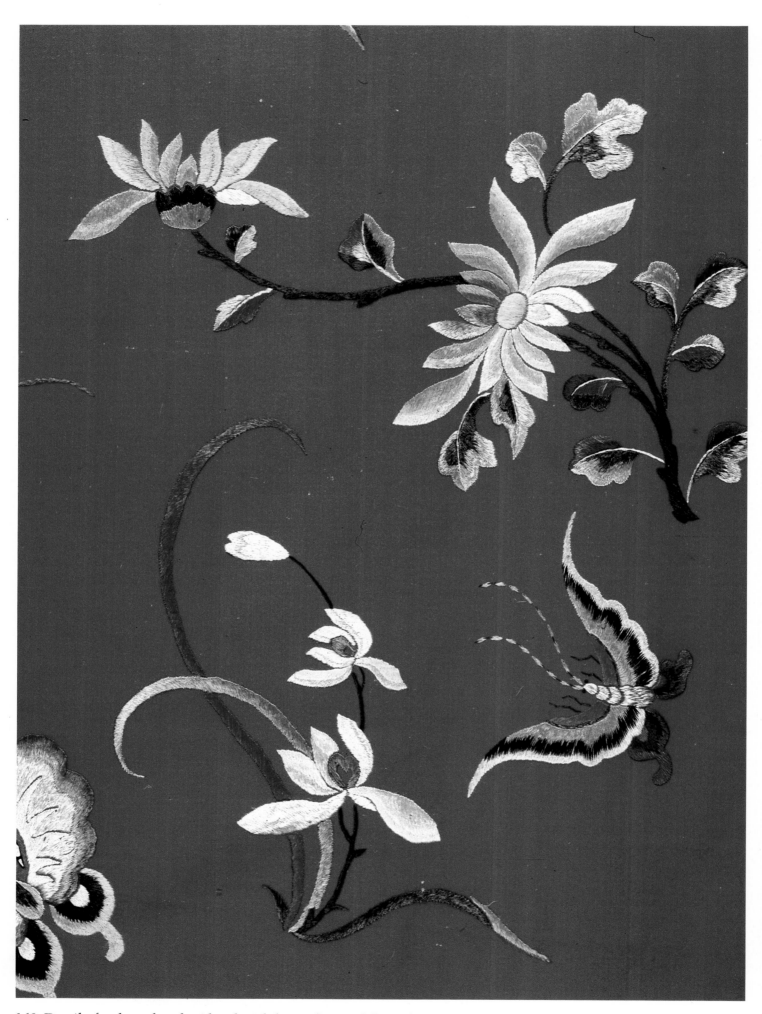

168. Detail of red wool embroidered with butterflies and flowers Qing

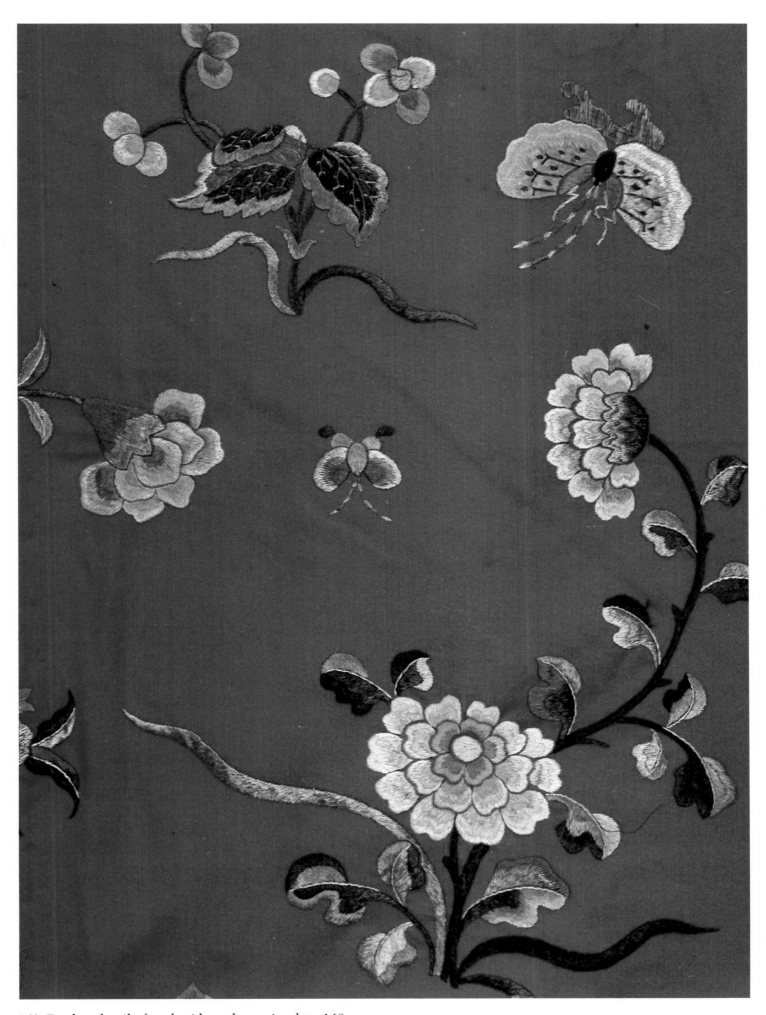

169. Further detail of embroidery shown in plate 168

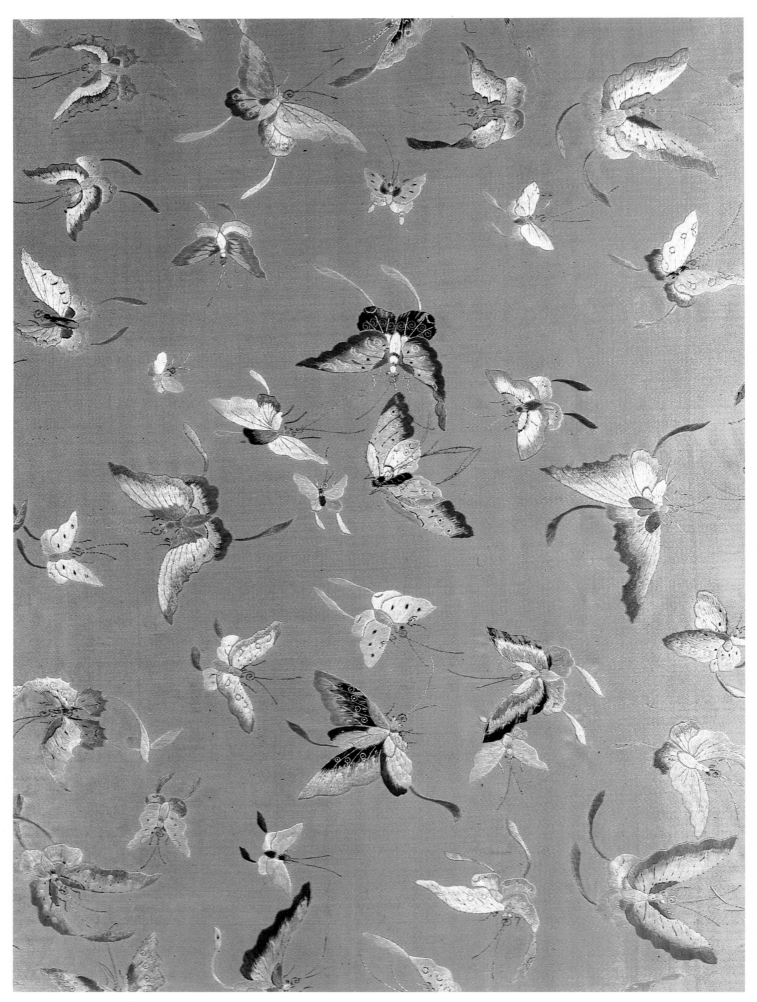

170. Detail of yellow *duan* chair-cover with design of 'a hundred butterflies' Qing

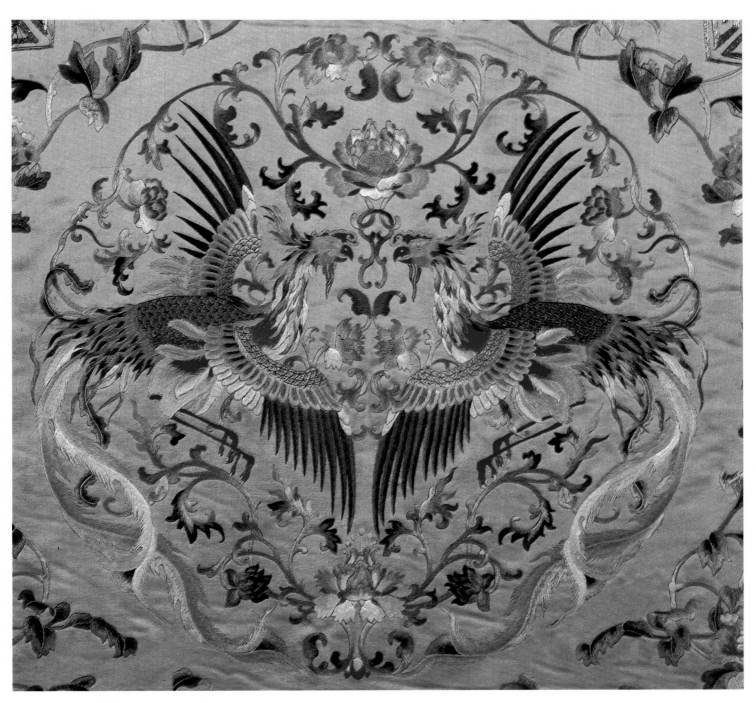

171. Detail of yellow *duan* embroidered chair-cover with design of paired phoenixes Qing

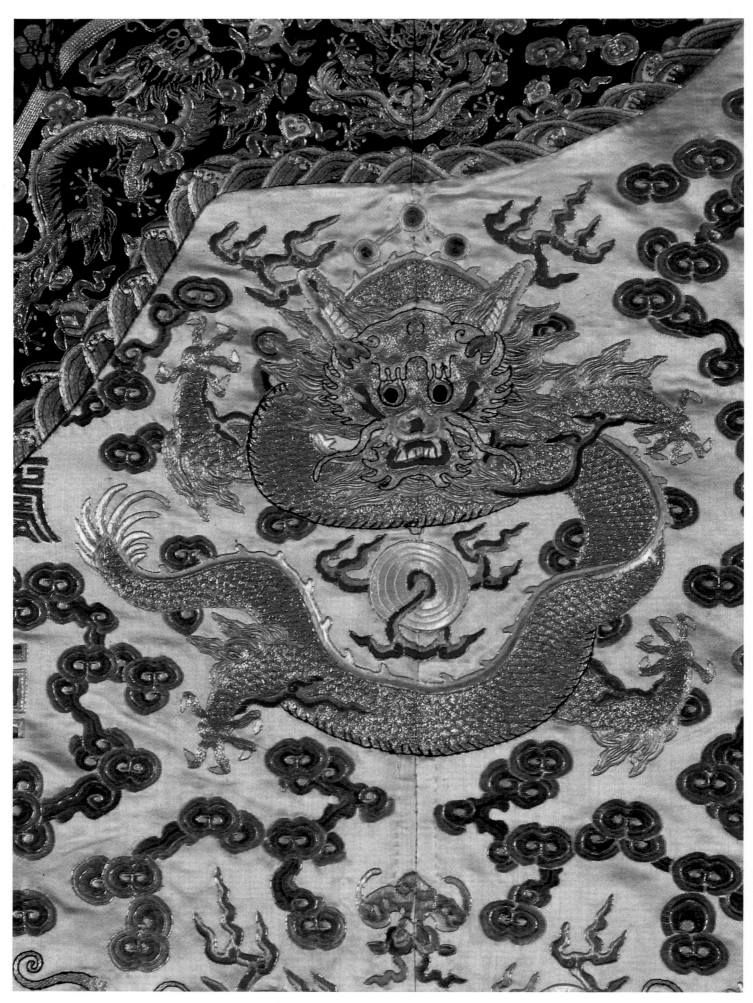

172. Detail of dragon robe Qing

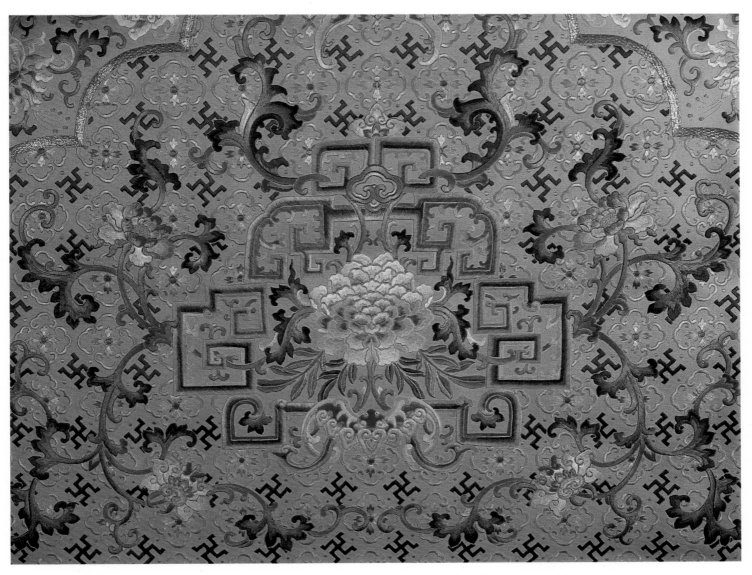

173. Detail of embroidered chair-cover with design of swastikas and 'riches, honours and blessings' Qing

174. Chair-cover with appliquéd design of *taotie* mask and *kui* dragons Qing

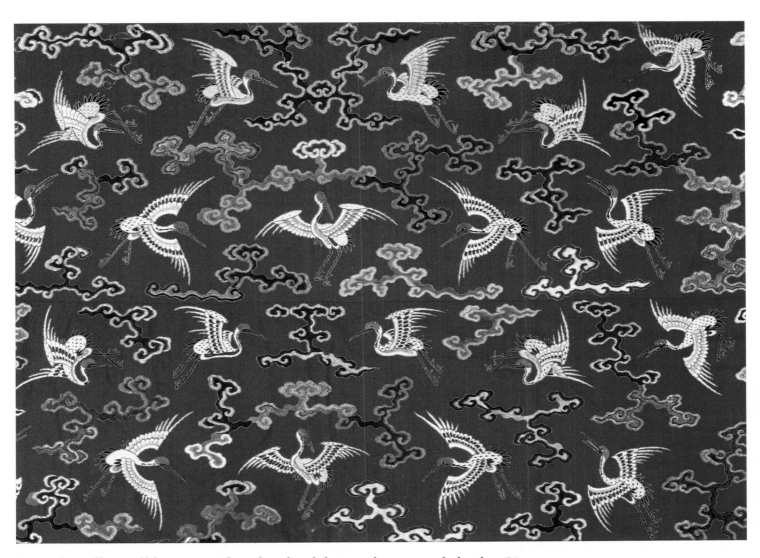

175. Red woollen wall hanging with embroidered design of cranes and clouds　Qing

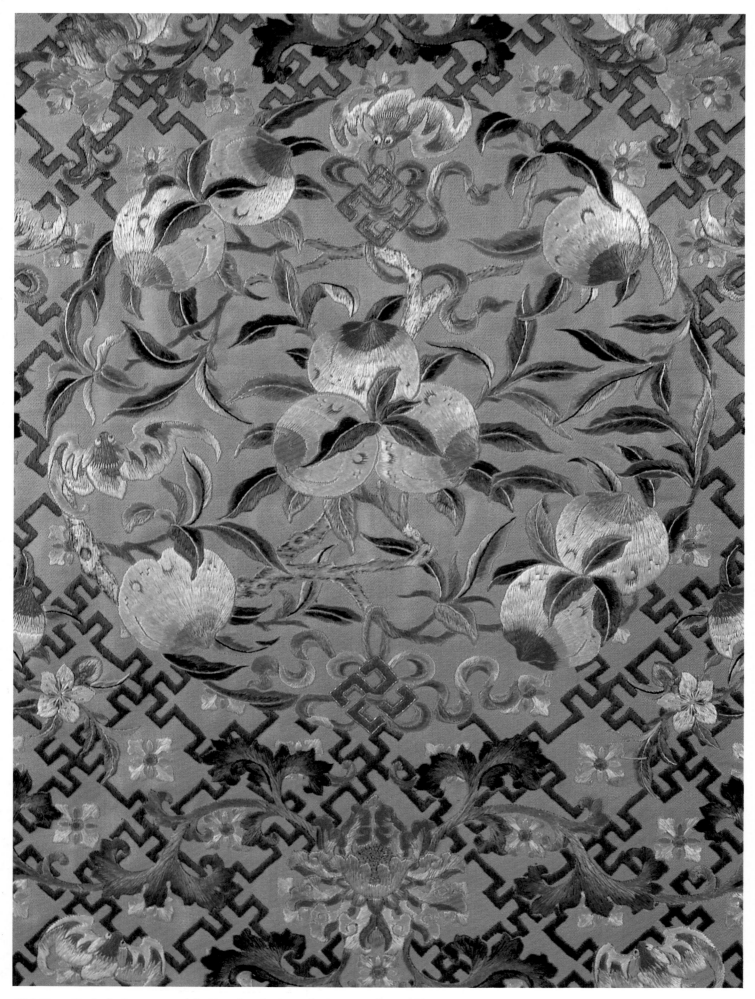

176. Detail of chair-cover with circular design of nine peaches Qing

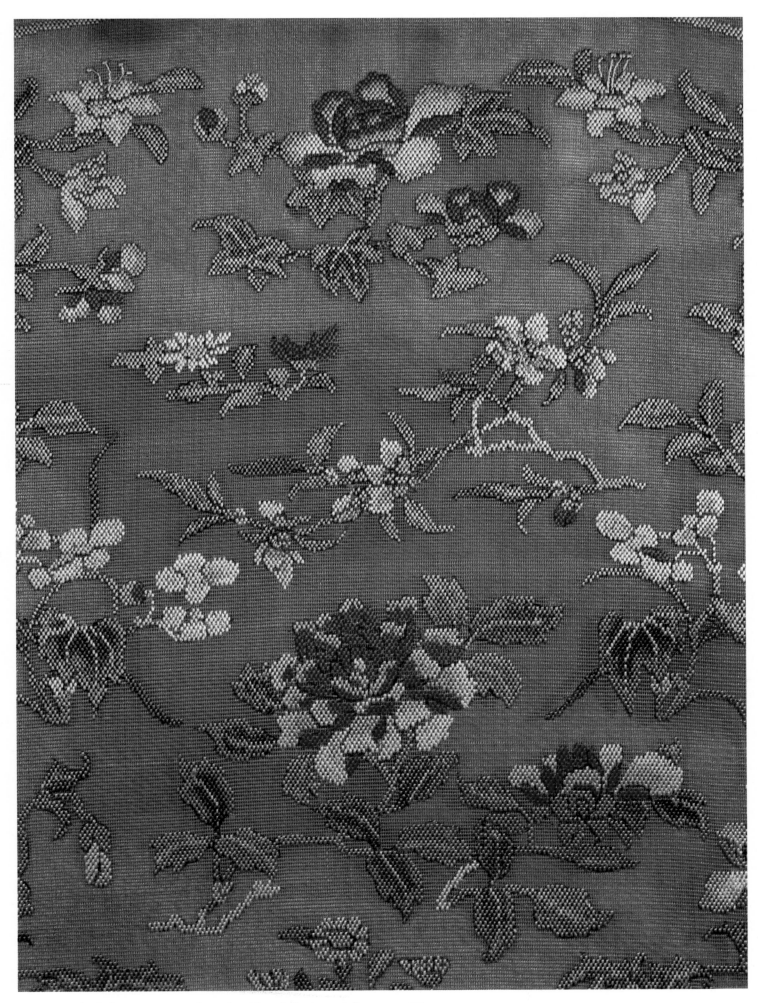

177. Detail of chair-cover with embroidered design of flowers Qing

178. Detail of embroidery with design of a group of immortals meeting to offer blessings Qing

179. Further detail of embroidery shown in plate 178

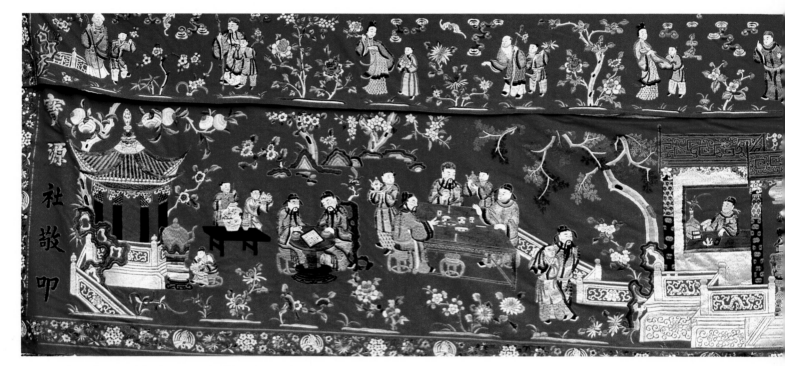

180. Embroidery with design of officials wishing the emperor long life Qing

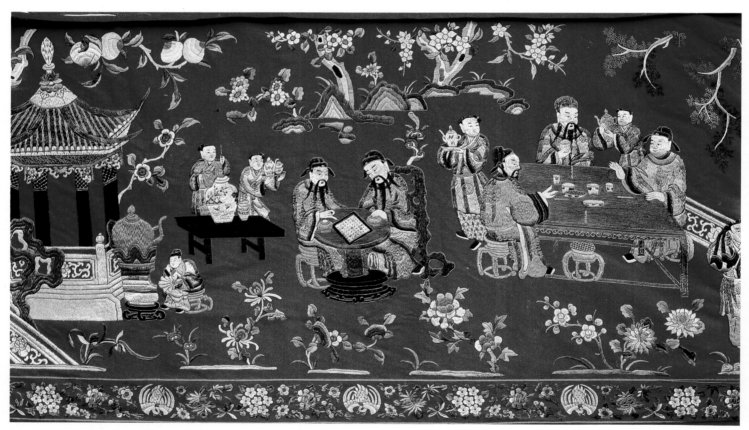

181. Detail of plate 180

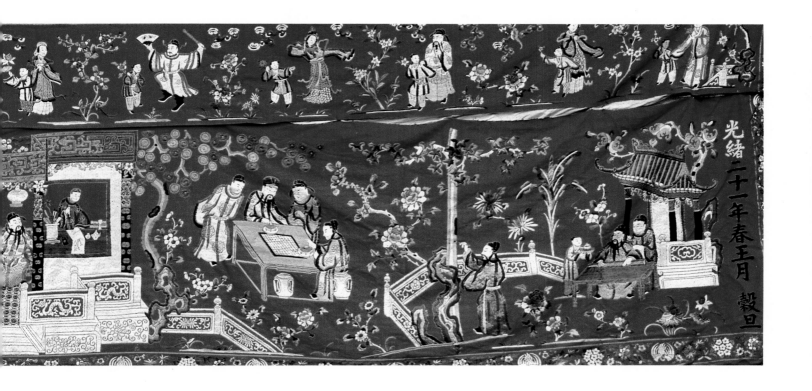

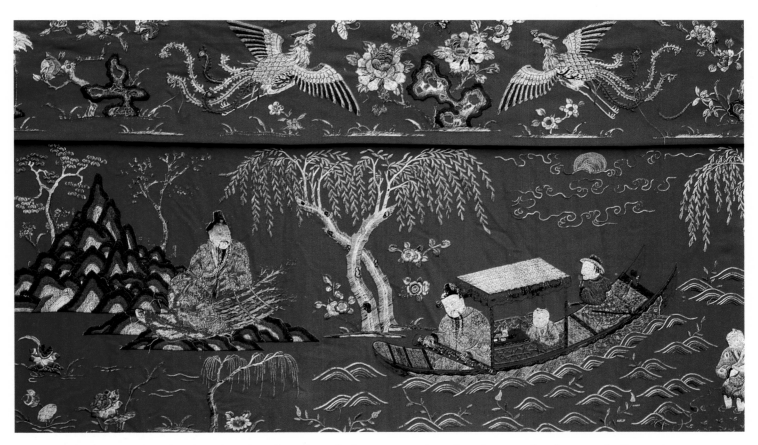

182. Detail of a Bian (Kaifeng) embroidery (peach and plum section) with a design of eighteen scholars Qing

197

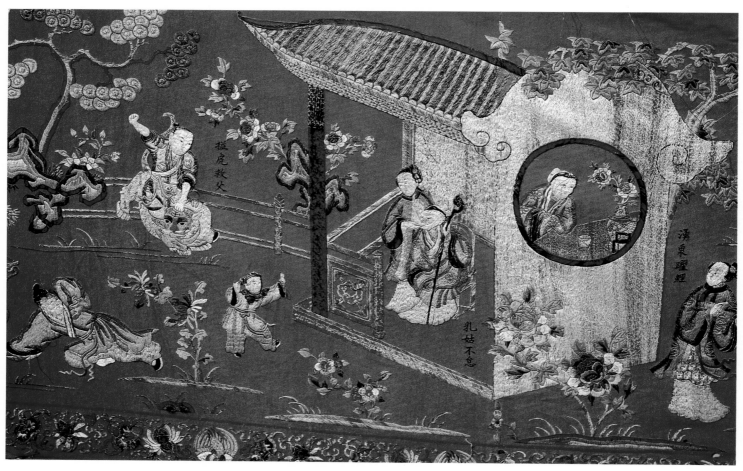

183. Detail of large Bian (Kaifeng) embroidery of the twenty-four acts of filial piety　Qing

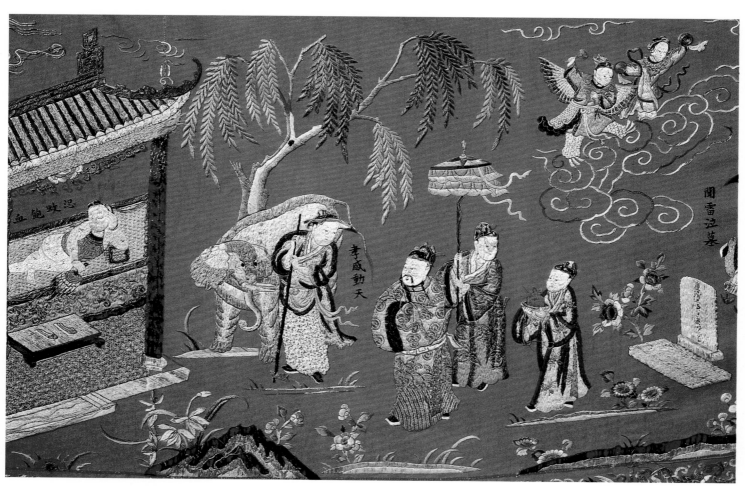

184. Further detail of embroidery shown in plate 183

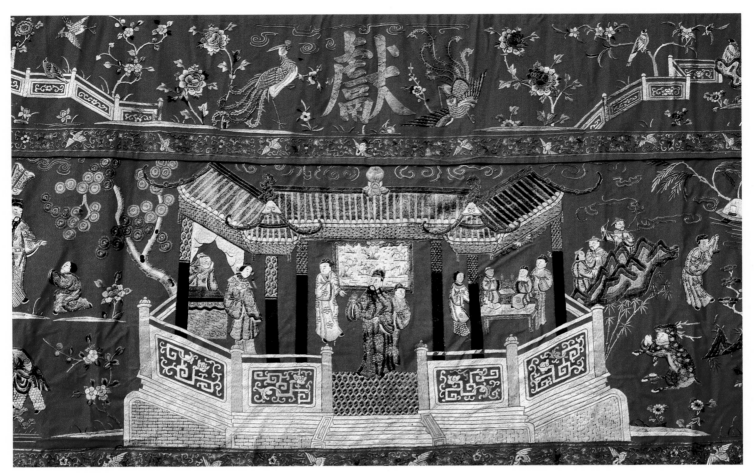

185. Detail of plate 186

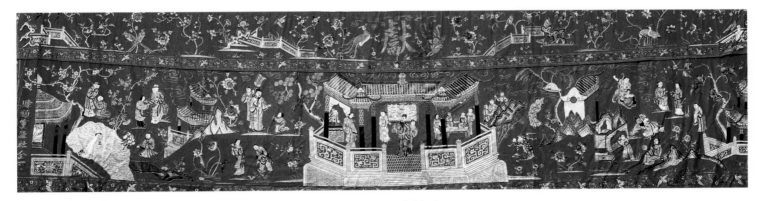

186. Small Bian (Kaifeng) embroidery of the twenty-four acts of filial piety Qing

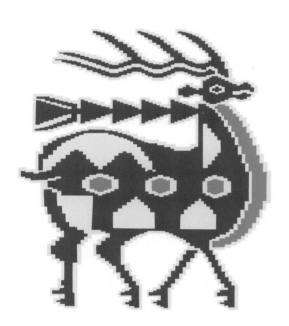

Plates II

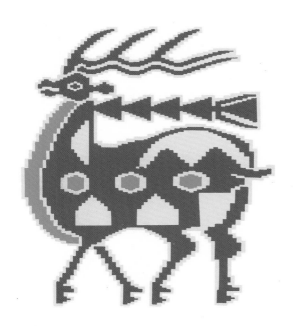

187. Silk woven material from a bronze spear Shang

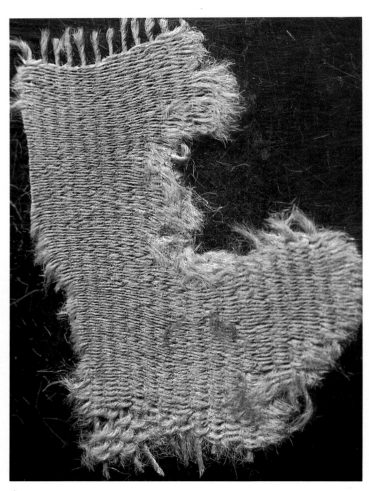

188. Woven woollen material Warring States

189. Cloth printed with scattered dots
 Warring States

190. Chain-stitch embroidery with winding pattern
 Early Spring and Autumn Annals

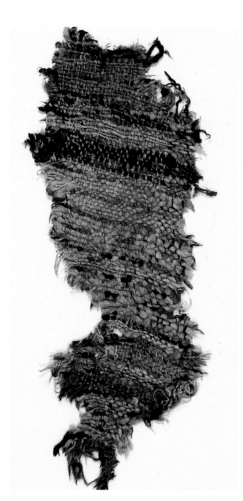

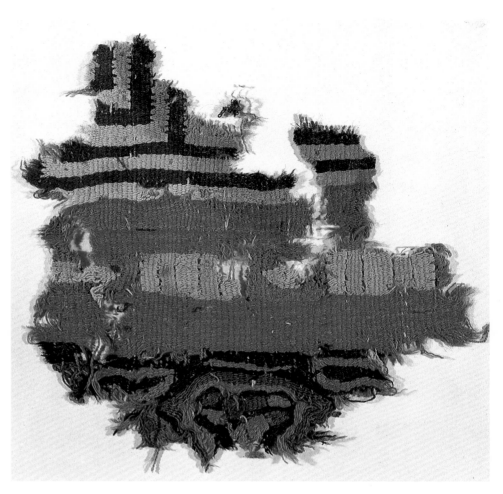

191. Carpet with coloured line design Eastern Han

192. Woollen carpet with coloured design Eastern Han

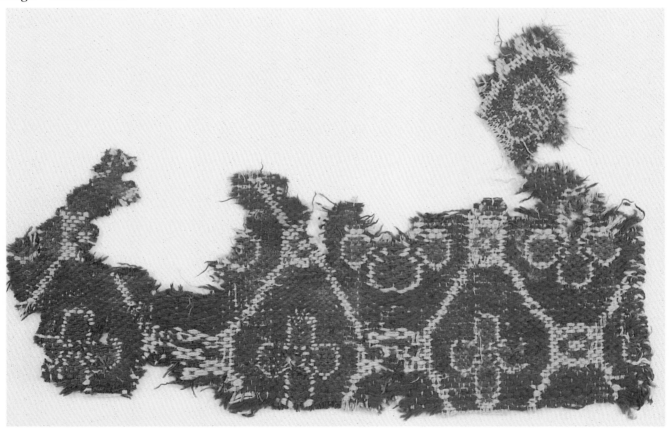

193. Woollen material with design of tortoiseshell and four-petalled flower Eastern Han

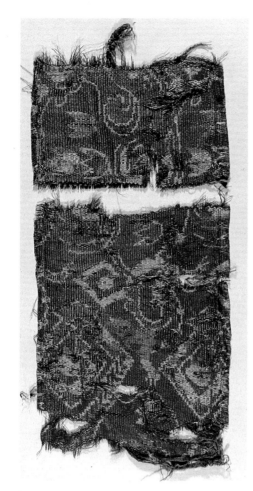

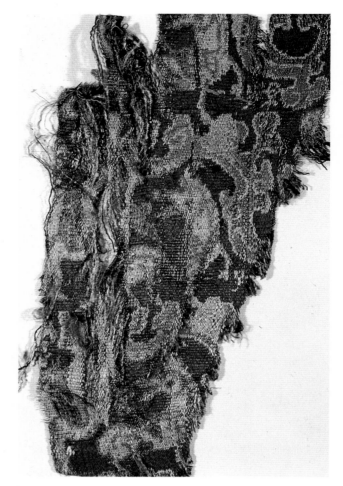

194. *Jin* with *zhuyu* design
Western Han

195. *Jin* with horse design Eastern Han

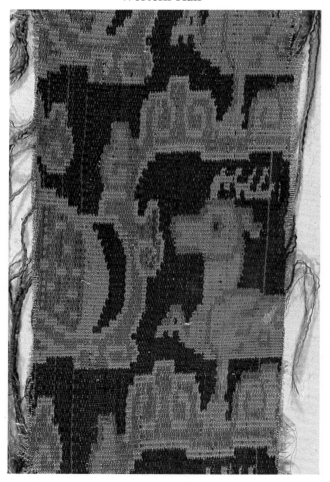

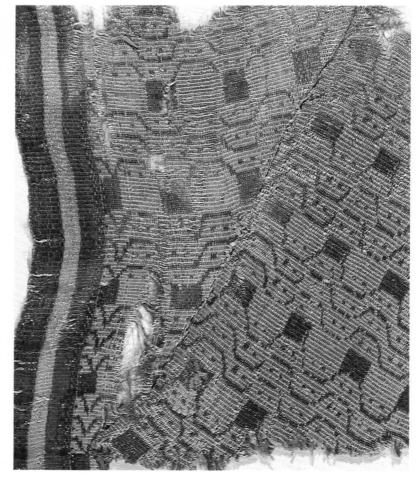

196. *Jin* with deer design Eastern Han

197. *Jin* with wave design Eastern Han

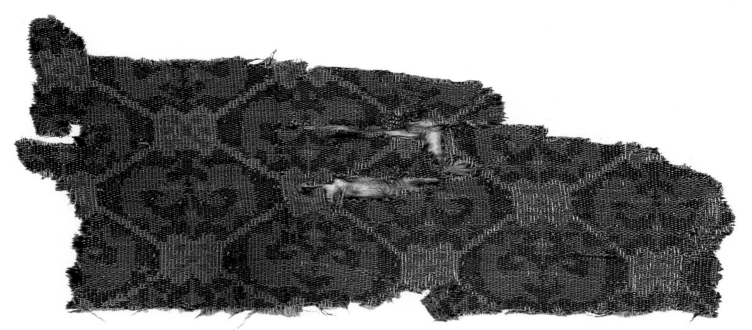

198. *Jin* with design of paired sheep Eastern Han

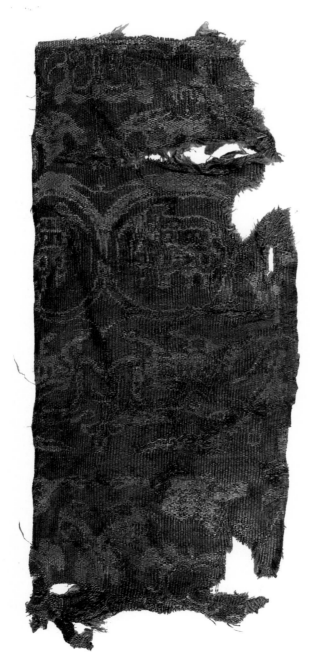

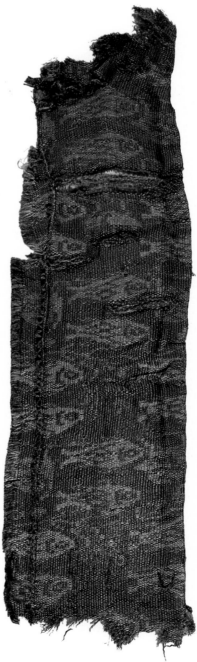

199. *Jin* with design of elephants
Eastern Han

200. *Jin* with design of fish and frogs
Eastern Han

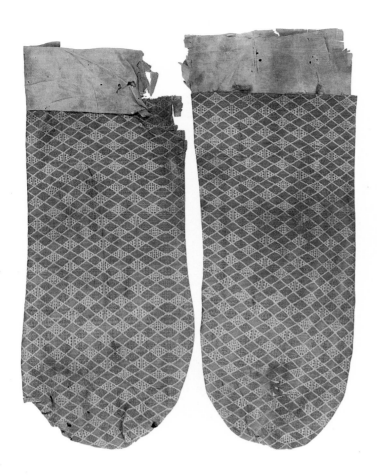

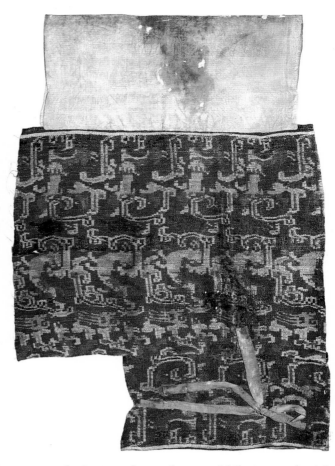

201. *Jin* socks with lozenge design and '*yang*' character motif Eastern Han

202. *Jin* with design of 'ten thousand lifetimes of wishes fulfilled' Eastern Han

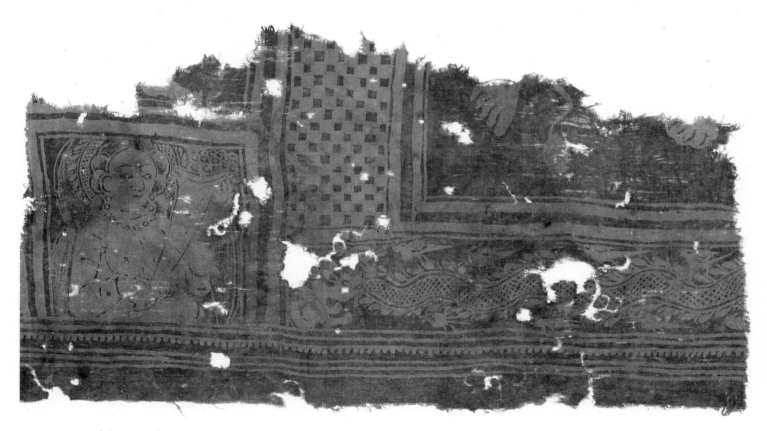

203. Cotton fabric with batik design of figures Eastern Han

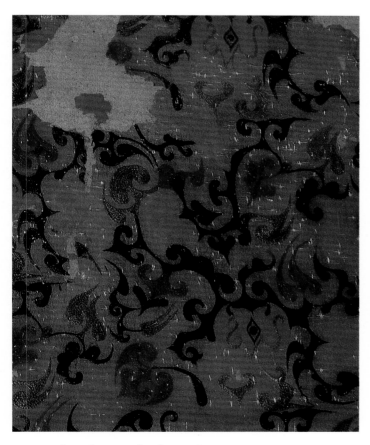

204. Embroidery with *zhuyu* design Western Han

205. Embroidery with design of ascending clouds
Western Han

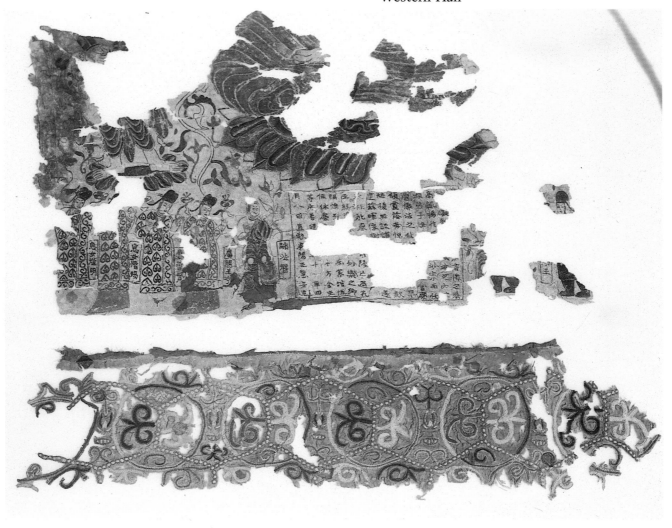

206. Decorative embroidered banner border depicting King Guang Yang supplying men Northern Wei

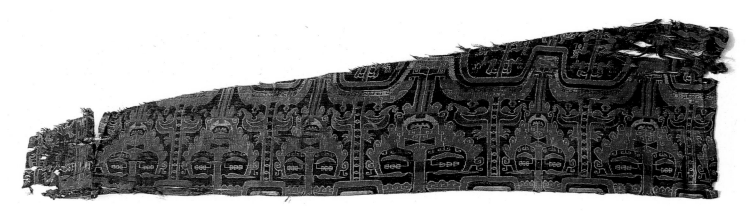

207. *Jin* with design of animals and birds Eastern Jin

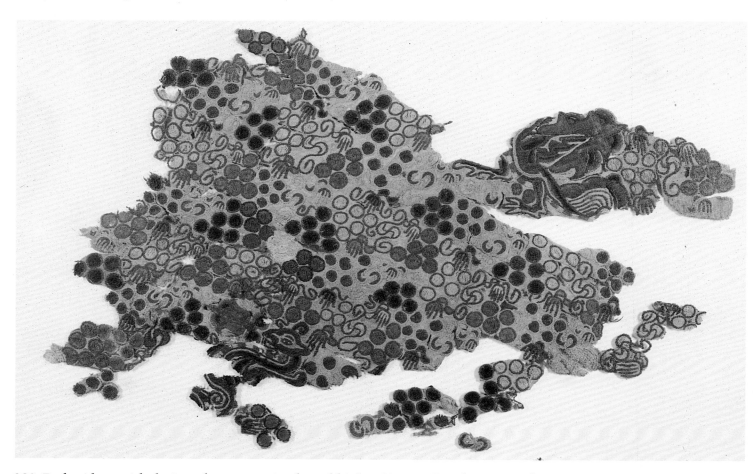

208. Embroidery with design of grapes, animals and birds Sixteen Kingdoms, Northern Liang

209. *Jin* with wood design Northern Liang

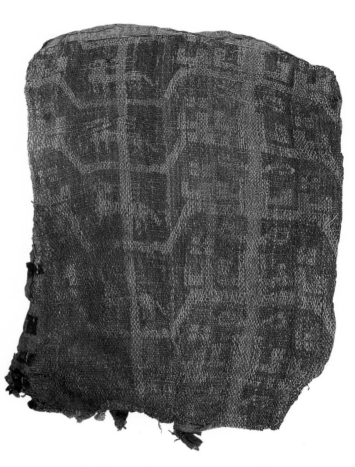

210. *Jin* with design of auspicious animals
Northern Dynasties

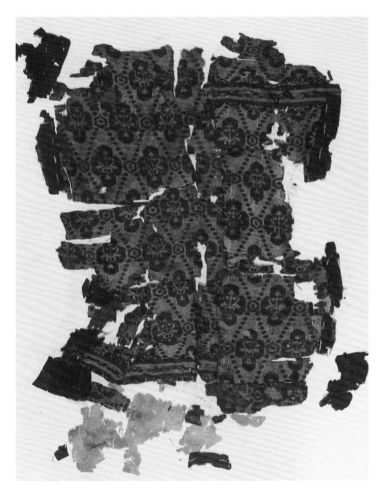

211. *Jin* with lozenge-and-honeysuckle design
Northern Dynasties

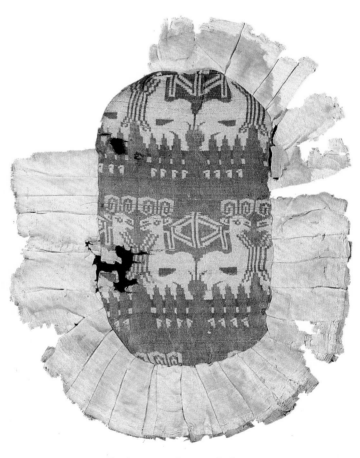

212. *Jin* cover with design of paired sheep
Northern Dynasties

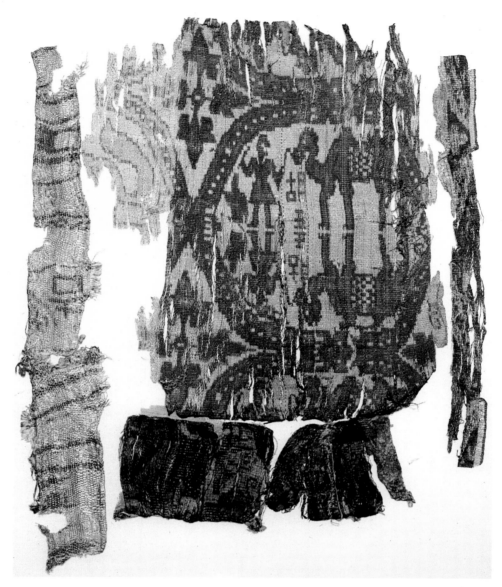

213. *Jin* with design of camels being led and *hu wang* (barbarian king) characters Northern Dynasties to Sui

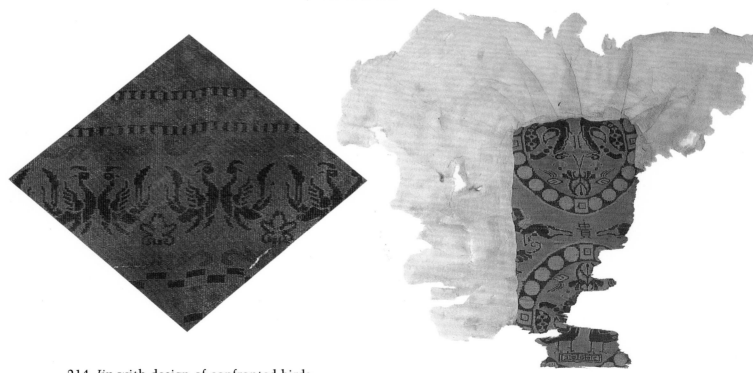

214. *Jin* with design of confronted birds
Northern Dynasties

215. *Jin* cover with design of peacocks, circlets of
pearls and 'honour' characters Northern Dynasties

210

216. Tie-dyed cloth with fish-roe design Northern Dynasties

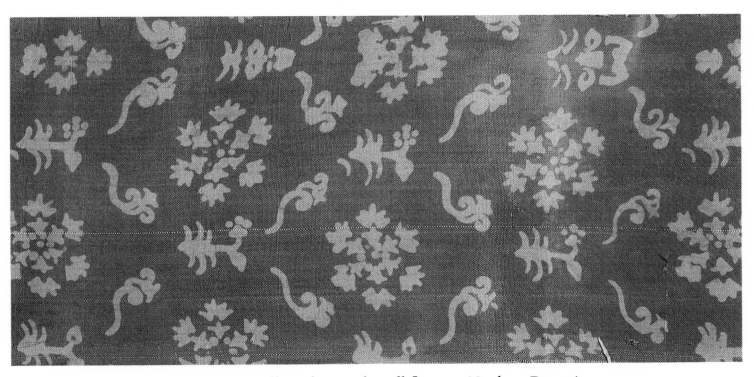

217. Resist-dyed cloth with design of scrolling plants and small flowers Northern Dynasties

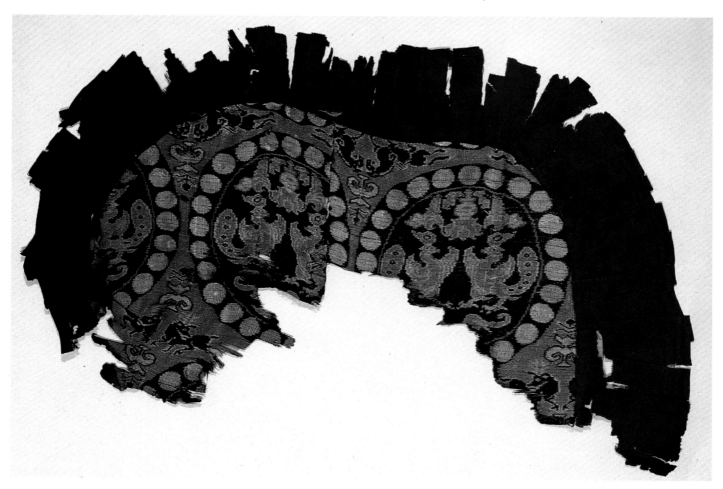

218. *Jin* with design of *luan* phoenixes encircled by linked pearls Tang

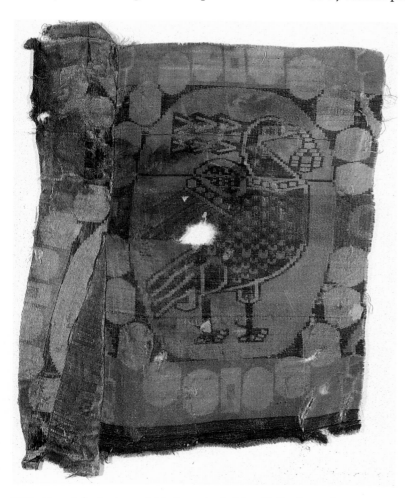

219. *Jin* with design of bird encircled by linked pearls Tang

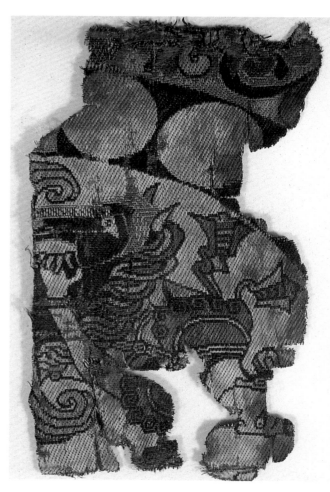

220. *Jin* with design of 'heavenly' horse and knight encircled by linked pearls Tang

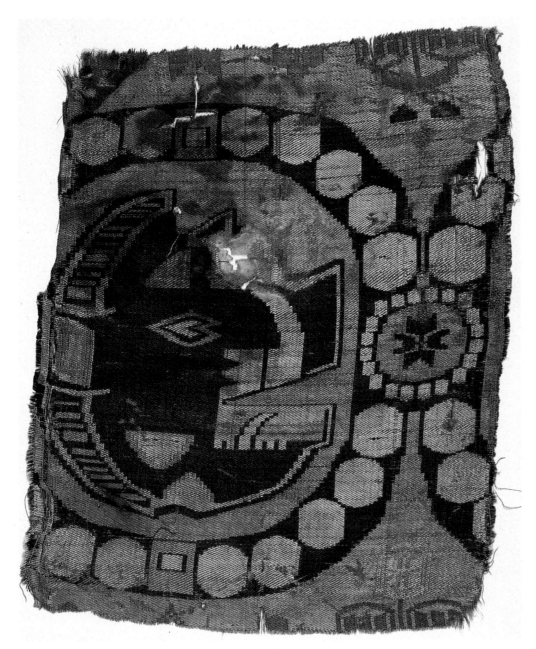

221. *Jin* with design of boar's head encircled by linked pearls　Tang

222. Detail of *qi* banner with herring-bone design　Tang

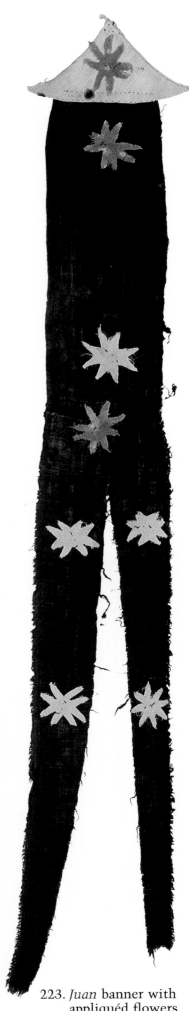

223. *Juan* banner with appliquéd flowers Tang

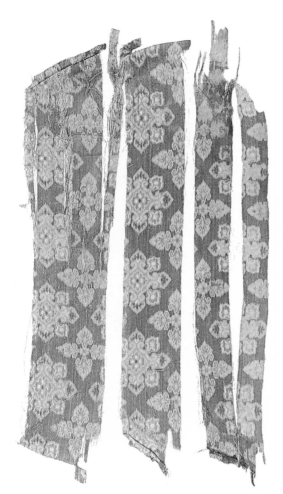

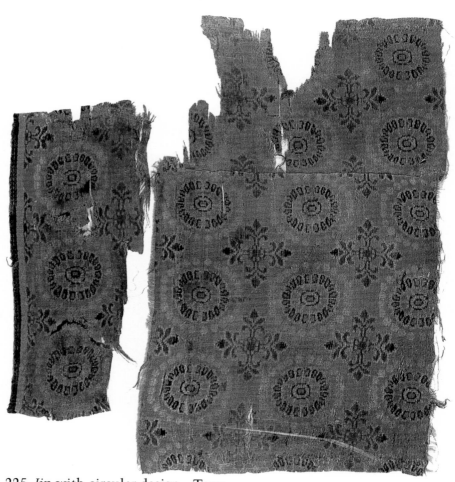

224. *Jin* with blue ground and
yellow floral design Tang

225. *Jin* with circular design Tang

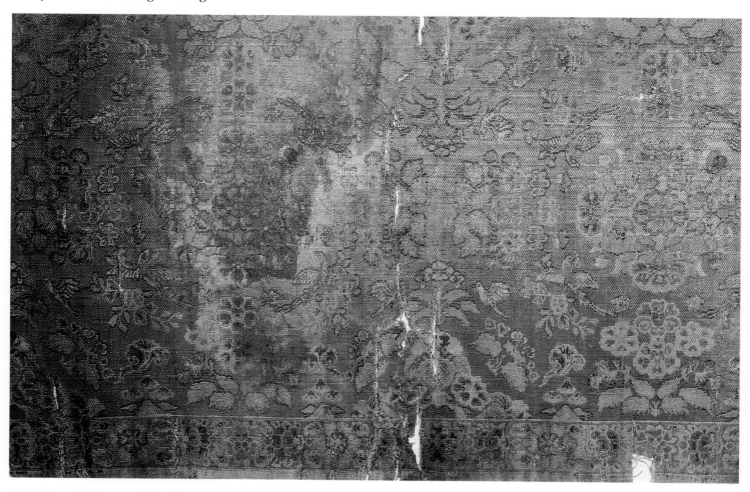

226. *Jin* with design of birds and flowers Tang

214

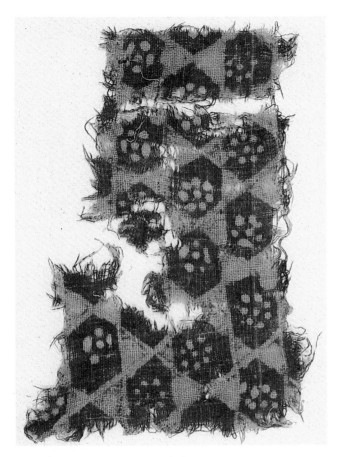

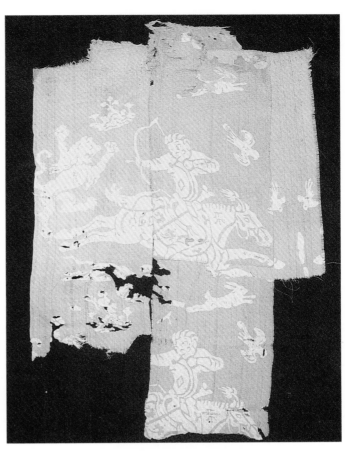

227. *Jin* with blue printed design Tang

228. *Juan* with printed hunting scene Tang

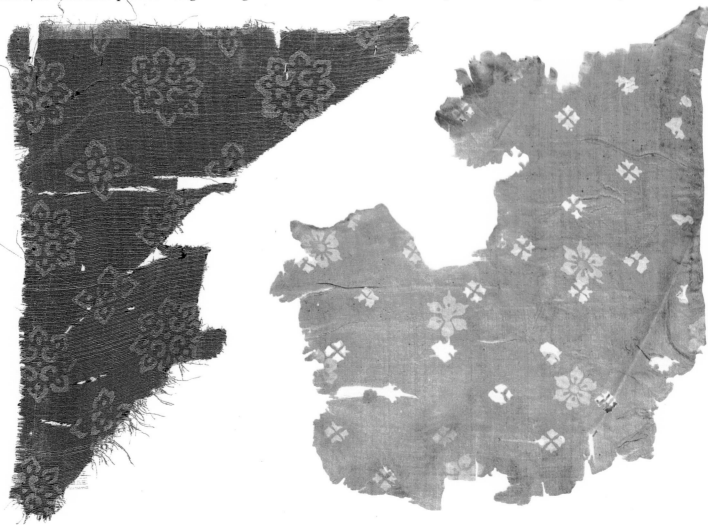

229. Brown *juan* with batik flower
 design Tang

230. *Juan* with printed flower design Tang

231. Rug with twisted pile Tang

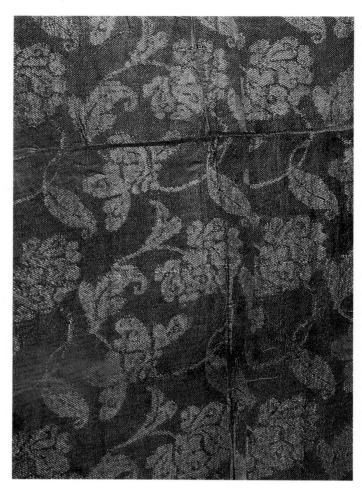

232. *Ling* with floral design of 'eternal spring' Song

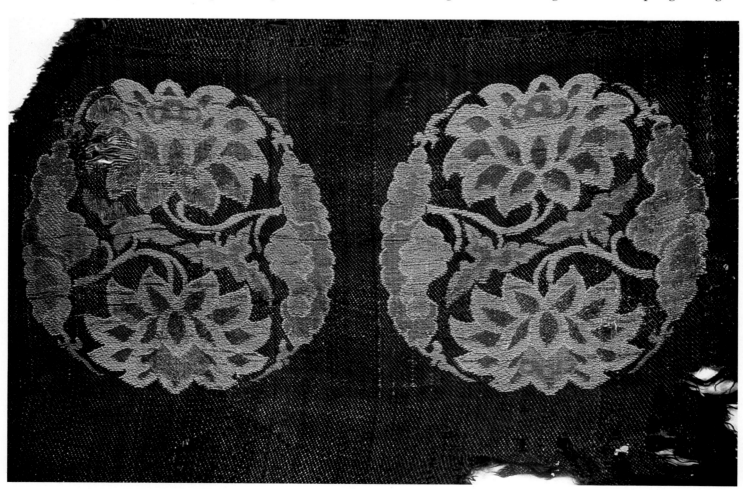

233. *Jin* with design of lotus on a blue ground Northern Song

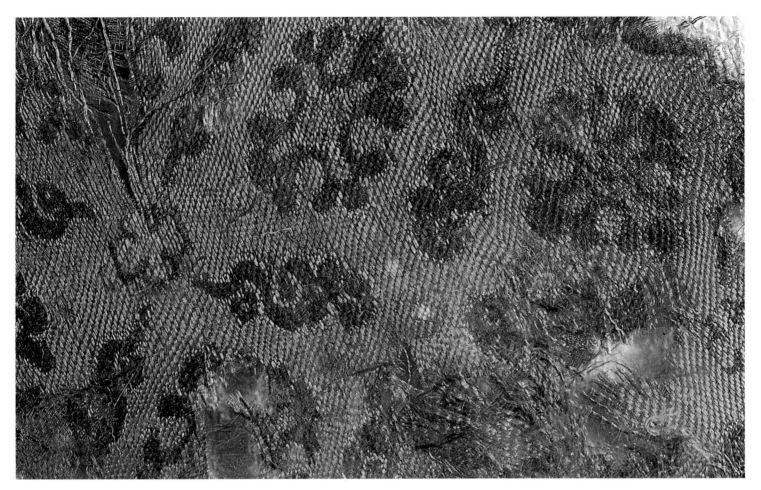

234. *Jin* with design of chrysanthemums, clouds and 'rice' characters Northern Song

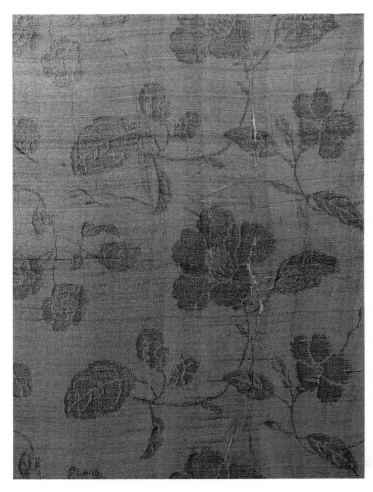

235. Gauze with camellia design Southern Song

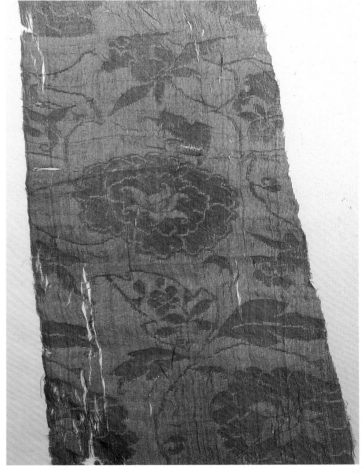

236. Crimson gauze with design of peonies Southern Song

217

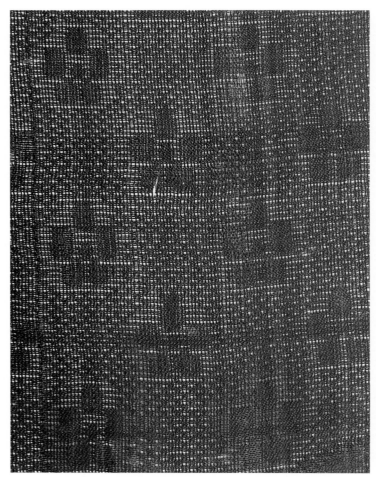

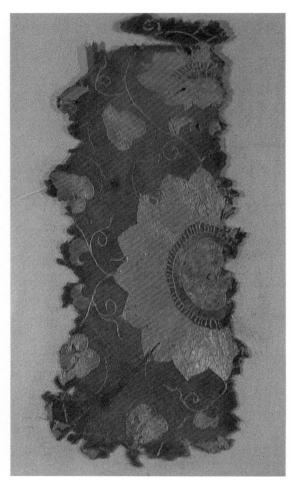

237. Gauze with design of hexagons and prunus
 blossom Northern Song

238. Embroidery with flower-and-plant
 design Northern Song

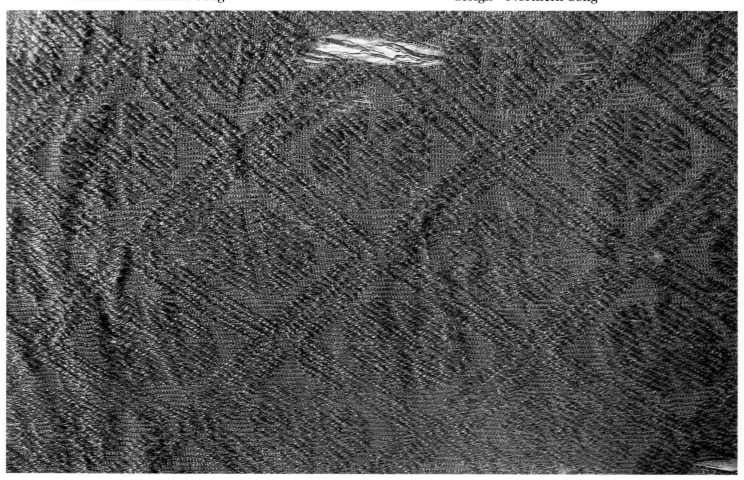

239. Gauze with checked and flowered design Song

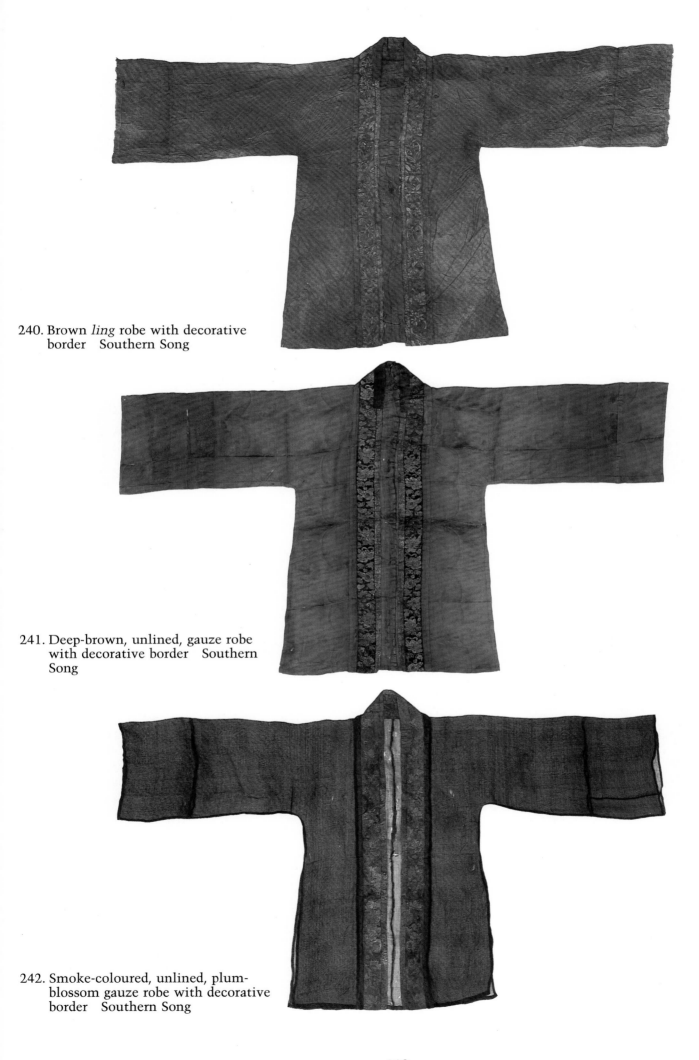

240. Brown *ling* robe with decorative
border Southern Song

241. Deep-brown, unlined, gauze robe
with decorative border Southern
Song

242. Smoke-coloured, unlined, plum-
blossom gauze robe with decorative
border Southern Song

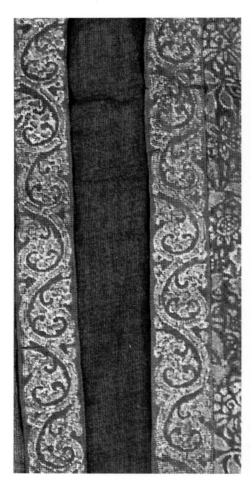

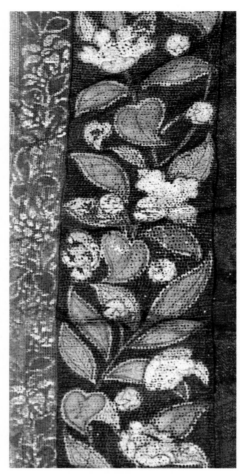

243. Detail of border of brown, camellia-patterned, unlined, gauze robe Southern Song

244. Detail of border of light-brown, unlined, *hu sha* robe Southern Song

245. Detail of border with brown ground and embroidered gold camellias and millet stalks Southern Song

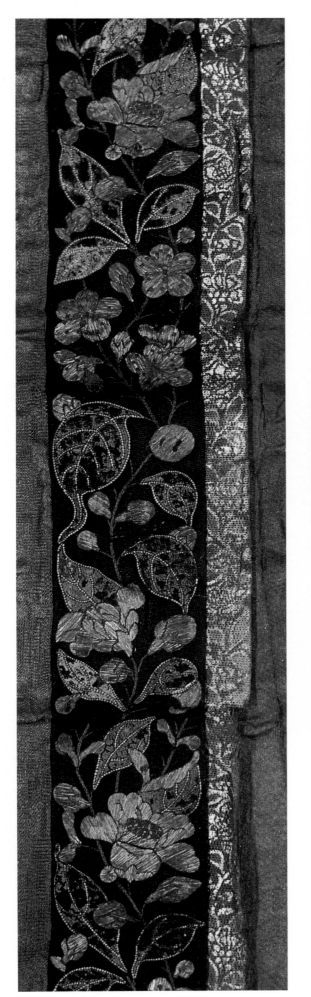

246. Detail of border of brown patterned *ling* jacket Southern Song

247. Waist pendant of bronze-coloured gauze with embroidered floral design Southern Song

221

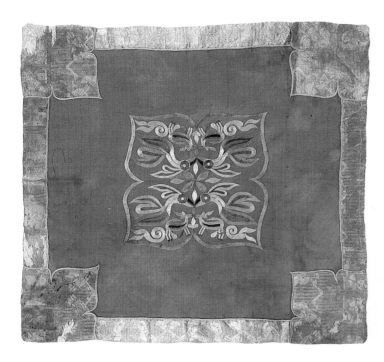

248. Blue silk cushion-cover with embroidered design of paired birds and sheep Northern Song

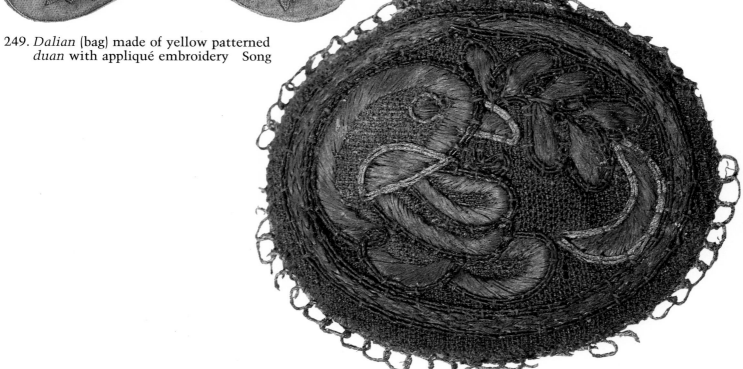

250. Embroidery with flower-and-plant design Northern Song

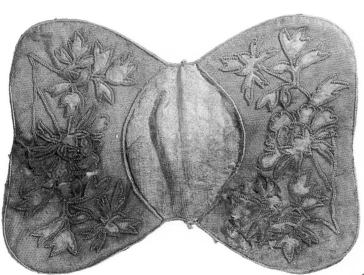

249. *Dalian* (bag) made of yellow patterned *duan* with appliqué embroidery Song

251. Perfume bag with embroidered design of bird and millet Liao

252. *Ling* with design of swastika characters Late Yuan

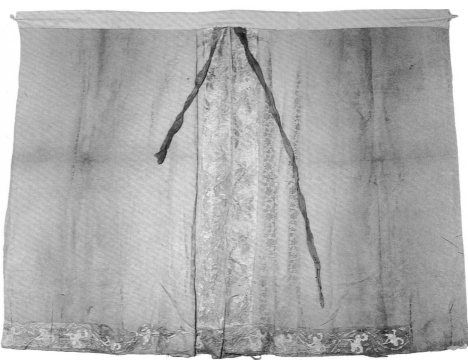

254. Partially embroidered skirt with decorative border Early Yuan

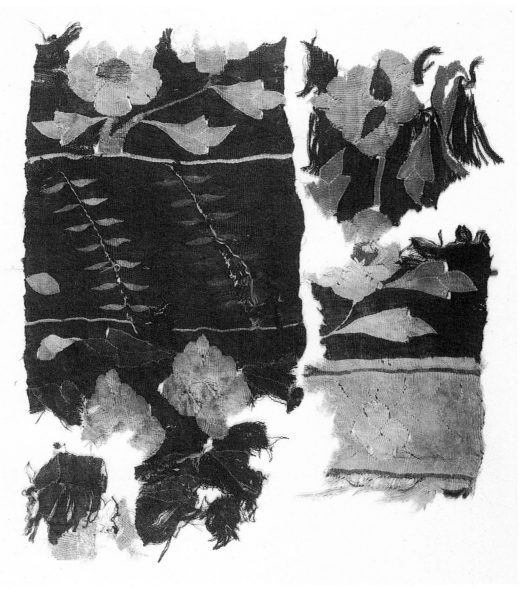

253. *Kesi* with *qing*-green ground and pink floral design Yuan

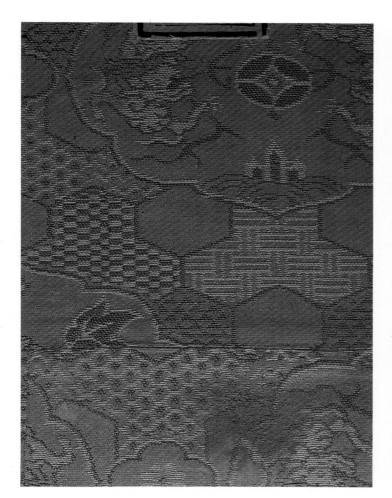

255. *Jin* with design of paired dragons playing with balls Ming

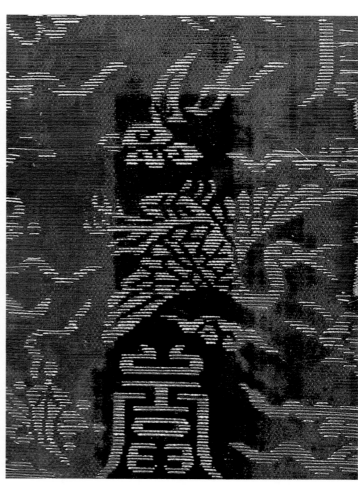

256. *Jin* with design woven in silver Ming

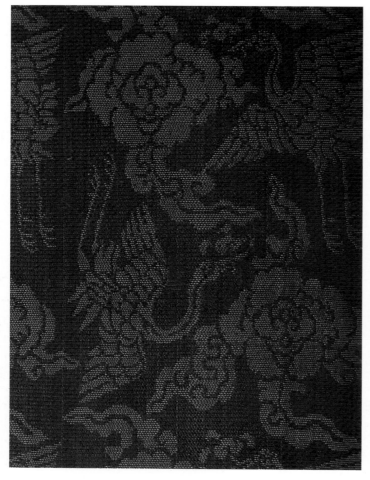

257. *Jin* with design of *ruyi*-shaped clouds and cranes
Ming

258. *Jin* with 'hidden' design of waves and dragons
Ming

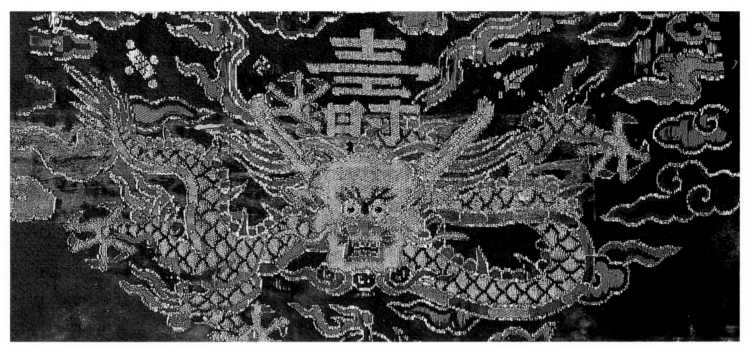

259. *Duan* with *qing*-green ground and design of clouds, 'longevity' characters and gold dragon Ming

260. Silk with design of overlapping clouds Ming

261. Silk with deep-yellow ground and cruciform design Ming

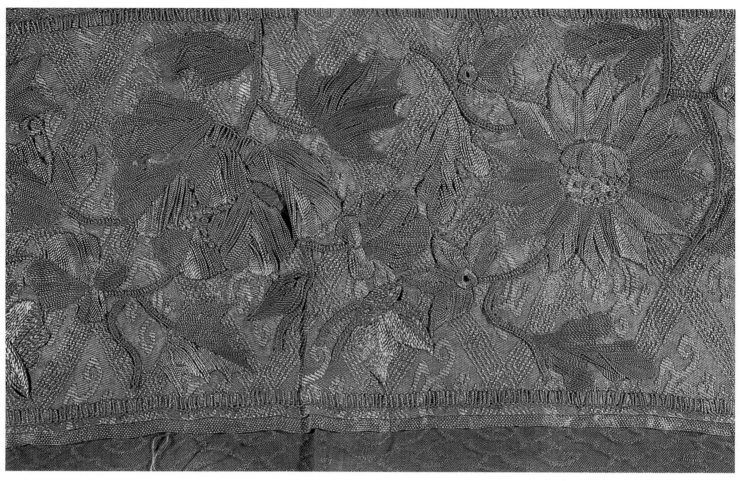

262. *Na* embroidery with 'precious flower' and peony design Ming

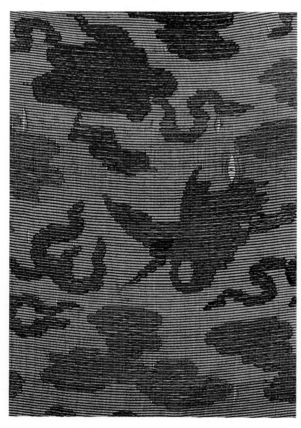

263. Detail of purplish-red gauze dragon robe
with design of clouds and cranes Qing

264. *Jin duan* with peony design Qing

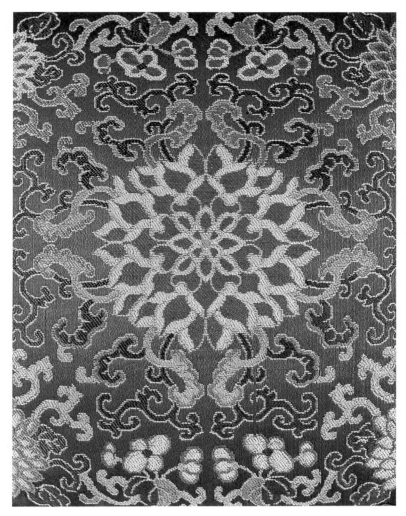

265. *Duan* with blue ground and 'honour and rank' design
Qing

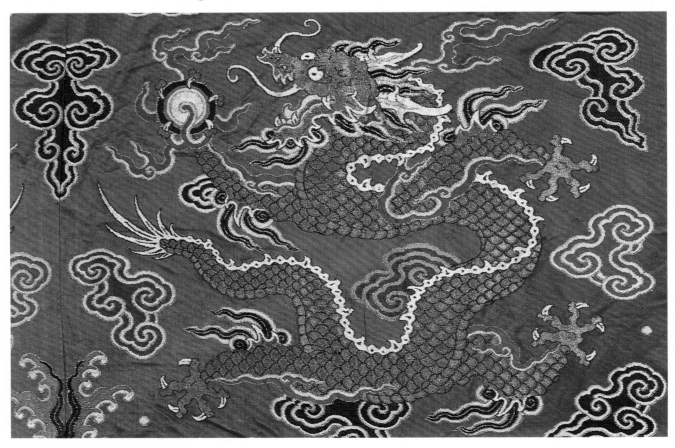

266. Detail of *duan* robe with scarlet ground and design of clouds and dragons Qing

267. *Jin* with 'precious flower' design and added gold
Qing

268. *Duan* with design of flowers, plants and 'much
good fortune' Qing

269. *Duan* with design of swastikas and 'riches and
honour' Qing

270. *Jin duan* with swastika ground and design of eight
auspicious objects Qing

228

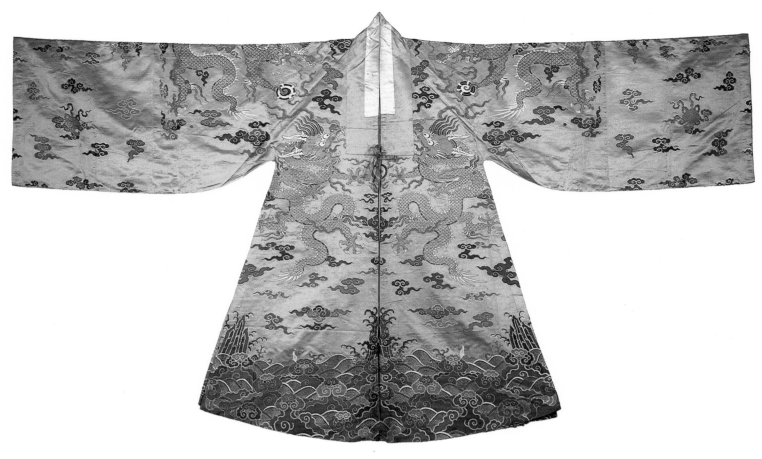

271. Actor's *duan* costume decorated with five-clawed golden dragons Qing

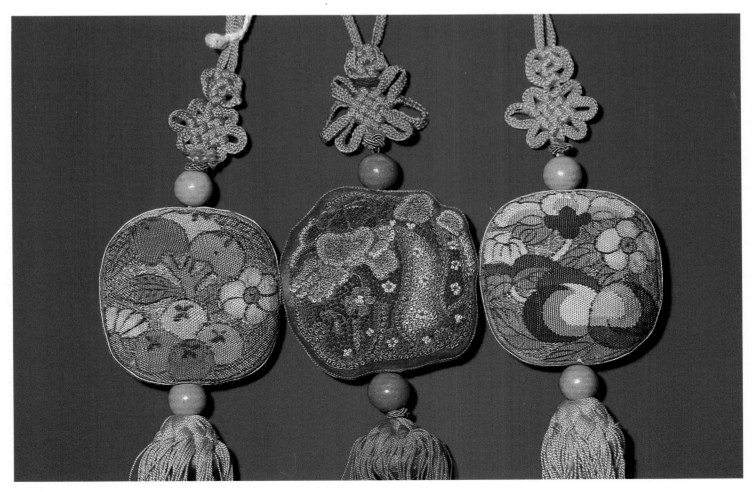

272. Embroidered and *kesi* perfume bags Qing

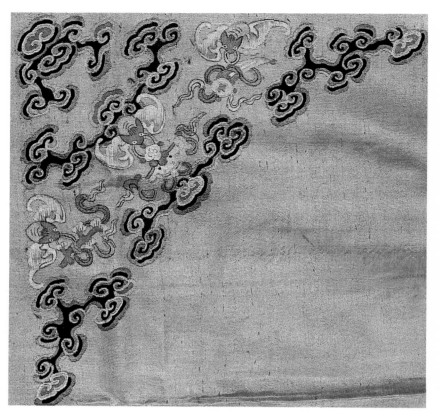

273. *Kesi* with design of coloured clouds and bats Qing

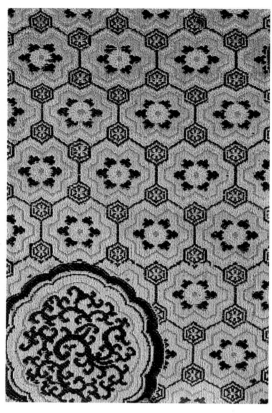

274. Embroidery with coloured circular design Qing

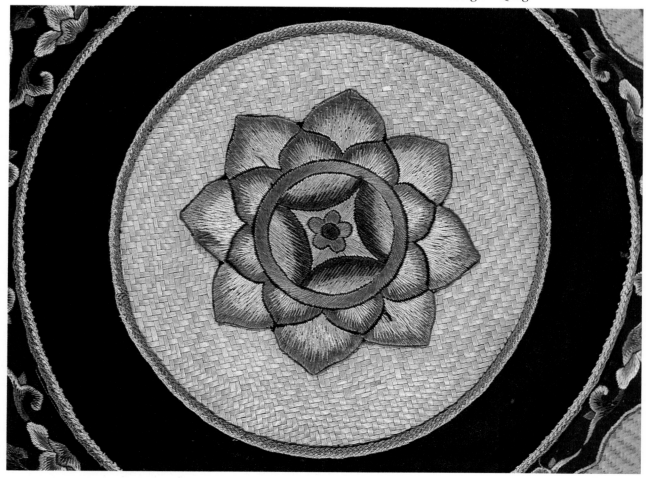

275. Hand-rest with Fuchuan matting and embroidery Qing

Extended
Captions

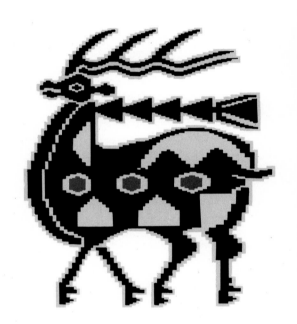

1. Looped silk ribbon with animal design
Warring States

Excavated from Chu tomb No. 1 at Mashan, Jiangling. This is the earliest example of looped ribbon with animal decoration to have been discovered in recent years. The ribbon, *jin* and *juan* have been sewn together to form the edging for a sleeve. The ribbon is 15 cm wide and 1.55 mm thick. The motif is a running animal, depicted using deep-brown and yellow silk threads. The coloured stripes between the two animals are of deep brown, reddish brown and earth yellow.

2. Silk with carpenter's square pattern on a brown ground
Warring States

Excavated from the Chu tomb at Zuojiatang, Changsha. This fragment is 19.9 × 8.2 cm and has a density of 80 warps × 40 wefts per cm. The fabric is woven in two colours with various types of carpenter's square pattern depicted in pale yellow against a brown ground. The weave is a three-over, one-under, four-twill structure. The yellow motifs appear slightly raised. A vermilion seal reading 'The Queen's Clan' has been applied to the surface.

3. Silk with geometric design on a brown ground
Warring States

Excavated from the Chu tomb at Zuojiatang, Changsha. This fragment is 32.5 × 23.5 cm. A three-over, one-under arrangement for the pale-yellow warp threads produces the geometric design of lozenge outlines against a deep-brown ground within the compound weave. The design is very similar to some of the geometric patterned silks from Chu tomb No. 1 at Mashan, Jiangling, and from tomb No. 1 at Mawangdui dating from the Western Han period.

4. Silk with red patterned band and 'secret' pattern of paired dragons and phoenixes
Warring States

Excavated from the Chu tomb at Zuojiatang, Changsha. This fragment measures 21 × 23 cm. The major pattern band depicts dragons and phoenixes of various kinds shown in brown and dark brown (the same colours as those of the ground, hence 'secret', or monochrome, pattern). Between the creatures are designs of large and small balls made up of six segments. The selvages have vermilion patterned border strips 0.8 cm wide. The bright vermilion design is produced using three-over, one-under against a symmetrical twill-weave. The motifs are segmented balls and *leiwen* (thunder pattern).

5. Painting on silk of a man sailing a dragon boat
Warring States

Excavated from a Chu tomb at Zidanku, south-east of Changsha. The painting measures 37.5 × 28 cm. The silk is a fine vermilion *juan*, and this is one of the earliest examples of painted silk. The techniques of 'applying the paint evenly' and 'filling in the colour' (within outlines) have been used together. The male figure has been outlined using a single line and then roughly coloured. The dragon boat, crane, fish and canopy have also been coloured and then partially painted with a golden-white powder. The man in the painting is riding a large dragon which has assumed the form of a boat. A crane stands on its tail. Above it is a canopy, and below it to the left there is a carp. The canopy, reins, clothing-ties and other loose items all stream out to the right, while the man, dragon and fish all face to the left thus producing an effect of movement. The theme of the painting, that of the dragon ascending to heaven, reflects the belief, prevalent during the Warring States period, that an ascent to heaven follows the attainment of immortality.

6. Painting on silk of a woman and phoenix
Warring States

Excavated from a Chu tomb at Chenjiadashan in the south-eastern suburbs of Changsha. The silk is a fine crimson *juan*, which has been painted with blue-black, black and powder white. The painting depicts a graceful, narrow-waisted female figure with her palms together in an attitude of prayer. Over her head is a long-tailed phoenix with wings outspread, fiercely fighting with a *kui* dragon. The dragon and the phoenix were both regarded as auspicious creatures in ancient mythology and were often worked into the designs on woven and embroidered items in the Warring States period.

7. Silk embroidery with phoenix and flower design
Warring States

Excavated from Chu tomb No. 1 at Mashan, Jiangling. This is part of an embroidered silk gown. The ground material is a yellowish-brown silk *juan*, which has been embroidered with deep-red, earth-yellow, deep-brown, yellowish-green and deep-blue threads in single and multiple rows to achieve colour variations. The tall phoenix design, measuring 57 × 49 cm is characteristic of Chu culture. The bird's outspread wings cause it to appear in an upright stance. On the tips of the wings to right and left there appear to be two additional phoenix heads. The bird's long neck and swelling body are embellished with bands and circular patterns, the eyes glitter with life and it has a crest resembling a corolla, while three coloured tassels hang down on either side of its head.

8. Detail of embroidered garment with design of dragon, phoenix and tiger
Warring States

Excavated from Chu tomb No. 1 at Mashan, Jiangling. This is the outer face of a gauze ritual garment and a fine example of Chu embroidery. The gauze background material is grey-white and has a patterned area measuring 29.5 × 21 cm. The most significant element in the design is the striped tiger shown here, which is outlined using a single row of chain-stitch. Elsewhere, double or multiple rows are used to produce blocks of colour within the outline to provide the stripes and the tail, which resembles a bamboo-section whip. Even though the gauze is fine, the embroidery thread thick and the chain-stitches long, the embroiderer has managed to keep the stitches even and round.

9. Wool carpet with coloured stripes
Western Han

Excavated from a Han-dynasty site in Xinjiang Province. This is a woven strip

made from double-ply thick woollen yarn in crimson and yellow. It has a plain weave. The weft threads are all yellow while the warp threads are alternately yellow and red, producing the distinctive pattern of horizontal stripes.

10. Vermilion gauze with 'ear-cup' shaped lozenge pattern
Western Han

Excavated from Han tomb No. 1 at Mawangdui, Changsha. The gauze is 49.5 cm wide. The threads forming the ground are twisted to form a net-like structure. The design is of vertical, elongated lozenge shapes with smaller lozenges partially superimposed so that each composite element resembles the traditional 'ear-cup' used for drinking in the Chu area.

11. Embroidery with design of scattered dots and broken twigs
Western Han

Excavated from a Western Han tomb at Fenghuangshan (Phoenix Hill), Jiangling. The base material is a brown *juan*, on which pattern units of scattered dots have been produced in knot-stitch. Vermilion thread has been used for the embroidery of the half-open flower buds. The flower calyxes are outlined in chain-stitch. The dots and sprigs are arranged so as to be scattered over the whole surface of the embroidery.

12. Embroidery with lozenge-checked tree pattern
Western Han

Excavated from Han tomb No. 1 at Mawangdui, Changsha. This is the oldest satin-stitch embroidery discovered to date. The ground pattern is produced using pale-yellow thread in satin-stitch. The complicated outlines of the lozenges are embroidered in deep brown, using a similar satin-stitch. The flower and tree motifs in the centre of the lozenges are embroidered in both yellow and brown to produce the effect of a double-toned, shaded pattern. This part of the design also resembles the 'luck' part of the character for 'longevity' and so has the implied meaning of 'auspicious tree'.

13. Embroidery with *zhuyu* (dogwood) and 'longevity' design
Western Han

Excavated from Han tomb No. 1 at Mawangdui, Changsha. The piece has a *juan* ground and is embroidered following the Chu tradition of chain-stitch. In the Western Han the *zhuyu* design symbolized the driving out of evil and long life without ageing. What started out as a plant design came to be used as a metaphor. In the Northern and Southern Dynasties the *zhuyu* motif was used on the famous 'ten kinds of silk' to produce the 'large *zhuyu*' and 'small *zhuyu*', and other famous silks.

14. *Jin* with woven design of 'longevity and glory'
Eastern Han

This is a double-layered warp weave. The displayed warp has a three-over, one-under structure, while the inner warp is three-under, one-over. The design consists of scrolling clouds as the framework, with different mythological and real creatures woven into the pattern. It is further embellished by the use of auspicious characters. Five animals can be identified: tiger, leopard, a large beast with two horns, a single-horned winged creature and a bird with a crest and long legs. The inscription 'Long life and honour' is produced in the official calligraphic style with a suggestion of seal script – only the strokes of the character 'honour' are rounded. The design is picked out in camel grey, yellowish red and bluish grey, while the background colour is sapphire blue. Yellowish red is also used to produce the fine vertical lines.

15. *Jin* with design of 'happiness and glory'
Eastern Han

This fragment of *jin* has the same weave and a similar type of design to plate 14. It differs, however, in that the character for 'longevity' is replaced by that for 'happiness', a large, galloping horse is depicted in place of the long-legged bird and the background is not striped.

16. *Jin* with design of 'ten thousand lifetimes of wishes fulfilled' (1)
Eastern Han

This is a *jin* with a five-coloured warp, the colours being crimson, white, dark reddish purple, pale blue and oil green. Crimson has been used as the background colour while the other warps have been grouped by colour to provide bands within the design. Each band incorporates three colours, and there are twelve different combinations of colour and pattern within the design. The design is primarily made up of scrolling-cloud motifs, shaped like *ruyi* heads, juxtaposed with *zhuyu* motifs. The four characters meaning 'ten thousand lifetimes of wishes fulfilled' are depicted in official-style calligraphy in the spaces. The fabric is from a *jin* robe excavated from the Niya ruins in Minfeng, Xinjiang Province.

17. *Jin* with design of 'ten thousand lifetimes of wishes fulfilled' (2)
Eastern Han

This fabric is from a narrow-sleeved, tightly waisted robe excavated from Minfeng in Xinjiang. It is a five-coloured warp *jin*, but employs the technique of dividing the warps into colour bands, which in turn intersect with the bands of three colours used for the weft. The pattern cycle of the weft threads is 3.9 cm, and that of the warp threads is 35 cm or more. The design is of scrolling clouds juxtaposed with *zhuyu* and interspersed with the four characters meaning 'ten thousand lifetimes of wishes fulfilled'. See plate 202 for full view.

18. *Jin* with design of 'eternal prosperity'
Eastern Han

This is a typical Han-dynasty warp-patterned *jin*. The pattern is displayed with floats of the inner and outer warps in turn. The warp threads are in four different colours. Deep green, pale brown and ochre are used throughout the width of the material, while moxa green only appears in bands, but this is handled very ingeniously so that no coloured lines disturb the design. The framework of the pattern is bands of undulating clouds interspersed with three-legged beasts and two-horned winged beasts, as well as sheep and tigers. The design

is further embellished with the characters for 'eternal prosperity', depicted in square style. The appearance of the pattern is very naïve and clumsy compared to those of the fabrics shown in plates 14 and 15.

19. *Jin* with design of 'prolonged life and many descendants'
Eastern Han

This is a warp *jin* arranged so that each band of the design has three colours with a deep-brown ground. The design is of phoenixes and beasts combined with *zhuyu* and scrolling clouds.

20. Detail of *jin* socks with lozenge design and '*yang*' character motif
Eastern Han

This illustration shows a detail of a pair of ladies' socks made in three-coloured Han *jin* with an overall lozenge design. The rows of lozenges are in two colour combinations which alternate horizontally. One row of lozenges has a deep-blue ground and a deep-red pattern, the next row has, alternately, lozenges with a white ground and blue pattern, and plain deep red. The design inside the patterned lozenges is composed of lines and tiny triangles. The yellowish-white colour is in fact the colour that raw silk fades to over a number of years. Although it is not visible in the illustration, at the woven edges of the fabric there is a line of white '*yang*' characters and a four-petalled flower design. The socks were excavated at Minfeng in Xinjiang. See plate 201 for full view.

21. *Jin* with design of paired animals
Eastern Han

This is a fairly typical Han-dynasty three-coloured warp *jin*. The warps are combined in turn to form the surface and then the inner warp. The deep-brown warp threads form the background, while the bluish grey and pale brown produce the design. The primary motif comprises a pair of animals, facing each other but looking in opposite directions. Apart from some areas of plain-brown ground colour, the bluish grey has been used to give an outline. The limbs and tail areas are depicted with outline on one side only, quite different from the double outlines seen later, and have a freedom and liveliness

that complements the unrestrained style of the design.

22. *Jin* with design of elephants
Eastern Han

This also is a three-coloured warp *jin*, similar in its use of fibres, structure, weave and colours to that shown in plate 21. The design in this case consists mainly of elephants within roundels. The depiction is bold and crude. This particular type of design is rare among Han woven materials but was quite prevalent during the Tang dynasty. It may be seen as a precursor of the floral roundel and animal type seen in later periods. See plate 199 for full view.

23. *Jin* with design of 'descendants'
Eastern Han

This *jin* is identical in weave and similar in design to the *jin* shown in plate 19. Although the fragment is quite small, the character for 'descendants' is visible on it. The original design possibly included the characters for 'prolonged life and many descendants'. This type of woven fabric is fairly common among the excavated articles dating from the Han period.

24. *Jin* with design of paired sheep
Eastern Han

This is a three-coloured warp *jin*. As is usually the case with Han-dynasty *jins*, the inner and outer warps change faces to produce the pattern. A deep blue is used for the background, while the pattern is produced by the orange and brown warps. The weft is pale in colour, and is not fully covered by the finer warp threads. In parts of the background, therefore, the deep-blue warp and the pale weft produce a shimmering effect. The pattern consists of pairs of sheep within lozenges, each flanked by four additional sheep in pairs and addorsed to form one pattern set. See plate 198 for full view.

25. Detail of cotton fabric with batik design of figures
Eastern Han

This fragment measures 86 × 45 cm and was excavated from the Eastern Han ruins at Niya, Minfeng, Xinjiang Prov-

ince. The wax-resist design includes a dragon's tail and foot as well as the figure shown in this illustration, which appears on the left-hand side of the fragment. The figure, in the style of a Buddhist image, has a string of pearls around the neck and holds a bunch of fresh flowers [or possibly cornucopia – translator]. The figure is looking straight ahead in an attitude of offering or receiving the flowers and is depicted in a free and lively style. It is the earliest extant example of woven material dyed by the wax-resist method. See plate 203 for full view.

26. Embroidery with design of double-headed phoenix
Eastern Jin

Excavated from an Eastern Jin site in Xinjiang Province. The fragment has a vermilion *juan* ground and employs single and multiple rows of chain-stitch to depict phoenixes, dragons, flowers and clouds. The double-headed phoenix is the principal central motif and is flanked by four birds, encouraging the impression of numerous birds paying homage to it. In the upper section of the design a dragon on the left-hand side and a tiger on the right face each other. There are also many varieties of flower shown in different stages of blossom. Two ascending dragons are placed on either side of the central decorative area. In the lower section of the design there is a cloud pattern, while to either side of the phoenix's tail embroidered flowers and garlands are depicted. There is an abundance of detail over the entire surface of the fragment, all done with considerable imagination and in the skilful style of the Chu embroideries.

27. Woven wool with checked pattern
Northern Dynasties

This is a plain-weave fragment excavated from a tomb site at Astana in the northern district of the ancient city of Gaochang, Xinjiang Province. The woollen warp and weft threads were first dyed yellow-brown and green. When the piece was being woven, the warps were arranged in groups to produce the narrow and wider lines. The two weft shuttles were also passed through in a specific order, and in this way it was possible to produce a lined

and checked design with a variety of shades and forms.

28. *Jin* with lozenge and honeysuckle design
Northern Dynasties

This two-coloured warp *jin* achieves an effect rather similar to a printed design. The piece was excavated from one of the tombs at Astana in Xinjiang Province. See plate 211 for full view.

29. *Jin* with tree-leaf design
Northern Dynasties

This *jin* was excavated from one of the tombs in the northern part of Astana, Xinjiang Province. Altogether five pieces of tree-leaf-patterned *jin* were excavated from this site, all having the same basic design but in different colours. They include this piece from Gaochang, dating from the first Heping year (AD 551) and measuring 20 × 6.5 cm. It has a two-layered warp weave and is woven in crimson, sapphire, leaf green, pale yellow and pure white. In the inventory of funerary items excavated from this tomb it is listed under the category 'large tree-leaf' or 'Cypress-leaf *jin*' and does not therefore appear to correspond to what used to be called 'tree-pattern *jin*'.

30. *Jin* cover with design of paired sheep
Northern Dynasties

This piece of fabric was used to cover the face of a corpse. A length of plain *juan* silk had been sewn around the *jin* material. The design of paired sheep is regular and simple, having inherited the style of Han-dynasty *jin* fabrics. It is a layered warp weave, the two different warp sets being revealed in turn. It was excavated from the Astana tomb site, Xinjiang Province. See plate 212 for full view.

31. *Jin* with design of checks and animals
Northern Dynasties to Sui

This fragment is a five-coloured warp *jin*, the warp threads being divided into sections, each section containing three of the five colours. The green and yellow warps were used alternately to produce the background colour. Frames within the pattern are delineated with thick vertical lines and thin horizontal lines in red, white and blue warp threads. A very varied checked pattern is thus produced. The animals within the frames are cattle, lions and elephants. The lions and the elephants are white, with outlines of red and sapphire blue respectively. The cattle are blue, outlined in white, and are more realistic than the other animals. This fragment measures 18 × 13.5 cm, and one side still has its selvage, which is 3 cm wide and has fine blue-white lines. It was excavated from tomb No. 99 in the northern part of Astana in Xinjiang.

32. *Jin* with design of paired sheep and birds
Northern Dynasties

This fragment is a four-coloured warp *jin* with blackish green as the ground colour and a design in white, crimson and orange. The design is in the style of the countries on China's western borders and consists of regularly placed addorsed pairs of sheep and birds. This kind of symmetrical design appears frequently on Tang-dynasty weft *jins*. There are two types of bird depicted in different colour combinations. There are also trees in the design, which are of a rather strange form, quite unlike those normally found in Chinese paintings and on handicraft items, which do vary but tend to maintain a 'drawn from life' flavour. This fragment measures 24 cm along the warp and 21.5 cm along the weft. It was excavated from the ruins of the ancient city of Gaochang at Astana.

33. Resist-dye stencil printed *juan* with design of scrolling plant and posy
Northern Dynasties

This fragment was excavated from a tomb in the northern area of Astana, Xinjiang Province. It measures 40 × 25 cm. The ground is crimson silk *juan*. The design was produced by attaching stencils to the material and smearing a white dye-resist paste on to the exposed areas. The fabric was dried, plunged into a vat of dye and then dried again before the white paste was finally removed. Woven goods such as this with a pattern on both sides produced by being clamped between two stencils are called 'clamped wax resist' or 'ash-grey wax resist' fabrics. See plate 217 for larger detail.

34. Detail of embroidery showing King Guang Yang supplying men
Northern Wei

This fragment was discovered in caves 125–6 at the Mogao Caves, Dunhuang. The piece shows figures making sacrifices, and measures 49.4 × 29.5 cm. The characters for the Northern Wei 11th Taihe year (AD 487) appear at the top. The message 'made by Huian (Yuanjia) for King Guang Yang' appears among the surviving characters. The chain-stitch embroidery on this fragment completely covers the yellow-brown hemp ground. The main motif of figures sacrificing is produced in vermilion and purplish black, and these colours have also been used for the designs on the figures' clothing (peach-shaped honeysuckle) and the Wei-style character steles. A single row of chain-stitch has been used to outline the figures' robes and the flowers, plants, branches and leaves. The character steles, the peach-shaped honeysuckle patterns and the feathers have been outlined with two rows of chain-stitch, while the surface of the leaves is covered using multiple rows, with contrasting colours for the veins. See plate 206 for full view.

35. *Jin* with design of flower clusters
Tang

This is an example of weft-twill *jin*. The weft threads are green, earth yellow and white and are divided into inner and outer wefts which are floated on the surface in turn to create the design. The warp threads are a single colour, earth yellow, and together with the earth-yellow weft produce the background to the design. The design itself is an elegant Tang-dynasty arrangement of repeated motifs placed side by side. The colouring is also quite elegant and restrained, completely unlike the gaudy colours usually seen in material of this period. This kind of woven article is also known as 'small circular nest' *jin*. It was excavated from Astana.

36. *Jin* with design of large deer encircled by pearls
Tang

This fragment was excavated from a tomb in the northern area of Astana. It measures 21.5 × 20 cm. A piece of yellow *juan* has been sewn around the *jin* to make a cover. Dark blue, blue and brown have been used to produce a design of roundels made up of twenty pearls. In the centre of each circle is a large, striped deer. The creature has an imposing head with sharp antlers; its legs are strong and vigorous and it is taking long strides forward. This kind of *lu* deer is a traditional Chinese motif symbolizing good fortune and an official's salary.

37. *Jin* with design of paired horses encircled by pearls
Tang

This fragment of three-coloured warp *jin* was excavated from a tomb in the northern area of Astana. The grouping of the warps includes bands of deep blue as well as brown and white. The weft threads are brown, brownish yellow and deep blue. The motif of sixteen pearls in a circle is arranged symmetrically with the Tang flower and Tang plant motifs so that four circular units make up a pattern element. The paired horses in the roundels have wings and are thus 'heavenly horses'. Beneath their legs are designs of dark-blue flowers and plants forming a lotus seedpod rising from the centre, with a three-petalled lotus flower with scrolling leaves trailing obliquely downwards. This type of 'heavenly horse' design for ribbon to hang around the neck has also been discovered among the silk woven goods from seventh-century Egypt and it is generally believed that it was influenced by Persian designs.

38. *Jin* with animal design
Tang

This is a layered warp *jin* with a simple and vigorous animal design, in the tradition of Han and Wei *jins*.

39. *Jin* with design of birds and flowers
Tang

This is a weft-twill *jin*, excavated from Astana. It is much more tightly woven and more solid than other similar fabrics. The disposition and spacing of the design is harmonious and the colours are fresh and resplendent. The form of the flying birds approaches realism and they adopt a lively stance. The flower and plant motifs are arranged variously in pairs, some large and some small, some densely packed and some dispersed. The piece exemplifies the mature skills seen in Tang-dynasty *jin* weaving. See plate 226 for larger detail.

40. *Juan* with printed hunting scene
Tang

This piece has a pale-yellow plain-weave *juan* ground with a white design of a horseman shooting at an animal with a bow and arrow. The technique used to produce this design could either be wax-resist dyeing or another method of dye-resist-paste printing. The depiction is lively and vivid and the motif is often seen on Tang-dynasty decorative arts. See plate 228 for full view.

41. Brown *juan* with batik flower design
Tang

This fragment was excavated from one of the tombs in the northern area of Astana. It measures 50 × 40 cm. The technique used to produce this design was to place a stencil over the piece of straight flat *juan* and to smear a dye-resisting white paste on to the exposed areas. The stencils were then removed and the material plunged into a vat of dye. After the dyeing of the *juan* was complete it was taken out and the white paste rinsed off in clear water, leaving the white flower design. Designs produced in this way are characteristically bold and free. See plate 229 for full view.

42. Detail of lined *jin* gown with design of 'circular road' and paired birds
Northern Song

This garment was excavated from a Song-dynasty tomb at Ala-er in Xinjiang Province. The facing material is a *jin* with a design of 'circular road' and paired birds, and it is lined with plain silk. The warp threads of the patterned *jin* are yellow and the wefts are pale yellow, black, yellowish green and white. It is a three-weft patterned twill. The so-called 'heavenly corona' or 'circular road' design was prevalent in Song times. The area within the roundel contains a pair of symmetrical addorsed birds. These birds have their heads held up and extended wings as if they were about to fly. Directly behind them are tall plants or trees. The roundel itself has a pattern interspersed with four birds, and has an interrupted linked-pearl pattern around either edge. This *jin* combines the characteristics of design from central and western regions.

43. Detail of *ling* with design of two children playing with a peach
Song

Only a fragment remains of this material, which was excavated from a Song tomb at Hengyang, Hejiacun, in Hunan Province. The ground is golden-yellow *ling* silk while the design in brown is of children climbing a peach tree to select from an array of peaches. The branches and leaves of the tree, and the outlines of the complex flower shapes, buds and veins are all extremely clear. The design is lively and elegant.

44. Gauze with design of hibiscus, camellia and Cape jasmine
Southern Song

This plain-weave patterned gauze with a three-to-one warp structure was excavated from the tomb of Huang Sheng in Fuzhou. The ground area has a crossed warp in the configuration one-over-two. There is an additional twist in the single- and double-warp plain weave of the patterned area. This kind of weave structure is firm and stable. The background to the design is distinct and the design itself is subtly presented in the style of a traditional line drawing.

45. Gauze with design of entwined branch and 'precious flower'
Northern Song

This example has a twisted-warp structure in the ground area and a plain-weave pattern, giving a 'clear ground and hidden pattern' effect. The 'hidden-pattern *sha*' referred to in Song-dynasty documents probably refers to this type of material. The unmade-up bolt of material has probably been dyed black;

black *shas* were popular in Song times for clothing and adornments, the black colour most often being obtained by dyeing the material five times using *qing* green, with vitriol as a mordant.

46. *Kesi* with design of clouds, phoenix and peonies
Song

This fragment, handed down through the generations, has a strongly individual style. The phoenix, peonies, mountains and coloured clouds are all formed in an attractively unsophisticated way, and the simple elegance of the colouring relates to ancient material. Rather than those *kesi* fabrics made by famous weavers such as Zhu Kerou and Shen Zifan, which incorporate more than just a suggestion of painting style, this piece is more like folk handicrafts such as paper cuts and cut velvets. In terms of style it is closer to the earlier woven products of the Tang and Five Dynasties periods and is quite interesting in its decoration. The techniques are relatively straightforward; the *ping* method is the one primarily used, but the 'long and short' method has also been employed occasionally for the flowers and rocks.

47, 48. Full view and detail of *kesi* with design of *luan* phoenixes and other birds
Northern Song

This tapestry originally measured 131.6 × 55.6 cm. It has a purple-warp silk ground and has been made using the *kesi* technique by which the colours appear in blocks. The warp face is primarily of single-thread *qiang* construction, with the *qi* method used in between. A double-warp thread has been used in the finest areas of the design, while a five-ply thread has been used in the thickest sections. The skill apparent in the weaving of this piece is considerable. Each pattern repeat is composed of five horizontal rows of flowers and birds. All the different birds are in flying postures with outstretched wings. The auspicious phoenixes are holding *ruyi* in their beaks and are flying among flowers. The flowers are mainly multicoloured peonies and Buddhist lotuses, but sprigs of other lotuses and flowering crab-apples are also depicted. The whole design has a com-

plexity and luxuriance that is typical of the style of the High Tang period.

49, 50. Full view and detail of *kesi* depicting the Eight Immortals greeting Shoulao (the God of Longevity)
Southern Song

This *kesi* is one that has been handed down. It was originally 38.3 × 22.8 cm. The multicoloured wefts are used in a *kesi* weave on an ivory warp to produce a vivid picture like a scroll painting. The wine gourd that Iron Crutch Li (one of the immortals) is holding is for the purpose of making an offering to wish for longevity. This *kesi* was originally in the Qing palace collection and on its upper surface are the imperial vermilion seals of the emperors Qianlong and Jiaqing.

51. *Kesi* with design of camellias and butterfly, by Zhu Kerou
Southern Song

This *kesi* has been handed down. It originally measured 25.6 × 25.3 cm. Three camellias with fully opened petals are depicted with a flying butterfly using multicoloured wefts in the *kesi* method on a porcelain-blue *juan* ground. The *qi* tapestry method has been used for the branches, leaves, petals and stamens of the open flowers. The wings of the butterfly have been picked out using the *jiang* method, while its feelers are done in the *gou* embellishing technique. The three unopened buds on the branch and the yellow leaf which has been nibbled by insects have been depicted extremely realistically. In the lower left-hand corner, Zhu Kerou's vermilion seal can be seen. The 'Zhu *kesi*' of the Southern Song have been lauded as epitomizing the tapestry skills of China.

52. *Kesi* with design of Chinese roses and quails
Song

Although this is a piece of fine quality, handed down from generation to generation, it does not appear to have been made by a well-known craftsman. In the lower part of the picture there are three quails, two with their heads down searching for food, the other with its head up calling out. Two rocks, a larger one centrally placed within the design

and a smaller one in the lower left, give an impression of depth. To the side of the large rock are branches of chrysanthemums and a clump of Chinese roses. Behind the rock can be seen several stems of bamboo. The picture 'carving' is extremely meticulous, and imitates the paintings of the Southern Song Academy. The weaving of this piece is exquisite and employs the *shen*, *qiang*, *jiang* and *ping* techniques to create a picture that is charming and true to life.

53. Gauze with printed design of paired tigers
Southern Song

This fabric was excavated from the Song tomb of Huang Sheng. The background material is crimson gauze; pattern stencils have been used to apply the indigo-blue pattern of paired tigers. Each pair of small, young tigers is a visual unit formed by the extension of the tails and, in turn, four pairs of tigers form a lozenge shape.

54. Printed border with design of lions playing with coloured balls
Southern Song

This fabric was excavated from the tomb of Huang Sheng. Pattern stencils have been used to produce a design on a crimson gauze ground. The design shows lions jumping, running, leaping and standing, each playing with a ball from which different-coloured streamers fly. Taking four lions as one unit, the stencils were cut in sets of two. One stencil was used with a yellow colour to depict the lions and balls, and the other was used with white to depict the ribbons. Vermilion was also used to produce the details of the lions' eyes and the balls. The fabric suffered from dampness in the tomb, resulting in the colours fading and the pattern becoming indistinct.

55. Border with printed and painted design of peonies in stripes
Southern Song

To create the design on this decorative border the outlines of the pattern were first applied using blocks with the design cut in relief, and then the colours were added. The size of the pattern repeat is 16.5 × 2 cm. At the time the piece was excavated, from the tomb of

Huang Sheng in Fuzhou, the flowers were pink, the butterflies soft yellow, the leaves grey-blue and grey-green, and the dye on the ribbon areas mottled from immersion.

56. Embroidery depicting a parrot on a plum branch with bamboo
Song

This handed-down Song-dynasty embroidery originally measured 27.7 × 28.3 cm. The background fabric is a soft-yellow *juan* on which coloured threads have been used to embroider the plum branch, the shining bamboo leaves and the multicoloured parrot perched on the branch with its head turned around and down. Satin-stitch is the one mainly used, but the parrot's neck, back and stomach have all been done in *qiang*-stitch to correspond with the texture of the bird's feathers, while the flower stamens and the bird's eyes are depicted in a realistic way in knot-stitch.

57, 58. Full view and detail of embroidered picture of an immortal riding a crane towards a jade terrace
Song

This piece has a brown *juan* ground on which coloured threads and rolled gold threads have been embroidered to produce a round fan-shaped picture of a landscape. On a multi-storey terrace, two youths welcome an immortal (Xi Wang Mu, the Queen Mother of the West); the effect is majestic as well as being full of wit and humour. Satin-stitch is the one mainly used, but the pine needles and fir leaves are done in pine-needle (or random) stitch using a single thread. The pattern of the brick, the brackets under the eaves, the drawn curtains and the outline of the balustrades are all depicted in *ya*-stitch. The roof tiles, beams and pillars of the building, as well as the tops of the balustrades, are marked out with couched twisted gold thread. The embroidery of the immortal astride the crane is meticulous in its stitching. The inspiration for this embroidery comes from a painting by a Southern Song Academy master.

59. Detail of cap embroidered with paired deer, flowers and plants
Liao

This cap was excavated from a Liao tomb at Yemaotai in Liaoning Province. It is made from a piece of embroidered cloth sewn on to some tapestry. The background fabric for the embroidery is a brown patterned gauze with lozenge design, on which golden-yellow threads have been used to embroider paired deer with flowers and plants. The main stitches are satin-stitch (both vertical and oblique) and *puwen*-stitch, but the branches are in chain-stitch and the speckled pattern of the deer skin is embellished with knot-stitch. Both deer have wings on their backs. This design of deer among flowers and plants is symbolic of good fortune and happiness.

60. Detail of woven picture of homage to a phoenix
Yuan

This woven picture has been handed down. Its original size was 53.5 × 54.7 cm. Gold-coloured weft threads have been used to pick out a design of many birds paying homage to a phoenix on a peach-coloured *duan* ground. Twisted gold thread outlines the feathers, tails and magnolia branches, and the pattern exhibits a dazzling splendour.

61. *Jin* with design of clouds and the eight treasures
Late Yuan

This material was excavated from the tomb of Madam Cao in Suzhou. It measures 12 × 11 cm and is a reversible *duan*. The design is of continuous curling clouds between which are placed *ruyi*, coral, jade bracelets, silver ingots and other items from the eight treasures.

62. Gauze with design of sprigs of peonies
Late Yuan

The woven ground is a two-warp crossed weave while the pattern is a plain weave, thus producing a 'bright ground and hidden pattern' effect. There are those, therefore, who claim that this is the type of 'hidden-pattern *sha*' mentioned in Song-dynasty documents, and

which from the Ming and Qing dynasties was also called 'bright-ground *sha*'. The loom and implements used to produce this type of weave correspond to those shown in the Southern Song Academy painting *Picture of tilling and weaving* preserved in the Nanjing Museum. The colour shades of the *qing* green are refined and pleasing.

63. *Ling* with design of twining stems of hibiscus
Late Yuan

The ground-weave of this *ling* is a two-over, one-under warp twill, while the pattern is produced in one-over, five-under weft twill. Because the warp is fairly fine and the weaving is tight and dense in comparison with the Tang-dynasty *lings* the design is able to be even more naturalistic. Although the warps and wefts are the same brown colour, the light is reflected differently off the threads and thus produces a clearly defined view of the 'hidden pattern'. The fabric was excavated from the Cao family tomb in Suzhou.

64. *Duan* with design of hydrangea branches
Early Yuan

This fabric was excavated from the tomb of Qian Yu and his wife in Wuxi, dating from AD 1321. It is a reversible *duan* with a pattern repeat of 12.5 × 4.8 cm. It has a density of 87 warps × 41 wefts per cm, and is among the earliest of the 'hidden pattern' *duans* still extant.

65. *Duan* with design of clouds, dragons and eight Buddhist objects
Early Yuan

This is a reversible *duan* with a warp-*duan* ground-weave and a weft-*duan* pattern-weave. Since the warps are fine and dense while the wefts are thicker and more sparse, a particularly beautiful pattern effect is achieved. The main elements of the design are clouds and dragons. Strewn randomly between them are the Buddhist treasures which symbolize good luck, including the conch shell, paired fish, endless knot, precious umbrella and Dharma wheel. This material may be regarded as a masterpiece among the early 'hidden pattern' *duans*. It was excavated from the tomb of Qian Yu in Wuxi.

66. *Qi* with design of phoenixes among peonies
Late Yuan

This is a woman's gown. The pattern is produced on a plain-weave ground using floating wefts. The weft floats vary from passing across three warps to passing across more than ten. Since the warp is fine, the weft coarser, and the weave dense and meticulous, the weft of the ground area appears raised like scattered millet. The two different forms of the phoenix, looking up and looking down, and the peonies with twisting branches which seem neither broken nor continuous, reveal some ingenuity of conception. The material is still quite lustrous, but its deep brown is probably rather different from its original colour. The gown was excavated from the Cao tomb in Suzhou.

67. *Qi* with lozenge pattern
Early Yuan

This fabric has a plain-weave ground with a weft pattern. The float length is the same throughout, always over three warps, arranged diagonally either to right or left. The woven item is quite light and fine; the pattern is simple and clear, resembling a chequered vaulted ceiling. It was excavated from Qian Yu's tomb in Wuxi.

68. Round-fan *kesi* with peony design
Yuan

This *kesi* has been handed down. It originally measured 22.6 × 26.3 cm. The peonies' red flowers and green leaves are depicted on a crimson ground using coloured threads in the *qi* and *jiang* tapestry techniques. The flower petals, leaf veins and stems are outlined using silver thread in the *gou* method, setting off the red flowers and green leaves in a sumptuous way.

69. Pictorial scroll depicting Dongfang Shuo stealing a peach
Yuan

The subject of this handed-down woven picture was inspired by a Song-dynasty painting. The design has been produced by the methods of adding colour, outlining with thread and irregularly alternating between two colours. At the edges, the *gou* tapestry method has been used to provide an outline, and where two colours meet, the long-and-short *qiang* method has been used to effect a smooth transition between them. In addition, threads have been used which have been made by twisting two different colours together. This is similar to the mixed woollen yarns used nowadays. In the upper part of the tapestry, branches of the peaches of immortality can be seen high in the clouds. In the lower part of the picture are *lingzhi* fungus, narcissi, bamboo and rocks. In the centre is Dongfang Shuo with hunched shoulders and head turned back, clasping the stolen peach in his hands.

70. *Jin* with design of lattice and scrolling branch
Ming

This was the original covering for a Ming edition of the *Buddhist Canon*. The warps are blue and the wefts red, giving a blue ground and a red pattern. Since the pattern is formed using relatively long and thick floating wefts, the design appears to be raised. The design is of scrolling flowering branches against a lattice background based on Buddhist swastikas. The flowers are lotus, peony and camellia.

71. *Jin* with design of plum blossom and butterflies
Ming

This fabric has a warp-faced twill ground-weave and a weft-faced twill pattern. The way that the butterflies flutter upwards and downwards among the apparently swaying sprigs of flowering plum is both realistic and lively.

72. Zhang *duan* square wrapper with 'precious flower' design
Late Ming

This example has a cut-nap design on a warp-*duan* ground. While the *duan* ground is smooth, the naps are densely packed. The design is simple and the style expansive.

73. *Duan* with design of lattice and peony
Ming

This fabric was excavated from the Taining district of Fujian Province. It is a reversible *duan* with a density of 109 warps × 41 wefts per cm. The pattern repeat is 5 × 7 cm. The warp threads, but not the wefts, are tightly twisted.

74. *Duan* with design of bees and scrolling flower stems
Ming

This is a reversible *duan* weave. The warp threads are extremely fine with a Z-twist, while the wefts are thick and untwisted, making the fabric smooth and level. Since the warp threads are fine and not dense enough to cover the wefts, the ground pattern effect is somewhat diminished. The design is of bees flying among flowers. There are six different types of flower shown on the scrolling branches. The style is simple, vigorous and spacious, and the bees, flowers and leaves are vivid and realistic.

75. *Duan* with design of clouds made up of four *ruyi*
Ming

This example was excavated from the Taining district of Fujian Province. It is a reversible *duan* weave with a pattern repeat of 10 × 13 cm and a density of 105 warps × 44 wefts per cm. Many pieces of this kind of weave were excavated from the same tomb.

76. *Duan* with dragon's head design
Ming

This woven fabric was used to cover an edition of the *Buddhist Canon* published in the reign of the emperor Wanli. It has a *qing*-green warp-*duan* ground with gold thread woven in to depict the body of the dragon. The dragon's eyes, ears and whiskers are produced using 'excavated' wefts.

77. *Duan* with small phoenix roundel design
Ming

This is a reversible *duan* of the sort frequently seen in the Ming period. The warp and weft threads were scoured and dyed before weaving and are identical in colour. However, because the ground-weave and the pattern-weave are different, a 'hidden pattern' is produced. Although this is a single-layered woven fabric, the warps and wefts are both

relatively thick and thus the material itself is thick. Because of the type of loom used to produce the fabric the pattern repeat and the pattern itself are both quite small. The design is composed of rows of roundels containing flying phoenixes with outstretched wings, the wing feathers and tail feathers forming the circle. The phoenixes face a different way in alternate rows; this type of arrangement was known as *zheng pou guang*. This kind of woven fabric was often used by Ming-dynasty ladies as the facing material for gowns.

78. *Duan* with design of clouds and *taiji* symbols
Ming

This fabric was used to cover an edition of the *Buddhist Canon*. The *yin* and *yang* symbols combine to make the *taiji* symbol of Chinese philosophy, representing the 'myriad things of heaven and earth are unified'.

79. *Duan* with Buddhist images
Ming

This illustration shows the design around the edge of a woven article. This part of the material has a weft-layered weave with weft floats providing the pattern on a warp and weft ground; the weft threads are divided into two layers – ground and pattern. The threads were first scoured and then dyed before being woven. The pattern is a continuous design in two directions. The standing Buddha has hands together and head bowed in a listening posture, while the seated Buddha is discoursing on an auspicious throne. In the upper part of the illustration there are precious flasks, conches and other auspicious objects, while the approximately circular spots are perhaps falling heavenly flowers.

80. *Duan* with design of sprigs of plum blossom
Ming

This is a reversible *duan* with pre-scoured and pre-dyed warp and weft threads of the same colour. The disposition of the sprigs of plum blossom is lively and they are realistic in appearance. This sort of fabric was often used for clothing and adornments in the Ming dynasty.

81. *Qi* with design of bees and scrolling branches
Ming

This fabric has almost the same pattern as that shown in plate 74, but it has a very different weave structure and it is doubtful whether they are from the same weaving household or mill. This example has a plain-weave ground and a twill-weave pattern. The tightness of the ground- and pattern-weave is different, so the pattern is slightly raised.

82. *Duan* with design of lotus and scrolling branches on a green ground
Ming

This is an enlarged detail of a fabric used to mount a Ming edition of the *Buddhist Canon*. It has a warp-*duan* ground with silver-red, pale-green, white, sapphire and blackish-green wefts used to produce the design. A varying weft-twill weave has been used to fix the floating wefts. The design is of multi-layered golden lotus stems, and has powerful lines.

83. *Duan* with blackish-green ground and 'precious flower' design
Ming

This, too, is a detail of a fabric used to mount an edition of the *Buddhist Canon*. It has a warp-*duan* ground with a coloured-weft design. The weft threads are relatively fine and thin so that the covering of the ground-weave is somewhat sparse. The design of scrolling stems of precious flowers and peonies is spacious and powerful in style.

84. *Duan* with design of 'abundant harvest of five grains'
Ming

This fabric has a warp-*duan* ground with the design 'excavated' in coloured wefts and outlined in gold thread. The pattern is of lanterns, bees and ears of grain, hence the name 'the five grains abundant (bees) harvest (lantern)'. This sort of design theme was seen quite early in the Song-dynasty Shu *jins*.

85. *Duan* with design of *ruyi*-shaped clouds and the eight treasures (1)
Ming

This material was used for mounting a Ming *Buddhist Canon*. It measures 40 × 13 cm. The eight treasures are: an ink stick, ancient coins, a gold ingot, rhinoceros horns, a *fangsheng* (the open lozenge, symbol of victory), a rock, a flaming pearl and a branch of coral. The fabric has a warp-*duan* ground with a floating-weft design. The warp and weft are of different colours.

86. *Duan* with design of *ruyi*-shaped clouds and the eight treasures (2)
Ming

This is another material used for mounting a Ming edition of the *Buddhist Canon*. Editions were printed during the reigns of Yongle and Wanli, and the *jins* and *duans* used to mount them were often taken from storage. Among the fabrics were old materials from the Song and Yuan dynasties as well as newly woven contemporary materials. This piece measures 40 × 13 cm and is a two-coloured, patterned *duan*.

87. *Ling* with design of mixed treasures woven in gold
Ming

The main design on this mount for a *Buddhist Canon* is produced using flat-gold weft floats, while the ground material is a *ling* with a 'hidden pattern'. The main design is of roundels containing miscellaneous treasures, such as a single rhinoceros horn, *ruyi* heads, branches of coral, flaming pearls and ancient coins.

88. *Ling* with design of scrolling plants
Ming

This material was used for mounting a *Buddhist Canon* printed in the reign of the Ming emperor Wanli.

89. *Ling* with design of continuous outlined swastika lattice
Ming

The design on this material is produced using floating wefts. The warps and wefts were dyed separately. The design is continuous across the entire width of the material, and the integral swastikas have an auspicious meaning. These

characters are produced at a slant, which gives the surface of the design a feeling of movement. Because the ground-weave is tight and closely woven, and the pattern-weave is loose and open, the pattern appears slightly raised.

90. *Ling* with design of *ruyi*-shaped clouds
Ming

This *ling* has a ground-weave of three-over, one-under warp twill, while the pattern-weave is one-over, seven-under weft twill. The woven material is dense and thick with a raised pattern composed of four joined *ruyi*-shaped clouds. It is possible that this fabric was scoured and dyed after it had been woven, which would also have entailed straightening it out afterwards so that it was even.

91. Gauze with cloud design
Ming

This fabric has a plain ground-weave and an intersecting-warp pattern-weave. It has been called a 'solid ground *sha*'. The pattern is made up of variegated *ruyi*-shaped cloud forms which are joined together to form a continuous design, so that although the pattern unit is small it nevertheless gives the feeling of originality and diversity. In order to colour the fabric purple, it may have been soaked in dye made from the catalpa tree with the additional use of *qing* green and an alum mordant. It was excavated in Jingyun County, Zhejiang Province.

92. Silk with design of silver ingots and swastikas
Ming

This fabric has a plain-weave ground and a floating-weft pattern. The pattern is slightly raised. The design is composed of a lattice of silver ingots enclosing swastika characters. The weave is smooth and the pattern distinct.

93. Silk with design of dragons
Ming

This material has a design of small dragons with a ground pattern of *leiwen* and swastika shapes, of the sort often seen in the Yuan and Ming periods.

94. *Kesi* with design of paired dragons with swastikas and 'longevity' characters
Ming

This *kesi* has been handed down. It measures 28 × 22 cm. Gold thread in the *ping* tapestry method has been employed for the swastikas and the round 'longevity' character. The heads, bodies and tails of the two *kui* dragons have been done in deep-blue thread, while the cloud patterns through which they ascend are outlined in gold thread in the *jiang* method. The pattern is compact yet lively.

95. *Kesi* with design of paired cranes and peaches
Ming

This *kesi* has been handed down. It measures 43 × 32 cm. The woven design is in red, yellow, blue, green and white on a brownish-yellow ground. The *qi* and *ping* methods are the ones primarily used, but the backs and outstretched wings of the cranes have been stitched using the fish-scale technique. The two peaches are outlined in golden yellow using the *gou* method, forming clear 'water roads'. The whole pattern is elegantly arranged.

96, 97. Detail and full view of 'Hall of longevity' *kesi*
Ming

This *kesi* has been handed down. The design depicts a scene from daily life at court as described in a tragic poem by Bo Juyi. To accord with the rich, dark lighting of the palace, crimson, purplish black and other warm colours are used. Rolled gold thread serves to outline and emphasize so that a resplendent and palatial atmosphere is presented. *Qi*, *ping* and *qiang* tapesty methods are all used, as well as fish-scale technique. The *gou* technique with gold thread serves especially to provide an intense colour effect.

The original inspiration for the 'Hall of longevity' was a scene from Bo Juyi's 'The long lament' which takes place in the palace on the seventh night of the seventh moon. The occasion is a tryst between the Tang-dynasty emperor Xuanzong and Yang Guifei. The characteristic feature of this tapestry is the outlining with gold thread of the contours of the landscape and the addi-

tional ornamentation of the clothes. In this way the depth of colour of evening is retained, while gloominess or dullness is avoided.

98. Hanging with design of immortals within a 'longevity' character
Ming

The character for 'longevity' is written in regular script, and from top to bottom it has the form of a well-proportioned teahouse pavilion. The 'brush strokes' are rounded and firm, and within the 'strokes' are arranged gods and immortals. Apart from the Eight Immortals, there are also the Star God of Longevity, the twin Gods of Harmony and Union, Dongfang Shuo, Nong Yu, Xiao Shi and an attendant – fifteen figures in all. The spaces between them are embellished with sea, mountains, clouds, pavilions, pine trees, cranes, peaches and *lingzhi* fungus strewn about. The 'longevity' character itself stands against an azure background, while the background colour of the picture within it is silver-red. The 'brush strokes' are light, the colouring is delicate and rather pale, but the overall colour tones are inclined to be warm so that the integrity of the whole character is preserved, and furthermore has a cheerful appearance. The spacing of the item is good, and the tapestry weave is fine with not a thread out of place.

99. Embroidery depicting a horse being washed
Ming

This is the first of the eight famous Gu embroideries by Han Ximeng in *Song Yuan ming jing ce* (*Album of Famous Works of the Song and Yuan*). It measures 33.4 × 24.5 cm. It shows a horse being washed, on a rice-yellow *ling* ground. The picture is worked using multicoloured silk threads as fine as hair. As far as can be seen, short, irregular *souhe*-stitches were mainly used, the horse's mane, markings and the expression in its eyes being embroidered with particular delicacy. The way that the man holds the reins and the brush is entirely appropriate. The banks have been emphasized with a pale wash of paint to add to the effect of the embroidery, giving it a romantic charm. The combination of painting

and embroidery is a characteristic of Gu embroideries.

100, 101. Detail and full view of embroidery depicting two phoenixes
Ming

This Luxiangyuan Gu embroidery of two perching phoenixes measures 86 × 38 cm. The embroidered picture shows phoenixes, rocks, jade-green parasol trees, emerald-green bamboo and an inscription and seals of the recipient or donor. The piece is worked on a *duan* ground with meticulous embroidery, and the faces of the rocks have been lightly coloured with paint.

102, 103. Detail and full view of Gu embroidery depicting apricot-blossom village
Ming

This Gu embroidered picture in the form of a hanging scroll has been handed down. It measures 84 × 40 cm. It is a representative masterpiece of the 'painted embroideries' of the Gu embroiderers of the Luxiangyuan area of Shanghai. The subject of the picture is an old man carrying an umbrella on his way to buy wine, and a boy on a water buffalo. The wine shop and the branches of the willow tree are embroidered in *qiping*-stitch, while the water buffalo and umbrella are done in *jiang*- and *souhe*-stitch, producing a layered shading effect within the different colours. The green grass and small trees on the hillside are painted in complementary shades of colour.

104, 105. Detail and full view of embroidery depicting a landscape and the Three Longevities
Ming

This embroidered picture measures 102 × 44 cm. It has a yellow *juan* ground, enhanced by the application of paint. The main subject of the picture is an old man with a high forehead, long eyebrows and a peaceful expression – the Star God of Longevity, Shoulao. There are also two attendants, one putting flowers in his hair and one offering wine, who have respectful and cautious expressions. The precise posture of the main figure has been drawn extremely vividly. In the background is a land-scape with pines, rocks, a flying crane, a wandering deer, many different flowers and realistic trees. The deer and crane are the familiars of Shoulao.

106, 107. Detail and full view of Gu embroidery depicting a crane holding a *lingzhi* fungus
Ming

This piece measures 135 × 54 cm. From the treatment of the subject matter, however, it can be seen that it maintains the characteristics of Gu embroideries. *Souhe*-stitch has mainly been used and the embroidered colours have been applied in an elegant and controlled way to the *qing*-blue *duan* ground. Knot-stitch has been used for the crown of the bird's head. The outstretched wings are beautiful in their form, and the rocks and water, clouds and hillsides are all appropriately arranged.

108, 109. Na embroidered pictures of beautiful women
Ming

These two pieces of embroidery are examples of Na embroidery. The ground material is a plain *sha* gauze, the holes in the gauze acting as the matrix for the execution of the *pu* embroidery. Some of the ground area remains uncovered, leaving parts of the *sha* as background to the design. On these two pieces there are six women altogether, burning incense, playing musical instruments, fluttering paper fans, etc., within hexagonal frames. The individual pictures resemble what one would see if one were to peer through the windows of the women's quarters. In the spaces between the frames there are hares, cats and birds.

110. Detail of hair embroidery of Weaving Maid Tower figures
Ming

This hair embroidery has been handed down and originally measured 54.5 × 26.7 cm. It is worked on a pale-crimson *duan* base and uses fine hair threads for embroidering. The figures produced in this way have their own characteristic appearance. The long robe of the man has wide sleeves and his facial expression is natural and unrestrained. The youth at his side is holding a musical instrument, a *qin*, in his right hand while he turns his head and gesticulates with his left arm. There is a full moon hanging in the sky. The primary stitch used is satin-stitch with long and short stitches, and the embroidery imitates a painted sketch. This is a fine example of a Ming-dynasty Gu hair embroidery.

111, 112, 113, 114. Lohans embroidered in colour
Ming

These examples of embroidered lohans/arhats are among the remnants of an album, eleven pages of which are now extant. On each page are embroidered one or two different lohans with eulogies in grass script embroidered on the opposite page. Each of the eulogies contains two sentences of seven characters. They are unsigned, but have vermilion seals. The inner area of the pictures measures 26 × 21 cm. It is not the case that these were inspired by the work of the Eastern Jin painter Gu Kaizhi. According to contemporary records, depictions of lohans of this kind did not exist at that time, and the Eighteen Lohans seen here emerged quite late. The translation of the *Fa zhu ji* (*Record of the Abiding of the Dharma*) by the Tang-dynasty monk Xuanzang only states that the Buddha instructed sixteen lohans to live in the mortal world among all living creatures. Later this was expanded and a figure with a dragon and a monk with a tiger were added to make the number up to eighteen. The earliest historical record of the Eighteen Lohans is in works by the two Tang-dynasty monks Zhangxuan and Guanxiu.

115. *Mashilu* cotton
Qing

This was used as a cotton padded quilt to put over a *kang* (a bed which can be heated from below). The fabric was an article of tribute from the Uighur people of Xinjiang. Dyed silk thread is used for the warps, while the wefts are cotton yarn. The warps are used to produce a raised-nap weave.

116. *Jin* with design of flowers
Qing

This is a traditional woven article of the Uighur people of Xinjiang, and was

presented to the court as tribute in the Qing dynasty. It is weft patterned, the wefts being divided into 'long shuttle' and 'moving colour' wefts. The 'long shuttles' are brown and white, while the 'moving colours' are red and blue and are used in section. The design has a regularity of placement which is distinctly Islamic in style.

117. *Jin* with design of octagons and circles on a black ground
Qing

This is a typical *jin* made in the style of the ancient Song-dynasty *jins*. It has a warp ground and a weft pattern. Precious flowers and small, petalled, flower designs have been added to the background design, which resembles a vaulted ceiling. The arrangement of the colours is elegant and refined. The fabric probably dates to the early part of the Qing dynasty and was used as material for bookbinding.

118. *Jin* with design of paired phoenixes, five bats and eight auspicious objects
Qing

This object is the cover for a chair-back, woven in a single width. Although it has a Song-style *jin* structure – a warp-twill ground and a weft-twill pattern – it uses a special binding warp to secure the pattern weft. The design incorporates a pair of phoenixes, five bats (blessings) and eight auspicious symbols (Buddhist canopy, lotus, conch shell, umbrella, endless knot, paired fish, precious jar and Dharma wheel). The pattern is further embellished with precious flowers and peonies. The use of colours is elegant and the colours themselves are rich.

119. Zhuang *jin* silk rug with checked lozenge-and-flower design
Qing

Zhuang *jins* are traditional items made by the Zhuang peoples of Guangxi, Yunnan and Guizhou, which were once sent as tribute to the Qing court. They have plain ground-weaves and a multi-coloured-nap weft, which produces the pattern. For the most part these nap wefts are only pulled through the weave in certain areas, so that they come close to the 'excavated' pattern of the cloud

jins. This technique is called 'picking the pattern'. The ground warps were covered by the nap and hence cheaper cotton threads were often used for them. The design in this example is of small flowers within a geometric framework. The two-layered ground and pattern wefts are of pale yellow and pale green. Apart from these, threads of pink, apricot, yellow, ultramarine and soft yellow are used in the design. Although the small flowers are all identical in shape, there is considerable variation in their colouring.

120. *Jin duan* with design of peaches, pomegranates and Buddha's hand citrus on a blue ground
Qing

These are two parts of a Buddhist banner with a warp-*duan* ground and floating-weft pattern. The design is composed of a ground pattern of swastika lattice, against which appear the main motifs of flowers, plants and fruit. The peaches symbolize longevity, the pomegranate symbolizes many descendants and the Buddha's hand citrus plant symbolizes blessings, so the whole design has the meaning 'blessings, longevity and many sons'.

121. *Jin duan* with design of hexagons and linked circles
Qing

This example has a warp-*duan* ground-weave, with floating wefts producing the pattern. The warp threads are divided into two sets: the ground warps are blue processed-silk threads, while the binding warps are the original raw-silk colour. The wefts are blue-grey, grass green, black, white and vermilion red.

122. *Jin duan* with design of 'many blessings and precious flowers'
Qing

This is a quilt cover. It has an eight-warp *duan* ground and a polychrome-weft pattern. The warp threads are divided into two sets, one to weave the ground and the other to bind the coloured wefts. The wefts are divided into 'long shuttle' and 'moving colour'. The design of the piece involves the smaller sprays of flowers in the four corners gathering around the larger central pat-

tern element in a manner popularly known as *si cai yi tang* (four vegetables and one soup). The central motif is composed of four bats and various lotus flowers.

123. Detail of *jin duan* with design of swastika-lattice ground and eight auspicious symbols
Qing

This is part of a Buddhist banner. The ground-weave is a patterned warp-*duan*, and the main pattern is produced by long floating wefts. The design is of the eight auspicious symbols on a ground of swastika lattice. The swastikas are light and dark blue. Of the eight symbols only three can be seen in full in this plate – the paired fish, the conch shell and the Buddhist canopy – while part of the endless knot is also visible. The colours used include mud gold, white, crimson, moxa grey, yellow and light brown, and each pattern area has up to six different colours employed within it.

124. Detail of *jin duan* with design of two children
Qing

This Buddhist banner has a warp-*duan* ground-weave and a polychrome floating-weft pattern. At the time of weaving the tension of the warp threads was fairly loose so that the ground warps look slightly uneven. The whole of the vertical extent of the pattern can be seen in this plate, but only part of its horizontal extension. The coloured wefts seen in the picture are black, white, blue, green and red. The main design is of two children quarrelling in a courtyard. In the background are balustrades, pine branches and small shrubs.

125, 126. Detail and full view of hanging scroll depicting the Western Paradise
Qing

This piece is an extremely large Song-style *jin*. In order to depict the content of this picture realistically, hand painting, embroidery and *kesi* weaving have all been used with a quite difficult *jin* weave. Although there are records dating from the Yuan dynasty describing woven images of emperors, empresses

and concubines, for instance in the *Yuan dai hua su ji* (*Notes on Yuan-dynasty Painting and Sculpture*), there are no extant material remains to support them. This woven *jin* hanging scroll of the Western Paradise is a masterpiece. The piece has a ground of warp-twill and nineteen different-coloured wefts and gold thread are used in the pattern. It has a single pattern with an area of 448 × 196.5 cm. The picture shows the Buddha, bodhisattvas, heavenly kings, guardians, lohans, mendicant monks and deva musicians – 178 different figures in all. Throughout the scene are distributed palaces, halls, ornamental floors, trees, rocks, flowers, birds, auspicious clouds, Buddhist canopies and so on. The colours and subject matter are profound and sumptuous.

127. *Duan* belt with design of pine, prunus and bamboo
Qing

This has a two-layered weft structure, with floating wefts being used to produce the pattern. The warp threads are blackish purple, and the wefts golden yellow and silvery white. The design has the frequently seen 'three friends of winter' as its main theme, namely branches of pine, prunus and bamboo. The pine and bamboo both stretch upwards, while the branches of prunus blossom droop down. Each pattern repeat consists of two units, each unit having one branch of each plant. In alternate units the coloration of the flower petals changes between yellow and white so that the cycle is larger if it is seen in terms of colour as well as form. The weaving would generally have been done on a special 'rail' loom (belt-weaving loom), but an ordinary multiple-heddle loom could have been used, and several strips of the belt could have been woven at the same time and later cut apart for use. In the Qing period, clothes were popularly worn with many layered edges, and thus this kind of *duan* belt strip was produced in large quantities.

128. Detail of *duan* with design of flowers and butterflies
Qing

This piece has an eight-warp-and-weft ground with a nap-weft 'excavated' pattern. Not all the design is shown in this illustration; hibiscus, rocks and butterflies form the main motif, surrounded by and embellished with small branches of flowers. There are four types of hibiscus – red, white, large and small – and over ten different colours are used for the butterflies, which are depicted in every possible pose. The rocks are exquisitely wrought. Because a large area of plain, uninterrupted, black *duan* silk appears as the background, it provides a serenity in contrast to the bustle of scarlet, sapphire and other bright colours used in the pattern. The motifs have been outlined with an extremely fine rolled gold thread, which is also appropriate for the antennae of the butterflies and other delicate parts. This is a rare and exquisite example of decorative *duan*.

129. *Duan* with design of eight auspicious symbols and golden 'longevity' characters
Qing

This piece has an eight-warp-and-weft *duan* ground with the pattern produced by coloured weft threads. The circular 'longevity' characters are of rolled gold thread, while the eight auspicious symbols – the carp, Buddhist canopy, lotus, endless knot, Dharma wheel, conch shell, precious jars and Buddhist haloes – are coloured wefts. The pattern is divided into specific areas in regard to wefts, each area having not more than three colours. A woven inscription reading, 'ten thousand years of peace and prosperity, this loom a true store of circular gold' has also survived on this piece.

130. Zhang *duan* with painted roundel design
Qing

This is a very rare Zhang *duan* (figured, or superior, satin). The ground is reversible six-warp weave, while the pattern is produced using an 'excavated' nap. The depth of the nap is formed by the technique of three-weft fixing and tying. The warp nap is white processed silk, while the ground warps are sapphire-blue silk. This means that in the weaving a blue ground was formed with a white pattern; the pattern was then painted by hand. This method of completing the coloration of a nap pattern

was very common, since it was difficult to use already dyed coloured warps to produce a nap design. The roundel designs on this piece are made up of peonies, *lingzhi* fungus, swastika characters, bats and longevity peaches. These items together provide a rebus for 'riches and honours as one wishes, ten thousand blessings for ten thousand years'. The colours used for painting the design are clear and harmonious, but do not conform to any conventional scheme. For example, the peonies are painted lilac and the peaches blue and green so that a decorative rather than a realistic effect is being sought. This specially designed woven object was used as the material for a sleeveless jacket. It measures 60.5 × 130 cm and is referred to as a 'piece' rather than a 'bolt' (of silk). The diameter of the roundels is 19 cm, and there are eight roundels altogether on the material.

131. Detail of Zhang *duan* with design of swastikas and 'a hundred blessings'
Qing

This is a detail of a *kang* quilt cover. It has a red warp-and-weft ground with green cut nap providing the ground pattern of swastika lattice; yellow floating wefts produce the design of bats and longevity peaches. At the loomhead edge of the cloth the yellow floating wefts become the background and the green cut nap outlines the swastika characters.

132. Nap *duan* with design of scrolling stems and lotus flowers
Qing

This remnant of cloth is quite large and was probably originally a *kang* quilt. A cut nap is used for the pattern background and coloured warps produce the design, which is outlined in gold thread. The warp threads are divided into nap warps (golden yellow), ground warps (yellow) and binding warps (red), while the wefts are made up of the ground wefts (yellow), rolled gold thread and polychrome threads (pea green, blackish green, scarlet and pink). The raised nap forms the pattern. The weaving technique used in this example is possibly the most complex and difficult of those ancient handicrafts produced on the loom; this fabric remains the only

material evidence of it. The design is of a large scrolling stem of lotus travelling across the whole width. The lotus petals are drawn in the form of clouds and seed-pods are woven among the buds in gold thread. Two different rectangular areas are arranged one above the other, each with a continuous horizontal pattern. One has a band of swastika lattice made up of paired swastikas in mirror image, while the other has the *kui* dragons with *taotie* masks popularly called *guaizi* (kidnappers). In the Kangxi period there were many instances of handicrafts imitating ancient examples, and these *guaizi* dragons have their origins in Shang- and Zhou-dynasty bronzes.

133. *Rong* quilt with polychrome design of 'many blessings' and lotus flowers
Qing

This fabric has a golden-yellow carved-velvet ground and a polychrome layered-weft pattern. The centre of the design has a large lotus surrounded by golden-bell lotus and bats. Because it was used as a quilt cover the upper surface of the section illustrated has been worn away.

134. Detail of *kesi* with design of drunken Eight Immortals
Qing

In the Ming and Qing dynasties there were many stories on the theme of the Eight Immortals; this work depicts one concerning their drunkenness, without conforming to any of the conventional designs. The construction of the tapestry and the coloration is very fine, but it is the composition of the design which is particularly striking. All the figures are placed in the lower right-hand corner with a few layers of coloured clouds above them to the left. At first glance the immortals appear to be crowded together in a heap, but in fact there are three distinct groupings. The uppermost group consists of Lu Dongbin who is offering drink to a reluctant Zhongli Quan. In the middle group He Xiangu is refusing drink offered to her by Zhangguo Lao. The lower group consists of Cao Guojiu, Lan Caihe, Han Xiangzi and Li Tieguai. Li appears not yet to have had a sufficiency, Cao and Han are completely inebriated and Lan

is asleep and snoring. Although all eight are similar in their drunken appearance, their expressions are quite individual.

135, 136. Detail and full view of *kesi* with design of a group of immortals celebrating with the Star God of Longevity
Qing

This design employs a combination of the techniques of tapestry weaving, embroidery and painting, and its style is similar to that of silk scrolls painted with a brush. Its central theme is that of the Eight Immortals and the Star God of Longevity coming together to celebrate the birthday of the Queen Mother of the West. It measures 102.4 × 61 cm.

137. *Kesi* with design of paired dragons looped through *bi* rings
Qing

Although this design was originally taken from one found on Shang and Zhou bronzes, it has been somewhat altered. The paired dragons that loop through the jade rings are *kui* dragons, while the strange winged creatures are a debased version of the *taotie* mask. Patterns on dyed and woven handicrafts in the reigns of the emperors Kangxi and Yongzheng were, like this one, often imitations of ancient designs.

138. *Kesi* chair-cover with design of nine dragons
Qing

This piece of woven tapestry was made for daily use in the emperor's quarters. It employs the *qiang*, *qi*, *gou*, double-*tao* and fish-scale tapestry techniques. The ground pattern is of a swastika lattice on which a design of waves and banks appears along the sides, with bats, longevity peaches and other auspicious objects added as embellishment. The nine dragons in various attitudes are the main motif. Eight of the dragons appear to be in motion. They surround a single central upright dragon.

139. *Kesi* quilt with upright-dragon design
Qing

The design is of a five-clawed upright dragon on which rolled gold thread has been used to depict the scales within

the woven tapestry. Five-coloured clouds and the sea and banks are depicted using the *gou* and *qi* tapestry techniques.

140. *Kesi* with dragon roundel design
Qing

This piece is for a table and is 40 cm square. On a yellow ground a five-clawed upright dragon and flaming pearl make up the central motif, with multicoloured clouds, bats, waves and banks encircling it. The dragon's body is in tapestry weave using rolled gold thread.

141. Detail of *kesi* chair-cover with design of 'blessings, longevity, wealth and honour'
Qing

The material for the chair-cover is mainly tapestry weave, supplemented by embroidery and painting. The main area of the design has a floral roundel of peonies (wealth and honour), around which the ground pattern is a swastika lattice, with an encircling band of bats (blessings), peaches (longevity) and peonies. The encircling bats are holding swastikas in their mouths. The peaches, leaves, flowers, bats' wings and other areas have been delicately painted. There is an undulating border around this main decorative area.

142. Printed cotton with camellia design
Qing

This example differs from that shown in plate 143 only in its design; its fabric, coloration and printing methods are identical. The pattern is of staggered rows of small sprigs of camellias in different orientations and in a style influenced by European designs.

143. Printed cotton with design of scrolling floral stems
Qing

This item was originally used as lining material for a *jin* banner. It is undyed, plain weave and printed using stencils. The design is of scrolling floral stems. The flowers are divided into two types and arranged in a continuous band across the fabric. The method of depicting the flower petals was influenced by

European designs, for instance in the use of small dots to produce the gradations in the shading, and it also has something of the style of rococo printed fabrics.

144. Embroidered decorative border with lilac ground and *lingzhi* fungus in brush-and-ink style
Qing

Black, grey and white threads have been used in this embroidery to give the effect of a brush-and-ink painting. The design is of *lingzhi* fungus in a continuous band across the fabric. The stitch primarily used is *qi*-stitch, leaving 'water roads' in the design.

145. 'All-over gold' fabric with design of ambulatory dragon in peacock-feather thread
Qing

On this piece, polychrome wefts have been used to 'excavate' the pattern and gold threads have been used for the outlines and to embellish the background, while the dragon's body has been woven with thread made by twisting together peacock feathers. The earliest woven item of this kind so far discovered dates from the Ming dynasty. In the Ming *Tianshui Bing shan ji* there is a list of 'patterned all-over golds'. Government factories in Suzhou and Nanjing also produced such items during the Qing dynasty.

146. Detail of purple gauze dragon robe
Qing

This is a detail of a dragon robe, the illustration showing the section between two fastenings. The fabric has a purplish-red ground and multi-coloured design woven with gold thread. The dragon's eyes have been embellished using silk threads in black, white and purple. The gold thread used for the dragon's body has been partially worn away.

147. Appliquéd mountain monkey
Qing

This embroidery measures 23.75 × 31.5 cm. Originally it was part of an album of eight pages of embroidery. The mountainous rocks, creeping and trailing vegetation and the monkey are all depicted using floss appliqué on a paper base with additional brush painting. In the lower left-hand corner are seal characters reading 'Shouping', perhaps indicating that this was done in imitation of the work of Yun Shouping, and 'seal of the precious treasures of the Zhu family', indicating that this was once part of the Zhu family's collection.

148. Detail of chair-cover decorated with flat-gold embroidery
Qing

This embroidery has a ground-weave of spice-coloured eight-warp *duan*. Gold-couched embroidery is used for the main part of the design, which is further embellished with couched silver. The design is of scrolling stems. The gold and silver both reflect the light and the effect is elegant and harmonious.

149. Detail of section of armour for a door god (1)
Qing

This part of the armour would have hung down from the waist over the stomach. Feather-stitch and other stitches have been used on a white *duan* ground to produce the design of a vigorous *qilin*. It would have been used as part of the stage costume for the character of a door god in the imperial acting troupe.

150. Detail of section of armour for a door god (2)
Qing

Apart from the fact that the body of this *qilin* is white, it is very similar to the piece shown in plate 149.

151. Detail of section of armour for a door god (3)
Qing

This piece is a good example of the armour costumes used in drama. The area shown in this illustration is the section which protected the chest. These were often embroidered with animal-mask designs.

152. Couchwork embroidery with crane roundel design
Qing

This cushion-cover has been handed down. It is worked on a black ground with the main motif, a roundel design of a crane, produced using rolled gold thread. The crane's red crown has been done in knot-stitch, its beak and legs in green couchwork and its tail feathers in blue couchwork. It is holding a *lingzhi* fungus in its beak, and this is also depicted in rolled gold couchwork. Rolled silver thread outlines the 'cash' pattern lattice that surrounds the crane, with additional embellishment in blue floss. The rolled gold thread has been couched down with vermilion silk thread, and this enhances the contrast between the gold and silver areas.

153. Couchwork embroidery with design of 'longevity' character roundel
Qing

Apart from the 'longevity' character roundel which replaces the crane roundel, this example is identical in materials, couchwork and composition to the example in plate 152.

154. Embroidery with design of dragons and 'wealth, honour and blessings'
Qing

This is a quilt cover with a yellow *duan* base. The central motif is a two-clawed upright dragon with a longevity lock which is surrounded by sprays of 'wealth and honour' flowers (peonies) and coloured cloud designs. In the centre of the longevity lock is a bat. In the lower section of the piece are two ambulatory two-clawed dragons. The longevity lock has been produced using applied goldwork. The outlines of parts of the design and the dragon's whiskers have been couched, while the flowers, leaves and the dragon's body have been worked in coloured *pu* embroidery.

155. 'Double happiness' embroidery depicting deities and immortals
Qing

This piece has been handed down and belongs to a type of embroidery that was common in the Qing period. Such

embroideries combined over ten types of stitch including *tao*, *qi*, *souhe* and feather. The figures of seventeen deities and immortals are arranged within the 'brush strokes' of the 'double happiness' character. As well as the gods of Blessings and Rank, the Three Star Gods and the Eight Immortals, the Lord of Heaven, the Queen Mother of the West and the twin immortals Hehe and Liu Hai are also depicted and the gathering is full of life and vigour.

156, 157. Detail and full view of hanging screen with appliquéd embroidery of the 'six harmonies of spring'
Qing

The 'six harmonies of spring' are made up of deer (*lu*, a homophone for *liu*, 'six' in classical Chinese), longevity cranes (*he*, a homophone for harmony) and pine trees. Homophones were frequently used in this way in the designs of dyed and woven items. Embroidery thread has been used to represent the strokes of the brush to provide outlines and shading of pale colours, while feather-stitch has been used on the bodies of the deer and the wings of the cranes. The embroidery is meticulous and in the style of brush-painting on a *juan* ground.

158. Detail of cushion with level-gold embroidery in 'heavenly corona' pattern
Qing

The cushion has a blue eight-warp *duan* as its base fabric. A mixture of gold and silver couching is used for the design on a flat base of *pu* embroidery. The design is of checked panels in the style of Song-dynasty *jins*; the disposition of the colours is both elegant and refined.

159. Detail of yellow *duan* cushion with embroidered design of 'precious lotus flowers'
Qing

In this embroidery, fine couchwork outlines the whole of the flower design; *pu* embroidery provides additional colour. *Souhe*-stitch is used for the areas of colour shading on the leaves and knot-stitch for the stamens of the flowers. The design has a 'precious lotus flower'

as its central motif, surrounded by other different kinds of flower with bats dancing in flight both above and below.

160. Detail of yellow *duan* chair-cover with embroidered design of five dragons
Qing

The main motif on this piece is a five-clawed upright dragon within a roundel of waves and banks. There are four writhing dragons in the corners and two bats in the lower part of the design. The dragons' bodies are embroidered in gold thread.

161. Detail of chair-back with embroidered design of dragons and 'blessings and longevity'
Qing

On this piece, the central motif of the upright dragon, as well as the bats, waves, banks and coloured clouds, have been embroidered in quite thick *na*-stitch. The characteristic background design of small lozenge-shaped checks has been produced using the method which leaves 'water roads'. The caisson ceiling type of design that surrounds the dragon (only part of which can be seen in this illustration) is in *pu*-stitch. The whole embroidery has the appearance of a woven *jin*.

162. Butterfly embroidery on azure *duan* ground
Qing

This square cushion-cover is made from satin embellished on its upper side with small coloured embroidered butterflies. It has a circular design, with an outer ring of plum-blossom branches and butterflies surrounding a roundel in which there is a floral canopy. There is a brilliant contrast between the azure ground material and the multicoloured embroidery, but they do not clash. The piece possesses a cheerful folk-style and is completely different from most articles from the imperial household now in the collection of this museum.

163. 'Happiness encountered by chance' embroidery on azure *duan* ground
Qing

This piece is a cushion-cover. *Pu*-stitch has been used as well as knot-stitch,

fish-scale stitch and couching of both gold and silver thread. The design is of a pair of dancing butterflies within a roundel, an auspicious theme often seen in the Qing period. The areas between the butterflies are filled with lotus, peonies, camellias and other flowers and leaves, having the feel of a coloured drawing. The use of colours in the design is particularly good.

164. Embroidered scrolls of rhymed antithetical couplets
Qing

These have a scarlet *duan* ground and were mounted with a Song-style *jin*. The first line reads: 'Grasping the brush and depicting the month passed in the Han hall.' This is an allusion to Zhang Chang of the Han dynasty who painted a woman's eyebrows and was reported to the emperor. The other line reads: 'Playing the flute and enticing the phoenix to ascend the Qin platform.' This alludes to Xiao Shi and Nong Yu, the daughter of Qin Mu Gong. Both of these allusions are to stories concerning the love of female beauty. The characters are in official style and are composed of flowers and leaves. They would have been used as congratulatory presents for a newly married couple.

165. Hanging scrolls with embroidered design of brush-and-ink bamboo painting in the style of Zheng Banqiao
Qing

The two scrolls illustrated here form part of a set of four. Black, grey and white silk threads have been used to embroider the bamboo in the style of brush-and-ink painting; it is delicate and clear in appearance and strong and vigorous in style. The embroidered inscriptions are in a distinctive calligraphy.

166. Palace fan with double-faced embroidery (1)
Qing

This fan was originally in the collection at the Bishushanzhuang Museum in Chengde but was moved during the Republican period and damaged so that the colour has faded. It was later mounted to form one page of an album. It was originally 30.1 × 29 cm and has a green

juan ground. The embroidery depicts camellias and a prunus-blossom branch with a sparrow perched on it. The primary stitch used is *qiping*-stitch.

167. Palace fan with double-faced embroidery (2)
Qing

This originally measured 29.9 × 28.8 cm. It has a green *juan* ground with a design of camellias, Cape jasmin and a bird perched on a branch, turning its head and singing. The main stitch is *qiping*, but there are some areas where single-thread knot-stitch has also been used. The sides of the fan have been damaged and repaired.

168, 169. Details of red wool embroidered with butterflies and flowers
Qing

The arrangement of colours on this piece of embroidery has certain specific characteristics. One of these is the use of quite strongly contrasting colours; for example, the flower inclined horizontally in plate 169 has petals side by side in pink and green. Another is the difference in the brightness of the colours, for instance the blackish green and the light yellow used on the leaves. The third is that the colours are not blended together; leaves are divided into blocks of blue, green, yellow, grey and other colours so that in different light conditions one has the impression that these could be shades of green.

170. Detail of yellow *duan* chair-cover with design of 'a hundred butterflies'
Qing

This piece depicts numerous butterflies in different colours, shapes and sizes embroidered on a yellow *duan* ground. The overall arrangement is artistically spaced and the shading of the colours is appropriate. Many different stitches have been used, depending both on the type of butterfly being depicted and also on the specific part of the individual butterfly being portrayed. These stitches include *tao*, *qiang*, *xuan* and couching. This is an excellent and refined piece of work from among those in daily use in the Qing imperial household.

171. Detail of yellow *duan* embroidered chair-cover with design of paired phoenixes
Qing

This cover has a yellow *duan* ground and the embroidery is mainly done in *souhe*-stitch, giving the design a rich, painted feel. The central design is circular, composed of two confronted phoenixes among scrolling stems, and surrounded by more scrolling peonies. The phoenix is the queen of birds and the peony the queen among flowers, so their combination on goods for the imperial household is symbolic of the respected position of the empress and imperial concubines.

172. Detail of dragon robe
Qing

This is one of the dragon robes worn by the emperor Guangxu. The dragon's body is embroidered using the fish-scale technique with rolled gold thread on a *duan* ground. The dragon is a five-clawed imperial dragon, placed on the chest section of the robe. The darker area of fabric with two small dragons is the decorative edging on the right-front section of the robe.

173. Detail of embroidered chair-cover with design of swastikas and 'riches, honours and blessings'
Qing

This piece has a *duan* ground, primarily embroidered with *pu*-stitch. The design has a background of alternating swastikas and cruciform flowers. The main motifs are a large peony (symbolic of wealth and rank) and a bat (harmony and blessings), which are framed by a longevity lock composed of scrolling leafy branches which extend outwards to the four corners. The colouring is elegant and harmonious.

174. Chair-cover with appliquéd design of *taotie* mask and *kui* dragons
Qing

On this piece, black *duan* has been cut to the desired design, applied to a yellow *duan* base and then stitched with a border of fine white thread. The same white thread has been used to provide details within the main shapes. The design takes its theme from the sacrificial vessels of the Three Kingdoms period. At the top of the design is a square animal mask with two horns curved like those of an ox, 'with a head and no body', and thus approximately like the *taotie* mask found on Shang and Zhou bronzes. In the lower part of the design are *kui* dragons confronting each other. The *Shan hai jing* (*Classic of Mountains and Seas*) and other historical sources describe the *kui* as 'a *qing*-coloured body shaped like an ox without horns' and 'like a dragon with one foot'.

175. Red woollen wall hanging with embroidered design of cranes and clouds
Qing

This embroidery is worked on a fresh-coloured red wool ground with smooth nap, and is an innovation of the Qing period. The forms of the 'longevity' cranes are varied and the cloud designs include floating clouds, *ruyi*-shaped clouds, large clouds, flat clouds, seven-part clouds, etc., all with delicate shapes. The pattern is arranged symmetrically along an axis so that the multifarious design has a certain stability.

176. Detail of chair-cover with circular design of nine peaches
Qing

The main motif of this example is composed of peaches, bats and swastika characters, which provides the rebus 'ten thousand blessings and ten thousand years of long life'. This is surrounded by a swastika lattice with peonies, bats and 'longevity' peaches providing the wish for 'wealth, honour, blessings and longevity'. The ground material is a yellow *ling*, and the pattern is mainly in *pu*-stitch. The embroidery of peaches, branches and leaves is so arranged as to give them a feeling of solidity. The swastikas are outlined in gold thread.

177. Detail of chair-cover with embroidered design of flowers
Qing

This has a yellow two-warp crossed *sha* gauze weave as the base fabric, embroidered in *na* (woven-in) technique using the holes of the weave as a matrix. This kind of embroidered

article is also called *sa* (sprinkled thread) embroidery or *na sha*. The design is composed of sprays of flowers – peonies, hibiscus, peach blossom and chrysanthemums – depicted both realistically and economically. The thickness of the embroidery thread used is everywhere roughly the same, except for the stamens of the flowers which are thicker. The length of the stitches is also quite constant so that the design formed is uniform. However, the arrangement of the entwined branches of the design is ingenious and therefore not at all stiff.

178, 179. Details of embroidery with design of a group of immortals meeting to offer blessings
Qing

These illustrations show details of the embroidery reproduced to different scales. Plate 178 illustrates a section from the centre-front of the horizontal pictorial band. It is in the style of the New Year pictures and takes its theme from Daoist legends and stories from traditional opera. Each individual in the crowd of figures in the centre of the picture is sumptuously attired. One is riding on a deer and one is astride a phoenix, but all have the appearance of wealth and honour yet lack the dignified bearing visually shown by immortals.

180, 181. Full view and detail of embroidery with design of officials wishing the emperor long life
Qing

This embroidery depicting officials drinking to the longevity of the emperor is a typical example of a Bian (Kaifeng) embroidered gift of the late Qing period. This type of handscroll form was produced by sewing two strips of fabric together, one forming the main design and the other to give a decorative border. The whole piece is added to a yellow *juan* mount with decorative tassels knotted to form a net-like structure. It is 488 × 106 cm, the main section being 76 cm across and the border 30 cm. The subject of the design is Guo Ziyi and his sons and sons-in-law. There are twenty-seven figures in all, including Guo Ziyi who is depicted in the centre wearing a kingly expres-

sion. The figures attired as officials are his sons and sons-in-law, and there are three guests, one contemplating a game of chess, one listening to music and one practising calligraphy. There are also nine attendant youths heating, ladling, carrying and pouring wine. The base material is a crimson *duan* and the picture is full of life and bustle. The towers and pavilions have no three-dimensional feel at all, and resemble the backcloths of a stage. This may be explained by the fact that the concept of this design originated in the theatre. Even though historically Guo Ziyi suffered many difficulties and hardships throughout his life, in folk stories and operas he was regarded as an ideal figure possessing the 'three perfections' – good fortune, rank and longevity – and was called Songheyanxian (kindly, handsome and admired).

182. Detail of a Bian (Kaifeng) embroidery (peach and plum section) with a design of eighteen scholars
Qing

This embroidery is similar in style to that shown in plates 180 and 181. The section here depicts the story of Yu Boya and Zhong Ziqi of the Western Zhou period. Yu was skilled at playing the *qin*, and his music evoked the tall mountains and flowing streams. Zhong Ziqi would listen and understand the music. After Zhong's death Boya broke his *qin* saying that only Zhong understood his music. In this depiction Boya is dressed as a Qing court official (he was a councillor in the State of Jin) and next to Zhong is a bundle of firewood (he was a woodsman, although he is dressed as a member of the gentry). In the background are high mountains and flowing water. The advantage of this handling of the picture is that it is easy to understand.

183, 184. Details of large Bian (Kaifeng) embroidery of the twenty-four acts of filial piety
Qing

There are two pieces of Kaifeng embroidery at Sheqi which take the twenty-four acts of filial piety as their theme. This is the larger of the two. In the whole depiction all the different stories are independent of one another.

The titles of the stories are shown in black stem-stitch, as, for example, 'Controlling the tiger to save his father', 'Never idling in the service of his stepmother' and 'Gushing spring and leaping carp'.

185, 186. Detail and full view of small Bian (Kaifeng) embroidery of the twenty-four acts of filial piety
Qing

This is the smaller of the two pieces of embroidery with this theme at Sheqi, hence its name. In fact, only sixteen stories are depicted instead of the full twenty-four. Among them, 'Controlling the tiger to save his father' and others are the same as those shown on the larger embroidery, but they do not have inscribed titles. The style and form are basically the same as on the larger piece.

Plates II

187. Silk woven material from a bronze spear
Shang

The bronze spear was excavated from the Shang-dynasty ruins at Anyang, Henan Province. This fragment of silk material was originally part of a sheath for the spear. It is still possible to discern that the material has a *qi* weave with a four- or six-end floating pattern on a plain-weave ground. This is the earliest extant damask-type silk woven material in the world.

188. Woven woollen material
Warring States

This fragment has a plain weave with fine dense warps and coarse sparse wefts. The difference in thickness and density between the warps and the wefts is considerable, giving the material a horizontal relief effect. The number of turns in the twisted warps and wefts is quite large and the material is also tight and even.

189. Cloth printed with scattered dots
Warring States
This was excavated from the Warring States tomb at Guixi in Jiangxi Province. It has a plain-weave base and is woven in hemp with a printed pattern in white.

190. Chain-stitch embroidery with winding pattern
Early Spring and Autumn Period
This fragment of embroidery was excavated from a tomb of the Huang state in Guangshan, Xinyang, Henan Province. It has a plain-weave *juan* ground. The doubly outlined winding patterns are first seen on bronze vessels of the middle Zhou period onwards; here, they are produced using chain-stitch embroidery, but arranged more sparsely and clearly than those found on bronze tripods of the same period.

191. Carpet with coloured line design
Eastern Han
Excavated from the Eastern Han Niya tombs at Minfeng, Xinjiang Province. The fragment measures 30 × 10 cm. It is a plain weave with fine warps and coarse wefts, the density being about 19 warps × 15 wefts per cm. Yellow, red, blue, dark-blue and other coloured weft threads have been divided into sections to change the colour, thus producing a multicoloured thick-line patterned carpet.

192. Woollen carpet with coloured design
Eastern Han
Excavated from Han-dynasty ruins at Minfeng, Xinjiang Province. The piece has coloured wefts producing rectangular designs. Crimson, earth-yellow, deep-blue and dark-blue weft colours produce coloured horizontal lines and 'excavate' the woven design. This should probably be classed with the woollen tapestry group of woollen fabrics. It is different in some respects from the 'pass warp and return weft' woollen materials excavated from the Eastern Han site of ancient Loulan in Xinjiang. With its 'passed-through weft' coloured stripes and separate sections of 'excavated' pattern it is quite rare.

193. Woollen material with design of tortoiseshell and four-petalled flower
Eastern Han
This fragment was excavated from the Han-dynasty site at Minfeng and measures 24 × 12 cm. The density of the warps is seven three-ply threads per cm and that of the wefts is thirteen two-ply threads per cm. The weft pattern is a yellow tortoiseshell design on a dark-blue ground with small four-petalled red flowers arranged in the centre of each shell marking. The design and the ground are quite distinct. The colours are fresh and harmonious and the design is in the style of the Central Plain area.

194. *Jin* with *zhuyu* design
Western Han
This fragment was excavated from tomb No. 1 at Mawangdui, Changsha. It makes use of a layered-warp weave structure with an alternating inner and outer warp. The pattern repeat is 8 × 6.9 cm, the density is 153–156 warps × 40 wefts per cm and the warp threads are three-ply.

195. *Jin* with horse design
Eastern Han
This is a typical Han-dynasty animal-patterned warp *jin*.

196. *Jin* with deer design
Eastern Han
This has a layered-warp weave structure with outer and inner warps alternating to produce the design.

197. *Jin* with wave design
Eastern Han
This was excavated from the Han-dynasty site at Minfeng. The fragment is a three-over, one-under, two-coloured warp *jin*. Vermilion warp threads in a damask-type weave produce the regularly undulating wave design. The upper part has square shapes arranged like castles built against the mountainside. The design is succinct but still has folk characteristics.

198. *Jin* with design of paired sheep
Eastern Han
See plate 24.

199. *Jin* with design of elephants
Eastern Han
See plate 22.

200. *Jin* with design of fish and frogs
Eastern Han
This has a layered-warp structure; inner and outer warps alternate to produce the design. The design is primarily composed of fish and frogs and is plain and crude in form – the sort of design prevalent in the painted pottery culture of the middle neolithic period in China, but rarely seen on Han-dynasty *jins*.

201. *Jin* socks with lozenge design and 'yang' character motif
Eastern Han
See plate 20.

202. *Jin* with design of 'ten thousand lifetimes of wishes fulfilled'
Eastern Han
See plate 17.

203. Cotton fabric with batik design of figures
Eastern Han
See plate 25.

204. Embroidery with *zhuyu* design
Western Han
This embroidery, an excellent example of the imaginative power and technique of the traditional art of Chu embroidery, was excavated from tomb No. 1 at Mawangdui, Changsha. It has a brownish-red *juan* ground and embroidery threads in vermilion, crimson, earth yellow, golden yellow, cloud purple and deep blue have been used to embroider the *zhuyu*, *ruyi* heads and scrolled-cloud designs in chain-stitch. Its surface and lines are both quite robust but nevertheless smooth. The elongated, peach-shaped, embroidered phoenix heads seem to have the feeling of rosy clouds and rolling mist, and indeed this piece is described in the list of grave goods as a bright rosy-cloud embroidery. The phoenix heads have

lozenge-shaped eyes embroidered in the middle with closely packed circles of single rows of chain-stitch to give them expression.

205. Embroidery with design of ascending clouds
Western Han

This embroidery was excavated from tomb No. 1 at Mawangdui, Changsha. It has a brownish-yellow gauze background with lozenge pattern, on which *zhuyu*, scrolling-plant and other fine designs have been embroidered in deep-vermilion and pale-vermilion threads. The *zhuyu* are arranged in rows and placed within the woven lozenge shapes of the gauze ground, with the delicate designs of the scrolling plant and clouds embroidered in the gaps. The principal stitch is chain-stitch, used in multiple rows for the *zhuyu* design and in single rows for the scrolling-plant and cloud designs. It is possible that this is the precursor of the scrolling-plant designs (the Tang grass design among them) of later times.

206. Decorative embroidered banner border depicting King Huang Yang supplying men
Northern Wei

This banner was discovered in the Mogao Caves at Dunhuang. The embroidered border measures 50 × 13 cm and has a brownish-yellow *juan* ground. Earth yellow, golden yellow, sapphire, dark blue and vermilion have been used to embroider the design of yellow tortoiseshell and four-colour circles. These are embellished in the centre with honeysuckle embroidered in multiple rows of chain-stitch; the border is outlined in single rows of chain-stitch in different colours, and knot-stitch is used for the continuous dot pattern on the tortoiseshell design.

207. Jin with design of animals and birds
Eastern Jin

This fragment was excavated from the tombs at Astana, Xinjiang Province. At the beginning of the Eastern Jin period the former Liang Zhang clan seized territory to the west of the river and founded Gaochang. The design of symmetrical pairs of standing confronted birds and animals is slightly different in style from the background of various soaring scrolling-cloud patterns of the type often seen on Han animal-and-bird *jins*.

208. Embroidery with design of grapes, animals and birds
Northern Liang

This fragment was excavated from a Jin-dynasty tomb at Astana and measures 23 × 17 cm. It has a yellow *juan* ground with an embroidered design of red and purple grapes and vermilion and dark-blue deer's heads and ducks' bodies – although the complete forms are not intact on this fragment. *Qiping*-stitch is the main one used, but the ducks' wings and legs and the deer's heads and necks are outlined in chain-stitch. The design conveys the Xinjiang sentiment 'the grapes are ripe'.

209. Jin with wood design
Northern Liang

This piece was excavated from a tomb at Astana. This kind of geometric design, inspired by wood grain, is rarely seen in the dyed and woven goods of ancient China.

210. Jin with design of auspicious animals
Northern Dynasties

This is one of the fragments excavated from Astana.

211. Jin with lozenge-and-honeysuckle design
Northern Dynasties

See plate 28.

212. Jin cover with design of paired sheep
Northern Dynasties

See plate 30.

213. Jin with design of camels being led and *hu wang* (barbarian king) characters
Northern Dynasties to Sui

This layered-warp twill weave with a warp pattern was excavated from the Astana tombs. The fragment measures 19.5 × 6.7 cm. The main design is of men leading camels, with the characters *hu wang*. Each unit of the pattern is inside a circle of linked pearls.

214. Jin with design of confronted birds
Northern Dynasties

This fragment was excavated from the Astana tombs. This type of *jin* design, which was common in the Northern Dynasties period, gradually declined after the sixth century.

215. Jin cover with design of confronted peacocks inside circles of linked pearls and 'honour' characters
Northern Dynasties

This was excavated from tomb No. 48 at Astana and measures 18.5 × 8.7 cm. It is a weft-twill *jin*. The warp threads are each made of two strands of silk with a density of 25 threads or 50 strands per cm, while the wefts are made of one strand each of blue, white and red with a density of 18 threads or 54 strands per cm.

216. Tie-dyed cloth with fish-roe design
Northern Dynasties

This was excavated from Astana. Millet seeds were used in the tie-dyeing process to produce a typical design.

217. Resist-dye stencil printed *juan* with design of scrolling plant and posy
Northern Dynasties

See plate 33.

218. Jin with design of *luan* phoenixes encircled by linked pearls
Tang

This fragment was excavated from Astana and measures 17.8 × 15.5 cm. It is a weft-twill *jin*. It has a density of 21 warps × 21 wefts per cm, the latter being made of single strands of red and white silk.

219. Jin with design of bird encircled by linked pearls
Tang

This piece was excavated from Astana.

220. _Jin_ with design of 'heavenly' horse and knight encircled by linked pearls
Tang

This weft-twill _jin_ was excavated from tomb No. 77 in the northern region of Astana; it measures 13.5 × 8.1 cm. The warp threads are three-ply with a density of 20 threads or 60 strands per cm. The wefts are made up of blue, green and white strands with a density of 26 threads or 78 strands per cm. The appearance and attire of the knight distinguish him from Han-dynasty figures.

221. _Jin_ with design of boar's head encircled by linked pearls
Tang

This fragment was excavated from tomb No. 138 at Astana. It measures 16 × 14 cm and was originally a cover. It has a density of 20 warps × 96 wefts per cm, the wefts being in three colours. The design consists of a wild boar's head with an upturned, long, sharp tusk and outstretched tongue. Above the head is a three-part _tianzi_ pattern.

222. Detail of _qi_ banner with herringbone design
Tang

This was excavated from the Mogao Caves at Dunhuang. It is a weft-patterned _qi_ with a raised design and a density of 42 warps × 38 wefts per cm. It was used as a Buddhist banner.

223. _Juan_ banner with appliquéd flowers
Tang

This banner was excavated from the Mogao Caves at Dunhuang. It has a plain-weave _juan_ ground and an appliquéd pattern of flowers.

224. _Jin_ with blue ground and yellow floral design
Tang

This fragment was excavated from the Tang tombs at Astana.

225. _Jin_ with circular design
Tang

This is a similar material to that shown in plate 35.

226. _Jin_ with design of birds and flowers
Tang

See plate 39.

227. _Jin_ with blue printed design
Tang

This fragment was excavated from the Tang-dynasty ruins in the south-west of Bachu County. Bachu was situated between the garrison towns of Anxi, Shule and Yutian. It was an important site on the northern Silk Road, and _jins_ produced there have a very long tradition.

228. _Juan_ with printed hunting scene
Tang

See plate 40.

229. Brown _juan_ with batik flower design
Tang

See plate 41.

230. _Juan_ with printed flower design
Tang

This fragment was excavated from the tombs at Astana.

231. Rug with twisted pile
Tang

The pile on this carpet has been tied to the ground-weave by knotting. It is now a tattered remnant with the pile worn away in places to reveal the ground. The threads of the pile are quite thick and have been dyed different colours, while the warps and wefts of the ground fabric are quite fine and a reddish brown in colour. The design, within a frame, consists of lozenge-shaped checks, each lozenge outlined in black and white pile then divided into four equal triangles alternately bluish grey and yellowish brown, giving a rich decorative effect.

232. _Ling_ with floral design of 'eternal spring'
Song

This _ling_ has a three-over, one-under, right-twill ground and a one-over, three-under, left-twill pattern. The fabric has been dyed after weaving and has a monochrome pattern dependent for its

effect on the different weaves. The design consists of scrolling stems of flowers and plants which cover the entire surface. It was excavated from the Song-dynasty tomb at Hengyang.

233. _Jin_ with design of lotus on a blue ground
Northern Song

This fragment was excavated from Ala-er in Xinjiang Province. It has a twill ground with the pattern formed by floating wefts. The floral roundels of the design measure 13 × 12 cm, and each is composed of two quite realistic lotus flowers. This example is representative of the _jins_ of the early Song period with its 'drawn from life' design.

234. _Jin_ with design of chrysanthemums, clouds and 'rice' characters
Northern Song

This fragment was excavated from the Huqiu pagoda in Suzhou. It has a single-warp, triple-weft, five-over, one-under, left-twill ground weave with the pattern produced by floating wefts. The fragment is tattered and in several pieces. The one illustrated here measures 15 × 10 cm.

235. Gauze with camellia design
Southern Song

This is a three-warp crossed pattern gauze excavated from Huang Sheng's tomb in Fuzhou. The warps are made from three separate threads, one thick for the crossing warp and two fine for the ground warp. The pattern is a warp plain weave and features realistic flowers.

236. Crimson gauze with design of peonies
Southern Song

This piece of material was excavated from Huang Sheng's tomb in Fuzhou. It is a three-warp crossed gauze with a monochrome pattern. The design is especially unusual: within the larger flowers and leaves of the peonies are woven smaller sprays of flowers and lotuses. It is outstanding in its concept and craftsmanship.

237. Gauze with design of hexagons and prunus blossom
Northern Song

On this fragment, crossing warps and a plain-weave structure have been used to form the sesame-seed ground pattern. Large hexagons have been created amongst these patterns and within the hexagons are five-petalled prunus blossoms, which have been created by varying the weave. This example is very similar to Qing-dynasty sesame-design *shas*. It was excavated from the Song tomb of Huang Sheng.

238. Embroidery with flower-and-plant design
Northern Song

This is a similar material to that shown in plate 250.

239. Gauze with checked and flowered design
Song

This fragment was excavated from the tomb at Hengyang. It has a crossed-warp ground-weave with a weft-twill pattern. The design is of eight-petalled flowers within lozenge-shaped checks. It was made by weaving the fabric and then dyeing it.

240. Brown *ling* robe with decorative border
Southern Song

This garment was excavated from the tomb of Huang Sheng. The lapels and sleeve of the robe are quite narrow. The collar has been sewn on and there are two patterned border strips on the lapels. The facing material is a *ling* fabric, while the lining material is a plain-weave *juan*.

241. Deep-brown, unlined, gauze robe with decorative border
Southern Song

This was excavated from Huang Sheng's tomb in Fuzhou. It has two lapels joining the collar at the neck but does not have sewn-on ties so that when it was worn the lapels would have opened to reveal the undergarment beneath. The fabric used is mainly a four-warp crossed pattern gauze, but the lapels have a plain-weave *sha* lining.

242. Smoke-coloured, unlined, plum-blossom gauze robe with decorative border
Southern Song

This garment was excavated from Huang Sheng's tomb in Fuzhou. The material for the robe is a four-warp crossed ground gauze with a two-warp crossed pattern, while the lapel lining is a plain-weave *sha*. One of the patterned borders is embroidered and the other printed with gold. Some state that this is what was called a *xuan* jacket in historical texts, while others take it to be what is meant by a *beizi*.

243. Detail of border of brown, camellia-patterned, unlined, gauze robe
Southern Song

This robe was excavated from Huang Sheng's tomb in Fuzhou. The wider of the decorative borders is painted. The design has first been outlined in gold and then painted with different colours. The narrower border is gold-appliquéd and printed – that is, the design has first been printed on to the fabric and then the gold has been stuck on and calendered. The spaces left on the leaves have been filled with a greyish-blue colour.

244. Detail of border of light-brown, unlined, *hu sha* robe
Southern Song

This robe was excavated from the tomb of Huang Sheng in Fuzhou. It is 71 cm long. Both lapels are edged with two strips. The narrower of these is 1.5 cm wide and has gold-appliquéd and printed designs of calamus and floating lotus. The other is 5.2 cm wide and is printed with hibiscus, young children, climbing floral stems and figures in pavilions.

245. Detail of border with brown ground and embroidered gold camellias and millet stalks
Southern Song

This fabric was excavated from the tomb of Huang Sheng. As a discarded remnant, it has not been stitched, and its colours have faded. It measures 90 × 4.8 cm. It has a gauze base with the flowers and their holders made from pieces of gauze stuck to the design and outlined using couching. The leaves are appliquéd dyed cotton outlined in gold couching. The centres of the flowers are depicted in knot-stitch embroidery and the stems in *bian* embroidery. The spaces between the flowers and leaves have been painted.

246. Detail of border of brown patterned *ling* jacket
Southern Song

This was excavated from Huang Sheng's tomb in Fuzhou. The narrower strip has a design of printed and appliquéd patterns while the wider strip employs many different embroidery stitches: the leaves are depicted using couched gold thread, the flower petals are in fine oblique *qi*-stitch, the leaf stalks are in *bian*-stitch and the centres of the flowers are in knot-stitch.

247. Waist pendant of bronze-coloured gauze with embroidered floral design
Southern Song

This object was excavated from Huang Sheng's tomb, where it was stored inside the bundle of funerary objects. It measures 195 × 6.2 cm and has a four-warp crossed gauze ground. Each unit of the design is composed of more than ten varieties of flower, including peonies, hollyhocks, pomegranates and Cape jasmin. The round medallion attached to the bottom is gold and has a relief design.

248. Blue silk cushion-cover with embroidered design of paired birds and sheep
Northern Song

This square cushion-cover has been embroidered using appliqué, *qi*-stitch and *xiang* and *na* techniques. The colours are fresh and bright, the design is regular but vivid. It is a fine piece of folk embroidery and has a very lively feel to it.

249. *Dalian* (bag) made of yellow patterned *duan* with appliqué embroidery
Song

This *dalian* was probably made in two parts to be fitted over the girdle when worn. When folded, the two sections

hanging down would have formed money bags. These were popular in the Song and Yuan dynasties and this is the earliest extant example.

250. Embroidery with flower-and-plant design
Northern Song
This fragment was discovered on the second storey of the Huqiu pagoda in Suzhou, built in the second Jianlong year (AD 961). The piece measures 230 × 130 cm. It has a four-warp crossed gauze base and a design of lotus and water-chestnut flowers. *Qi-*, *zheng-*, *qiang-* and *souhe*-stitches have been used.

251. Perfume bag with embroidered design of bird and millet
Liao
This bag was excavated from a Liao tomb at Yemaotai, Liaoning Province. It has a deep-brown *sha* ground, and brown and gold embroidery thread has been used for the design of a bird's head with a stalk of millet in its beak. The bird's head and the stalk of millet have been done in *qi*-stitch, *xuan*-stitch and *puwen*-stitch. The beak, eyes and other areas are depicted in gold couchwork, while the bird and the millet stalk are outlined in couched silver thread. The encircling frame has been produced using a chain-stitch with two rows of couched silver outlining it inside and out. The outer edge of the perfume bag is decorated with a type of chain-stitch.

252. *Ling* with design of swastika characters
Late Yuan
This is the facing material for a lined jacket; it was excavated from the tomb of Madam Cao in Suzhou. The *ling* weave has a design of swastika characters which appear in slight relief.

253. *Kesi* with *qing*-green ground and pink floral design
Yuan
This fragment was excavated in Xinjiang Province. It measures 31 × 16 cm. The shaded effect of the flowers has been enhanced by threading the colours with a shuttle, and the technique of 'odd and even, son and mother' warps gives a raised pictorial effect.

254. Partially embroidered skirt with decorative border
Early Yuan
This was excavated from Qian Yu's tomb in Wuxi. It is made of silk with an embroidered pattern border on gold gauze. The design is of a monkey scroll.

255. *Jin* with design of paired dragons playing with balls
Ming
This was used as mounting material for an edition of the *Buddhist Canon* printed during the reign of Wanli. It has a warp ground with a floating weft producing the pattern. The design is of small three-clawed dragons playing with balls inside an ogival frame with a design of water and banks directly below them.

256. *Jin* with design woven in silver
Ming
This material was used as a mount for a Wanli period *Buddhist Canon*. The main design is formed by floating wefts made of flat-silver threads on a monochrome patterned ground. The design includes 'longevity' characters, various treasures, clouds and a crane, although the whole of the pattern cannot be seen in this illustration.

257. *Jin* with design of *ruyi*-shaped clouds and cranes
Ming
This *jin* was used as a mounting material for a Ming edition of the *Buddhist Canon*. It has a warp ground and a weft pattern. The warp threads are *qing* green and the wefts are spice-coloured. The design is of a crane holding a *lingzhi* fungus in its beak and encircled by clouds.

258. *Jin* with 'hidden' design of waves and dragons
Ming
This *jin* was used as a mounting material for a Ming edition of the *Buddhist Canon*. It has a warp ground and a weft pattern. The warps are pale ochre and the wefts dull red, so that the design is rather indistinct. Four-clawed flood dragons among waves cover the entire fabric.

259. *Duan* with *qing*-green ground and design of clouds, 'longevity' characters and gold dragon
Ming
This has an 'excavated' pattern on a warp *duan*. The dragon's scales and the 'longevity' character are depicted using rolled gold thread in an 'excavated' weave, while the coloured clouds and various treasures (this illustration only shows a rhinoceros-horn and stone) are 'excavated' using coloured nap wefts; gold thread is used for the outlines.

260. Silk with design of overlapping clouds
Ming
The pattern on this material is produced using long threads to depict layered clouds. It is a monochrome patterned silk and is rare among Ming woven articles.

261. Silk with deep-yellow ground and cruciform design
Ming
This was used as a mounting material for a Wanli *Buddhist Canon*. The geometric design is made up of small square and rectangular areas, and is fairly typical of its kind.

262. *Na* embroidery with 'precious flower' and peony design
Ming
The technique used on this embroidery is rather special. *Qi*-stitch embroidery is added to a monochrome foundation which completely covers the ground using twisted threads of the same colour as the ground. The stitches are long and overlap, giving the design a solid appearance. The technique transforms a plain and simple folk embroidery.

263. Detail of purplish-red gauze dragon robe with design of clouds and cranes
Qing
This is a similar robe to that shown in plate 146.

264. *Jin duan* with peony design
Qing

This fabric has a warp-*duan* ground with a weft pattern. The weft threads were passed through the whole width of the cloth using a shuttle.

265. *Duan* with blue ground and 'honour and rank' design
Qing

This piece has a warp-*duan* ground and a multicoloured weft pattern. The flowers are outlined in white, rather than gold or silver, to provide a contrast.

266. Detail of *duan* robe with scarlet ground design of clouds and dragons
Qing

This robe would have been worn by an actor taking the part of a python. Rolled gold thread is used for the dragon's body, while the clouds are multicoloured and outlined in woven flat gold. The ground is a warp *duan*.

267. *Jin* with 'precious flower' design and added gold
Qing

This elegant hand-rest has a warp-faced twill ground and a multicoloured weft pattern, with gold thread used for outlines. A twill weave is also used between the floating wefts. The shape and coloration of the design place this example in the category of Song-style *jins*.

268. *Duan* with design of flowers, plants and 'much good fortune'
Qing

This material was cut lengthwise and sewn together to make a Buddhist banner. The illustration shows the straight seam where the pieces were joined. It has a warp-*duan* ground and a floating-weft design of bats and sprays of flowers. The background is vermilion, the flowers pink, the leaves green and the branches, stalks and vines yellow. It is colourful without being vulgar. The form of the sprays is splendid.

269. *Duan* with design of swastikas and 'riches and honour'
Qing

This is part of a Buddhist banner. It consists of an 'autumn spice' coloured warp-*duan* ground and pale-yellow floating wefts depicting a ground design of swastika lattice. In addition, peach-red and indigo-blue floating wefts produce the main design of sprays of peonies. The floating wefts are fixed by the ground warps since there are no special binding warps.

270. *Jin duan* with swastika ground and design of eight auspicious objects
Qing

This is a Buddhist banner of several strips sewn together to produce quite a large design. The section shown in the illustration has the Dharma wheel, endless knot, conch, precious canopy and precious jar.

271. Actor's *duan* costume decorated with five-clawed golden dragons
Qing

This decorated costume has a long collar and facing lapels, large sleeves and slits on either side at the hem. It is called a 'man's cape', and was used in plays as the everyday dress of the emperor and civil officials, and as the normal wear of the gentry. The design of five-clawed dragons was used by those playing the part of the emperor and princes.

272. Embroidered and *kesi* perfume bags
Qing

The centre perfume bag in this illustration is embroidered in knot-stitch. The two on either side are tapestry weave, employing the techniques of *gou* and *qi*. Gold thread is used for the ground and can be seen in the gaps in the design of flowers and fruit. Although the bags are small, the work on them is extremely fine, and their colours are elegant and refined.

273. *Kesi* with design of coloured clouds and bats
Qing

This tapestry is of the same type as that shown in plate 137.

274. Embroidery with coloured roundel design
Qing

This embroidery uses similar techniques to those shown in plates 162 and 163.

275. Hand-rest with Fuchuan matting and embroidery
Qing

This item combines the skills of appliqué embroidery, *xiang*, *na* and others. In the centre and in the four corners, is a Fuchuan mat design with plaited 'gold-silk' and previously cut appliqué flower designs placed on top and supplemented with *pu* embroidery. A *qing*-coloured *duan* is used to mount this and the whole object has an embroidered circular border design.

Picture Acknowledgements

Bishushanzhuang Museum, Chengde, Hebei Province: plates 118–19, 127, 129, 137–9, 141, 144, 146, 148–54, 158–63, 168–77, 265–6, 271, 275; Chinese Museum of History, Beijing: 117, 274; Cultural Relics Research Institute, Dunhuang, Gansu Province: 34, 206, 222–3; Fujian Provincial Museum: 44, 53–5, 72–3, 75, 80, 89, 235–7, 240–47; Gugong Museum, Beijing: 42, 69, 71, 84, 99, 115–16, 125–6, 128, 130–2, 145, 187, 233, 248; Gushan, Fuzhou, Fujian Province: 76, 78, 88, 255–6, 259, 261; Henan Provincial Museum: 190, 194; Hunan Provincial Museum: 2–6, 10, 12–13, 43, 45, 74, 77, 79, 81, 90, 93, 108–9, 204–5, 232, 239, 260, 262; Jiangxi Provincial Museum: 189; Jingzhou Museum, Hubei: 1, 7, 8, 11; Liaoning Provincial Museum: 47–51, 56–60, 68, 110, 147, 166–7, 251; Nanjing Museum, Jiangsu Province: 52; Sheqi County Cultural Palace, Nanyang, Henan Province: 178–86; Suzhou City Museum: 46, 61–3, 66, 85–6, 92, 94–5, 100–105, 111–14, 135–6, 140, 234, 238, 250, 252; Wuxi City Museum: 64–5, 67, 254; Xinggong Museum, Chengde, Hebei Province: 120–24, 133, 142–3, 263–4, 267–70, 272–3; Xinjiang Archaeological Research Institute: 9, 14–16, 21–4, 188, 192, 195–200; Xinjiang Uighur Autonomous Region Museum: 17–20, 25–33, 35–41, 191, 193, 201–3, 207–21, 224–31, 253; Zhejiang Provincial Library, Rare Books Section: 70, 83, 87; Zhejiang Provincial Museum: 82, 91, 257–8; Zhenjiang City Museum, Jiangsu Province: 96–8, 106–7, 134, 155–7, 164–5, 249.

Technical
Terms
Explained

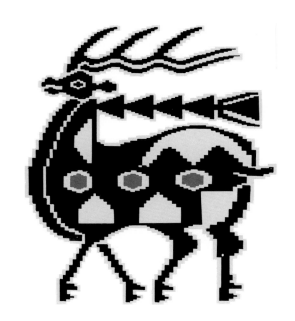

Weaves

1. *Luo* (gauze)

This is a very light woven fabric made of fine silk threads. The warp threads are twisted together to produce what is usually an open fabric.

i. Simple gauze weave. In simple gauze weave the warp threads are twisted in pairs once for each weft thread passed through the shed. The weave can be plain or patterned. The patterned types are produced by combining a plain gauze weave with a tabby weave or floating wefts.

Simple gauze weave

Simple gauze weave Gauze weave with warps twisted in sets of three

ii. Gauze weave with warps twisted in sets of three. This is a patterned gauze. In each set of three warps there is one warp twisted around the other two, which remain in place. The twisting warp winds first to the left and then to the right of the other two warps. There are several variations on this weave, among them those that have a pattern in tabby weave, those patterned with float and those with 'hidden' pattern.

Gauze weave with warps twisted in sets of three and 'hidden' pattern

iii. Gauze weave with warps twisted in sets of four. This type of gauze tends to have a fairly open weave with the openings formed as the four-warp sets twist from left and right. There are two kinds, plain and patterned.

Enlarged detail of plain gauze with warps twisted in sets of four

Patterned gauze with warps twisted in sets of four

2. *Sha* (tabby)

This is a fine, loose, soft, plain-weave silk fabric with square holes. The holes are evenly distributed over the whole of the woven surface as the basic weave has a unit of two ends and two picks, and each end passes over and under one pick. After the Song and Yuan dynasties a compound open-weave material with areas of twisted warp was also, at times, referred to as *sha*.

Sha

3. *Hu* (crêpe)

Hu is a form of *sha* with an uneven surface effect of raised and indented areas resembling clouds. It is formed by using yarn made of doubled grège threads which have been thrown to the maxi-

mum (i.e. have been tightly twisted) for both warp and weft.

Hu

Enlarged detail of *hu*

4. *Qi* (patterned tabby)

Qi is a woven silk fabric with patterns formed by warp or weft floats. The design can be formed either by successive warps or successive wefts, or by every other warp or weft. The latter is known as 'Han-style weave' *qi*.

Successive warp *qi*

Successive weft *qi* Alternate weft *qi*

5. *Ling* (twill weave)

This is a woven silk fabric with a pattern formed by a basic binding system with a unit of three or more ends and three or more picks, in which each of the ends passes over two or more adjacent picks and under the next one or more.

i. Single-direction *ling*. This is also called separate-unit single-direction *ling*. The fabric is produced using a weave unit in which the warp and weft sequences are different, but the floats forming the pattern all go in the same direction.

Single-direction *ling*

ii. Different-direction *ling*. This is also called single-unit different-direction *ling*. It has a warp and weft with even weave units, and floats that go in different directions and form both pattern and ground.

Different-direction *ling*

Enlarged details of different-direction *ling*

6. *Duan* (satin and damask)

This refers to all types of plain and patterned silk materials that have a satin weave. The satin binding system is based on a unit of five or more ends and a number of picks equal to, or a multiple of, the number of ends. Each end passes over four or more picks and under the next, or vice versa, with the binding points off-set on successive picks to give the appearance of the entire surface being covered. The result-

ing material is smooth, lustrous and particularly fine. With a floating warp it is called warp-satin and with a floating weft weft-satin.

i. Reversible five-end damask. This was called 'five thread' in ancient times. It has a five-end warp-satin ground and a five-pick weft-satin pattern. The principal use for this weave was for making monochrome patterned damask; it was common in the Ming dynasty.

Reversible five-end damask

ii. Six-end satin. Also called 'six thread' or six-end non-reversible standard *duan*. It has a weave unit of six warps and six wefts.

iii. Reversible eight-end damask. Also known in ancient times as 'eight thread'. It has a ground of eight warps and wefts and a pattern of eight warps and wefts. It is smoother and more shiny than the reversible five-end damask and was fashionable in the Qing dynasty.

iv. Monochrome patterned damask. This has warps and wefts of the same colour and depends on the production of different textures to display the pattern. It is often seen on the reversible five- or eight-end damask weaves.

v. Woven-gold damask. This is a patterned damask with a warp-satin ground and a pattern of floating wefts of gold thread.

vi. Relief-patterned damask. This is a polychrome damask with a special weave structure. 'Excavated' areas tend to be the principal elements in the design. The outer face of this fabric has

many coloured wefts producing a pattern on a warp-satin base, while the reverse side has unfixed floating wefts.

Back of a relief-patterned damask

7. *Jin* (brocade)

Jin is a general term used in ancient China to refer to polychrome warp-faced or weft-faced compound-tabby or twill silk weaves.

i. Warp *jin*. This is a woven *jin* fabric with polychrome warp floats to produce the pattern, mainly popular before the Han and Northern and Southern Dynasties.

Three-coloured warp *jin*

Cross-section of a three-coloured warp *jin*

ii. Weft *jin*. This is a woven *jin* fabric with polychrome weft floats to produce the pattern, most popular between the Northern and Southern Dynasties and the Song. Its weave structure corresponds to that of the warp *jin* but turned through an angle of ninety degrees.

Detail of a weft *jin*

iii. Woven-gold *jin*. In the Yuan dynasty this was also called *nashishi* (from the Persian word '*nasich*'). It is particularly lustrous because of the gold threads woven into it. Both round gold (twisted gold) and flat gold (strips of gold) threads were used.

Detail of a flat-gold *jin*

I	single warp
III	double warp
≡	gold thread (double)
■	ground weft
∘	warp thread

Weave structure of twisted-gold *jin*

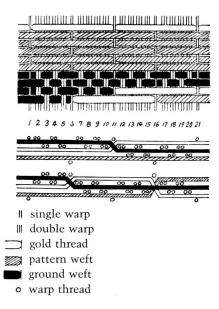

II	single warp
III	double warp
⊐	gold thread
▨	pattern weft
■	ground weft
∘	warp thread

Weave structure of flat-gold *jin*

iv. *Zhicheng*. These were 'excavated' pattern-weaves which used an additional polychrome brocading weft (a supplementary weft introduced over the basic weave). At one time it was specifically intended to be used for clothing and adornments. Both silk and wool fibres were used and it was introduced during the Han dynasty when this type became differentiated from the normal *jin*.

v. Shu *jin*. This is the general term for the characteristic *jins* produced in the Shu area (modern-day Chengdu in Sichuan Province) during the Han and the Three Kingdoms period. Originally they were all warp *jins*, but after the Tang dynasty the skills of weft-patterning were gradually incorporated into their production. The style and patterns developed and evolved, but the use of bright red and of coloured lines in the direction of the warp has remained characteristic of these Shu *jins*.

vi. Song *jin*. These are layered-weft *jins* with three-layered wefts producing the pattern. They started to become fashionable during the Song dynasty. In later times binding warps and a three-end warp-twill were used. These fabrics were primarily used for the mounting of paintings and calligraphy.

vii. Cloud *jin*. This is a general name for the traditional *jins* produced in the Nanjing area. The three major types are relief pattern, *ku* (storehouse) *jin* and *ku* damask. They emerged in the Yuan dynasty and reached their peak in the Ming and Qing dynasties, but the name itself developed fairly late.

viii. *Gaiji*. Also known as double-layered *jin*. This is a double-weave silk which produced two layers of plain weave simultaneously, one above the other, the two textiles changing position (above or below) as required by the pattern. It was fashionable during the Ming.

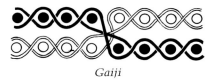

Gaiji

8. *Rong* (velvet)
This is a silk woven material in which a pile is produced by raising either warp or weft threads above the ground-weave, the loops of which may be left as loops or cut to form cut pile.

i. Looped-pile *jin*. This is a *jin* with a raised pattern surface of different-sized loops of floss. It was invented in the Han dynasty.

ii. Zhang *rong*. This is a raised-pile silk woven fabric which, according to tradition, originated in Zhangzhou in Fujian Province. It consists at its most basic level of a variety of unpatterned weave (solid velvet), but a pattern may be added to its surface by using cut loops in certain areas. The unpatterned variety is called 'plain' *rong* while the patterned type is called either 'carved patterned' *rong* (cisele velvet) or 'patterned' *rong* (voided velvet).

section of *rong* with wefts not already taken out

section of *rong* with wefts taken out

Weave structure of a looped-pile *rong*

A	B	C	D
base pattern warp I	velvet loop warp	ground warp	base pattern warp II

Diagram of carved pattern *rong*

Horizontal cross-section

Cross-section of Zhang *rong* showing
the fixed rods
(top) 3 wefts fixed
(bottom) 4 wefts fixed

iii. Zhang satin. This refers to a compound-velvet-type silk woven fabric which combines a warp-faced satin pattern with a method of introducing rods during the weaving to raise loops above the ground-weave, thus producing both pattern and ground. It is also possible to add a gold weave to the basic weave. This velvet-based weave uses the W-shaped method, and wefts of varying thickness are arranged to produce a pile that stands upright. Tradition has it that this fabric originated in Zhangzhou.

iv. Double-faced *rong*. This is a silk woven material with a raised pile on both sides, which emerged during the Ming dynasty.

before cutting

after cutting

Double-faced *rong*

9. *He* (woollen twill)
This is a general term for a twill-weave fabric made using thick wool thread.

10. *Ji* (fine wool)
This is a fine woollen fabric made using a compound weave.

11. Wool carpets
These are thick, heavy, wool woven fabrics used for rugs. There is the type which has no pile, such as the Tibetan rug woven in 2/2 twill (the *pulu*, made of yak's hair), and the type that has an inserted knotted pile. The latter can be divided into those using an S-shaped knot and those using a hoof-shaped knot.

Knotted pile rug
with horse-hoof knots

Pulu weave

12. *Zhan* (felt)
To produce this material, animal hair (usually sheep's wool) goes through a process of humidification, heating and extrusion to turn it into a non-woven material in which the fibres are matted together. The fabric exploits the scaly surface of the woollen fibres and the way that they contract in certain conditions.

Silk Tapestry

1. *Kesi* (silk slit tapestry)
This is made by the technique of 'passing the warp and returning the weft' (i.e. where colours meet, the weft threads are returned around adjacent warp ends). An ordinary, light, plain-weave wooden loom is used. A separate boat-shaped shuttle (about 10 cm in length) is used for each different coloured thread and the pattern is worked section by section. This particular method of weaving results in slits and small gaps in the finished tapestry between the pattern and the base colour and between the different colours within the pattern, and it is, therefore, also known as 'carved' or 'cut' silk. It is also called 'subjugating' silk because the thick polychrome weft completely masks the fine plain warp.

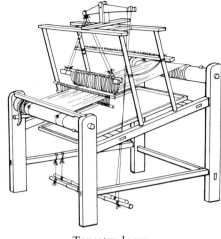

Tapestry loom

Boat-shaped shuttle

2. *Qi* tapestry technique
This is the technique whereby the design and the colours are painted lightly on to the warps as a guide, thick wefts of matching colours then being used to weave each area and section using a plain weave, hence its name '*qi*' (regular) or 'plain weave' tapestry. A clear vertical 'water road' is left between areas of different colours.

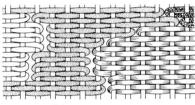

Qi tapestry weave

3. *Qiang* tapestry technique
In this technique, coloured wefts of different tones are used, and the parts of the tapestry are woven in such a way that the change from one colour to another is gradual. In this kind of tapestry, two or more neighbouring colours 'vie for' (*qiang*) the area where they meet, or are blended according to the outline and form of the design. It is generally used to depict layered wave or cloud motifs, but has also been used for flowers and leaves.

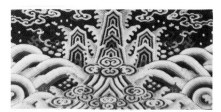

Qiang tapestry (see plate 139)

4. *Gou* tapestry technique

This technique involves outlining clearly the edges of the individual motifs with gold or different-coloured threads. There are single and double *gou* tapestries, in both of which there is an effect of demarcating colour changes and defining outlines.

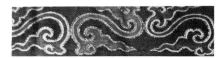

Gou tapestry

5. *Tao* tapestry technique

In this technique, thick wefts of different tones are used and in the areas between the different colours, these are made to overlap in sequence, 'dovetailing' (*tao*), thereby reducing the 'water roads' and making the finished tapestry stronger. In this type of tapestry the wefts are short and fairly fine so that the colours displayed change in a harmonious and graceful way with a richness of colour shading. Clouds and feather patterns produced using this technique are smooth and velvety.

6. Zhu tapestry technique

This is the abbreviated name given to the long-and-short *qiang* tapestries made by Zhu Kerou in the Song dynasty. He used weft threads of many different dark and light colours, irregularly dovetailing them to produce a decorative effect of progressively changing colours.

7. Tapestry with gold

This is a general term for Yuan-dynasty tapestries with designs woven using twisted threads of either red or pale gold. In the Ming dynasty, flat-gold threads were also used. The 'three-coloured gold' tapestry of the Qing dynasty used red-gold, pale-gold and silver twisted threads against a deep-coloured ground, which produced a golden, glittering effect.

8. Scale tapestry technique

This technique was used for such details as dragon-scales, fish-scales and phoenixes' wings. Gold thread and thread made from peacock feathers were used to weave the scales (or wings), and each was individually outlined also in gold, which clearly delineated them and gave the design a very solid feel.

Scale tapestry

9. 'Three blues' tapestries

These were basically *qiang* tapestries with a pale ground on which threads in three shades of blue – deep blue, purplish blue and moon blue – were employed, sometimes with the addition of gold thread. *Shuimo* (ink wash) tapestries are those which use the three tones of black, dark grey and pale grey against a pale ground to produce designs. The designs are outlined in either a dark colour or white and are elegant and sombre.

10. Embroidered and painted tapestries

These are articles which have primarily been made using tapestry techniques, but where the tapestry weave has been augmented by embroidery and painting.

Printing and Dyeing

1. Wax-resist or batik technique

On items produced using this technique, insect wax, beeswax or resin is used as the dye-resistant substance. After waxing, the fabric is put into the dye solution and the wax is later removed using boiling water; the pattern appears in white against the coloured ground. The most common dye was indigo, but sometimes pigs' blood or animal dyes were also used.

2. Tie-dyeing, or 'bunched' dyeing

Articles produced using this technique are tied in order to resist the dye. The material is bunched up and tied in certain places according to a predetermined pattern, and then immersed in dye. Because the dye is unable to penetrate those parts of the material which have been tied, the finished fabric is patterned. There are patterns with names such as 'young-deer purple', 'fish roe' and 'flowers'.

Tie-dyeing methods and results

3. Resist-dye stencil printing

This is a printing technique in which stencils are placed on both sides of a fabric. The pairs of stencils are clamped together so that the fabric to be dyed cannot move, and coloured paste is smeared on or poured into the holes so that when the stencils are removed the pattern appears. If dye-resistant white paste is applied instead, and the fabric is then dyed, a white pattern on a coloured ground is seen when the white paste is rubbed off the material.

4. Relief-block printing

With this technique, coloured patterns can be applied to a fabric using blocks with the patterns cut in relief. Coloured paste is smeared on to the part of the block left in relief, and the block is then put down in alignment with the pattern on the spread-out fabric, which has already been boiled and scoured. The block is pressed on to the material so that the pattern carved on the block is transferred. Different blocks could be used to add different colours to the pattern unit.

main design

supplementary design

dot pattern

single unit of the finished pattern

Steps used to produce a relief-block printed design

5. Stencil printing

Stencils are placed on previously treated woven material in the correct position for the design. Coloured paste is then applied to the holes in the stencil, thereby directly producing part of the design. If any parts of the design are not continuous with the rest, it is necessary to add some kind of network to link them.

Border-pattern stencil print

6. Mordants

A mordant is a substance used in conjunction with dyes which do not themselves have an affinity with the fibre, in order to fix the colour. Mordants frequently used in ancient China were alum (for madder red) and alunite (for black dyes).

7. Dyeing by immersion

This is the method of dyeing where the material is repeatedly soaked in the dye liquid, constantly being stirred around.

In *Erya: Explanation of Utensils* it is noted that: 'Dyed once and it is called orange, twice and it is called pale red, three times and it is called deep red.' This short passage makes clear the process used for dyeing silks by immersion in the Zhou dynasty.

8. Dyeing with compound colours

This process involves immersing the fabric in a number of vegetable dyes in a specific order to obtain a colour that is a mixture of the original colours. For example, the dye from the indigo plant can be combined with the dye from the flowers of the Chinese scholar tree to produce 'official's green', a dark glossy green. If combined with the dye from the bark of the cork tree it gives a natural green, and with dye from reeds or the bark of the red bayberry it may produce black. Combined with dye from the *Caesalpinia sappan*, indigo can produce sky blue or grape purple.

9. Dyeing by 'tying the warps'

This is the technique where the warp threads, which have been tied into batches, are dyed and then used in conjunction with white or pale-coloured weft yarn to weave a material with extensive areas of floating warp patterning. The principle of tying and dyeing the warps has some similarities to that of tie-dyeing, but the result is quite different.

10. Painting

This is the technique of using paints or dyes to depict the design on woven material or clothing. It was a distinctive feature of the clothes of the Shang-dynasty kings and nobles. In antiquity the technique of painting known as 'vegetable and mineral dyes' was often used. The ground would first be dyed using vegetable dyes, and then the design painted on with mineral-based colours, white being added last for the outlining.

11. Mineral dyes

Dyes produced from finely ground minerals were, in ancient times, called stone dyes.

i. Cinnabar. A bright red colour which is the chemical compound mercuric sulphide. It is also known as *dan* (red) and *dansha* (red sand). The finest cinnabar is *jingmian* (mirror-faced) cinnabar.

ii. Ochre. A dull-red hydrated iron oxide, today called haematite. Its principal component is the iron oxide Fe_2O_3.

iii. *Hu* powder. In antiquity this white colour was used for printing, painting and powdering women's faces. It is also known as white lead. Its chemical ingredients include a basic copper carbonate.

iv. 'Silk cloud' mica. A pale mineral which comes in the form of thin flakes and has a rich lustre like spun silk. Also called muscovite. It is a silicate of aluminium and potassium.

v. Pine soot. A light and extremely fine unset black powder made of carbon. There is also a crystalline allotropic form of carbon known as graphite. Both are formed by the incomplete combustion of organic matter.

vi. Malachite. A green-coloured mineral whose principal component is a basic copper carbonate.

12. Vegetable dyes

These are dyes produced from the leaves, stems, bark, roots or flowers of plants. In ancient times they were called grass dyes.

i. Madder. Also called *qian* grass, *rulu* and congograss. It is a perennial herbaceous climber with reddish-yellow roots. Its principal pigments are alizarin and purple alizarin. When used with the mordant alum, a bright, fresh red is produced. It was especially common in the Shang and Zhou periods.

ii. Safflower. Also called red-blue plant. The petals contain carthamine pigment in the form of carthamine glucoside. The dye can be used directly on many different types of spun and woven fibres to produce a lustrous and fresh red known as 'true red', or scarlet.

iii. Sappan tree. This is a tall tree, also called Brazilwood, or *Caesalpinia sappan*. It belongs to the pulse family and contains sappan pigment. When used with metallic mordants, reds of varying shades are produced.

iv. Indigo. A blue dye extracted from many kinds of plant. Varieties include knotweed indigo, amaranth indigo, tea indigo (Song indigo), acanthanaceous indigo (*Strobilanthes cusia*) and Wu indigo. The process of extraction involves breaking up and kneading the leaves to make an indigo sludge which is combined with limewash to create a dye. This is then fermented and reduced

to form white indigo. White indigo can then be dissolved in an alkaline solution and used to colour fibres. If, after dyeing, there is a process of atmospheric oxidation a fresh bright blue is produced.

v. Hispid arthraxon. Called *lu* green or king's hay in antiquity, it is an annual whose stalks and leaves contain a yellow pigment, the principal component of which is arthraxon. When used with a copper compound mordant it gives a fresh green colour. It was already in use in the Zhou dynasty.

vi. Buckthorn (*Rhamnus davurica*). Also called great green, ice green or red-skinned green tree. The tender fruits and bark contain substances of the arthracene-quinone type which produce a dye when boiled in water. The dye from the fruit contains saffron acid and after steeping in cold water produces a yellow dye. If dyed directly, a fresh yellow colour is obtained, whereas, if it is used with different mordants, different shades and tones of yellow can be obtained.

vii. Cape jasmine (*Gardenia jasminoides*). The Cape jasmine of the madder family is an evergreen and has been cultivated as the plant source of a yellow dye since Qin and Han times. The dye is made from the fruit, which contains saffron acid. Like the fruit of the buckthorn it is steeped in cold water which is then boiled to produce a yellow dye. Different mordants can produce a variety of shades of yellow.

viii. The Chinese scholar tree (*Sophora japonica*). Popularly called yellow scholar tree. The dye comes from the flower stamens and petals which contain rue glucoside; by mordant dyeing, different shades of yellow can be obtained.

ix. *Curcuma aromatica.* A plant belonging to the ginger family. The dye is made from the stalks and, used with mordants, produces various yellows. Fabrics dyed with this substance also smell of it.

x. Asian puccoon (Chinese gromwell). Formerly known as *miao* and Chinese redbud. It is a perennial herbaceous whose roots contain acetyl bloodroot. A purplish-red colour is obtained when it is combined with ash from the Chinese tree of heaven and with the mordant alum. It was used in areas of Shandong Province at the time of the Western Zhou dynasty.

xi. Acorns. The fruit of the oak tree; the outer shells contain a tanning agent. They had already started to be used in the Zhou period to make black dye.

xii. Gallnuts. These are formed from the gall produced on the Chinese sumach tree and other plants by parasitic insects of the *Cynipidae* family. They contain a surprising amount of a substance that can be used directly or with a mordant as a black dye. It has been quite widely used since Tang times.

13. Animal dyes
These are dyes made from substances secreted by animals and used to dye fabrics.

i. Purple lac. This is a resinous encrustation produced on certain trees by the puncture of an insect (*Coccus lacca*). When melted, strained and formed into plates it is known as shellac. If used with an alum mordant it dyes a reddish purple. It was in use before the Tang dynasty.

ii. *Qilin*'s blood. Also known as dragon's blood. Used to produce a red dye. The *Tang Bengcao* (*Tang Herbal*) considered it to be very much the same as lac. Modern analysis suggests that this was a substance secreted by trees, insoluble in water, which when finely ground could be made into a dye to spread on or paint with.

Embroidery Techniques

1. Chain-stitches
These are produced by forming a loop with the embroidery thread so that the resulting pattern resembles a chain. The technique is one of the oldest in Chinese embroidery. The embroidered designs have a 'woven gauze' appearance.

i. Basic chain-stitch technique.

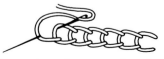

ii. Open-ring chain-stitch. This kind of stitch forms chains which have larger open-ring holes.

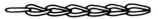

iii. Closed-ring chain-stitch. This is where the needle goes back into the same needle hole that it came out of.

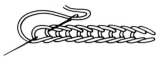

iv. Double-ring chain-stitch. This is the technique whereby each ring is closely fastened to the next one in order to obtain a denser effect.

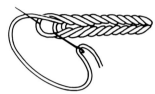

v. Heavy braid chain-stitch. This is a type of chain-stitch in which the needle passes through the thread of the previous loop, thus holding it down, and is pulled tight towards the inside of the stitch, so forming a stitch resembling hair braids.

vi. Split-stitch. This is a backstitch where the needle comes through to the front of the material and pierces the thread of the previous stitch, thus splitting the strands of silk. When this is repeated the effect of the stitch on the surface of the cloth is like that of the closed-ring chain-stitch. It was a development of chain-stitching techniques.

2. Satin-stitches
Satin-stitches are arranged neatly and regularly in flat rows so that no space is left between them, but neither do they overlap. The major stitches in this group are satin-stitch, shading satin-stitch (close-knit stitch), *qiang* (layered short straight) stitch and *souhe* (mixed straight) stitch. The effect of these is to give a gleaming, satin-like surface.

i. Satin-stitch. This stitch is arranged in level rows, hence its Chinese name of 'even' stitch. The different arrangements of the stitching rows can produce divisions into areas of vertical, horizontal and oblique satin-stitch and also open fishbone-stitch. It is generally

used to embroider small flowers and leaves or in large areas to provide a ground layer for the pattern. Open fishbone-stitch is often used for branches and leaves, and for the feathers and fur of birds and animals.

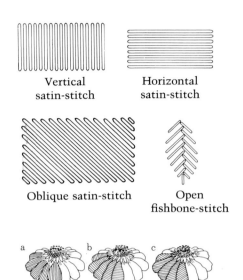

Vertical satin-stitch Horizontal satin-stitch

Oblique satin-stitch Open fishbone-stitch

Flower design executed in (a) vertical satin-stitch, (b) horizontal satin-stitch, (c) oblique satin-stitch

ii. Shading satin-stitches. This technique involves blending together long and short stitches of different colours in the same area. The technique can be divided into single-, double- and multiple-layer stitches. The stitches were frequently used for embroideries which imitated paintings, and on double-faced embroideries as the basic stitch. The technique enables lifelike depictions of flowers and plants, wings and fur.

Single-layer shading stitch is a technique whereby long and short stitches are continuously alternated. The stitches are usually quite long and the embroidery thread fairly coarse. It is most often used for flowers and plants.

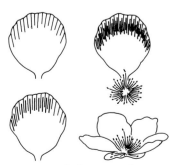

Single-layer stitch

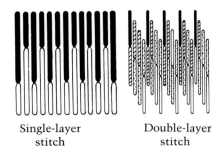

Single-layer stitch Double-layer stitch

Double-layer shading stitches are placed closer together, giving a more dense appearance than the single-layer technique. The stitches are long and arranged in staggered lines, but are shorter where the colours change to facilitate colour blending. This type of stitch was therefore used for embroidering wing feathers and other minute details.

Multiple-layer shading stitch involves the use of stitches of equal length arranged in staggered lines worked from the outside of the pattern inwards. Each stitch is aligned towards the centre of the design so that when the centre is approached the innermost stitches may be hidden. This technique was used principally for circular designs.

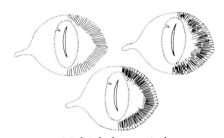

Multiple-layer stitch

3. Encroaching, or straight, stitches

This is a technique whereby long and short stitches are irregularly arranged, layer by layer, according to the shape of the pattern, the earlier and later stitches being linked in a variety of ways. The colours of the threads can be changed to produce an almost three-dimensional shading effect, depending on the tone of the colours used. The realistic and highly decorative effect of large flower petals and wing feathers embroidered in this way is especially impressive.

i. *Qiang*-stitch. This technique uses short straight stitches closely joined in layers according to the dictates of the pattern. When the design is worked from the outside inwards it is known as inward *qiang*-stitch, and when worked from the inside outwards it is known as outward *qiang*-stitch. For areas of the pattern that should appear to overlap, such as flower petals, a strip of the ground fabric is left unembroidered at the junction between the two petals making a 'void', or 'water road'. When coloured threads are used, colour shading to give the effect of light and dark areas can be achieved.

With inward *qiang*-stitch the first row of stitches outlines the outer edge of the design with short straight stitches (see illustration). The second layer overlaps the end of the first layer, and the succeeding layers are stitches in a similar manner.

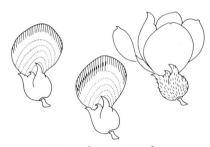

Inward *qiang*-stitch

With outward *qiang*-stitch the stitches go from the inner part of the design outwards, linked end to end, the direction of the threads being the same and progressing in regular order. To take the following example (see illustration): first, a satin-stitch is used to make the first layer and to demarcate the particular areas of the striped pattern on the butterfly's wings. An additional tied thread starts to be used with the second layer – the stitch being made from two slanting threads joining at the end. The stitches of the next row then start from the central point of the dividing line, that is, at the point of the V-shaped tie-stitch, and they are worked from that point out towards the edges.

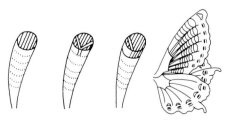

Outward *qiang*-stitch

ii. *Souhe*-stitch. This uses long and short stitches alternately; the spaces between the stitches can be seen. The first row consists of vertical satin-stitches of varying length. The stitches in the second row are of the same variable lengths and are worked in the spaces left by the first row, while the stitches of the third row continue from the ends of the stitches of the first row. The embroidery is worked from the inside of the design outwards. The technique was often used for tree trunks, stones and other inert objects. The harmonious blending of colours was possible and could be altered easily and flexibly so that the design appeared particularly realistic.

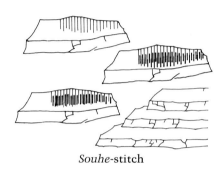

Souhe-stitch

Another kind of *souhe*-stitch is vortex-stitch, where long and short stitches are arranged so that they lie irregularly in an oblique radiating manner as if whirling. Animal motifs embroidered in this way are particularly effective.

Embroidery using vortex-stitch

Fur- or feather-simulating stitch uses stitches of unequal lengths which are produced in rows according to the required texture of the motif. The density of the stitches is gradually increased by the systematic addition of some scattered stitches, making possible a great variety of colour effects.

Feather-simulating stitch

4. Knot-stitches
These are formed when the embroidery thread is wound around the needle before being passed back through the material. When the thread is drawn through and pulled tight, small pellet-shaped knots are formed on the surface of the fabric, hence the name 'ring-seed' embroidery. The embroiderer usually works from the outer edge inwards adding details to the design. Knot-stitch is often used for dot designs, eyes and the stamens of flowers.

Method of forming a knot-stitch
(from right to left)

Different varieties of knot-stitch

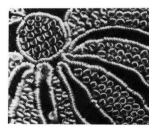

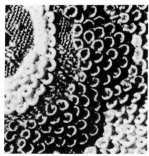

Examples of the use of knot-stitch

5. Appliqué
This is a technique whereby particular parts of a design, which have been prepared beforehand (and can include material such as coloured feathers), can be fixed on the surface of the material with chain-stitch or a short straight stitch.

6. Couching
Couching is the technique whereby fairly thick threads, either single, double or in groups, are overlaid on to the surface of the embroidery using short straight stitches of another finer thread, to form a pattern. When gold or silver threads are used the technique is called 'metal-thread work' or 'level-metal work', and if coiled-gold patterns are produced it is known as 'coiled-metal work'.

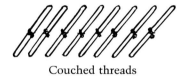

Couched threads

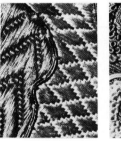

Examples of the use of couching

7. Carved-scale stitch
This is where *souhe*- and *qiang*-stitches are combined to produce the fan-shaped details of fish-scales, dragon-scales and insects' wings. A 'water road' is left between the scales.

scale-layering

scale-laying

scale-delineation
Carved-scale stitch

8. Gauze embroidery, or woven-in designs

This is when the coloured thread is passed through a plain *sha* gauze fabric following the woven pattern. It is called *na sha* when the stitches are used across the surface of the fabric but gaps are left, and *na jin* when the whole of the surface is covered without any spaces, giving the appearance of brocade.

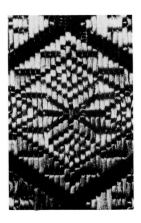

Gauze embroideries

9. Gu embroidery

Gu embroideries use many stitching techniques in order to imitate famous paintings of landscapes, birds, flowers and people. Painting may be used to replace some of the areas that would otherwise be embroidered; the colour shading and layering in the embroidery itself is extremely rich. If hair was used as thread, the embroidery was known as 'hair embroidery', and when pheasants' feathers were used it was called 'feather embroidery'.

Bibliography

1. 賈思勰：《齊民要術》，嘉靖三年刻本。
2. 劉歆：《西京雜記》，乾隆丙午刻本。
3. 王禎：《農書》，農業出版社，1960年版。
4. 許慎著、段玉裁注：《說文解字段注》，成都古籍書店影印嘉慶戊辰刻本。
5. 薛景石：《梓人遺制》，"永樂大典"本。
6. 宋應星：《天工開物》，廣東人民出版社，1976年版。
7. 佚名：《天水冰山錄》，"知不足齋叢書"版。
8. 徐光啓：《農政全書》，崇禎十二年刻本。
9. 李時珍：《本草綱目》，萬曆十八年刻本。
10. 褚華：《木棉譜》，"上海掌故叢書"（1935年版）。
11. 任大椿：《釋繪》，"皇清經解"第六十種收。
12. 朱啓鈐：《絲繡筆記》，存素堂版。
13. Agnes Geijer, *A History of Textile Art*, London, 1979.
14. *Tissus de Touen-houang*, Vol. 13, 1970.
15. Vivi Sylwan, "Silk from the Yin Dynasty", *BMFEA*, No.9（1937）.
16. V. 西爾凡：《額爾濟納河和羅布淖爾出土的絲織物研究》，1949年。
17. 魯博·雷斯尼欽科：《古代中國的絲織物和刺繡》，列寧格勒，1961年。
18. 佐藤武敏：《中國古代絹織物史研究》，風間書屋，1977年。
19. 布目順郎：《養蠶の起源と古代絹》，雄山閣，1979年。
20. 西村兵部：《中國の染織》，芸草堂，1973年。
21. 太田英藏："古代中國的機織技術"，《天工開物研究論文集》，商務印書館，1959年。
22. 內田星美：《日本紡織技術の歷史》，地人書屋，1960年。
23. 陳維稷主編：《中國紡織科學技術史》（古代部分），科學出版社，1984年。
24. 高漢玉等：《長沙馬王堆一號漢墓出土紡織品的研究》，文物出版社，1980年。
25. 《中國大百科全書·紡織》（紡織史分支部分），中國大百科出版社，1984年。
26. 夏鼐：《考古學和科技史》，科學出版社，1979年。
27. 福建省博物館：《福州南宋黃昇墓》，文物出版社，1982年。
28. 新疆維吾爾族自治區博物館：《新疆出土文物》，1975年。
29. 新疆維吾爾族自治區博物館：《絲綢之路·漢唐織物》，文物出版社，1972年。
30. 湖北省荊州地區博物館：《江陵馬山一號楚墓》，文物出版社，1985年。
31. 嚴中平：《中國棉紡織史稿》，科學出版社，1955年。
32. 高漢玉："藁城台西村商代遺址出土的紡織品"，《文物》，1979年第6期。
33. 江西省博物館："江西貴溪崖墓發掘簡報"，《文物》，1980年第11期。
34. 李也貞等："有關西周絲綢和刺繡的重要發現"，《文物》，1976年第4期。
35. 高漢玉："西夏陵區108號墓出土的紡織品"，《文物》，1978年第8期。
36. 高漢玉："從出土文物探溯蠶桑業的起源"，《蠶桑通報》，1981年。
37. 河南信陽地區文管會："春秋早期黃君孟夫婦墓發掘報告"，《考古》，1984年第4期。
38. 浙江省博物館："河姆渡遺址第一期發掘報告"，《考古學報》，1978年第1期。
39. 包銘新："妝花緞初探"，《華東紡織工學院學報》，1983年第3期。
40. 包銘新："中國古代的暗花絲織物"，《華東紡織工學院學報》，1985年第1期。
41. 包銘新："關於緞的早期歷史的探討"，《中國紡織大學學報》，1986年第1期。
42. 包銘新："中國古代的雙層錦"，《絲綢》，1983年第8期。
43. 包銘新："間道的源與流"，《絲綢》，1985年第3期。
44. 高漢玉等：《中國科技史話叢書——紡織史話》，"中國古代紡織技術大事記"，上海科學技術出版社，1978年。
45. 王亞蓉：《中國民間刺繡》，商務印書館香港分館，1985年。

Glossary

This is not a comprehensive glossary of Chinese words in the text. Words that appear only once, with their definition, are not entered. Many Chinese terms have no technical English equivalent; in such cases a literal translation of the character is given instead.

bi	flat jade disc with circular hole in the centre
bian	chain (stitch). Literally 'plait'
chan	'binding' or 'wrapping' (stitch)
dadian	name of a technique. Literally 'to put in order'
dalian	a bag or pouch carried over the girdle
duan	satin
gaiji	double-faced damask
gou	tapestry with defined outlines
he	coarse woollen material. *Also* a crane (a homophone for 'harmony')
hu	crêpe
jianfeng	'cut' (stitch)
jin	brocade or damask
jiqie	backstitch. Literally 'stolen record'
juan	thin, unbleached silk. A type of pongee
kang	bed which can be heated from below
kesi	silk tapestry
leiwen	thunder pattern
ling	twill
lingzhi	fungus (of immortality)
luan	mythical bird
luo	gauze
na	'woven-in' (stitch)
ping	'even' (type of tapestry weave)
pu	'extending' (stitch)
purong	'spread floss' (stitch)
puwen	'extending lines' (stitch)
qi	patterned tabby. *Also* plain-weave tapestry
qiang	graded or overlapping (of tapestry colours). *Also* short, straight embroidery stitch
qilin	mythical creature
qin	lute
qing	the colour of nature. Green, blue or black.
qiping	'evenly arranged' (stitch)
rong	velvet or raised-pile fabric. *Also* floss
ruyi	lappet shape derived from a fungus, its name providing a homophone for 'everything as you wish it'. *Also* a sceptre
sha	plain-weave tabby
shen	'leaking' or 'soaking through' (stitch)
souhe	alternately long and short straight embroidery stitch
taiji	symbol of harmony
tao	dovetailing (of tapestry colours)

taotie	monster mask
tianzi	field character (田)
tiao	'jumping' or 'crossing' (stitch)
xiang	'bordering' (stitch)
xinqi	literally 'sincerity'
xuan	'vortex' (stitch)
ya	couching. Literally 'keeping in order'
yang	male, light (*see* yin)
yin	female, dark. The yin-yang symbol is a circle divided by an S-shape. It symbolizes cosmological harmony
zai	'planted' (pile)
zha	'binding' or 'tying' (stitch)
zheng	'regular' (stitch)
zhuyu	dogwood

Index

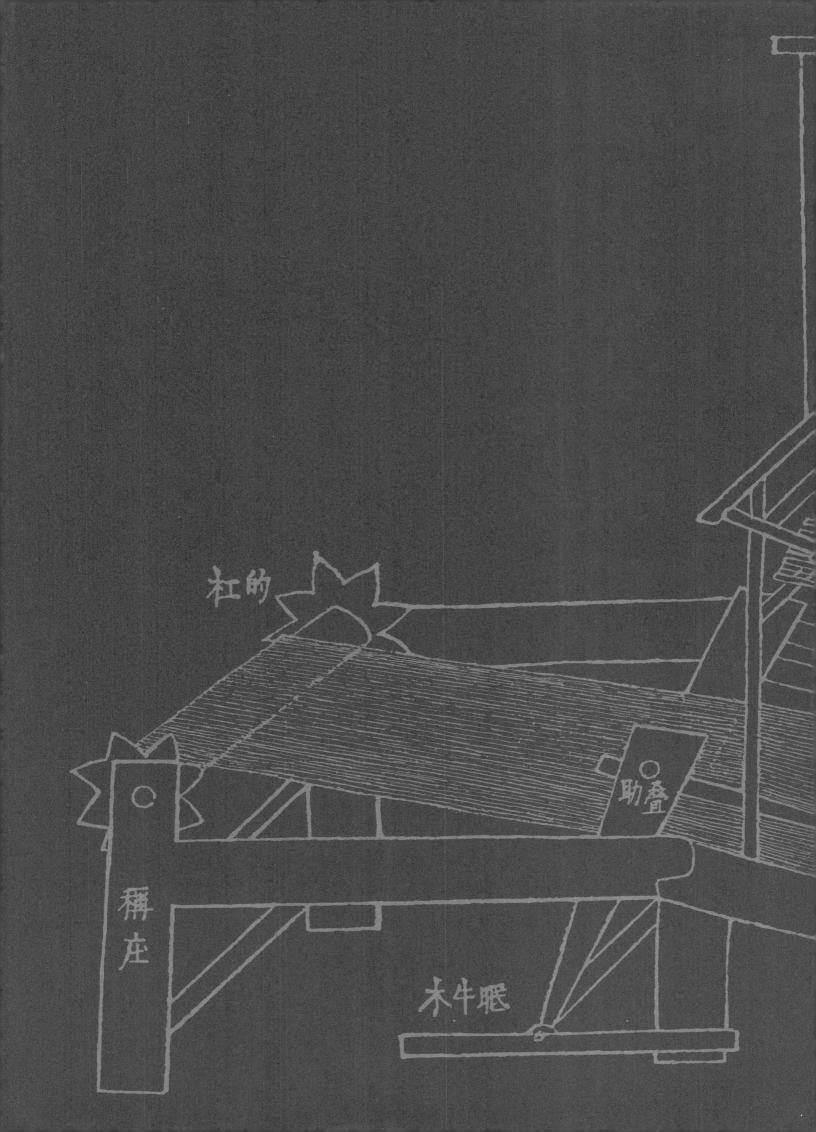